FLICKERING TREASURES

FLICKERING

REDISCOVERING BALTIMORE'S FORGOTTEN

TREASURES

MOVIE THEATERS AMY DAVIS

Foreword by Barry Levinson

JOHNS HOPKINS UNIVERSITY PRESS · BALTIMORE

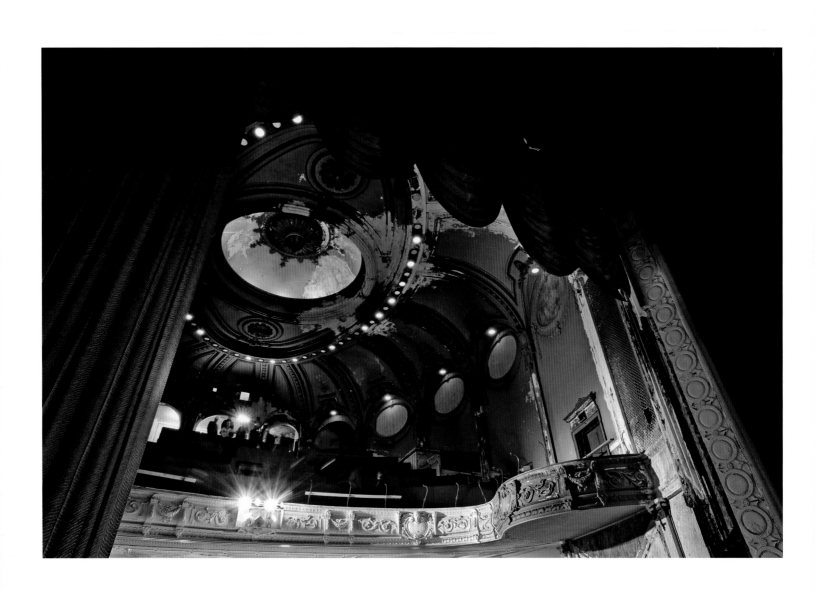

CONTENTS

There was nothing quite as exciting as going to the movies on a Saturday, starting for me around the age of seven in the late 1940s. Not nighttime ones, that would come later, when I was old enough to date. But when I was seven or eight years old, my cousin Eddie and I, like a ritual, went to the movies just two blocks away at Gwynn Oak Junction.

There were two theaters there: the Gwynn was on one side of the street and the much more elaborate thirties deco theater called the Ambassador was on the other. We didn't really know the difference between a so-called A picture or a B picture, we just knew that the Gwynn had the most exciting pictures. Those films didn't begin with an MGM lion, or the Paramount mountain, or the Universal globe—they were made at places called Republic Studios or Monogram. A lot of those films seem to begin with a canvas-topped truck filled with dynamite speeding along a mountain road; then the truck would go off the cliff and explode. That was a good beginning. And there were a lot of Westerns, but not the John Ford type of Westerns. These were the Gene Autry or Roy Rogers types, and they didn't seem to take place in the Old West. Somehow, mixed in among the horses and the stables, there would be a pickup truck and a ranch house that had a radio.

So, we saw a number of Roy Rogers movies, but we didn't care for the singing parts. And we certainly had no interest in the girlfriend, Dale Evans. But we were fascinated by the color. Everything seemed orange, or a variation of orange. Roy had very blue eyes, I believe, and a very orange face. His horse, Trigger, also seemed orange. One day I checked the movie poster and discovered that it was not a Technicolor movie, it was a Cinecolor movie. So from that day forward, whenever we saw a Roy Rogers movie, we looked forward to an orange experience. The stories didn't seem to make a lot of sense, but we didn't really care. The Saturday matinee was an activity in itself.

Sometimes we went next door to Ben Franklin's, which was sort of a five-and-dime store, and we'd load up with peashooters and bags of peas. This became a fun diversion when we lost interest in the film; we could just shoot peas at one another in the dark. We'd hide behind the chairs or crawl along the aisles—it was eight-year-old warfare. There were multiple movies that you would see in the course of the day—two, sometimes three, a bunch of cartoons, short subjects, some short films, some serials, as well as the newsreel that covered current events and some college football games. On occasion, we would wander over to the Ambassador. I remember seeing *Samson and Delilah* there, which was a big-screen biblical movie that caught our attention and imaginations. This was the first "spectacular" film that we'd ever seen: a cast of a thousand, Technicolor, with big music. We debated for hours how it was possible for Samson to push the two

columns so that the entire building would collapse in on itself. I kept wondering . . . what would happen if Samson spread his arms to knock down the columns and he was just two inches too short to be able to push them down simultaneously?

Suddenly, or so it seemed, the Gwynn closed down. There didn't seem to be a warning; one day it was just shut down for good. So, we turned our attention to the Ambassador Theater. The Ambassador was a far more impressive theater and had what seemed like a beautiful auditorium. Every Saturday we'd go. We never knew what was playing. There were one too many Esther Williams movies for our taste, but that didn't stop us from watching. Some of the movies in 1951 that we saw were *Strangers on a Train; An American in Paris*, which had too much music for our taste and a big dance number that seemed to go on forever; and *The Thing*, which, to an eight-year-old mind, was perhaps the greatest movie ever made, followed closely by *The Day the Earth Stood Still* and *The African Queen*. We didn't remember the story of *The African Queen* too well, but there was a scene where Humphrey Bogart got covered in leeches, and we talked about that endlessly for days. There was a movie called *People Will Talk*, which was considered a comedy-drama-romance, but the only thing we remembered about the film was the scene with the model trains going in and out of rooms.

I loved watching films. I didn't know anything about who wrote them, I didn't even really know about a director, nor did I pay attention to any of that until I saw *On the Waterfront*. There was a defining moment in it for me, when Marlon Brando was walking with Eva Marie Saint. They're talking and she drops her glove. Marlon Brando picks it up and as the conversation continues, he tries to put that glove on his hand. Here was a one-time boxer trying to put a woman's glove on his hand, and that moment mesmerized me. I couldn't understand how that happened. Who thought of that?

After the movie, I walked outside, and I looked at the poster. It said that it was directed by Elia Kazan, and I looked at who wrote it, and his name was Budd Schulberg. From that moment on, I no longer just watched a film as sheer entertainment. I always wanted to know who wrote it, who directed it, who did the music, who was the cinematographer . . . who made it all happen. I didn't know it then, but that was perhaps step one to my future.

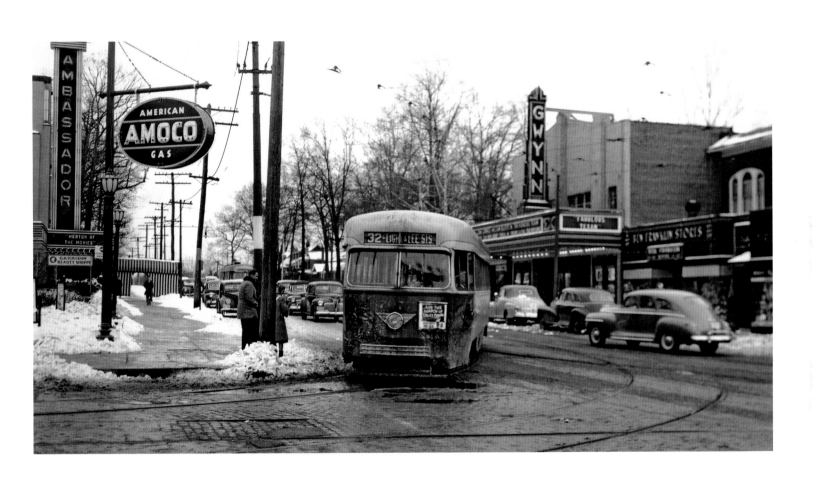

The Senator Theater, an Art Deco treasure built in 1939 and just three blocks from my house, was a beacon on York Road: a comforting, constant presence that enhanced the pride I felt for my neighborhood. When my children and I watched the searchlights raking the night sky for film premieres, we were reminded that there was more to watching movies than sitting close to the cool glow of our small television. Then in 2007 the Senator faced foreclosure. What would become of the last single-screen theater in Baltimore? Its uncertain fate sparked my curiosity about the city's other movie houses, already extinguished. So began my exploration of Baltimore's forgotten movie theaters.

I was stunned to discover how many theaters are still among us, ghosts on the battered streets of Baltimore. Many of our neighborhood theaters are boarded up, even burned out, while others hang on with varying degrees of dignity as churches or stores. Today, it is hard to imagine that Baltimore has been home to more than 240 theaters since the first moving pictures flickered across muslin sheets at the close of the nineteenth century.

The earliest moving images projected on a screen for Baltimore audiences were shown in 1896 at Electric Park, an outdoor amusement park in northwest Baltimore. In downtown Baltimore, short films were shown sporadically for the next few years as added attractions at vaudeville houses and legitimate theaters. Small storefront theaters with cheap 5-cent admissions began to spring up in more densely populated areas of the city around 1907.

By 1916, movie-crazy audiences in Baltimore could choose from among 129 theaters to enter the realm of cinematic fantasy. Every major city had opulent downtown theater palaces by the late 1920s, seating from 2,000 to more than 5,000 patrons. Neighborhood movie houses offered more modest surroundings, but were cheaper and within walking distance. In 1950, when the city's population peaked, the number of theaters in operation reached 119, its second-greatest total. These monuments to popular culture, adorned with grandiose architectural flourishes that implied permanence, led us to assume they would endure forever. Three generations later, by 2016, the number had dwindled to a measly three.

Many movie houses faded from sight because their former purpose is now indiscernible. The vintage black-and-white photos in this book are essential to understanding the dramatic metamorphosis that every theater has undergone. Disregard for architectural preservation seemed to be more prevalent than chewing gum under theater seats.

This is not a conventional "then and now" album, wedded to the formula of matching old and new photographs taken from the same vantage point. Many of the early photos I discovered inspired my photographic approach, but

capturing the character of each theater and its streetscape from the best vantage point available was more essential than finding a duplicate view. I sought a dialogue with the past, not its replication.

A photograph captures one arbitrary slice in time. It instantly catapults the present into the past, but its narrative, like cinema, is less about the death of the moment than the fluid passage of time. The juxtaposition of old and new reminds us of what we've devalued and discarded, but over time that meaning will continue to evolve.

Virtually every aspect of the moviegoing experience is reflected in the stories told by moviegoers and theater employees and owners, which I chose from more than 300 interviews. Each anecdote is particular, yet the emotions recalled so vividly decades later demonstrate the powerful connections we all experience in a darkened theater. Some stories honor the imaginative sparks kindled by film, the cinematic influences that can shape a life. Other memories are nestled in nostalgic detail, reflecting the flavor of a particular neighborhood and time. Those who worked in the business offer insights about the industry and the mechanics of running theaters. Through these collective voices and photographs, an intimate story of the city of Baltimore unfolds. The saga of change, survival, and loss, seen through the prism of our movie theaters, becomes simultaneously joyful and heartbreaking.

Every vestigial theater I encountered, regardless of condition, was poignant to me. I selected theaters that would represent almost all of Baltimore's neighborhoods without too much overlap. Many buildings merited inclusion because of their distinctive architectural elements, while others, victims of outrageous disregard for architectural preservation, begged for redemption through the camera. A repurposed marquee, remnants of fine ornamentation and craftsmanship, quirky modifications, or irresistible nymphs and gargoyles that flirt from above—all of these called out to me as if to say, "You missed my heyday, but I'm still here!"

Imperiled theaters facing demolition or theaters that have been preserved demanded a photographic approach that recorded every detail. Forsaken theaters, already dramatically altered, needed an unconventional documentary approach to suggest their transitory, precarious existence as fragile cultural icons. The technique of selective focus, framed by blurred edges, isolated the most significant elements. I used Lensbaby specialty lenses mounted on a Nikon digital camera to evoke mood for some of the images, eschewing artificial manipulation through post-production methods. A decrepit building still has layers of history embedded within its walls. Rather than surrender to the seductiveness of decay for its own sake, my images acknowledge, sometimes through a veil of soft focus, that an idealized memory of place must still be a part of a building's meaning. The time traveler roaming through these pages is invited to imagine the past within the present.

The chasm between the past and present can be very painful. Our most disfigured and forgotten theaters are metaphors for a city that has fallen short of its promise, its former stability shaken by drugs and crime and disinvestment. Like the vacated theaters themselves, the scarred inner city finds itself surrounded by a wall of indifference. For residents who return to beloved childhood haunts in their old neighborhoods, the transformation is sorrowful.

But what if this blighted scene is your neighborhood? As I photographed the streetscapes of Baltimore's theaters, I hunted for every spark of life that intersected

my viewfinder. In once-bustling commercial corridors, often the only active enterprises were liquor stores, bail bondsmen, and dollar stores. At the sight of my camera, drug dealers scattered. Occasionally, a bold teenager demanded to know, "Are you the "PO-lice?" With my camera mounted on a tripod, I waited for moments of serendipity, sometimes for hours. Each theater and street eventually revealed itself to me in changing light. The sidewalks became a new stage and the residents filled in as the actors. The facades of the old theaters posed as my own colorful stage sets.

Initially, I was reluctant to include theaters that had been torn down, not wishing to create a compendium of parking lots and garages. The importance of the magnificent Stanley, Baltimore's grandest downtown theater palace, and the celebrated Royal, the mecca for top African American entertainment, earned these two a place in the book without hesitation. I documented the wrecking ball that crushed the New Theater in 2010; this demolition must stand in for all the great theaters that disappeared before this project began. The Century and Valencia, as well as five other demolished theaters, charmed their way into the book after I learned how much they mattered to Baltimoreans.

My notion of movie theaters was completely romantic, but film is a product governed by changing rules of distribution. Tracking the openings and closings of theaters over more than a century, I came to realize that movie exhibition is, first of all, a business. The rise and fall of movie theaters is tied to the impact of technological developments, economic conditions, and social change.

The arrival of television and the growth of the suburbs after World War II delivered a double wallop to city theaters. The abandonment of the city by the white middle class, which accelerated after the 1968 riots, was devastating for theaters. Both the downtown palaces and the neighborhood movie houses had functioned as cultural anchors, communal destinations, and economic magnets in their communities. As the city's population shrank over six decades, so did its number of theaters: only fifty-one were in operation by 1970, then twenty-five by 1980, twelve by 1990, and just eight by 2000.

The revival of the Parkway in 2017 represents the first increase in the number of movie theaters in Baltimore in more than half a century. Landmark Theatres, Harbor East opened ten years ago, and another seven-screen theater, CinéBistro, replaced the Rotunda Cinemas in north Baltimore in early 2017. All five active theaters, including the surviving Senator and Charles, offer multiple screens.

We cannot talk about the evolution of Baltimore or its theaters without confronting the issue of race. Most neighborhood theaters had two lives: first as whites-only theaters, and then, as the demographics of urban neighborhoods changed, as primarily black theaters. Painful stories of segregation are plentiful among the reminiscences in this volume, but there are also surprising anecdotes about individuals who bucked the accepted rules. My photographs examine the complicated legacy of the abandonment of neighborhoods by the middle class in all corners of Baltimore. After whites fled the city, middle-class blacks followed in the next decades, leaving behind a population mired in poverty.

The reminiscences are weighted toward the thirties through the sixties, because so many of the contributors are in their seventies or older. These intimate oral histories sweep us into the front row seats of each decade. Remembrances of the nascent years of moving pictures are drawn from newspapers. In periodicals,

theater programs, and building signage, the British spelling for "Theatre" was often used, but I discovered so many variations in name spellings that for consistency I generally opted to use "Theater" throughout the book when referring to theaters by their full name.

Documenting our movie theaters has been a constant reminder that our street-scape, which contains the building blocks of community, is as transitory as the light that illuminates its architecture. The only certainty is that nothing stays the same. Some of the theaters pictured here will no doubt be lost, either demolished or modified beyond recognition. Can we preserve our cinematic cultural history? Can we dream big without the big screens and the buildings that gave us sustenance for so long? The transformational experience of cinema is indestructible, even if the structures that conveyed that message crumble. Loss and change are inevitable, but memory endures.

So take a good look now at what was, what is, and what could be.

FLICKERING TREASURES

1896

1909

"If I knew things would no longer be, I would have tried to remember better."

Sam Krichinsky (Armin Mueller-Stahl), from *Avalon*, 1990
Barry Levinson, director

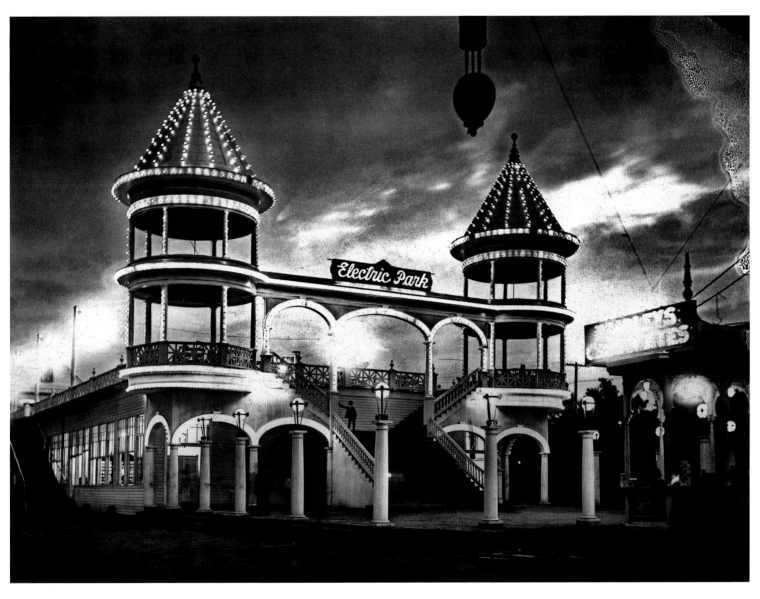

Electric Park, 1905. Courtesy of the Enoch Pratt Free Library, Maryland's State Library Resource Center.

ELECTRIC PARK
1896–1915

Belvedere Avenue and Reisterstown Road

SEATING CAPACITY: 5,000

ARCHITECT: Henry L. Copeland

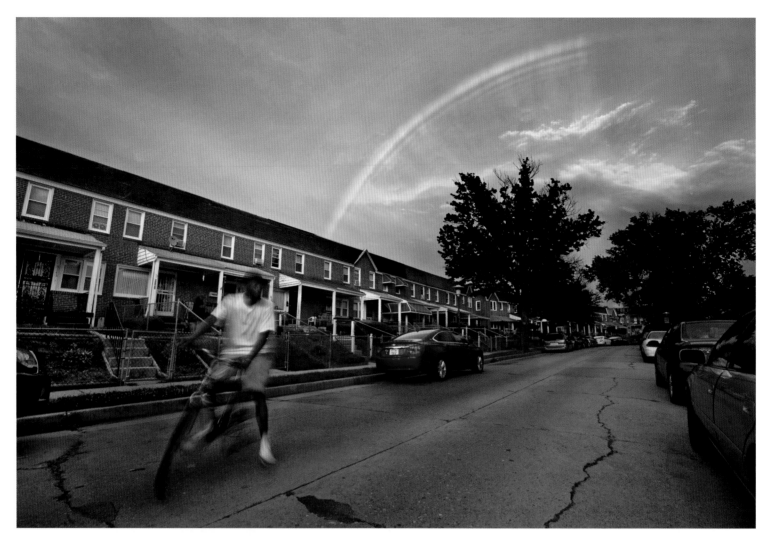

Former location of Electric Park, 2013. A rainbow frames Nelson Avenue (just south of Belvedere Avenue), near the site where projected movies were first shown in Baltimore.

Summer crowds flocked to outdoor amusement parks such as Electric Park, located in northwest Baltimore on the grounds of the old Arlington racetrack, southwest of Pimlico Race Course. The *Baltimore Sun* gushed on February 6, 1896, that "the electrical illuminations will be the most brilliant and extensive yet seen anywhere and will include thousands of incandescent and arc lights." That summer, beneath this spectacular evening glow, visitors enjoyed music, dancing, dining, swimming, rides, and a simulation of the Johnstown Flood tragedy, complete with flowing water. Moving pictures, projected for the first time in Baltimore, became one of the park's biggest draws by 1907. They were shown in the park's casino, which stood in the vicinity of Belvedere and Nelson Avenues. Nine years later Electric Park was razed for residential development.

I can hardly imagine what it would have been like to sit in the audience at Electric Park on that mild, humid evening in June 1896 and watch images moving about on a screen. I wonder if the audience laughed, cried, or jumped out of their seats in terror. Did they go home with their heads spinning? Did they think these movies were inventions of the devil? The audience in the 5,000-seat casino that night witnessed the first exhibition in Maryland of a movie projected on a screen. Movies had been around in Baltimore for almost two years, but they had to be watched as peep shows by looking into viewing cabinets. Today we would consider those first films quaint, girls dancing with umbrellas, four workers at a blacksmith shop, the busy corner of 33rd Street and Broadway in New York City, and a girl skirt dancer, but it must have been a thrilling moment when these images danced across the screen accompanied by the music of Prof. Fisher's band.

Electric Park opened on June 8, 1896, to spectacular reviews. It is not clear when the first exhibition of the Vitascope took place. Something went wrong with the projector on opening night and movies could not be shown. An article on June 13 reported that the Vitascope exhibitions would continue the following week. An exhibition was certainly given on June 16. The twenty-four-acre park was built by August Fenneman's Electric Park & Exhibition Company on the old John L. Kreis estate on Belvedere Avenue. In addition to the casino, where the movies were shown, the park also had a lake and a racetrack. It was one of several parks built on rail lines around Baltimore where people could go for relief from hot summer weather.

Fenneman asked Charles E. Ford, the popular Baltimore theater man, to run the shows at Electric Park. Ford contracted with representatives of Raff & Gammon to provide the Vitascope projector. The Vitascope and its movies were so popular that the Baltimore American said, "The Vitascope was the main feature of the evening, and the reproduction by it of scenes from life made one realize the greatness of the Wizard Edison, who invented it." Edison didn't really invent the Vitascope—that honor goes to Thomas Armat and C. Francis Jenkins—but Edison's name sold more tickets. In Electric Park's second week, the Vitascope moved to top billing. Before Electric Park closed in 1915, it introduced thousands of Baltimoreans to motion pictures and provided pleasant outings from the hot Baltimore summers.

Robert K. Headley, theater historian

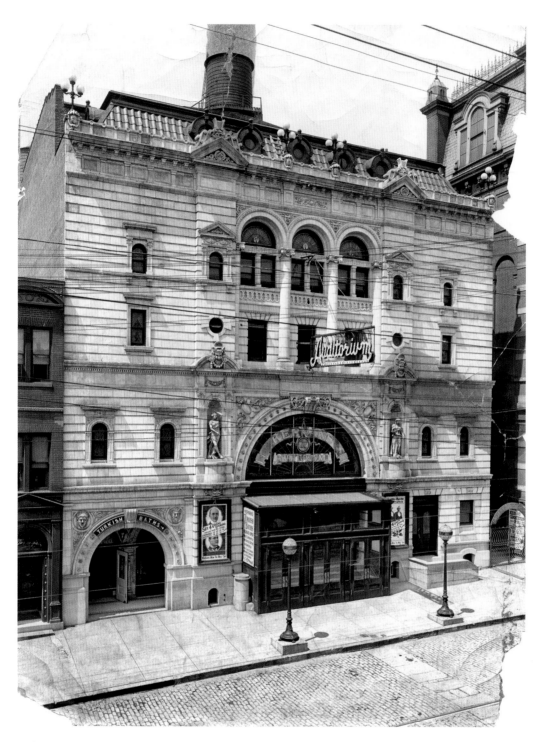

Auditorium Theater, 1904. Courtesy of the Jacques Kelly Collection.

Opposite: 508 North Howard Street, 2014. Eugene Bell.

AUDITORIUM/MAYFAIR
1904–1986

508 North Howard Street

ORIGINAL SEATING CAPACITY: 2,000

ARCHITECT: J. D. Allen & Company

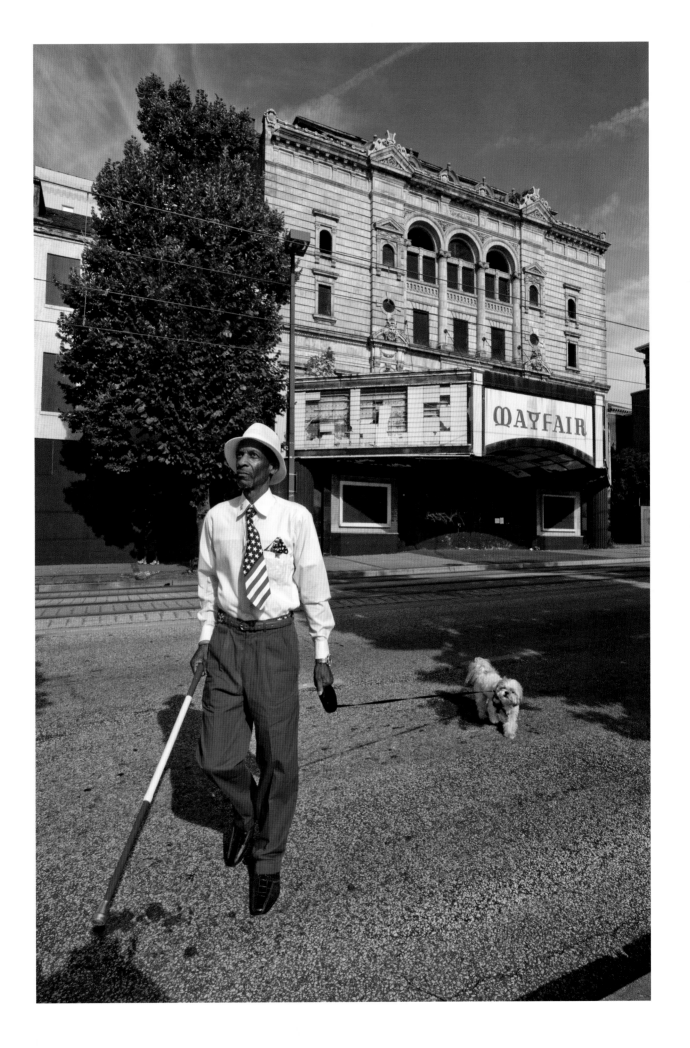

The Mayfair and Stanley stood side by side for almost four decades. Like aging family members, these once-splendid showhouses leave unresolved the question of whether sudden death or a long, drawn-out demise is more painful to witness. The Stanley was bulldozed in 1965. Only the Beaux-Arts facade and shell of the lobby remain of the abandoned Mayfair, which was left to disintegrate by the city after it closed in 1986. The Mayfair is a heartbreaking example of demolition by neglect.

The history of the Mayfair site is fascinating. Theater impresario James Lawrence Kernan converted a two-story bathhouse into a legitimate theater called the Howard Auditorium in 1891. Three years later, Kernan transformed the theater into an "ice palace" for skaters, with a rooftop garden. This too was short-lived, and the building was remodeled into a theater in 1895. Beginning in 1896, the Auditorium, as it was known, occasionally exhibited short moving pictures. The Auditorium that Baltimoreans remember from the years leading up to World War II was the third theater constructed at this address in 1904.

Kernan had ambitious plans for an entertainment complex. The elegant new Auditorium opened on September 12, 1904, as part of the "Million Dollar Triple Enterprise," which also included a hotel and the Maryland Theater around the corner on West Franklin Street. The Maryland was razed in 1951, but Kernan's hotel, later called the Congress, still exists as an apartment building. The buildings were connected via underground tunnels, and luxuries such as marble-lined Turkish baths were available in the basement of the Auditorium.

Since the Maryland presented a mix of film and vaudeville, the Auditorium began to offer legitimate theater and concerts. Kernan's empire gradually declined after his death in 1912. It wasn't until 1915 that a permanent projection booth was installed in the Auditorium. Sound equipment was added by 1929, but during the Depression the Auditorium floundered.

The Hicks circuit bought the Auditorium in 1940. Baltimore architect E. Bernard Evander created a new theater box inside the old one. A huge marquee obscured the statuary above the front entrance. In 1941 it reopened as a first-run movie theater called the Mayfair, but over the years it struggled to get good product.

Jack Fruchtman bought the aging Mayfair in 1957. He replaced the marquee, and installed 70mm equipment before the Baltimore premiere of *Lawrence of Arabia* in 1963. The modernization included new seats, which reduced the seating capacity to 783. The Mayfair played other exclusive engagements, including *Exodus*, *West Side Story*, *Mary Poppins*, and *Dr. Zhivago* in the 1960s. In its final years, the Mayfair, like the other faded downtown theaters, became a grind house, presenting action adventure pictures, martial arts flicks, and quasi-soft-core porn mixed in with first-run films.

The year after the Mayfair closed, Baltimore City acquired the boarded-up theater. By 1998 the roof had collapsed, leading to the disintegration of the exposed interior structure. Trees sprang up between the decaying seats. A fire in 2014 destroyed the adjacent nineteenth-century building, and the resulting structural degradation led engineers to determine that the rear of the theater, including all but the front and lobby, needed to be demolished. Salvaging the noble facade will enhance the character of future redevelopment, but the stately Mayfair had so much more potential.

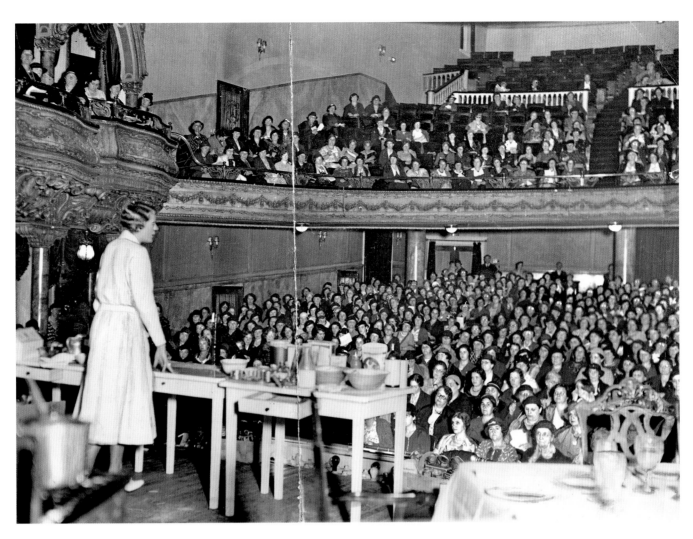

Above: Auditorium Theater, 1933. A cooking lecture at the struggling Auditorium during the Depression. © Hearst Communications, Inc. Courtesy of the *Baltimore News-American*, Special Collections, University of Maryland Libraries.

Right: Mayfair Theater, 2008. For many decades the two statues above the entrance were obscured by the marquee.

I was nineteen, going to college, and it was just a summer gig in 1968, supervising the Mayfair, Little, New, Town, and Hippodrome [theaters]. I walked into the Mayfair clutching a bulging scrapbook provided to me by Milton Friese, 82, who had worked at the Auditorium/Mayfair for over fifty years. We sat on one of the red banquettes and Milton leaned toward me to tenderly turn the pages that included old photographs, playbills dating back to 1905, movie posters, blueprints, and newspaper clippings. Hours passed and when we shut the book I could feel what it was like back in the early 1900s when gilded carriages would drop off Baltimore's wealthiest citizens at the Auditorium, which offered legitimate theater as well as beautiful marble Turkish baths. After the baths would come a swim in one of three ornate pools, followed by a respite of brandy and cigars.

Milton smiled as he escorted me deep into the theater, for he knew what treasures were waiting: large dressing rooms with the original silk wallpaper and large ornate mirrors, pulleys and levers used to move sets around, still exactly in place. Scattered around like debris were Louis XIV desks and bureaus, heavy damask chairs, embroidered sofas, and Turkish carpets. Milton turned me around to face a particularly large dressing room and proclaimed, "That was the great John Barrymore's dressing room . . . you know, he liked his scotch neat!" As a time traveler with Milton, I moved from the clopping of horses to the roar of Packard convertibles in the early twentieth century as the swells arrived for vaudeville, plays, and moving pictures.

Remodeled in the 1940s, the Mayfair, as it was now called, began to show first-run movies. One day in late March of 1970 management booked the movie Woodstock. Customers came, not in beautiful carriages or fancy open convertibles or wearing long dresses with white gloves, but in bell-bottomed pants and hair, lots of hair, high stacked shoes, and dope, lots of dope.

Jeffrey Jay Block, insurance broker

The Mayfair was where I grew up. I had just turned sixteen, and my cousin Chuck Arbogast, a projectionist at the Mayfair, got me the job of marquee boy at the Mayfair and Mayfair II. The former Little Theater across the street was renamed Mayfair II when JF Theaters took it over. I remember putting up "Clint Eastwood as the Enforcer" in metal letters, 2½ feet tall. Since I needed more work, my cousin said, "We'll train you to be a projectionist." But to be in the union, you needed a license to run motion picture equipment in Baltimore City. My cousin Chuck and his uncle trained me. You had to be eighteen to get your license, so they told Local 181 that I was eighteen. The Maryland Censor Board just took their word for it.

Carbon arcs are what they used to light the projectors. The copper-coated carbon negatives look like pencils. When the positive and negative carbons touch, it starts the electricity flowing. Then you back them apart about a quarter of an inch, and you have this ball of gas between them burning about 10,000 degrees. When the crater at the end of the positive carbon lights, it projects the light into the reflector, where it is gathered and focused toward the aperture of the projector. You try to get it as bright as possible without a hot spot. It pinpoints the heat right at that surface. It reflects light, but heat is passing through. A hot spot can cause film damage while the film is running. They are usually good for about forty, forty-five minutes. You always had changeovers to another projector because one carbon couldn't handle a whole film. Carbon arcs were replaced by xenon lamps in the late seventies. Carbon arcs could be dangerous. You could get electrocuted.

Dominic Wagner, projectionist and former theater owner

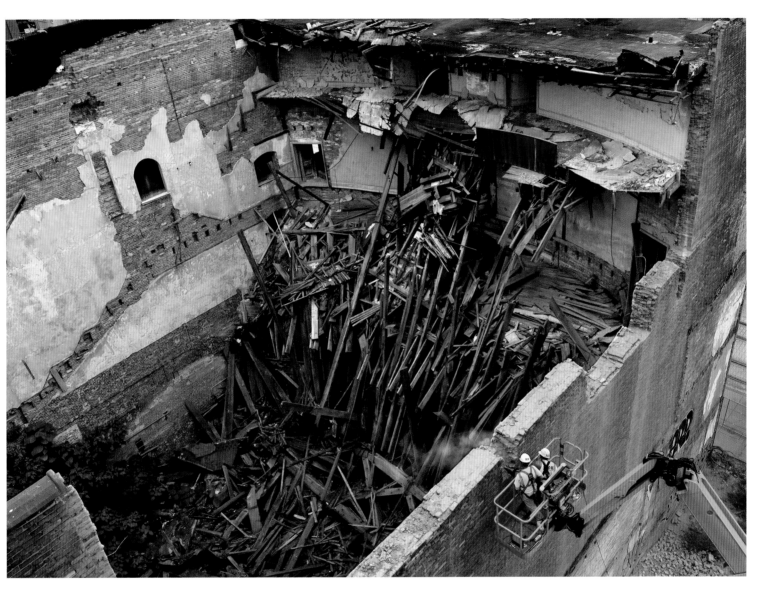

Partial demolition of the Mayfair Theater, 2016. The interior was ruined after the roof collapsed in 1998.

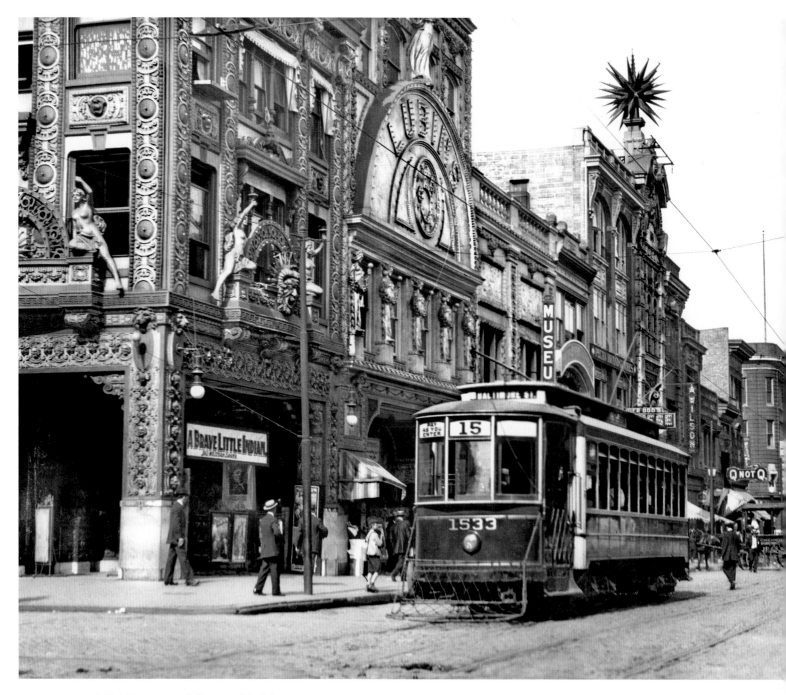

Lubin's Theater, c. 1908. Courtesy of the Baltimore Streetcar Museum.

COLONNADE/LUBIN'S/PLAZA

1905–2010

404–406 East Baltimore Street

ORIGINAL SEATING CAPACITY: 35

ARCHITECT: unknown

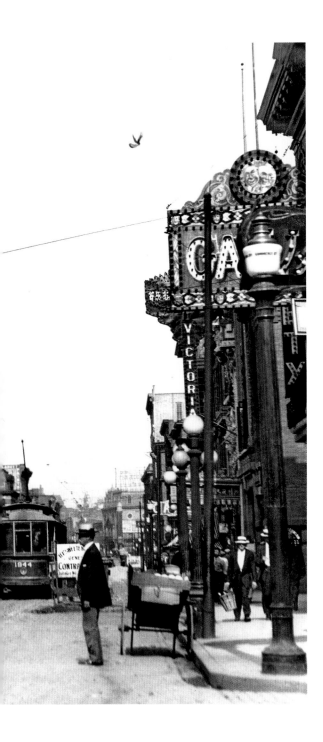

Flames shaped the saga of Lubin's, even before the arrival of Blaze Starr, the legendary stripper on "The Block." The first indoor theater designed for the exhibition of motion pictures, it opened in a building constructed after the Great Fire of 1904, which leveled much of downtown Baltimore. A penny arcade occupied one-half of the ground floor, and William Brown set up a thirty-five-seat theater in the other half in 1905. Before he could show his first reel, a fire broke out in the projection area, and he was finished.

Brown sold the place to Marion S. Pearce and Philip J. Scheck, pioneer film exhibitors. Seating was expanded to seventy-five seats and admission was a nickel. In 1906, as the Colonnade, vaudeville was presented upstairs.

Siegmund Lubin, an optician turned theater owner from Philadelphia who also had his own film studio, took over the theater and invested thousands of dollars in renovations. The ostentatious stucco facade included five female statues, with "Lubin's" and "5¢" illuminated by incandescent light bulbs. Lubin's architect, Franz Koenig of Philadelphia, kept the space as a "combination house," showing moving pictures on the first floor and vaudeville and films upstairs. Soon thereafter, Lubin expanded to 408–410 East Baltimore Street, where he opened the short-lived Lubin's Family Theatre.

Lubin's changed hands several times, and in 1927 it became the Plaza. The following years were not kind, as the theater began to reflect the seedy character of the burlesque joints and bars in the red-light district. Echoing the bad luck of Mr. Brown, another fire broke out in the projection booth in 1935. A fire at the Gayety across the street in 1969 led to the establishment of Gayety Show World in the Plaza. Two strip clubs and an adult video store with private viewing booths were entertaining customers when a five-alarm fire engulfed The Block on December 6, 2010. On a bitterly cold night, scantily dressed dancers fled 404 East Baltimore Street, where the fire had started. Scorch marks are still visible on the four-story shell of Lubin's, Baltimore's first purpose-built theater.

The Block was The Block. It always was. On the north side, The Block had the Grand, Lubin's, Clover, Globe, and Rivoli. At the Clover and Globe you'd get two movies, minor league vaudeville, and strip-tease. Only the Rivoli was a first-run theater on The Block. That one was classy.

Lubin's was next door to the Grand. It was still 10 cents in the early thirties. They had two aisles; the center had maybe eight to ten seats, and the sides, four to five seats. I was ten or eleven years old. A guy comes out with his spray during the movie, to kill the bugs. He goes up and down both aisles, spraying on the floor, left and right. Then he comes out again, with a cooler filled with ice cream sandwiches. He calls out, "Ice cream, 5 cents." I didn't have money for ice cream, not that I wanted any after the bug spray. It was a real scratch house.

I went to St. Leo's School in Little Italy. On All Saints Day, a Holy Day of Obligation, you went to mass in the morning. Then you were free. So I walk down to The Block. I look at all the posters. Lubin's had Tarzan the Ape Man, with Johnny Weissmuller. I could barely reach up to pay the dime. The ticket taker asks, "How come you are not in school?" She wouldn't take my dime. I was very upset, because I really wanted to see the movie. It just so happened that a neighbor was there. I said to him, "Tell this lady this is a Holy Day of Obligation!"

Victor J. Lancelotta, retired real estate developer

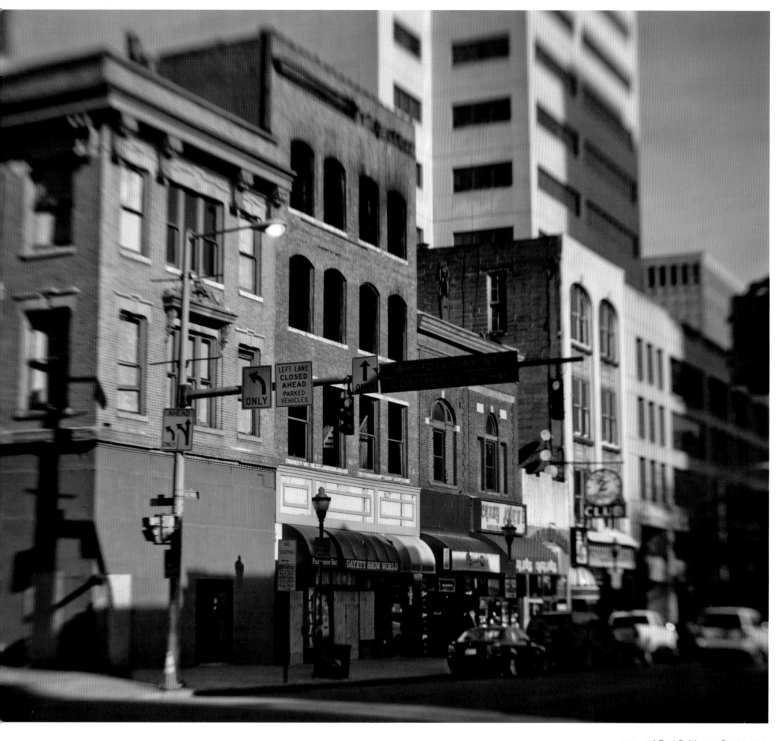

404–406 East Baltimore Street, 2011.

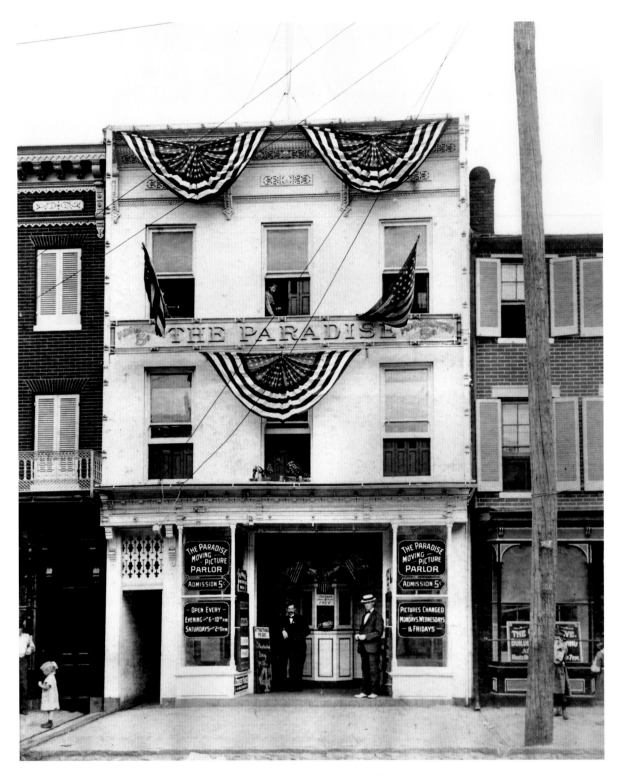

Paradise Theater, c. 1906. Owner J. George Hoffmeister, wearing a straw hat, stands by the ticket booth.
Courtesy of Charles and Pat Wrocinski.

PARADISE

C. 1906–1912

1727 Fleet Street

ORIGINAL SEATING CAPACITY: 125 to 200

ARCHITECT: unknown

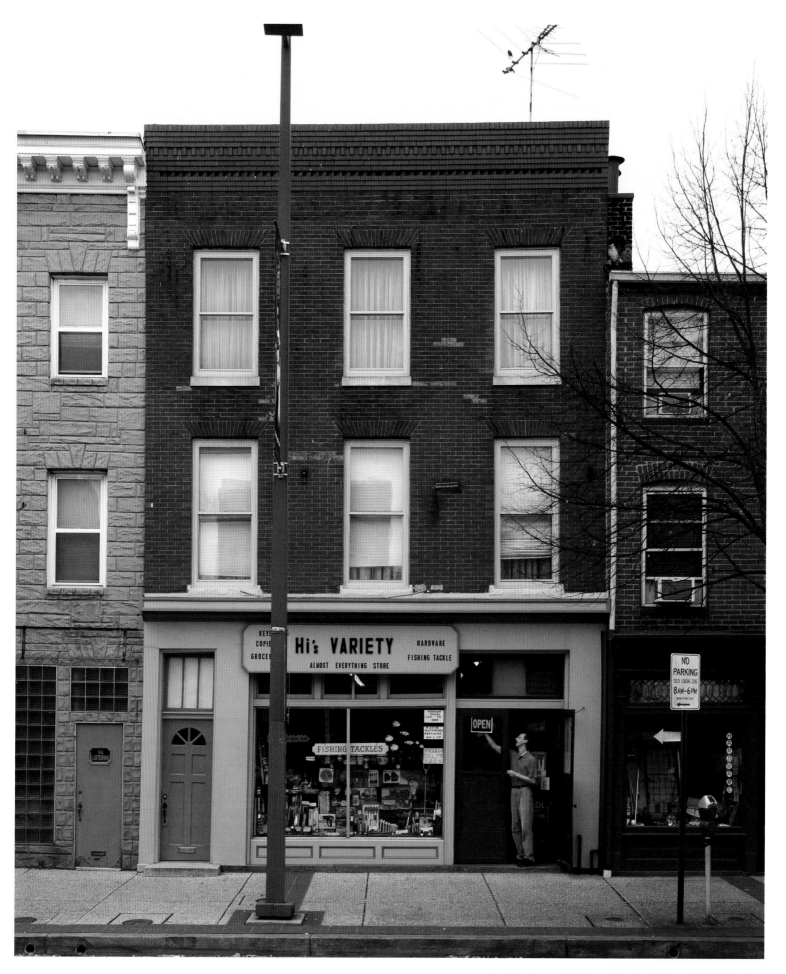

1727 Fleet Street, 2014. Pat Wrocinski begins his day at Hi's Variety store.

Charles and Pat Wrocinski, the brothers who own the well-preserved Paradise Moving Picture Parlor building, are rightfully proud of what they believe is Baltimore's first movie house. The debate over whether the Paradise is actually Baltimore's earliest theater designed specifically to show moving pictures will not be resolved here. Theater historian Robert K. Headley and others give the nod to the makeshift theater on East Baltimore Street that later became Lubin's.

The debate hinges on whether theaters that showed movies as part of their vaudeville program should be considered or whether only theaters designed for the exhibition of movies ought to be included. Viewings of the earliest short films made by competing companies took place from 1896 through 1900 in churches, halls, stores, and several theaters, including the Lyric, Ford's, Academy of Music, Auditorium, Monumental, and the Lyceum. Sporadic showings of film continued in the early 1900s at various theaters known primarily for vaudeville, musical comedies, and plays. Since these were never solely movie houses, none of these qualify as Baltimore's inaugural movie theater.

A legitimate contender to Lubin's is Tom Bohannon and Harry Lewy's Wizard, a sixty-six-seat theater at 219 North Eutaw Street, at the corner of Clay Street. Robert K. Headley ranks this enterprise, which operated from 1906 to 1913, as Baltimore's second movie theater. Most of the films shown at the Wizard in the beginning were four minutes long; *The Great Train Robbery* was a whopping twelve minutes and had to be shown in two parts.

This brings us back to the Paradise. A hardware store owner named J. George Hoffmeister was operating the Paradise as a nickelodeon by 1906. The Paradise eventually became a pool hall, a Polish press and print shop, and Tom's Cut-Rate Meats.

Although the timing of its opening as a picture parlor is uncertain, we do know that the remarkably unchanged Paradise, on a quiet block of Fleet Street, is still standing. Charles and Pat Wrocinski continue to operate Hi's Variety, an indispensable neighborhood shop begun by their parents, in this one-time nickel movie house. They are fiercely loyal to the preservation of their charming building.

My husband, J. George Hoffmeister, bought [The Paradise Moving Picture Parlor] in 1905 from Pearce and Scheck, who had opened it only that year but had already gone broke. The problems of running the Paradise were great, because movies were so new and strange. Nothing was automatic; the projector was operated by cranking a handle. Sometimes Frank Sousa, the operator, would doze off and the film would slow down. Then you'd hear shrieks from the crowd.

The films had a habit of breaking at the most crucial moments, too. Then Frank would have to flash a slide saying, "One Minute, Please!" while he glued the torn ends together. That was the signal for everyone to start stomping their feet.

Talkies were of course unknown, yet there was more noise in the Paradise than in a modern theater. Sound effects were ably supplied by the piano playing of Mr. Bredelmeyer. When he was sick, phonograph records were played—which could be amusing, for then sometimes a military march came on during a love scene. A couple of years after he bought the Paradise my husband put two people behind the screen to talk in time with the actors.

Those early moviegoers could be really rowdy. Because movies were so new, perhaps, and because people were so used to stage shows, they took the films as some sort of huge joke. When the villain was getting the best of it, they would hiss and boo. They would cheer for the hero and laugh at the love scenes. And the boys were not above throwing stink bombs.

Ella Hoffmeister, wife of the owner of the Paradise Moving Picture Parlor
"I Remember When . . . The Talkies Walked Off Stage,"
The Baltimore Sun, *February 26, 1950*

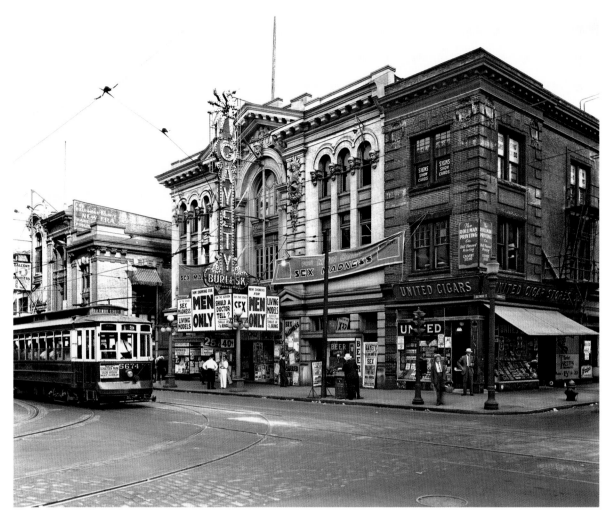

Gayety Theater, c. 1940. Photo by John Dubas. Courtesy of the Maryland Historical Society, #MC9256.

GAYETY
1906–1969

405 East Baltimore Street
ORIGINAL SEATING CAPACITY: 1,600
ARCHITECT: J. B. McElfatrick & Sons

The Gayety is not remembered for its films, which it did show occasionally from 1907 on, but for its burlesque entertainment. What was risqué then would be considered quaint by today's hardcore standards. The suggestive exterior by J. B. McElfatrick, a prolific and innovative theater architect in the late 1800s, is still a wonder to behold.

In its heyday, the Gayety's four-story animated neon sign, featuring a kicking girl on top, was a landmark of the red-light district. Sailors and soldiers the world over knew of the Gayety. Couples came to The Block, and women made up almost a third of the Gayety audience.

John H. "Hon" Nickel, who bought the Gayety in 1910, brought big-name talent to its stage for over fifty years. Strippers like Ann Corio, Margie Hart, the Carroll sisters,

Valerie Parks, Blaze Starr, and Irma the Body packed the house. Red Skelton, Jackie Gleason, and Phil Silvers were a few of the nationally known comedians who cracked jokes on the creaky stage. In the sixties strippers tried to keep the tease in striptease, but by then popular adult entertainment had lost any subtlety, and the accompanying bands were replaced by phonograph records and a lone drummer.

A five-alarm fire in 1969 gutted the Gayety. The exterior was preserved and the interior was converted into office space, but a bland and respectable future was not to be. In 2003 Larry Flynt's Hustler Club leased the Gayety, and "Hustler Honeys" have replaced the "Kuddling Kuties" of 1928.

The Baltimore Block was a great adventure. It attracted a number of high school teenagers like myself from DC. We lived in a time of sexual repression and the mere suggestion of something was titillating. The girls at the Gayety were a little prettier—not that they were bad at the Two O'Clock Club!

It was the comedy routines that were the surprise. I found myself enjoying those old burlesque sketches, especially at the Gayety. Routines like "Floogle Street" and "Niagara Falls" were really masterpieces of precision and effectiveness. I think it engendered in me a love of comedy. Without duplicating it, I think it seeped into my work. The Addams Family used vaudeville as its source in many ways.

I transferred to Johns Hopkins University and stayed at the Phi Kappa Psi fraternity house. I was opposed to the typical hazing that went on. When they asked me to be the pledge master I decided that we would do things differently. I had one of the initiates dress up as a priest and get a box seat at the Gayety. It completely changed the show into the cleanest and most awkward burlesque show I had ever seen. The strippers kept more on than ever. I would imagine that some of the attendees not with us wished they had their money back. They'd get to a spot where they had a risqué joke, and they'd self-censor it. Yet there was this group of fraternity boys laughing like hell. Everyone was wondering why we were laughing.

John Astin, actor

My mother was a dancer at the Gayety and also participated in the vaudeville with the comedians. The lights would come down, and the announcer would say, "Here comes Bunny Holiday." As a small child, about six, I was in the wings while she was doing her exotic dance with pasties on and tassels. We used to get to see her tassels go in opposite directions. She had flaming red hair and she was short and everybody loved her. Blaze Starr was one of her friends. There was an art to taking your clothes off. They never stripped all the way down. This was around 1948 to '50.

I remember being in the dressing room with all the dancers, but I was too young to get excited. It was a chance to be with her. She boarded me out for $7 a week. I lived with strangers on Homestead Street in Waverly. Lived between them and my grandmother, back and forth. After several years the payments stopped coming and they raised me anyway. Her real name was Emma Manning. She died young.

Charles Parrish, real estate investor, broker, and teacher

You weren't a man until you had been to the Gayety burlesque. It was a rite of passage, the thing to do, at age fourteen or fifteen. In those days the only way to see naked women was in Playboy and National Geographic. The guys from Poly had to wear coats and striped rep ties, and that's how we went to the matinee at the Gayety in 1965 to '66, cutting the last few classes and carrying our brown bag lunches.

The audience was mostly teenage boys and old men with trench coats over their laps. We saw a couple of strippers and baggy pants comics, plus a tired old three-piece jazz combo. Women would go down the aisles selling cigarettes and how-to sex manuals. Women stripped down to G-strings and pasties: there was Virginia Bell with her twin Liberty Bells and Tempest Storm. There was no drinking in there.

It was a classic old burlesque theater, but in disrepair by the sixties. There were always seedy characters hanging around the red-light district, which spanned four to five blocks. Renowned stripper Blaze Starr said to me, "It used to be so elegant. The beginning of the end was when they allowed you to come into the clubs in jeans."

Steve Yeager, filmmaker and professor

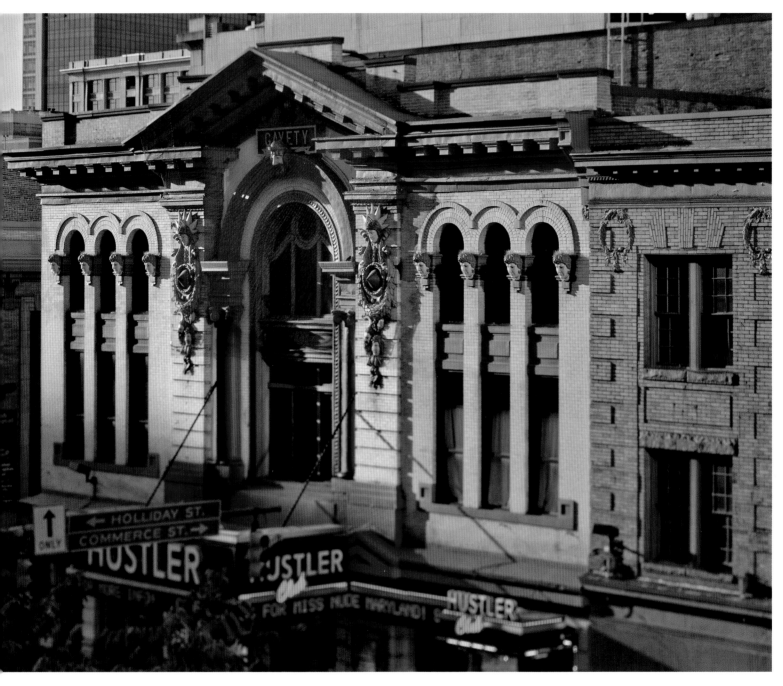

405 East Baltimore Street, 2014.

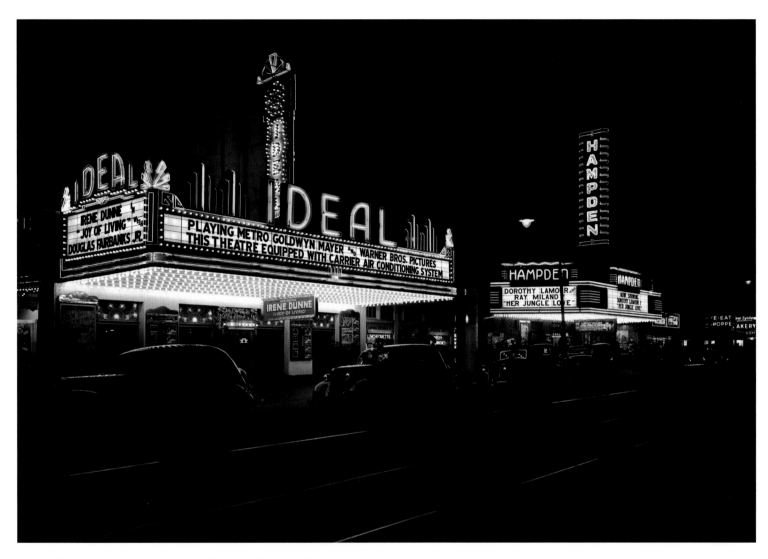

Ideal and Hampden theaters, 1938. Courtesy of the Robert K. Headley Theatre Collection.

IDEAL
1908–1963

905 West 36th Street
ORIGINAL SEATING CAPACITY: 300
ARCHITECT: unknown

Julius Goodman bought the Ideal in 1922 from Pearce and Scheck, who had built the small theater in Hampden in 1908. Goodman also purchased an open-air theater on the north side of West 36th Street. The Airdome had no ceiling or floor and seated 500 on hard benches. During steamy summer months, the Ideal only opened during bad weather. When rain stopped the outdoor show, the audience would troop across the street to the Ideal, where the movie would be continued. The rowdy crowds led to the Ideal's early nickname, "the madhouse."

In 1930, the Ideal expanded next door, doubling its size. Many Art Deco details from this period have been preserved, such as a stylized sun design painted on the large domed light in the center of the auditorium. Elissa and Al Strati, who owned the Ideal from 2005 to 2014, replicated the sunburst wall lights and restored other Art Deco features for their antiques emporium.

The Ideal was a typical neighborhood theater, or "nabe," with a 15 × 20 foot screen. It was a twenty-one-day house;

pictures arrived twenty-one days after opening downtown. Julius Goodman's son, Sol, kept the Ideal running until revenue dwindled in the late fifties.

An Arundel Ice Cream store was conveniently located between the Ideal and its friendly competitor, the Hampden Theater. The Hampden, which appears in both photographs, opened in 1911 and was run by the Hicks family until it closed in 1974. The current building was built in 1926.

In 1960, the Schwaber organization bought the Ideal, but it lasted only three more years before becoming a Salvation Army store. After a change in ownership in 2014, the Ideal was leased to the Ministry of Swing dance studio and became a multi-use arts performance space. Coming full circle, George Figgs and Rob Hatch, organizer of the Baltimore 48 Hour Film Project, initiated occasional film screenings in 2016.

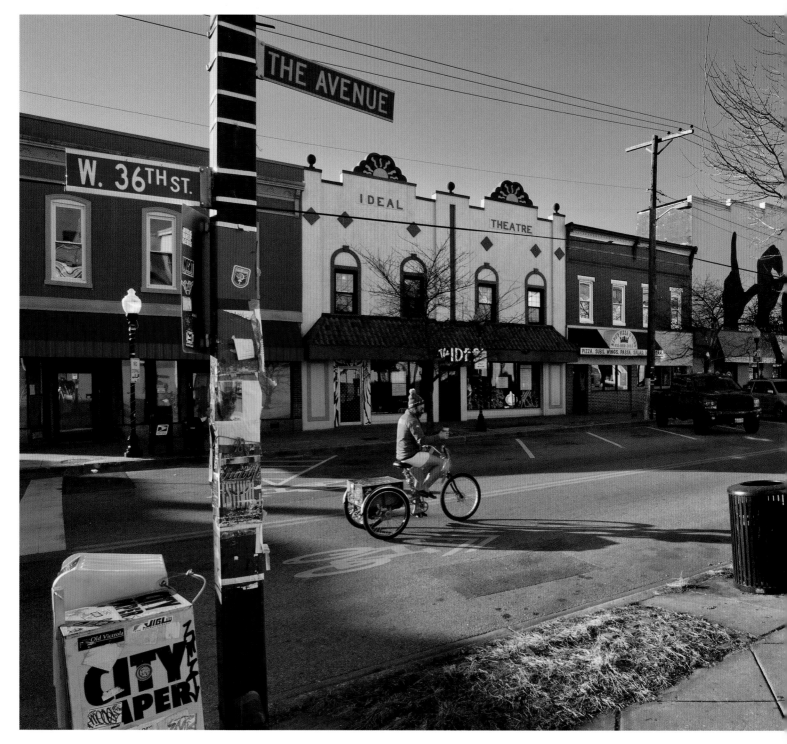

905 and 911 West 36th Street, 2016. Lou Catelli, who calls himself the patron saint of Hampden, pedals by the Ideal.

My father, Julius Goodman, purchased the Ideal after leasing it around 1916. The Depression was the golden era for movie theaters, all cash. People wanted to forget their troubles and stay cool. When World War II came, the movie business boomed. After the war, it was still popular, until the advent of television. Television ended the movie theater business.

My father would get on the B&O to Washington, DC, every Monday, have breakfast on the train, and go to the Film Exchange on Jersey Avenue. He'd negotiate with MGM, Warner Bros., and RKO; those were our majors. My father screened every movie, to make sure the sound was right. I ran the Ideal after my father died in 1949.

We had a cashier who worked for us forever, named Miss Florence Mules. She must have come with the building. She worked from the time we opened until the time we closed, seven days a week. When children would come in, she would say, "How old are you? When are you going to be twelve?" The kid would say November. In November she would remember to charge the adult price. We didn't allow any roughhousing. Miss Mules would say, "You are banished for three months." So the kids were afraid of her.

During the Depression the daytime prices were 15 cents for adults, maybe 5 cents for kids. After 6 p.m., it was 25 cents for adults and 15 cents for kids. I remember when Gone with the Wind came we charged 50 cents. That was unheard of.

John Wayne, Glenn Ford, Gene Autry, and the Bowery Boys were big draws. No matter what Esther Williams made, it was a smash. Clark Gable was only a fair draw. Bette Davis, Katherine Hepburn, and any picture that had "love" in the title was death at the box office. Andy Hardy and Lassie were very big.

I'd call Miss Mules around 10:30 p.m., after the last ticket sales. One night the receipts were $3. This was about 1953 to 1954. That was when I knew that the movie business as we knew it was through.

Sol Goodman, former theater owner and retired auto leasing executive

My mother had a breakdown. I was taken to the movies by my next-door neighbor every day for an entire year. That's when I developed the theory that movies were a religion. I noticed the projection beam coming out of the hole in the secret projection booth. I associated the beam of light with the Sunday school Bible pictures of God's rays coming out of the sky. I became really, really curious, and snuck up there one time because I wanted to see God. I met the projectionist at the Ideal, Mr. Jimmy, who had two-tone shoes, a gabardine suit, loud tie, and hair slicked back. He'd take me up to the booth. I was five or six.

Instead of watching the movie, I'd watch the movie in the beam. I'd see the chiaroscuro of lights and darks when I sat in the front seat, looking obliquely at a forty-five-degree angle into the beam of light. I was seeing this abstract thing that was turning into the movie. I'd be hypnotized.

The Ideal had a fake stone grotto in the lobby with a fountain with goldfish in it. They would let me do my homework in the lobby, and I would help the candy lady. They knew my mother and they kept an eye on me.

George Figgs, artist, film historian, and former operator of the Orpheum Cinema

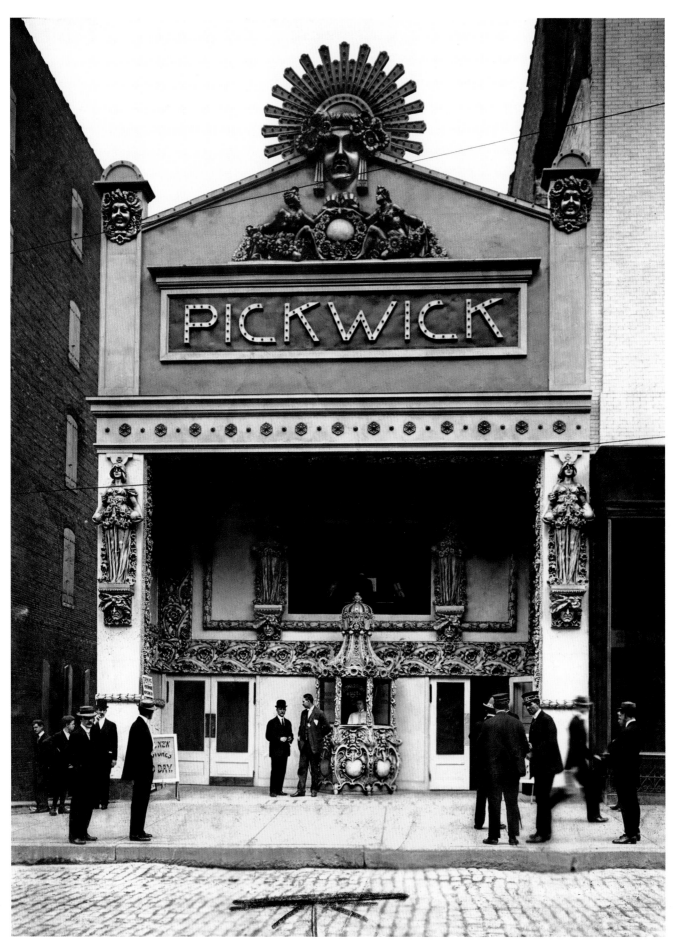

New Pickwick Theater, c. 1910. One of the owners of the Pickwick, J. Howard Bennett, stands to the left of the ticket booth in a derby hat. Courtesy of the *Baltimore News-American*, Special Collections, University of Maryland Libraries.

NEW PICKWICK/HOWARD
1908–1985

113 North Howard Street
ORIGINAL SEATING CAPACITY: 250
ARCHITECT: Franz Koenig

It is surprising that any part of the 1908 Pickwick survives on frayed North Howard Street, a commercial strip long past its prime. Yet the rosettes that once held incandescent light bulbs still punctuate the cornice above the second floor. Other details, inside and out, are long gone.

In the silent film era, the first talkies were the creation of actors who spoke while hidden behind the screen. Around 1910 the Pickwick had a trio of "talkers" playing all the parts and creating sound effects. The talkers were able to follow the action from behind the thin screen.

The moving picture parlor was called the New Pickwick, to differentiate it from the Pickwick, a smaller nickelodeon at 312 West Lexington Street. New owners brought in local architect Oliver B. Wight to remodel the Pickwick in 1920 and four years later another operator changed the name to the Howard. A big, boxy marquee was added after World War II, but other than that the Howard stagnated for the next thirty years. It attracted shoppers, city workers, students playing hooky, and transients from the bus station seeking a place to nap.

The longevity of the theater, which operated for seventy-seven years, can be attributed to its location in the heart of the downtown shopping district. After the Howard closed in 1985, it became a Dunkin' Donuts and then an athletic shoe store. As plans shift for redevelopment of the commercial district, its future is uncertain.

When we'd go downtown at night in the mid-1940s, [we'd see] these two elderly black entertainers outside the Howard. They were a couple down on their luck, performing for pocket change in front of the movie. The woman was named Snowflake, and the man was a dancer like Bojangles, but with less talent. His name was Tombstone. He would do this crazy dance, jump up and down, and stomp his feet. Snowflake played the washboard and hummed. They were funny as hell.

Paul Hutchins, retired Baltimore Sun **photographer**

The Howard was a small theater; it didn't have much of a lobby. I worked there in the early to mid-sixties, under owner Walter Gettinger. His saying was that he liked a theater that was like an old shoe, because that's what he had.

Gettinger knew his audience. He didn't play first-run pictures, so he didn't have to buy pictures based on a percentage. He showed later runs. That was a flat rental. It catered somewhat to people who hung around and wanted to kill a couple of hours. Some gay men also congregated around there. You had to keep order, but there were never a lot of people there at the same time.

Fritz Goldschmidt, retired film booker

What I remember the most about the Howard to this day is The Pawnbroker, starring Rod Steiger. I must have gone back to see it two or three times. The movie captured the existential misery of the Holocaust. The late sixties was a very difficult time. The poor, blacks, US soldiers in Vietnam—many were fighting for survival back then.

I was in Saint Mary's on Paca Street between 1967 and 1969. The seminary bordered Pennsylvania Avenue and we could hear gunshots and see flames. I remember standing on Paca Street as the United States Army rode past with truckloads of soldiers. It was a very tense time. When we had a break we went to the movies quite a bit; the Howard and Hippodrome were the closest.

At the Howard you knew you were in an old theater because it had some ornate decorations on the walls and ceilings, but they didn't do anything to highlight them. It was always dark. The walls were a dingy maroon. The seat cushions were cut. Sometimes there was a musty smell. I usually went with a group of people. It was not a place you would want to walk in by yourself.

Afterwards you went to the Palmer House restaurant for a pizza and a drink. The Palmer House had a tarot card reader. Howard Street at that time had Stewart's, Hutzler's, and Hochschild Kohn's department stores. So you had this contrast between the Howard—this dump—and all these fancy department stores right down the street.

Tony Abbondandolo, psychologist

Opposite: 113 North Howard Street, 2010. Chris Foxx Clanton.

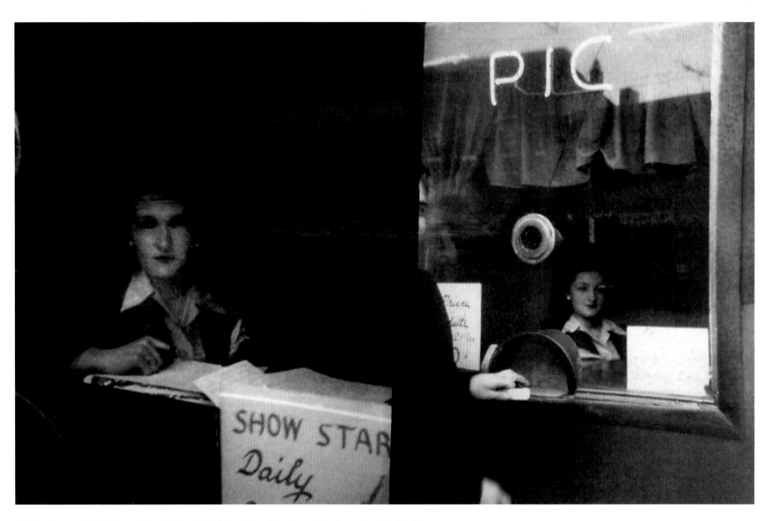

Pic Theater, c. 1940. Shoshana Shoubin Cardin, ticket cashier. Courtesy of Shoshana Shoubin Cardin.

CROWN/IMPERIAL/ROY/PIC

c. 1908–1950

756 Washington Boulevard

ORIGINAL SEATING CAPACITY: C. 250

ARCHITECT: unknown

The Pic, a plain movie house in working-class Pigtown, sported several names and had numerous owners. J. George Hoffmeister followed up his success with the Paradise Moving Picture Parlor with this little nickelodeon, first known as the Crown. Around 1932 the name was changed to the Imperial, by 1934 it became the Roy, and by 1938 it was a third-run house called the Pic. It was never a particularly attractive theater; by its Pic days it was rather dreary.

Its biggest competition was the Columbia, a large and pretty theater demolished for Martin Luther King Jr. Boulevard. Also nearby was the Superba, which opened two years after the Crown, but closed down under the name Majestic by 1935. The Superba survives as an average office building at 906–908 Washington Boulevard. The Pic went out of business in 1950 and was used for a succession of stores before being converted into office space in 2014.

Several silkscreened cardboard posters from the Roy, circa 1936, were discovered under an old linoleum floor in a row house on East Fort Avenue in South Baltimore, where they had been used as insulation. Above the dates and titles for films such as *The Man Who Lived Again* and *Night Waitress*, the signs tout the Roy as "The only theatre in this section to employ bona fide A. F. of L. Operators." Theater historian Robert K. Headley recalls that at one time "5¢" was written in the tiles of the lobby floor, and that the name "Roy" was set into the sidewalk in front. Sadly, both of these clues to its movie house days have disappeared.

756 Washington Boulevard, 2012.

My father, Samuel Shoubin, was an accidental theater owner. He had been a Hebrew teacher in Palestine, where I was born. The Pic was a full-time job for my father, seven days a week. He had the Pic for about four years when I was in my early teens.

It was about 1938 when my father asked me if I would come down to the theater and serve as a relief cashier on the weekends. I was eleven or twelve. We ran double features. When things weren't going too well, my father would book King Kong. People would come to see that over and over again, willing to be frightened each time. The appeal was partly the technical creation of this huge gorilla. That was the most popular movie we showed in the early forties.

The Pic was on the edge of Pigtown, an area totally unfamiliar to me. I was in a rough neighborhood. I had on my most mature voice as I would go up and down the aisles with a flashlight. There was a woman who came in, dressed in a long black dress, followed by a young, unattractive woman with a book. She was the local prostitute and the young girl would write down the place and time for the appointment. The prostitute and her friend probably came in five or six times. I never interfered with her. That was one of my important educational experiences.

The cartoons were especially popular with the children left behind by their parent for a double feature. Parents needed time to do their errands. For 11 cents they could bring their children and leave them all day. In this way, the neighborhood movie theater was a very important social instrument, both of education and behavioral socialization. The movie house was an essential part of the social fabric. Everyone had the same needs for time and for themselves; for husbands and wives to be alone for a while. In those days it was a safe place to park your children.

Shoshana Shoubin Cardin, educator and international leader in the Jewish community

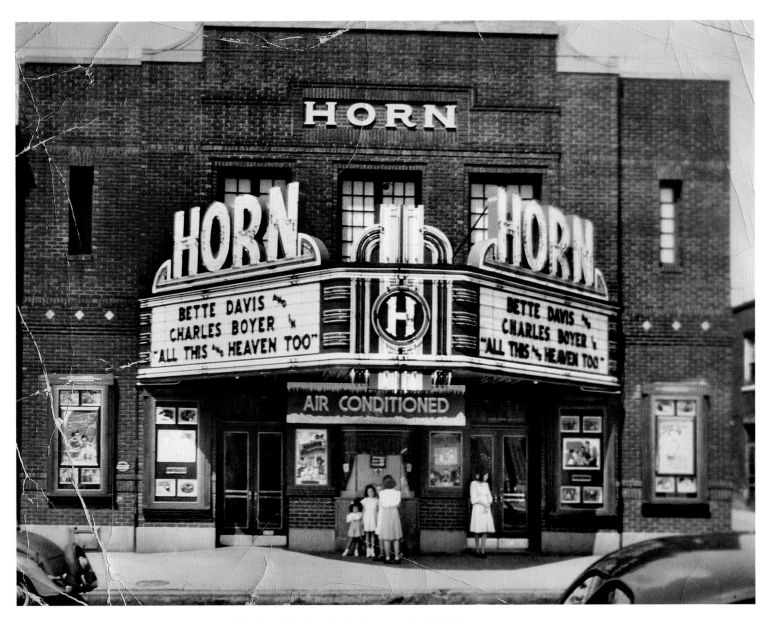

Horn Theater, c. 1940. Courtesy of Frank Hornig III. *Opposite:* The Horn name is still visible, 2012.

HORN

1909–1970

2016 West Pratt Street

ORIGINAL SEATING CAPACITY: 192

ARCHITECT: Francis E. Tormey (1920)

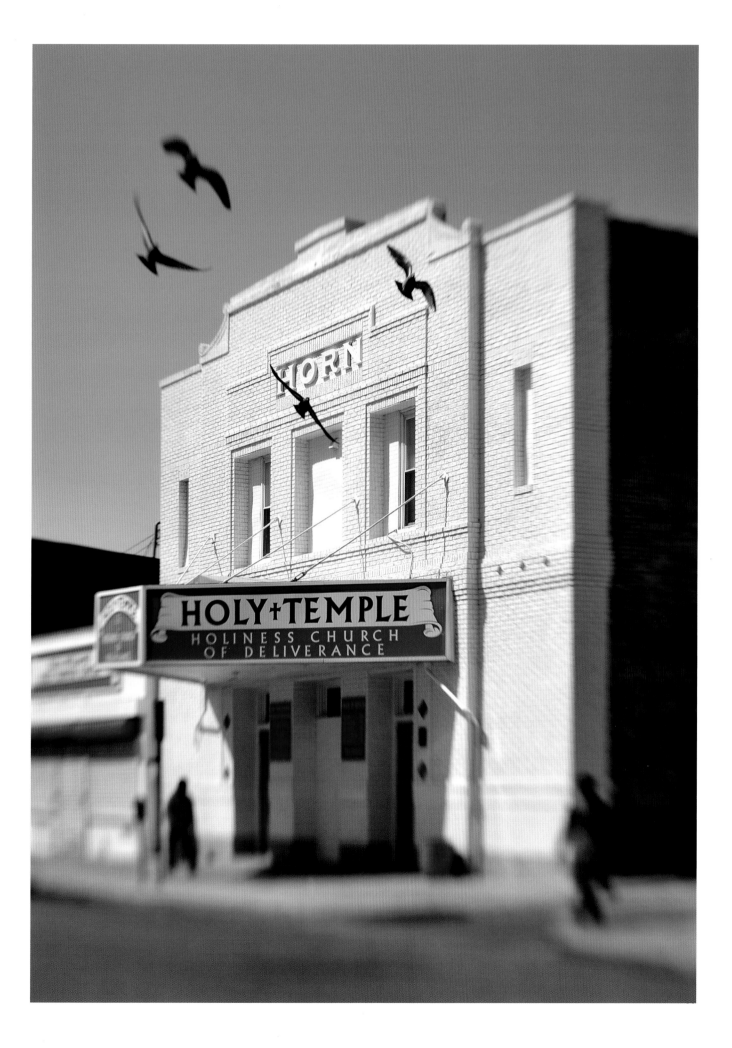

The Horn was built as a low, one-story theater with a wide archway over the exterior ticket booth. When the Horn opened, Pratt Street was paved with cobblestones and growing as a commercial district. In 1915 Civil War sagas were popular, and Cecil B. DeMille's silent film, *The Warrens of Virginia*, played at the Horn. It was a profitable theater location, because its southwest Baltimore neighborhood was two miles from the theaters downtown.

The Horn was rebuilt in 1920, when a second story was added and the seating was tripled. The Horn was second-run, but showed MGM and 20th Century Fox films, movies in the Laurel and Hardy series, and Alice Faye and John Payne musicals. Writer Russell Baker recalled the Horn of his youth in the thirties as "raffish." After the Hornig family sold the theater in the late 1950s, it was called the New Horn.

The Horn became The Holy Temple Holiness Church of Deliverance in the late 1980s. The red brick building has been painted white, but the marquee has survived and the raised letters spelling "Horn" are clearly visible. This stretch of West Pratt Street retains its isolation from downtown and is more rough than raffish these days.

Before the Horn was built, there were just rows of homes along West Pratt Street, no businesses. My great uncle Paul Hornig had the idea to get in the moving picture business, and my grandfather Frank Hornig was his partner. The first Horn theater was only the width of two homes, but they added a third home to make the existing build- ing around 1920. During the Depression my grandfather and father made a ton of money, because a person beaten down by hard times would spend a dime to go to the movies to feel good.

The Horn Theater also had vaudeville and a piano. In the late thirties Martha Raye performed there. The Three Stooges came during that period, too, and my mom reported: "They were drunk as skunks, but nobody knew it because they packed the house."

As a second-run theater, there were a lot of pictures Dad couldn't get. The singing cowboys—he could get those first. A lot of films were shared with the Capitol and Lord Baltimore. They were competitors, but far enough away. Dad would come home pretty weary, shuttling films back and forth. He thought the movie picture business would last forever, but it didn't.

Frank Hornig III, retired owner, Conway Furniture Company

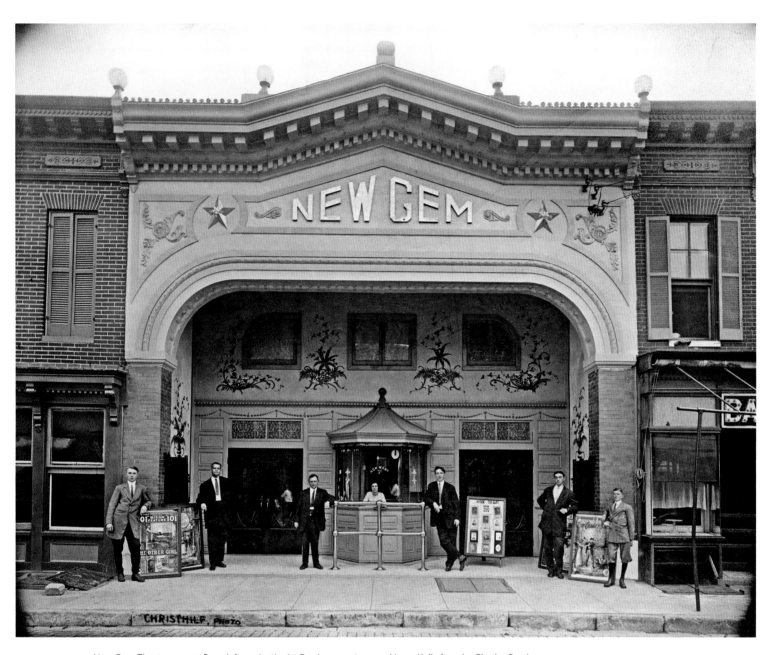

New Gem Theater, c. 1912. From left, projectionist Ray Levy, part-owner Henry Kolb, founder Charles Bender, part-owner Nick Burns, an unidentified cashier and usher, and Henry Parecki, who played the violin at the New Gem, according to G. R. Scherman. Courtesy of the Robert K. Headley Theatre Collection.

NEW GEM

C. 1909–1924

617–619 North Duncan Street

ORIGINAL SEATING CAPACITY: C. 300

ARCHITECT: unknown

617–619 North Duncan Street, 2013. Shawn Arrington, left.

The exterior of the petite New Gem was festooned with more decorative flowers and garlands than a traditional wedding cake. The interior walls were covered with murals, including Swiss mountain scenes and a depiction of the sinking of the *Titanic*, which dominated the news when the theater was remodeled in 1912. Small blade fans positioned between the murals whirred above the hard wooden seats. Today, the exterior southern wall, exposed after the adjacent buildings were demolished, is adorned with a colorful mural of East Baltimore scenes. North Duncan, a narrow street adjacent to the Northeast Market, is lined with nineteenth-century alley houses. The lively shopping district probably spurred the extension of the moving picture parlor back to North Collington Avenue in the early twenties. Toward the end, the New Gem briefly tried burlesque shows. Following its theatrical days, the building, stripped of its ornamentation, became a post office, a hardware store, and a warehouse, now inactive.

It cost only a nickel to go to the New Gem, and you certainly got your money's worth. I guess it was 1911 that my parents first took me to the New Gem. Before the show started, you got music—if you could call ragtime piano that. The Gem always had good piano players. A movie parlor had to, because the piano was such an important part of pictures, providing background music and creating a mood.

The movie started out with slides of the coming attractions. Then came the comedy. Mack Sennett's Keystone Cops, which began in 1913, were the favorite funny men. And there were John Bunny and Flora Finch, and Charlie Chaplin and Harold Lloyd; they appeared in one-reelers and two-reelers. After the comedy came the most exciting part of the show, the serial. Pearl White was easily the favorite. Then you had George Chesebro and, a little later, Tom Mix.

I remember the afternoon the theater was thrown open for a free performance of Go Get 'Em Hutch, which was about tugboats. Well, every kid in East Baltimore was there, it seemed. When the showing was over, they were escorted out—all but me and a couple of friends. We hid under a seat so we could see the evening show free. We did—it was Tom Mix in Eyes of the Forest. Nobody caught us, except our parents, who gave us a tanning.

G. R. Scherman
"I Remember the Days of the Nickel Movie"
The Baltimore Sun, November 25, 1956

1910

CHAPTER TWO

1914

"Don't big empty houses scare you?"

Cicily (Nydia Westman)

"Not me, I used to be in vaudeville."

Wally Campbell (Bob Hope)

from *The Cat and the Canary*, 1939

Elliott Nugent, director

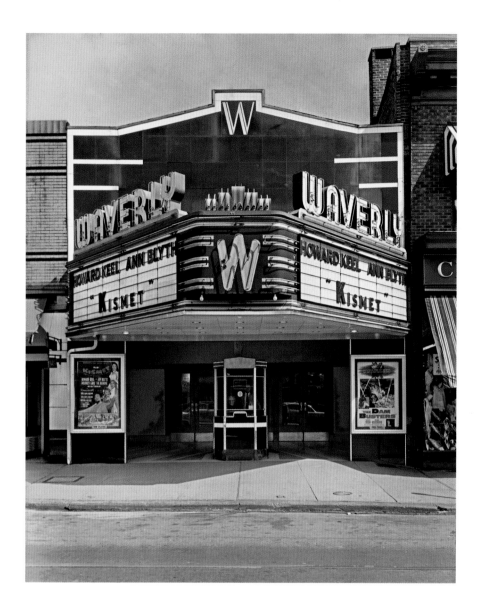

WAVERLY

1910–1969

3211 Greenmount Avenue
ORIGINAL SEATING CAPACITY: 485
ARCHITECT: Herbert C. Aiken

Grown-ups flocked to the elegant Boulevard Theater up the street, but the Waverly with its B movies was the destination for hordes of children on Saturdays. Cowboys! Action! Sci-fi! Come back next week to see if our hero eludes death! The Waverly has itself eluded destruction, but the villainy of hideous siding covers the "W" at the peak of its shiny Art Moderne makeover in the thirties. The original Waverly was enlarged in the twenties into a handsome brick structure with an interior box office and a decorative metal awning under a broad arch framing its name.

Pacy Oletsky, whose grandfather, Peter Oletsky, owned the Waverly from about 1915 until it was purchased by Durkee Enterprises in 1929, ruefully commented that his grandfather "was done in by talking pictures." (Durkee Enterprises grew into the largest circuit of neighborhood theaters in the city.) The Waverly had a stage for live entertainment and a penny candy store next door. The projection booth was reached by ladder. Under Durkee management, the Waverly was well run for decades, but could not overcome an increase in crime and the subsequent deterioration that plagued Greenmount Avenue after the mid-sixties. It is now a clothing and shoe store.

3211 Greenmount Avenue, 2013. Martin Wilson. *Opposite:* Waverly Theater, c. 1955. Courtesy of Frank Durkee III.

I was permitted to go to the Waverly by myself, but there was one occasion when my father was interested in seeing a movie. So he and I, at about 8 o'clock one night, went down to the Waverly. The movie was black and white, and it had something to do with the American Revolution . . . Sons of Liberty. I suppose I was about ten.

Dusk had fallen about an hour before, and I went out in my yard, as I frequently did, to collect lightning bugs in the palm of my hand. I put them in a little brown paper bag. We walked down to the Waverly, about three blocks away, and I still had this bag with me. I sat down. Halfway through the film, unconsciously but deliberately, I opened the bag. I put the bag about five or six seats away at the end of the aisle from where I was sitting. Slowly, one by one, these forty or fifty lightning bugs got loose, trickling out one at a time very slowly. They could attain a pretty good height. It really created quite a scene in this absolutely darkened theater, when twenty minutes later everybody was looking up and staring. It seemed like we filled the theater with them. But I never got caught for that, and as a result I never got barred from the Waverly. I think my father suspected, but he was as amused as I.

Charles E. Moylan Jr., retired judge, Court of Special Appeals

Before the regular feature started on Saturday you could see a cowboy movie, two cartoons, and a serial. My favorite serial was Rocket Man. He strapped on a leather jacket, which had two jets attached to it. He zipped up the jacket and the controls were on a triangular plate that he'd connect. He put on a helmet. Then he would run and jump, and suddenly they'd cut to him in the air. He was a good guy. At the end of a chapter, when you thought he got killed, they'd ask, "Is this the end of Rocket Man?"

With the Western movies, Gene Autry was always in sepia tone with his Wonder Horse Champion. He was the singing cowboy. Roy Rogers was in color, and always wore the shirts with the fringes. My two absolute favorites were the Durango Kid and Lash LaRue. Charles Starrett would ride into this cave and come out as the Durango Kid. He was all in black, on a white horse, and he had a black kerchief that covered his face. Lash LaRue had a gun and a bullwhip. He bore a slight resemblance to Humphrey Bogart.

When the bad guys came on, all of us kids would take our cap guns and start shooting at the screen. I think it got out of hand; those who had the caps would shoot them off, and those who didn't would just pretend and go, "Bang, bang, bang!" Eventually they made you check the guns in the lobby behind the concession stand.

Across the street from the Waverly was the Little Tavern. They used to have these 10-cent hamburgers. We called them death balls. For $1, you'd get ten of these to take into the Waverly. Then you'd buy malted milk balls or Jujubes as dessert. The boxes that the candy came in—we'd tear them up into small pieces, lick them, grab a handful, and throw them up into the projector beam. You'd have to sit in the middle of the theater to do that . . . what a great time.

Steve Yeager, filmmaker and professor

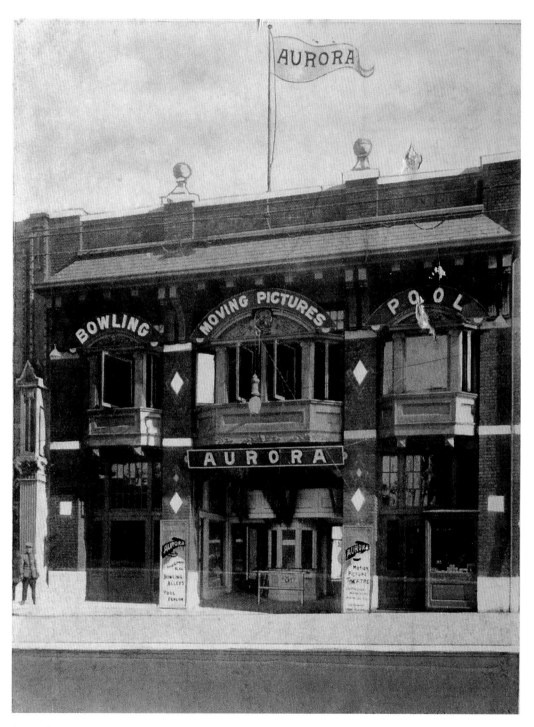

Aurora Theater, c. 1910. Courtesy of the Russ and Jane Sears Collection.

AURORA/7 EAST/CINEMA NORTH
1910–1984

7 East North Avenue

ORIGINAL SEATING CAPACITY: 485

ARCHITECT: Francis E. Tormey

7 East North Avenue, 2010. "Explorer," a sculpture by Matt Johnson, adds an ironic note to the name of the church that replaced the Aurora.

The tiny Aurora was overshadowed first by the sumptuous Parkway one block to the west, and later by the stylish Centre, which opened across the street in 1939. Even so, the tenacious Aurora outlasted them both. The Aurora was a pretty building with three copper bay windows topped by lions' heads.

The Goucher women who lived nearby when the college was still on St. Paul Street nicknamed the playhouse the "Uproar." Starting in the twenties, the Aurora was sandwiched between two popular cafeterias, the Oriole and Bickford's. The Oriole later became the home of the Center Stage theater company.

The Rappaports, who operated the Town and Hippodrome, remodeled the Aurora after acquiring it from the Cook family in 1949. It became a first-run theater, opening with *Psycho* in 1960. After a brief ownership by the Trans-Lux Corporation, the Aurora was placed on the auction block in 1964. The Schwaber circuit picked it up, and created a 303-seat art house called 7 East, run by Howard "Boots" Wagonheim. Wagonheim's attempt to screen *I am Curious (Yellow)* ran into censorship roadblocks all the way to the US Supreme Court, which upheld the state's ban of the Swedish sex film.

The fire that destroyed Center Stage in 1974 marked a turning point in the viability of North Avenue for middle-class theatergoers. After the fire, new owners converted 7 East into a soft-core porn house called North Cinema. The grand opening was made more exciting by the vice squad, which raided the theater during a screening of the uncut version of *Deep Throat*. In 1981, film buff Robert L. Brown reopened it as a revival house and brought back the Aurora name. In less than a year, the struggling cinema was back to adult films. The Solid Rock Church of Baltimore has owned the Aurora since 1990.

I only remember going to the Aurora when I was very young. The darkened theater was spooky. Everything was Victorian and very dark, except the walls. The theater posters were behind ornate gilded picture frames in the lobby. There was a partial wall with brass railings on top in the back of the theater for standing room only patrons. I believe you went through a heavy curtain to get to your seats, which folded up and were covered in dark red velvet. When I had to go down to the office behind the stage with its big dark red velvet curtains, it frightened me.

My great-grandfather, Eugene Cook, built the theater in 1910. The basement had the bowling alley, just six alleys. You didn't have automatic pinsetters. My mother told me that at that time the pinsetters were referred to as "darkies," and you tipped them. The pinsetters went up above the pins with their legs spread on each side. Then they'd jump down and reset them, and then they'd jump back up. The bowling lasted longer than the pool tables upstairs. The pool tables had to be taken out to make room for the equipment for talkies.

When I was a child the pictures were black and white and every frame would be flickering, kind of jumpy. The first movie I went to see there as a child was Song of the South, *[which combined] Uncle Remus stories, a Disney cartoon, and live action.*

The people who were living in that neighborhood were quite wealthy when I was a kid. By the late forties my family had sold the theater. In later years we would drive by it once in a while. It wasn't a neighborhood you'd go to by the time I was a teenager in the late fifties.

Lynn Hollyday Battaglia, retired bookkeeper

We leased the Aurora and converted it from a last-run to a first-run theater. We bid heavily for Psycho *and got it. The lines were very long because the theater only had about 300 seats. We bought a couple hundred umbrellas because we wanted to maintain our lines around the theater for each show. So when it rained, we could hand them out to the patrons. Then we'd collect the umbrellas from them when they entered, to use again.*

M. Robert "Bob" Rappaport, retired theater owner

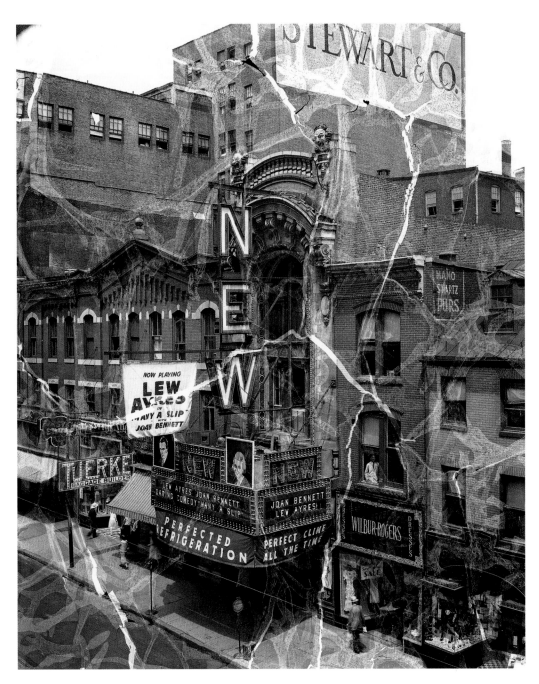

New Theater, 1931. Courtesy of the Baltimore Museum of Industry, BGE Collection.

Opposite: 210 West Lexington Street, 2010. The wrecking ball brings down the century-old building.

NEW

1910–1986

210 West Lexington Street

ORIGINAL SEATING CAPACITY: 1,400

ARCHITECT: A. Lowther Forrest and Oliver B. Wight

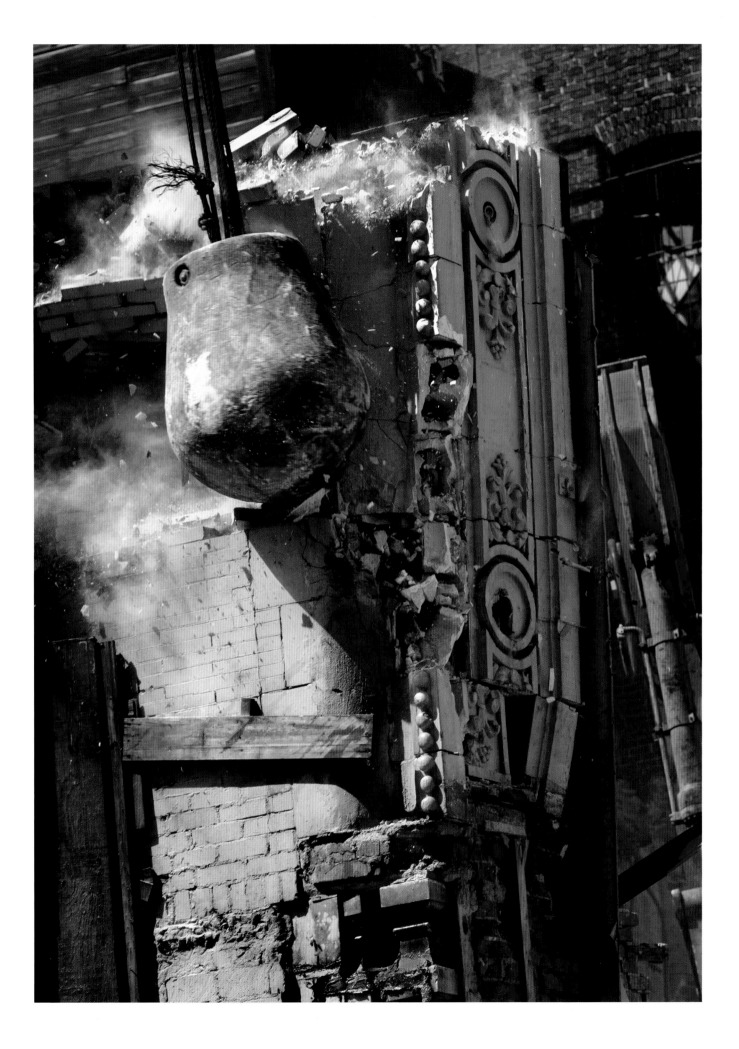

The New was a major first-run downtown movie theater for over seven decades, yet it was built in 1910 as a vaudeville house. The owner, Charles E. Whitehurst, declared, "It will in no sense be a moving-picture house." A mere four years later, after his initial investment of $300,000 for the building and land, Whitehurst spent another $25,000 to remodel the theater for film exhibition. His turnaround shows the remarkable rise in popularity of movies during this period.

The original interior was neoclassical with many rococo touches. Above the fancy box seats on either side of the proscenium arch were cherubs with trumpets. A huge ceiling painting titled "Beauty" loomed above the orchestra seats.

The most radical change occurred after Morris A. Mechanic bought the New in 1929. The interior was completely gutted and rebuilt in 1945 to '46. The second balcony was eliminated. An enormous, 60-foot tower spelled out the name of the theater above a triangular marquee. The bland modernization by Armand Carroll is probably a key reason why Baltimoreans are less nostalgic about the New than other downtown theater palaces.

Another redesign took place in 1967. The entrance to the L-shaped theater was moved around the corner to Park Avenue. The New came down in 2010. Most of the block was razed for some undetermined future redevelopment. Neatly mowed grass has replaced a century of history.

The New had a problem in the early fifties when CinemaScope came in. The projector was angled straight down because the screen couldn't go back any further. It created a keystone effect. Twentieth Century Fox patented CinemaScope, so the New got stuck with a lot of wide-screen movies that looked terrible. They were constantly retrofitting the screens and changing the technology, but it never got better. Little by little they perfected the anamorphic lens and now it's really a wide-screen without distortion. Took a good twenty years to get it.

Don Walls, retired film critic

In January 1957, when we were in the seventh grade at St. Dominic's school in Hamilton, a large group of school friends went to the opening of Cecil B. DeMille's epic, The Ten Commandments, *at the New. My recollection is that we were given free passes in school and were encouraged by the nuns to see it. We waited a long time in line. Just as we thought we had made it, the police stood directly in front of us on the sidewalk and linked hands together so no more could get in. In what seemed only a few seconds, a girl in our class, Donna Zimmerman, pretended to faint. Now I have not seen or heard anything about Donna in over fifty-five years, but I do remember that! The police quickly unlinked and went to assist her, and just that quick several of us crawled by the officers and actually got in to see the show.*

The next day, the TV stations and newspapers were talking about the near riot of Catholic school kids at the opening of The Ten Commandments. *I kind of felt happy then, and even today, that I was part of that little bit of history in Baltimore.*

Joe Neville, structural engineer

The New Theater played The Sound of Music *for nearly two years. Today you are lucky if you play something for six weeks. Road shows would have one exclusive run in the city. They would have a head start, a twenty-eight-day window before opening up in the suburbs. A road show was ten performances a week, and you'd have to buy a hard ticket at the box office, like a legitimate theater. In 1968,* Funny Girl *was a road show at the New, the Hippodrome had* Star!, *and the Town had* Finian's Rainbow.

Downtown theaters changed after the riots in 1968. Right afterwards, they were still playing road show movies. The road shows stopped in the early seventies. I went from wearing a tuxedo during the road shows to regular clothes when I was running the theaters later on. Years ago, when people would go to the downtown theaters they would dress up, especially on Friday and Saturday night. It would be something very, very special.

Ira Miller, Horizon Cinemas theater owner

Empire Theater, 1911. Courtesy of the author.

EMPIRE/PALACE/TOWN/EVERYMAN

1911–1937, 1947–1990, 2013–PRESENT

315 West Fayette Street

ORIGINAL SEATING CAPACITY: 2,200

ARCHITECT: Otto Simonson/William H. McElfatrick

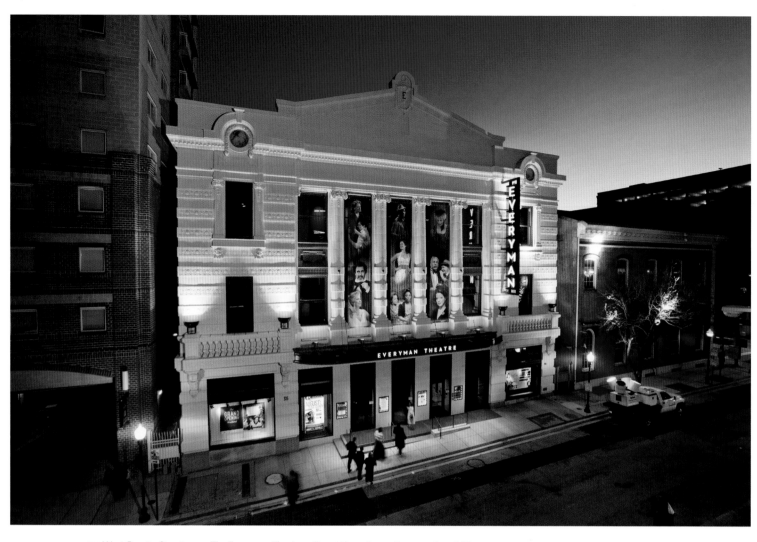

315 West Fayette Street, 2013. The Everyman Theatre rolls out the red carpet on opening night.

The letter "E" adorns the pinnacle of an old burlesque theater on West Fayette Street called the Empire. Today the "E" stands for Everyman, a professional theater company that has reawakened a moribund downtown block on the west side. In 2013 Baltimore architects Cho Benn Holback and Associates transformed the Empire, known by then as the Town, a 1,550-seat theater vacant since 1990, into an intimate 253-seat studio theater. Its classical Grecian stone facade with marble and terra cotta ornamentation has been fully restored.

When it opened in 1911, the Empire promised "burlesque of a better sort." Apparently this was not enough; the theater switched to a program of vaudeville and movies in 1913 and was renamed the Palace. Big names like Mae West and Joe E. Brown appeared in the early 1920s, but by the end of the decade, the Palace lost ground to its burlesque rival, the Gayety. Even a splendid soda fountain, rathskeller, and shops could not bring in enough customers. The theater's finances remained shaky in the thirties, when Minsky's striptease acts brought police raids rather than investors. The Palace closed in 1937.

The "playhouse palatial" was almost torn down for a parking lot, but the managers of Ford's theater across the street and the Hippodrome around the corner supported a plan for a garage. The regal theater was gutted to create the Palace garage in 1937. Cars glided in where the marble-lined lobby had been, but the facade was saved.

The Hippodrome's owner, Isidor Rappaport, rescued the theater from its ignominious fate in 1947, when he boldly converted the garage back into the Town Theater. John J. Zink, assisted by another Baltimore architect, Lucius R. White Jr., added a curved Art Deco marquee as part of the $500,000 reconstruction. Ten years later another expensive alteration was needed to install Cinerama. *Ben-Hur*, the Cinerama epic starring Charlton Heston, premiered at the Town in 1960, under the management of JF Theaters. The next three increasingly grungy decades were a far cry from the Empire's elegant beginnings. In 1990, both the Town and Hippodrome went dark.

My father, Isidor Rappaport, bought the Palace Garage after the war, gutted the whole thing, and put a balcony back. It was a very modern, 1,500-seat deluxe movie theater—and it was one of the biggest mistakes he ever made. The film companies had a franchise to play pictures. After World War II RKO became an important studio; they had been a secondary supplier for us. He bought the Town because he was afraid they were going to give half the product away to the Mayfair because we couldn't handle all the new releases at [his other theater,] the Hippodrome.

RKO offered us It's a Wonderful Life *for the grand opening of the Town on January 21, 1947. Jimmy Stewart and director Frank Capra attended the premiere. Jimmy Stewart was about 6′3″; my dad was much shorter, only 5′7″. Afterwards, Stewart was in a hurry to get back to New York. He was trying to make the 11:30 p.m. train to New York from Penn Station, and he grabbed the wrong coat, my father's. He discovered he had the wrong coat at the station when he went to put it on.*

Cinerama arrived in the fifties when the movie industry was in big trouble because of television. We needed something new. Seats were taken out in order to add three new projection booths and a curved screen. We used the old booth for sound; it was so clumsy. We didn't do the marketing properly. Every place Cinerama played had big populations to draw from. We had no draw, and we died.

M. Robert "Bob" Rappaport, retired theater owner

An FBI agent and a thirty-four-year-old California [bank robber] were dead today after a point-blank gun battle on the Town Theater mezzanine between the bandit and four agents who cornered him in a telephone booth while he chatted with a newspaper man in Los Angeles.

Most of the theater audience, absorbed in a crime movie, never heard the gunplay. But the man in Los Angeles, who had stalled until telephone operators could trace the call, heard a noise "like someone with a handful of quarters had poured them into the phone booth in six blasts."

"I'm sorry, sir, the phone's out of order," a Baltimore operator told the West Coast listener as the line went dead. Also dead was the man in the phone booth, John Elgin Johnson, who had wounded two of the four Federal agents after deciding to shoot it out with them. One of the agents, J. Brady Murphy, hit in the abdomen, died at Mercy Hospital.

The Evening Sun, *September 26, 1953*

The audience didn't hear the gun battle that riddled the theater phone booth, because they were watching, in stereophonic sound, Mickey Spillane's *I, The Jury*. The ad copy for the film noir thriller bragged: "So Raw, So Big, So Full of Naked Fury it had to be filmed in 3-D . . . Violence Blasts Out of the Screen at You."

WEST END
1911–1923

1601 West Baltimore Street
ORIGINAL SEATING CAPACITY: C. 500
ARCHITECT: Paul Emmart

The domed West End Theater, at the merger of Frederick Avenue and West Baltimore Street, is a beautiful relic from the silent movie era. An open-air theater may originally have operated near this location, according to theater historian Robert K. Headley. The West End Moving Picture Parlor was built on the site of an old flatiron building that had been used as an ice chest factory, and later, a refrigerating plant. Designed by Baltimore architect Paul Emmart, the vaudeville and motion picture house opened in 1911. It was a reinforced concrete building with a facade of ornamental marble, stone, and metal trim. The upper floor held a dancing academy. The hall was also used for civic meetings.

The playhouse had a short run. When the swankier Capitol Theater opened diagonally across Baltimore Street at the corner of Gilmor, the West End couldn't compete. Two years later, the Capitol Theatre Company bought the West End. Before it closed in 1923, it offered films such as Harry Carey in *The Canyon of Fools*, Gladys Walton in *The Love Letter*, and Hoot Gibson in *Ridin' Wild*. The Salvation Army has owned the building since 1924.

Juan Shearin, front, continues the nineteenth-century arabbing tradition, 2010. *Opposite:* West End Theater, 1920.
Photo by the Hughes Company. Courtesy of the Maryland Historical Society, #MC6286.

Schanze Theater, 1977. Courtesy of the Theatre Historical Society of America. *Opposite:* 2426 Pennsylvania Avenue, 2014.

SCHANZE/MORGAN/UPTOWN/ CINEMA THEATRE

1912–1949

2426 Pennsylvania Avenue

ORIGINAL SEATING CAPACITY: 495

ARCHITECT: Paul Emmart

Schanze Theater, 2010. Schanze's vaulted lobby ceiling, once studded with incandescent light bulbs, is now hidden from view at the Arch Social Club.

Frederick W. Schanze built a theater for vaudeville and moving pictures next door to his popular pharmacy and soda fountain on North Avenue in 1912. The building's most distinctive feature is the two reclining muses on the pediment. The serene Schanze ladies have surveyed Pennsylvania Avenue ever since.

Above the entrance, the theater's name was written in leaded stained glass within a lunette window. A high vaulted ceiling studded with incandescent light bulbs and plaster carvings dazzled visitors in the lobby. This marvelous ornamentation (pictured above) is regrettably hidden above a dropped ceiling.

Vaudeville performances were interspersed with silent films. On Monday through Wednesday during a typical week in 1913, the theater offered a skit followed by an acrobat and a female ventriloquist. A female vocalist, a handcuff king, and a trick harmonica player entertained audiences from Thursday through Saturday. Later on, like other modest sub-run houses, Schanze only exhibited pictures after they played downtown, or minor pictures that first-run theaters didn't want.

In 1938, the Rome circuit remodeled the theater and renamed it the Morgan. In 1940 it became the Uptown, and began catering to African Americans. In the early 1940s, as the Cinema Theatre, Yiddish films and live entertainment attracted Jewish immigrants. Samuel Shoubin, who had operated the Pic in Pigtown, turned the theater back into an African American movie house in 1946, recycling the Morgan name. The theater's movie days ended abruptly after a fire in 1949.

Wilson's, a popular seafood restaurant next door, used the theater until it became the home of the Arch Social Club in 1972. This club, one of the oldest African American men's clubs in the nation, continues Pennsylvania Avenue's tradition of musical entertainment. A grant from the state and the Baltimore Development Corporation enabled the club to restore the facade in 2013.

In 1928, when I was seven, Schanze's was the first movie house I went to. The box office was in the middle of the sidewalk. A nickel to get in, but first I'd stop and get a nickel's worth of toffee in a big bag.

It was small, with a center aisle and wooden seats on either side, a wood floor, high ceiling, and no air-conditioning. It had a large stage and curtain. Upstairs was Schanze's Hall. In its day they had live music for dancing and weddings. On the corner was Wilson's seafood restaurant. The only thing that separated the theater and the restaurant was a stairway that led to the projection booth.

In 1928 to 1930, the Saturday matinees had cowboy pictures, twelve-chapter serials, and coming attractions. When the newsreels came on, that's when all the kids got up. They'd let you move and talk during the newsreel. It was boring for kids. Movies were only about sixty-five minutes. The rest filled it out to around one and a half hours. If your mother allowed you, you stayed and saw the second show.

Aaron Seidler, retired film buyer/booker and theater manager

Schanze's was a second-rate theater in those days, the 1940s. My mother didn't want to go out by herself, so she made me go with her. I was ten or eleven. We either walked, about a half hour, or took a streetcar on North Avenue. It was safe to walk even at 10 p.m. It was a joint, considered dirty and old-fashioned. It was dim. North Avenue was white. Pennsylvania Avenue was black. It was a white theater in a black neighborhood.

They had stage shows, serious drama, music, and comedians. You could see Yiddish films or personal appearances by actors from the Yiddish theater, like Molly Picon. It was more like a traveling show, just on Sunday nights. The theater was packed. In those days there were a lot of foreign-born Jews from Russia and Poland who spoke Yiddish. My mother came here as an older teenager from Poland. It meant more to her than to me. It made my mother happy.

Irvin Cohen, retired schoolteacher

New Preston Theater, 1943. Courtesy of the Robert K. Headley Theatre Collection.

FLAMING ARROW/NEW PRESTON

1913–1944

1108 East Preston Street
ORIGINAL SEATING CAPACITY: C. 300
ARCHITECT: Fred E. Beall

Who could resist a theater named the Flaming Arrow? When this modest movie house opened in 1913 in East Baltimore, Westerns were a very popular genre in silent films. The colorful name may have been inspired by a film short of the same name, made by Bison Motion Pictures and released in March 1913, about four months before the theater opened.

Barely a month after the theater was renovated and became the New Preston, real flames erupted in the projection room when the film ignited on September 15, 1925. The operator stuck to his post as he tried to stop the spread of the fire beyond the booth. The pianist, Bessie Westgaard, was equally brave. To avoid panic, Westgaard continued playing, but switched to loud jazz numbers to encourage the audience to exit in an orderly manner. The audience of 300 filed out, and the projectionist, C. Robert Moore, temporarily overcome by fumes, was then dragged out to safety.

The theater was modernized when the Rome organization bought the New Preston in 1936. After closing in 1944, the New Preston was used as a furniture warehouse before becoming a church. The Canaan Missionary Baptist Church has thankfully preserved the original exterior cornice molding and the decorative arch above the entrance, so characteristic of early silent movie era neighborhood theaters.

1108 East Preston Street, 2012.

The Preston Theater was like the Wild West. I lived about two blocks away, at 929 East Chase Street, when I started to go to the movies in the 1930s. I was around 7 or 8. Back then they had what they called chapters, running stories that were continued each week, like The Lone Ranger. If it was crowded, we had to sit two in a seat. They were hard wooden seats. It was not a luxury theater!

When I became a teenager, everyone had to go to the Preston on Friday nights. It was so crowded that some people sat on the radiators. In the early forties, the war was just about starting, and there was a lot of news about Germany and Japan. Movietone News brought us up to date on what was happening overseas. Everyone would boo when the Japanese planes came on. Every time President Roosevelt came on everyone would cheer and clap.

It was primarily an Irish neighborhood. There were a lot of Italians also, but it was mainly an Irish Catholic community. St. John the Evangelist church was on the corner of Eager and Valley. The 10th Ward had a lot of firemen, policemen, and politicians. Governor Herbert O'Conor came from the 10th ward. That was a big thing.

After the war, people got automobiles. A lot of people moved out to different parishes, in the Belair Road area or in Govans. That's how the St. John's Old 10th Ward club was formed. People wanted to keep the spirit of the church alive and wanted all the neighbors to stay in touch. Once we took a bus trip back to the old neighborhood and some people got very upset. People said they would never go back again. It was just too sad.

Eileen Burke Grund, homemaker

Grand Theater, 1954. Courtesy of Frank Durkee III.

GRAND

1913–1985

511 South Conkling Street

ORIGINAL SEATING CAPACITY: 1,600

ARCHITECT: Henry Bickel

511 South Conkling Street, 2014.

The Grand was built on the site of an abattoir when South Conkling Street was still called Third Street. There were several slaughterhouses nearby, giving the street behind the Grand the nickname "Hog Alley." Perhaps pigs were lumbering toward the L. Sellmayer & Sons packing plant a few doors from the Grand on Valentine's Day, 1915, when the *Baltimore Sun* noted that "an unusual vaudeville bill, of which Hunt's Pony and Mule Circus, including four educated ponies and the original Hee-Haw Mule, Maud," was the featured act. As a combination vaudeville-movie theater, the Grand had low-ceilinged dressing rooms below the shallow stage, and a big fly loft in back.

When Durkee Enterprises took over in 1926, the Grand became a movie house. After a major fire in the projection booth in 1928, the theater was completely rebuilt, increasing the seating capacity to almost 2,000 and adding a new Egyptian-inspired Art Deco facade and jumbo vertical sign. A program for the remodeled theater boasted, "The Grand is the first and only theatre in Baltimore that has been built especially for acoustic results of Sound and Talking Pictures."

The theater had a mezzanine lobby and a very wide balcony. James Coburn came to the Grand in 1980 for the premiere of *The Baltimore Bullet*, a comedy about pool hustlers. Reflecting the decline of the surrounding shopping district, the Grand became a discount movie house in 1982 and closed three years later. The Southeast Development Initiative Corp. purchased the theater in 1999. The Grand made a cameo appearance in John Waters' *Cecil B. Demented*. There was talk of saving the facade when the closed theater site was selected for a new branch of the Enoch Pratt Free Library. Despite some local opposition, the Grand was demolished in 2000.

What stands out most about the Grand, with its soaring green, ochre, and gold facade, is that it's gone. The preservation movement was in its infancy when the Rivoli, Century, and Stanley were demolished, yet the Grand was bulldozed at the same time that the Hippodrome was being restored. The Southeast Anchor Library is a significant asset for the community, but it is a tragedy that it came at the expense of the beloved Grand.

At the Grand Theater (pronounced thee-AY-ter) on Saturday morning, kids used to line up early for the cowboy shows. Hopalong Cassidy, Roy Rogers; I know I saw a Charlie Chaplin there. I remember the silent movies, and I think they had a piano, too.

It only cost 10 cents to get in there. This was back in the late twenties. Even 10 cents was hard to get in them days. We used to go around and collect soda bottles. I think we got 2 cents for Coke bottles, and a nickel for big soda bottles.

They had a good-sized balcony, and nice cushioned seats. Most of the kids wanted to be up in the balcony. We went in with a bag of hamburgers [from] the Little Tavern. They were good. The balcony smelled like hamburgers. Next to the Grand was the Yankee Bakery. They used to sell cream puffs and éclairs for a nickel or a dime.

When I was young, it was mostly all German around here. Now it's Spanish. This was always called Highlandtown. I was born in this house. When my parents bought this house [on Gough Street] in 1912, it was Baltimore County. It was a good neighborhood. I still think it's good.

Henry Reif, retired precision spring maker with Kirk-Habicht Company

Aldine Theater, c. 1954. Courtesy of the author.

PICTORIAL/ALDINE

1913–1951

3310 East Baltimore Street

ORIGINAL SEATING CAPACITY: 285

ARCHITECT: unknown

3310 East Baltimore Street, 2014.

The Aldine opened as the Pictorial in 1913 on the site of two row houses that had been razed after a fire. It changed hands several times and was remodeled extensively in 1927 as a 320-seat theater. The operator, Arthur B. Price, was also running the Leader, New Preston, and Avalon in the late twenties. After the theater expanded to a third row house in 1928 under new ownership, the name was changed to the Aldine.

East Baltimoreans refer to their neighborhood movie house as the "al-DYNE." The bathroom was behind the screen, so when the door opened, light leaked out onto the edges of the screen. Patricia Calvano remembers going

to the Saturday matinee around 1948 to 1950 for 12 cents, and watching the *Black Widow* serial, the news, cartoons, and cowboy movies. The Aldine also showed revivals of classic films.

After closing in 1951, the Aldine became an office, a church, and a store before becoming the home of the Baltimore Science Fiction Society in 1991. The society has been a good caretaker of the building. The seats are gone, but the sloped floor remains. The society has a lending library and occasionally shows films. The exterior blended in with its neighbors when it was formstoned in the 1970s.

It was a scratch house. It made you itch. It was just the way it was. I went when I was a teenager, around age fifteen. This was in the 1930s. It was cheap, kind of run-down. Cost a nickel or a dime. We went on Saturdays for the cowboy pictures and chapters. They wanted you to come back every week to see another chapter. The neighborhood really hasn't changed except when they put all that Formstone on. I think it is cheap looking.

Henry Reif, retired precision spring maker with Kirk-Habicht Company

Honey, all I know is that when I was a kid we had a bunch of kids in the neighborhood, and Saturday was the day we all went to the movies. It was a double feature, a chapter, coming attractions, with something like a Three Stooges film in between, and cartoons. Mainly they showed cowboy and horror movies.

We earned our money back then. I scrubbed them steps for a couple of customers. We took our own buckets, scrub brushes, and harsh brown soap and rag. You scrubbed the vestibule with a marble step, then you went out and scrubbed every one of those steps, and then you did that marble that went across the big window. Believe me, they checked your work, to see if you did it right. I was only six or seven years old. Oh Lordy, you worked for that 50 cents. You didn't mind; that was the way of the neighborhood.

I grew up on Baltimore Street one block from the Aldine. Inside the Aldine was just a center aisle, so you had to climb over people to get to your seat. They had the old-fashioned little light sconces; it was very dark. The seats were metal. If you leaned back too far, you fell back. Many of the seat cushions were torn. I believe there was an old-time stage, which they probably used back in vaudeville days.

That large window you see from outside, that was the projection room. We would see the man put the big reels in. Sometimes they would stop in the middle of the movie, and everybody would holler and stamp their feet.

Formstone got popular in the 1950s. The Aldine got Formstone much later, after it closed. I like my Formstone. If the Formstone is still good, keep it. I look out at [the Aldine] from my house. It looks good.

Mary Triolo Brown, retired custodian

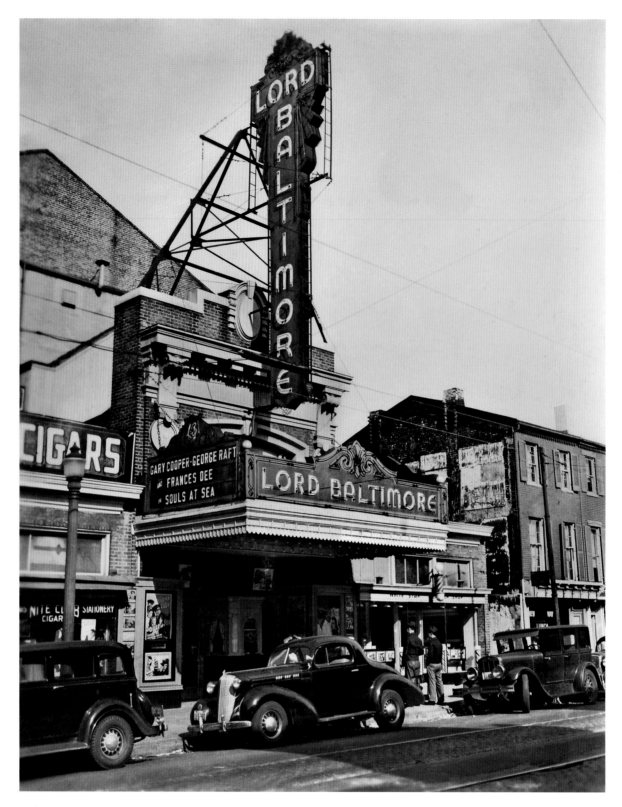

Lord Baltimore Theater, c. 1937. Courtesy of Virginia L. Ingling.

LORD BALTIMORE

1913–1970

1110 West Baltimore Street

ORIGINAL SEATING CAPACITY: C. 1,000

ARCHITECT: J. C. Spedden

1110 West Baltimore Street, 2012.

The Lord Baltimore opened November 24, 1913, in West Baltimore in the same month that the Grand, seating 1,600, opened on the east side. These were the largest theaters outside of the downtown theater district. Theater operators Pearce and Scheck were more interested in vaudeville than movies when they built the capacious Lord Baltimore. Accordingly, the generous stage measured 43 feet wide and 40 feet deep. When Pearce and Scheck opened the Hippodrome one year later, their top vaudeville acts moved to Eutaw Street.

The Lord Baltimore was situated on a lively retail stretch traversed by streetcars near Hollins Market. In summertime, when cakes of ice were placed next to whirring fans to create the "air-cooled" interior, children would hang around the delivery truck to get chips of ice. A 1941 renovation added a splashy 46-foot-long marquee with the state flag and the Battle Monument outlined in neon. In later years, the Lord Baltimore housed the offices of Pearce and Scheck.

In the sixties the Lord Baltimore hosted screenings for the Baltimore Film Society. Toward the end, the film fare was X-rated. After closing in 1970, the second-run house briefly became a church, but it has long been vacant. Hideous gray stucco envelops the brick building, making the Lord Baltimore the homeliest gray elephant in town. It may yet be rescued, as development spurred by the University of Maryland BioPark creeps westward, breathing new life into a tired street.

Meyer "Mike" Leventhal, who befriended me early in my career, worked for Pearce and Scheck in the early days as an usher, projectionist, then manager/projectionist. He was one of the older guys who had been around forever and knew everything. He told me that when they were building the Lord Baltimore, a horrible building error was made. They forgot the projection booth! They had to tear the roof down and somehow build an additional structure on the roof for the projection booth with an outside entrance.

Aaron Seidler, retired film buyer/booker and theater manager

To me the Lord Baltimore was big. We saw Shirley Temple, cowboy movies, Bette Davis. This would have been the late twenties and thirties.

On Saturdays I'd go with my girlfriends to the movies. I went to the Methodist or Baptist Church, but almost all of my friends were Catholic. They had to go to confession first. My nine-year-old girlfriend would say, "Give me something to confess, I haven't done anything." They went to confession early at St. Martin's on Fulton Avenue, and we'd go to the movies after lunch.

The Lord Baltimore had a small lobby. The theater was real wide and fairly deep, but not as deep as the Capitol. In the thirties they had child vaudeville performers on Saturdays, with tap dancing and singing. It seemed like the Capitol didn't have as good a reputation as the Lord Baltimore. We never thought to go there first.

Fern Preiss, homemaker

When Jim Crow racial segregation relaxed its grip on Baltimore in the 1960s, the Lord Baltimore theater opened its doors to blacks out of indifference more than nobility. In the 1950s West Baltimore's movie houses were identified by race. There were no posted signs, but everyone understood that blacks patronized the Capitol Theater on Baltimore Street, near Gilmor Street, and that the "white" movie was five blocks due east.

As to crossing our cinematic dividing line, whites were received with as much racial hostility as blacks. However twisted, a tacit affirmation of the principle of free association was at play. Black disdain for the Lord Baltimore was not "sour grapes" posturing—it was real.

We knew there was nothing special about the Lord Baltimore from spies like my best friend's dad, nicknamed "Castro" for his bearded resemblance to the Cuban dictator. He operated two newsstands on Baltimore Street, each near the rival theaters. Castro was welcomed at both addresses. On the whole, the Lord Baltimore was no better than the Capitol, and no worse.

Gregory L. Lewis, attorney

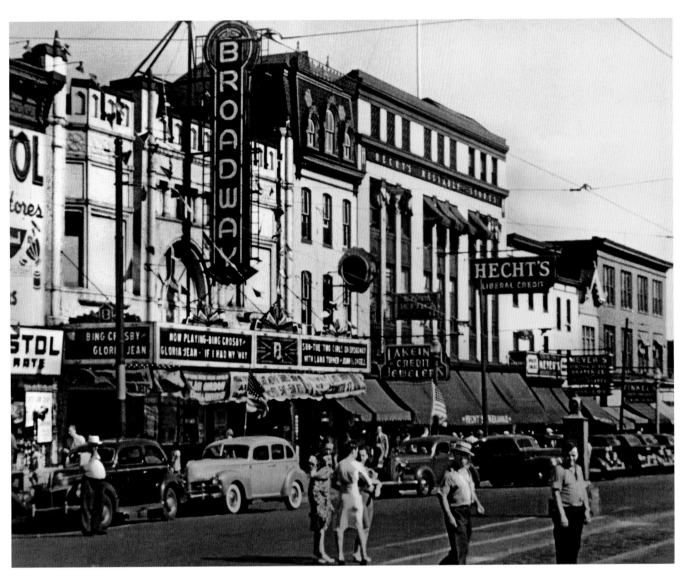

Broadway Theater, c. 1940. Courtesy of the Russ and Jane Sears Collection.

BROADWAY

1914–1977

509 South Broadway
ORIGINAL SEATING CAPACITY: 848
ARCHITECT: Benjamin Frank

South Broadway, a bustling shopping district, was home to more than a dozen storefront theaters in the earliest days of silent movies. Most were short-lived. The Broadway Theater, where the MGM movies played, was the fanciest.

Architect A. Lowther Forest carved the original Broadway Theater out of the first floor of an old warehouse in 1914. Less than two years later it was destroyed by fire. The surviving castle-like building, designed by Benjamin Frank, was erected in 1916. When it was remodeled about ten years later, a bigger stage and balcony were added, bringing the number of seats to 900. Another facelift took place in the late forties.

Polish, German, Irish, Jewish, and Russian families lived in the neighborhood. Following its closing as a movie theater, the Broadway had brief stints as a Polish club, a restaurant, and a dinner theater. In 1999, the Broadway became the Latin Palace nightclub, catering to the influx of Latino residents to Baltimore. In late 2016, the building changed ownership, leaving the preservation of the highly ornamental exterior and its remaining balcony, ticket booth, and chandeliers in doubt.

509 South Broadway, 2012.

Broadway was a nice theater and they had a little area where you could beg for money. The Broadway had soft seats. Classy. I always liked to be close to the screen. That way they jumped right at you. I saw Bela Lugosi at the Broadway.

I did three movies with Lugosi. Glen or Glenda was my first movie for Ed Wood. All I got was $35, and I had to split it with my brother Henry. The second was Bride of the Monster. The third one was Plan 9 from Outer Space. It was called "one of the best worst movies of all time." I was the young baby face.

Conrad Brooks, actor

Your parents would threaten you: "If you don't behave, you won't go to the movies." So all week you might be ornery, but come Saturday you were an angel. Then I would get to go to the movie with my brother Teddy. Our parents issued another stern warning: "Don't go through the Broadway Market." That didn't make sense to us. The market had everything—we lived there. So we went through the market.

One time when we were walking through the market to go to the Broadway movie, I got smacked in the rear with the strap at the end of an espantoon. The sergeant said: "Didn't your father tell you not to go through the market?" My brother and I were wondering, how did he know we weren't supposed to do that? We didn't tell our father when we got home.

Two weeks go by. We are all sitting on the front stoop on a Sunday, and up the street, swinging his espantoon, is Sgt. Sandler. He says to our father, "George, did he tell you that I smacked him on the rear end?" Like lightning, bang! my father hits me. He didn't ask Sgt. Sandler, "What did he do?" That's how we were brought up.

Ray Weber, retired insurance agent and owner, Weber Funeral Home

I grew up in Little Italy in the 1940s, then moved to the Perkins projects between Broadway and Little Italy. The Broadway Theater was our favorite destination. We'd all chip in a few pennies and designate one kid to buy a movie ticket. He'd open the back door in the alley to let the rest of us in. Sometimes we'd get caught. An usher would tap us on the shoulder and give us the old heave-ho. But if we took the time we could shimmy in. We'd get close to the ground and pull ourselves along on our elbows. It was slow and tiring but safe, because the ushers couldn't see you over the chairs.

When I got to Marine Corps boot camp, we crawled the infiltration course using that same elbow technique. You'd put your head close to the ground and push with your toes so that you didn't stick your butt or head up in the air. Then you'd shimmy on your elbows by thrusting one elbow forward, over and over again. A sign on the infiltration course noted that John Wayne couldn't get through this course any better than anyone else. I remembered seeing a movie with John Wayne called Red River at the Broadway when I was nine. At 18, going through that course at Parris Island, I was thinking that I learned this same maneuver to get into the Broadway to see John Wayne. Only this time they were firing live machine gun rounds above us.

John Strumsky, retired banker, insurance agent, and marathon runner

Hippodrome Theater, 1921. Courtesy of the Maryland Historical Society, #SVF.

HIPPODROME

1914–1990, 2004–PRESENT

12 North Eutaw Street

ORIGINAL SEATING CAPACITY: 3,000

ARCHITECT: Thomas W. Lamb

12 North Eutaw Street, 2015.

The venerable Hippodrome, Baltimore's biggest surviving theater palace, celebrated its 100th birthday on November 23, 2014. Marion S. Pearce and Philip J. Scheck ballyhooed the Hippodrome as the largest playhouse south of Philadelphia. It was their crowning achievement, but its high cost—more than a half-million dollars for the property and construction combined—was their undoing. The renowned theater architect Thomas W. Lamb designed an elegant, acoustically superior auditorium. It had a custom Moller pipe organ, good sight lines, and beautiful canopied proscenium boxes that were ripped out later to accommodate wide-screen formats.

Marcus Loew introduced movies a year after he leased the theater in 1915. Apparently the cramped projection booth was an afterthought, forcing the projectionist to haul up the film cans by ladder. The playhouse offered a mix of movies and vaudeville until 1951. Isidor "Izzy" Rappaport, who took over the debt-ridden operation in 1931, was astute at spotting new talent, and kept vaudeville going long after other venues had given it up. Rappaport also jazzed up the front of the Hippodrome with a new marquee flashing 8,000 yellow lights.

A young Frank Sinatra debuted as a big band soloist at the Hippodrome with the Harry James Orchestra in 1939, and he later returned with the Tommy Dorsey Orchestra. Glenn Miller, Benny Goodman, Ella Fitzgerald and the Chick Webb Orchestra, Cab Calloway, and countless other stellar big bands appeared on the Hippodrome stage. Red Skelton, Bob Hope, Martha Raye, Sophie Tucker, Abbott and Costello, the Three Stooges, Jack Benny, and Milton Berle were always top draws. Filling in between the big acts was a colorful mix of jugglers, acrobats, dog acts, magicians, and ventriloquists. Every stage show opened and closed in dramatic style, with a kettle drum roll and a crash of cymbals by the house orchestra as a huge "H" appeared on the curtain.

By the early fifties, the Hippodrome was strictly showing first-run movies. Trans-Lux acquired the lease for the Hippodrome in 1962. They replaced the gaudy marquee with a utilitarian one, and redid the interior so that generations of Hippodrome fans no longer recognized their beloved theater. Pepto-Bismol pink curtains covered the walls, and even the magnificent allegorical mural above the proscenium was hidden.

The decline of the shopping district in the 1970s hurt the Hippodrome. Blaxploitation, kung fu, and X-rated films became the typical fare. The Hippodrome was the last downtown theater in operation when it closed in August 1990. The theater sat ghostlike for about ten years.

Continental Realty Corporation, which had acquired the Hippodrome from JF Theaters, couldn't sell or lease the run-down theater, so it was donated to the University of Maryland. In turn, the university gave the decrepit playhouse to the Maryland Stadium Authority, which oversaw a $70 million restoration. The two handsome nineteenth-century banks on the north end of the block were incorporated into the renovation overseen by New York architect Hugh Hardy. A new building filled in the south corner to compensate for the Hippodrome's small lobby, and the facade was returned to its original 1914 appearance. Renamed the France-Merrick Performing Arts Center, the theater—still called the Hippodrome by Baltimoreans—now hosts traveling Broadway shows and other performing arts productions. Despite the occasional complaint that the seats are too small, more people recall the old Hippodrome with affection than any other theater in Baltimore.

Wilbur and William Baron, c. 1934. Courtesy of Brent Baron.

Twins were quite a novelty. The Hippodrome was the first big vaudeville house we played. As eight-year-olds, they had to hide our ages at some places, or say we were midgets. You had to be sixteen, but kid acts were allowed if you followed the special work restrictions. In Baltimore we could play the Hippodrome and be a top act, whereas in other cities we'd be an opening act.

We were always nervous. Our big problem was worrying that our buttons would come off our pants. This happened once—we were so embarrassed that we danced a little bit and ran off stage.

Tap dancing was still a novelty when we started at the Hippodrome in 1930, but it became hot in the thirties. We called it hoofing, fast movement, and tap, tap, tap. Tap dancing has a sound; music plays and then there is a pause. We had a full band or a piano playing "stop time," and they had mics on the floor so you could hear the taps more clearly.

As identical twins, our specialty was the Mirror Dance. We'd do motions, like combing our hair, fixing our tie. Every step was precise, so it seemed like we were one person doing it. Then one of us would make a mistake so we could end it off. It was hard work, vaudeville. Afterwards, we always got an ice cream cone or sundae from our father.

Wilbur and William Baron, retired vaudeville performers

The acts used to like to play the Hippodrome because it was very intimate. They looked good and they sounded good. The restoration, from an aesthetic point of view, is very good. Anyone who sees it today is seeing it as it really was.

My father, Isidor Rappaport, came from Philly. He recognized talent and knew how to package shows. That was what made him. When vaudeville ended in the early fifties, the Hippodrome was one of the last vaudeville houses in the country.

One week my dad needed a comedy act to fill in because an act had canceled. The booking agent said, "I'll send you Abbott and Costello, they're out of burlesque. These guys are so funny, they're unreal." He saw they were terrific. My father had a relationship with Kate Smith, who played at the Hippodrome. He asked her to put the boys on her show, and he helped manage them for seven years.

My father should have gotten out sooner, because television came, and Las Vegas. We couldn't compete. Vaudeville was a great proving ground for television. It's where Berle, Jackie Gleason, Abbott and Costello, Bob Hope, Sid Caesar, and the Three Stooges all got their start.

Vaudeville is one of the few things that I regret ended. I saw you couldn't stop change, but I wish there was more live entertainment today.

M. Robert "Bob" Rappaport, retired theater owner

Uncle Jack's Kiddie Club was broadcast from the Hippodrome over WBAL radio. Talent shows with kids were very popular in the thirties, and radio carried a lot of mystique in those days. They would advertise stars as appearing on "stage, screen, and radio." Kids sang and danced and did impressions and were comics. One regular tap danced on roller skates—imagine that over the radio. Sometimes the headliners at the Hippodrome would be in the show, just to talk and make an appearance. They always opened and closed with music, accompanied by a piano on stage. Then you could stay for the show.

My mother brought me to see Snow White in 1939, when I was seven. There was always a line outside the theater for big movies, but it was totally mobbed for this film.

The next time I came was with my uncle. He agreed to bring me to the Hippodrome to see the Andrews Sisters. Uncle Bud wanted to leave as soon as the movie was over, but I pleaded, "I want to see it again." I wouldn't leave. I held onto the seat and wouldn't let go. We sat there until the Andrews Sisters came on again. At the end he said, "I'll never take that brat downtown."

Bob Gist, retired English teacher, Baltimore Opera
costume supervisor, and Hippodrome docent

Button. Courtesy of the Russ and Jane Sears Collection.

My grandmom would take me about once a week to the State or the Hippodrome. She loved the stage shows. We'd sit up in the boxes, what they called the front loges. From those seats, when the movie came on that huge screen, the people were distorted because you were up so close.

At the Hippodrome my grandmom would always buy Jujubes and put them on the ledge of the balcony. Then she'd shoot them off the balcony onto the people below. The ushers would invariably come up, pull aside that green velvet curtain, and say to her, "Missus, you are going to have to speak to the little girl." She'd say, "Oh, I won't let her do that anymore." They weren't going to kick out a little girl and an old lady. Before the usher was down the steps, she was off shooting more Jujubes. She was a pistol to go to the movies with.

Marlene Hronowski, retired, McCormick Consumer Affairs

When I was a young teenager, about fourteen, we heard that a very young Frank Sinatra was appearing at the Hippodrome. We dressed in our teenage uniform of blue jeans rolled to the knee, our brothers' shirts, saddle shoes, and white socks. My mother took one look at me and said, "You are not going downtown dressed like that!" It was okay to wear these clothes around the house, but to go downtown to Hutzler's or a show one was expected to dress properly. But we did anyway and we fell in love with Sinatra. The girls went wild. They were screaming and yelling and carrying on. He could really sing.

Patricia W. Waters, homemaker and mother of filmmaker John Waters

My friend's date introduced me to his best friend, Isadore "Goody" Goodman, who was five years older than me. We were dating about a year, and he knew he was going to be drafted. When we had a special night out we'd go to the Hippodrome. We sat in the first row and it was Christmas Eve, 1942. I was seventeen. I remember him giving me the ring; it was a square-cut diamond. I put that engagement ring right on and it's never been off my finger.

He wanted me to join him when he was sent to Camp Meade. My father said, "No, you cannot get married." I said, "You let me get engaged." My father explained, "Engaged is one thing, and marriage is another. You can be pregnant, and a widow." Goody was gone for three and a half years. We got married six weeks after he came back. We were married sixty-three years. He died on Christmas Eve, 2009.

Shirley Goodman, retired secretary, Johns Hopkins Bloomberg School of Public Health

Playing at the Hippodrome, Christmas Eve, 1942: *A Night to Remember*, co-starring Loretta Young and Brian Aherne, and Walt Disney's Donald Duck in *Der Fuehrer's Face*.

My mother took a girlfriend and me to see Abbott and Costello at the Hippodrome in 1945. The manager announced that anyone who wanted an autographed picture could meet him in the alleyway after the show. The line was very long, and before [we] reached the manager, he ran out of pictures. He noticed us, two young girls standing there brokenhearted. He came over and apologized: "Would you like to meet them?" He took us backstage to their dressing room. Costello was sitting playing solitaire. He looked up at us and didn't say much. Abbott turned around, stood up, and showed us around the dressing room while eating a large tomato, like you'd eat an apple. He was very outgoing and sweet to us. We bragged about it to all our friends. We felt very important in our neighborhood, like celebrities ourselves.

Norma Hofmann, homemaker and retired clerk, Baltimore County Public Library

In 1942, I took over the Maryland Display Service. We did the Hippodrome Theater, utilizing two 20-foot billboards outside every week, plus the Royal Theater. They had big fronts outside the theater and a 30-foot banner above the doors. They each had new stage shows every week.

The most difficult time I ever had was when Abbott and Costello were booked at the Hippodrome. At that time they were having an argument. Monday night I get a call that Abbott would not appear. I was told to make a larger sign saying just "Lou Costello in Person." On Tuesday, it was "Bud Abbott in Person." By Wednesday morning, I was told that both of them would appear. At least I got to charge them for three fronts.

Al Zlaitin, retired owner, Maryland Display Service

I had my eye on this girl. Finally I got a date, and I went to pick her up. I didn't have a car, so I traveled by trolley down Eastern Avenue. On the back of the trolley was the guy who collected the money. All I had was a $20 bill. The fare was 10 cents. He gave me $19.90 back in nickels. They were weighing my pockets down.

I was trying to make an impression with this girl, but the nickels were falling out of my pockets. When I bent down to get a nickel, more nickels would fall out. She was so embarrassed; she never cracked a smile. When we finally got to the Hippodrome, there was a line around the block. I paid my 25 cents. I sat down and money started to fall down into the seats. I don't think the girl talked to me at all. Every time she looked in my direction, I was on the floor collecting nickels.

When she got home, she shut the door on me. That was it. Many years later, when I was campaigning in Northwood, she recognized me.

Tommy D'Alesandro III, former mayor, Baltimore City

On Sunday nights when my husband Ray and I were dating, we would go downtown to the movies. We went to the Hippodrome to see the Ames Brothers. This was the early fifties. We had to sit way up high in the balcony. I had Mary Jane shoes on with heels, and my heel broke. If Ray hadn't grabbed me, I would have gone over the balcony. Ray gave the broken shoe to an usher. When we were ready to leave, the usher returned the shoe, repaired. The usher had found a shoemaker around the corner. Back in those days people worked all the time, even at night.

Gloria Weber, retired logistics manager, Rukert Terminals Corporation

Back in the fifties my mom took me to a matinee at the Hippodrome to see Snow White and the Seven Dwarfs. Segregation was real, but my parents shielded us from it. The usher seated us in the balcony even though the place was basically empty. My mom didn't like the way she was treated, so we didn't go there anymore. When The Lion King came to the Hippodrome, my wife wanted me to take her there for her birthday. I wanted to sit in the balcony, thinking that would be the best place to see the show, but those were the hardest seats to get. They were sold out. We ended up six or seven rows from the front.

Lester Hudgins, I.T. engineer, Northrop Grumman

Hippodrome Theater, c. 1953. The glow of the 8,000-bulb marquee illuminates the entire block. Courtesy of M. Robert Rappaport.

Overleaf: Hippodrome Theater, 2013. The meticulous restoration of the building to its original appearance was completed in 2004.

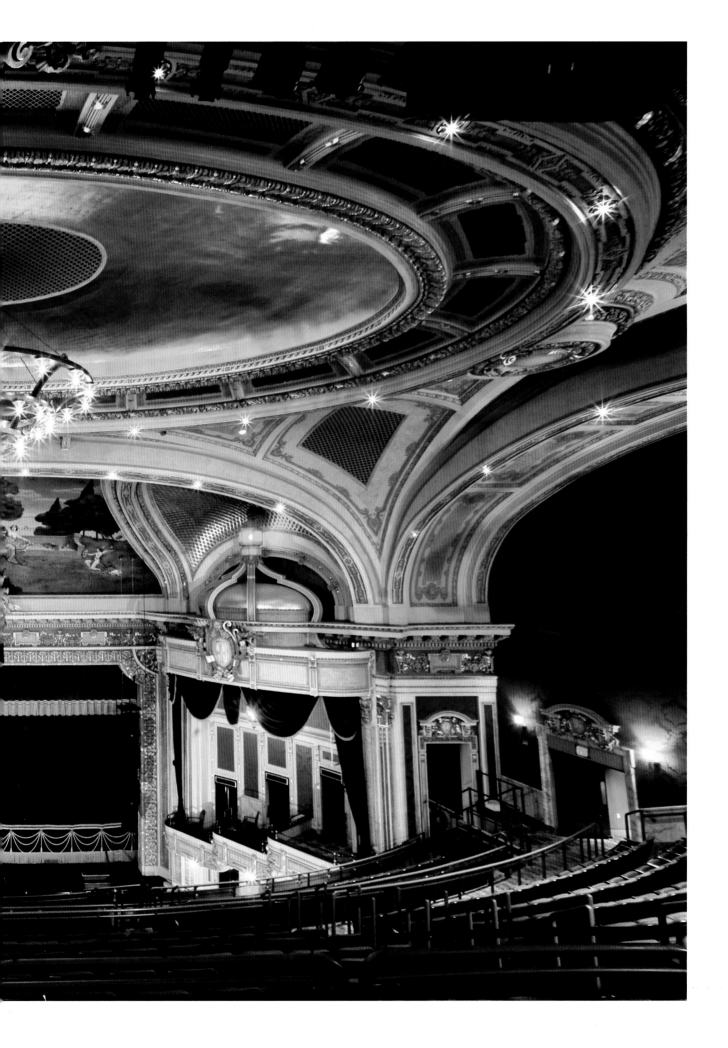

Started working as a manager for JF Theaters in 1980. After a stint at the Town, Jack Fruchtman says, "I want to move you to the Hippodrome. I want you to stop people smoking in there." One day, I'm upstairs. I shined my flashlight at five big men smoking cigarettes. They were not responding. Instead, they abruptly stood up, grabbed me lengthwise like a rolled up rug, and walked me down to the edge of the balcony. I was dangling. I wasn't sure if I was going head first or feet first. That's when I yelled, "Hey, white boy coming down!" to alert everybody. It crossed my mind I could kill somebody if they dropped me. I didn't know what to do. "Hey, white boy coming down!" They caught me in the aisle. "Do you need help?" my rescuers asked. About twenty-five or forty people walked up to that balcony with me, like an army, and we put them out the exit door. I said, "Out, out!" and boom, they went out, all five. Miracle of miracles, I didn't get hurt.

D. Edward Vogel, owner of Bengies Drive-In Theatre

After the unrest in 1968, theaters returned to segregation—by choice. Big Hollywood films were dying at the box office. They would show My Fair Lady *Monday through Friday, but on Saturday night show two to three black films. Black patrons kept these stately theaters open. Unfortunately, the care of those theaters was not good.*

One of our favorite places was the Hippodrome. We got to see Shaft, Uptight, *and* Super Fly, *and actors with huge star quality, like Flip Wilson, Ossie Davis, Sidney Poitier, and Harry Belafonte. When you had Curtis Mayfield and Isaac Hayes pushing the soundtracks you'd run to the movies. What people call "black exploitation" films, I call full employment. You had more actors, producers, hair stylists, security, and cable people in the history of Hollywood working on films that were very, very bad and at the same time incredibly beautiful.*

Michael Eugene Johnson, executive director, Paul Robeson Institute for Social Justice

Morris Mechanic was the human wrecking ball. Baltimore was a big tryout town with a long tradition of theater. Mechanic tore down the legendary Ford's and two other grand theaters, the Century-Valencia and the Stanley, to make way for his Mechanic Theater, which was useless for staging big shows.

They built the Hippodrome in three months. They knew what they were doing. It is a perfect acoustical envelope, simply fabulous. Under the mezzanine they carved out domes to keep sound moving. At the time, Lamb was the premier theater architect. He designed it to be acoustically perfect; it doesn't need amplification.

The Hippodrome was almost lost. They didn't drain the sprinkler and they had a leak. There was an ice storm, and a deep freeze, and no one could get to the wheel to turn off the sprinkler. I went to a pay phone, and woke up Mayor Schmoke. He got a crew to the Hippodrome with a map. They discovered a manhole cover had been black-topped over. When I got to the Hippodrome it was a mess, but we saved the theater.

**Donald Hicken, stage director and retired theater department head,
Baltimore School for the Arts**

1915

CHAPTER THREE

1919

"Yes, I can see now."

The Blind Girl (Virginia Cherrill), from *City Lights*, 1931
Charles Chaplin, director

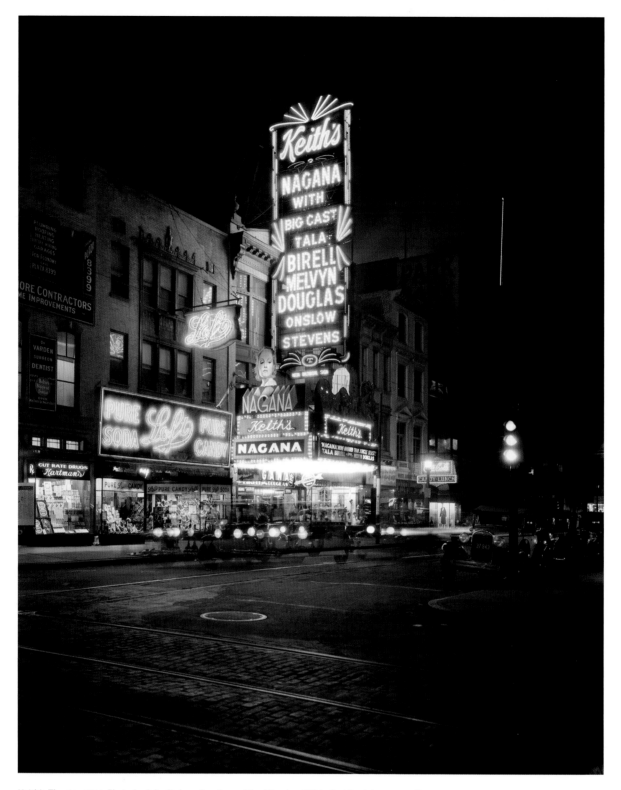

Keith's Theater, 1934. Photo by John Dubas. Courtesy of the Maryland Historical Society, #MC9258.
Opposite: 114 West Lexington Street, 2010.

GARDEN/KEITH-ALBEE/KEITH'S

1915–1955

114 West Lexington Street

ORIGINAL SEATING CAPACITY: C. 2,700

ARCHITECT: Thomas W. Lamb

The three-story, mustard-yellow facade on West Lexington Street provides no hint that it once led into Baltimore's fourth largest downtown theater. The massive marquee and 60-foot vertical sign are gone, revealing a boarded-up building on a bedraggled block. Keith's Theater, which extended to Clay Street to the north, seated close to 3,000 patrons.

The Whitehurst organization hired New York architect Thomas W. Lamb to build the Garden, a combination vaudeville–movie theater, in 1915. The regal auditorium had marble walls and a cantilevered balcony with unobstructed sight lines. Frederick C. Schanberger, president of the James L. Kernan Company, took over the Garden in 1927. Renovations left the interior more utilitarian than the other downtown palaces.

The Garden was renamed the Keith-Albee, and then Keith's, in recognition of the vaudeville circuit owner, B. F. Keith, associated with the theater. After vaudeville ended in 1932, live music was the primary entertainment. Keith's remained a popular first-run house throughout the 1940s. A Mr. Peanut character from the nearby Planters Peanuts Store offered free hot-roasted peanuts as patrons approached the theater.

Indicative of the changing times was the final stage show at Keith's on December 3, 1955: the rock and roll act Bill Haley & His Comets. Keith's had been built on the site of a taxicab garage. The theater was torn down four decades later for a parking garage, now gone.

In my day, Keith's was owned by my dad, James L. Schanberger, and his father, Fred C. Schanberger Jr. My dad grew up in the business, and in fact, was named after James Kernan, who developed the Auditorium and Maryland theaters and the Kernan Hotel. My dad described it as an "intimate theater." Instead of being long and narrow, it was much wider, with a loge. This was the lowest part of the balcony, perhaps four rows deep, separated by an aisle from the rest of the balcony. Also on both sides were the boxes, which we loved as kids.

There was an elevator to the Roof Garden, five or six stories above the main floor. It was basically a large dance hall. There was a stage for the dance band, and an open dance floor with tables halfway around and a bar. You reached the projection booth by way of the indoor fire escape.

Bill Schanberger, retired clinical psychologist

When I was thirteen, we used to hop onto the back of the streetcar going down Saratoga Street. We'd stand on the coupling and hold onto the back of the shelf at the bottom of the window on the old yellow streetcars—just hung on the back. You had to crouch down so they wouldn't see you. Always went with my two older brothers. They were fifteen and sixteen.

When we'd get downtown we'd go over to Keith's on Lexington. We'd wait for someone to go to the bathroom downstairs, and when they'd come out the back exit door we'd sneak right into the movie.

Leo Guinan, retired firefighter

Keith's Roof was on the blacklist as far as my parents were concerned. When I was a senior in high school, in 1945, a group of us decided we would go because Gene Krupa was playing. We had heard that he made this funny noise while he was playing the drums because he was on drugs. Drugs were just beginning to be talked about.

For me, Keith's was scary; it was like going into a speakeasy. The patrons were all ages. I was scared I'd see someone who was a friend of my parents. The guys in the band had watch chains hanging down, pleated pants, oh lord. They had really good music there. When we got out, we realized that Krupa's head was somewhere else.

June Finney, retired teacher, The Bryn Mawr School

Anybody who was anybody went to Keith's Roof. We were all jitterbuggers in those days. When I was fifteen to eighteen, that was sensational. We were all dolled up in our best. Zoot suits with shoulders a mile wide. In every corner of Keith's was a reflection of another ethnic group—Italian, Irish, German, Polish. It was the first time we met people from the other neighborhoods.

Tommy D'Alesandro III, former mayor, Baltimore City

In the early 1950s, Keith's was one of my favorite downtown theaters. You got your ticket below one of the most spectacular marquees and signs in town. Then you walked through a long, bright, mirrored corridor to the rear of the auditorium. The auditorium was always dark and kind of creepy; it had seen better days. The rear rows of the orchestra level were unfortunately located under large openings in the mezzanine level. Young thugs enjoyed bombing patrons from these openings with cups filled with water.

Robert K. Headley, theater historian

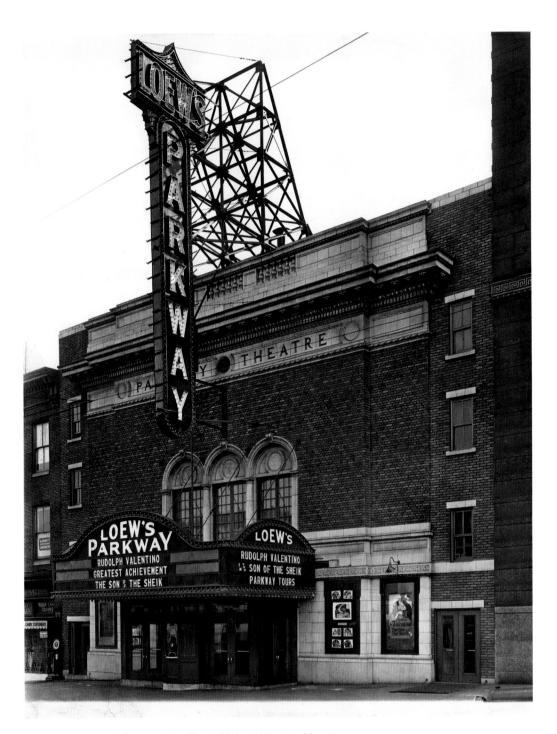

Parkway Theater, 1926. Courtesy of the Theatre Historical Society of America.

PARKWAY/FIVE WEST

1915–1977, 1999, 2017–

5 West North Avenue

ORIGINAL SEATING CAPACITY: 1,100

ARCHITECT: Oliver B. Wight

Hidden from view for almost forty years, the Parkway was Baltimore's Sleeping Beauty, waiting to be awakened by a prince's kiss. In this North Avenue fairy tale, princes from three kingdoms came to the rescue: the Maryland Film Festival, Johns Hopkins University, and Maryland Institute College of Art. Together they are reviving the elegant century-old theater and three adjacent buildings into a hub for film exhibition, live music, and education.

Baltimorean Henry W. Webb built the Parkway as a vaudeville and film house. In 1917 he exhibited an early version of talkies invented by his brother. George R. Webb's singing pictures used phonographs, connected by wires to speakers behind the screen, in synchronization with the projector. The sound could not be effectively amplified or sustained for films running longer than the playing time of two phonograph records. Webb's talkie machine was eclipsed by the Vitaphone system.

The Parkway passed into the Whitehurst organization in 1920 and was taken over by Loew's in 1926. The Parkway's studio affiliation switched from Paramount to MGM, the studio owned by Loew's. A new MGM movie would play at Loew's first-run Century, typically for two weeks, and then come to the Parkway. Thus the Parkway was called a fourteen-day house and would have an exclusive run before the film moved to the neighborhood theaters, twenty-one days after the film had opened downtown. When Loew's brought in architect John Eberson to remodel the French rococo interior, the charming domed royal boxes were eliminated.

Morris A. Mechanic shut down the Parkway soon after buying it in 1952. No movies were shown again until the Schwaber circuit purchased the Parkway in 1956. Milton Schwaber's son-in-law, Howard "Boots" Wagonheim, replicated the successful Playhouse model by converting the Parkway into an art house called the Five West. The formula included comfortable rocker chairs, which drastically reduced the seating capacity to 435, and lounges featuring local artwork and free tea and coffee. This concept lasted until the mid-seventies. By 1978 the Five West was finished.

The ground floor was leveled to create retail space in 1989, but fortunately the upper level was left intact. The Parkway had one more brief stint of stripped-down movie exhibition when Michael Eugene Johnson leased the theater to present African American films in 1999. For the next sixteen years, the only sound heard inside was the occasional thud of falling plaster. Conditions weren't conducive to resuscitate the quiescent theater until the Station North arts district started to jell around 2013.

The Maryland Film Festival, a champion of independent cinema, opened the $18 million Stavros Niarchos Foundation Parkway Film Center in 2017. At the corner of Charles Street, a modern addition designed by Ziger/Snead architects is connected to the Parkway and contains two small theaters. The 416-seat auditorium, now with a wider screen suspended in front of the proscenium, is an architectural palimpsest. Rescued, or rather restored to her original polish, the Parkway wears her chic patina of decay like the royal vestments of a cinema princess. The remarkable new beginning of this venerable theater is our fairy tale's happy ending.

Facing page: 5 West North Avenue, 2013.

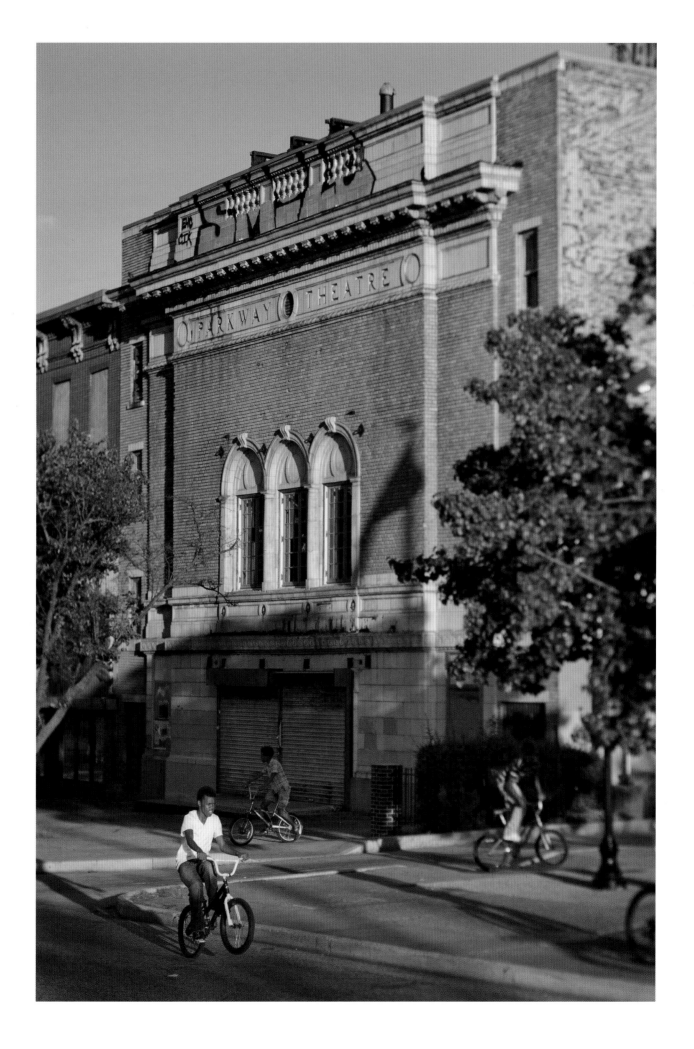

A schedule discovered before the Parkway's renovation lists the running times
for five daily shows featuring *The Guardsman* on November 27, 1931.

For many years my Aunt Rose was the box office cashier at the Parkway Theater. Along the way she was able to have her younger sister hired as an usherette at the Parkway. This was in the late 1920s. Amelia Juliet Campeggi was the beauty of the family, with black hair in finger curls and beautiful black eyes. She was well built. Their father was an immigrant from Rome, Italy, and had a fruit stand at the Belair Market.

A young trained baritone named Robert Wiedefeld came occasionally to sing at the Parkway, where he met this beauty Amelia and fell in love with her. (Later he performed in New York at the Met and on Broadway as Robert Weede.) His family was more prosperous, and they didn't want him to marry her.

In no time at all they were engaged and married at St. Ignatius downtown. Following the ceremony, my parents shared a car with some of Robert's relatives. My mother heard the groom's older sibling say, very disdainfully about the marriage, "The Parkway did this!"

Virginia Southard, retired secretary

The Five West played a big part in changing my life. That was the closest theater when I was a student at the Maryland Institute. I was a fine art student, a painter. *Juliet of the Spirits* was the first Fellini film I ever saw. I have to say that I was tripping. A lot of people were. Fellini influenced me in many ways; certainly with the theatrical color and operatic aspect we created in John Waters' films. At that time, film was considered more of a realistic medium. Seeing Bergman, Fellini, and those kinds of films took me to another point. It made me really think about film as an art form for the first time, rather than just seeing films as entertainment. I know that I never saw a Fellini film growing up in South Baltimore.

Vincent Peranio, production designer

In 1956, Boots Wagonheim turned the Parkway into an art house and renamed it the Five West. In the sixties and into the seventies, Boots also had the Seven East, which is what he renamed the Aurora, one block east of the Five West. Think about the fact that we also had the Playhouse on 25th Street concurrently—three art houses! When it came to foreign films you had to come to the theater. Before video, no way it could come to you.

On North Ave., the most significant symbolic event was when Center Stage burned down in 1974. North Avenue was still an entertainment district into the 1970s. As exhibition patterns started to change, the whole North Avenue corridor deteriorated at the same time. In its final years in the late seventies, the Five West was not X-rated, but it became a grind house. The floors were sticky and the movies were slimy.

A lot of that has changed in recent years. What are anchors in a neighborhood? Educational institutions and cultural attractions. Fred Lazarus of MICA established a presence on North Avenue. It's the feet on the street that make a street safe. After the students, the businesses spring up on their own, and it feels like a cultural corridor again.

Mike Giuliano, educator and arts journalist

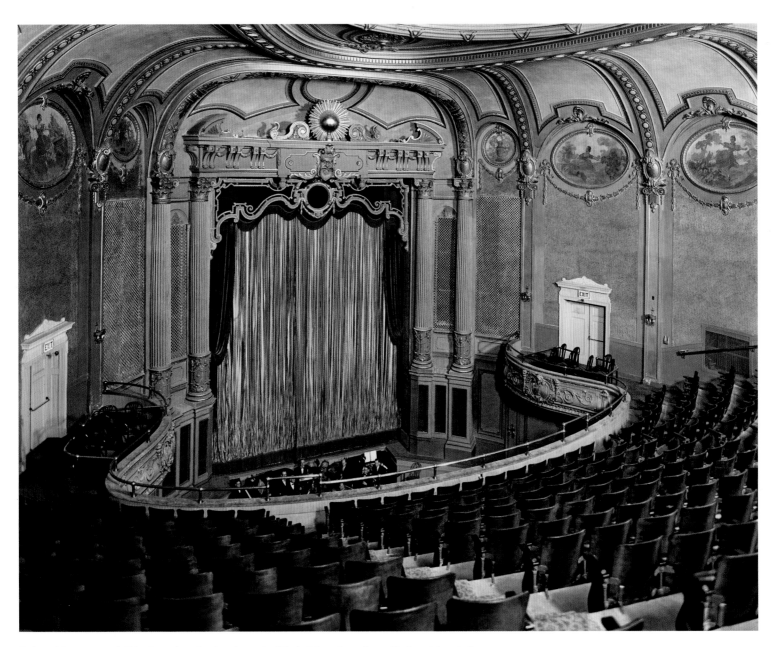

Parkway Theater, c. 1926. This view, taken after Loew's acquired the building, shows the auditorium stripped of its domed royal boxes overlooking the stage. Courtesy of the Theatre Historical Society of America.

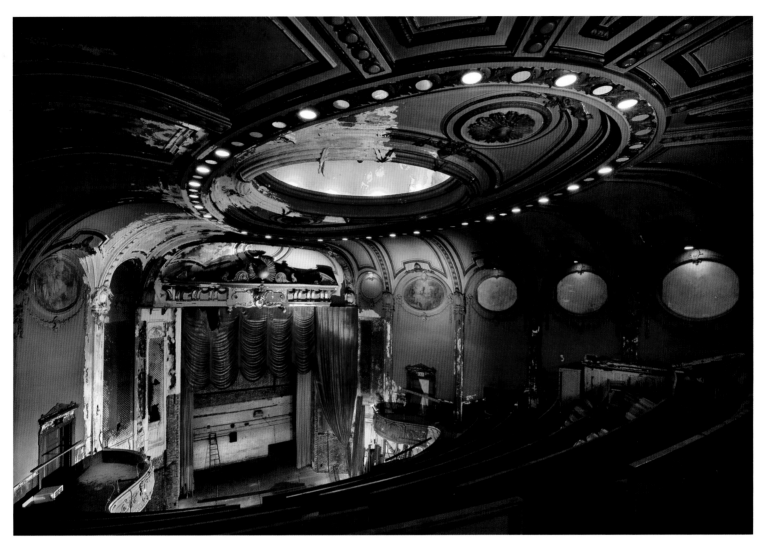

Parkway Theater, 2012. The auditorium retains much of its French Baroque glory, despite more than three decades of abandonment.

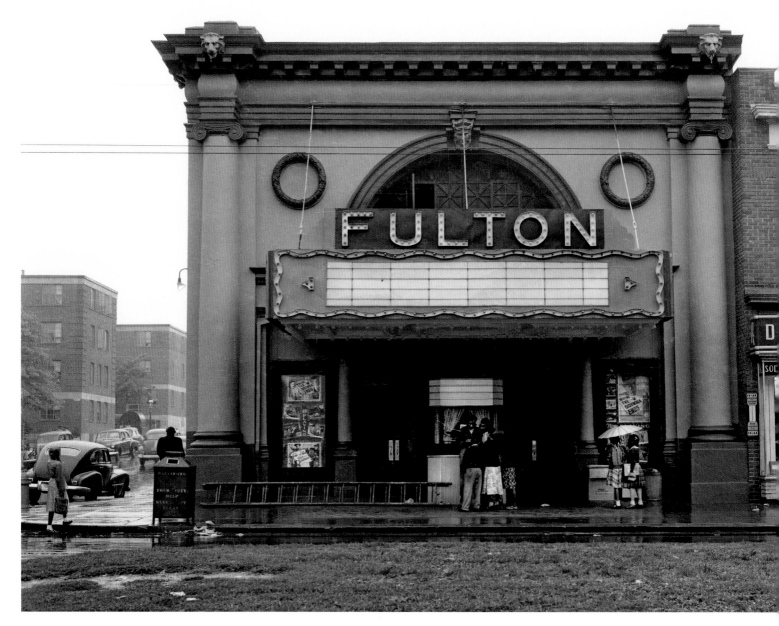

Fulton Theater, 1950. Photo by I. Henry Phillips Sr. Courtesy of the I. Henry Phillips Sr. Collection.

GERTRUDE McCOY/FULTON

1915–1952

1563 North Fulton Avenue

ORIGINAL SEATING CAPACITY: 500

ARCHITECT: Francis E. Tormey

Silent movie actress Gertrude McCoy attended the opening in 1915 of the 500-seat movie theater named for her in the Easterwood section of West Baltimore. She was a prolific actress during the silent movie era, but faded away before talkies came in. At the time of McCoy's retirement in 1927, the theater's name was changed to the Fulton.

The Fulton Theater was built by the Lord Calvert Amusement Company, which operated several other neighborhood houses on the east and west sides of the city. Among the theaters in this small circuit, only the York on Greenmount Avenue outlasted the Fulton. The Fulton had wooden-back seats bolted to the concrete floor. Warner movies were shown after their run at the Metropolitan.

Durkee Enterprises took over the Fulton in 1930. It was sold again in the forties to Henry Hornstein, who had a small group of African American movie houses. Hornstein turned the Fulton into an African American theater in 1945. Seven years later it closed and became a supermarket.

The handsome Fulton had the solidity of a bank. A large arch, topped with a woman's head, framed the entrance above the ticket booth. A lion's head crowned the Ionic columns at each corner, but only one has survived. Fragments of ornamental plasterwork in the lobby, including another lion's head, survived after a fire gutted the interior in 2007. The church that bought the Fulton in the early 1970s was unable to rebuild after the fire and sold the building in 2014. The charred Fulton remained standing for another decade, until the city razed the theater in 2017.

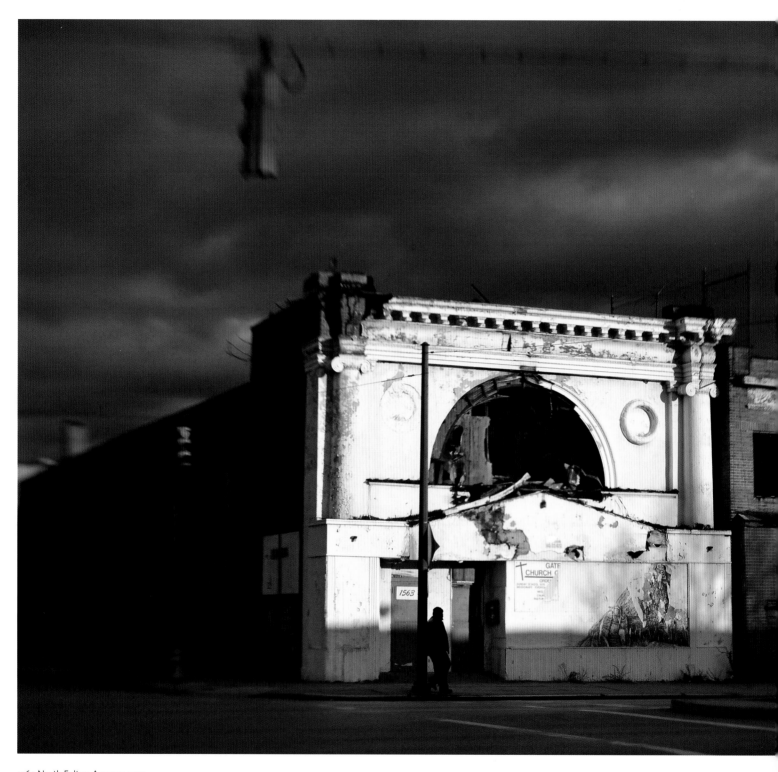

1563 North Fulton Avenue, 2012.

Saturday was a day of observance. Not of religion but of the movies. My favorite temple was the Fulton Theater, only a few blocks from home. I used two nickels to buy a ticket and held onto the third for candy. Peanut Chews were my favorite. Usually, the show didn't begin exactly on time. When that happened, one or two kids began stamping their feet. Pretty soon, the whole theater was vibrating with the marching rhythm of impatient children. When the first image appeared on screen, loud cheers, whistles, and shouts of jubilation erupted.

The Mummy's Hand was the second feature. Somewhere in Egypt a group of bad men dressed in jodhpurs and wearing pith helmets were digging into the graves of buried Egyptian pharaohs to steal hidden treasures. Behind them, a dusty mummy began to stir. The mummy took one step forward, then another. The ribbons of cloth dropped away from the mummy's face to reveal Boris Karloff, looking gaunt, skeletal and terrifying. The mummy's hand slowly stretched forward. One of the villains realized the mummy had come to life and he went insane. He screamed. That did it! I was beyond terror. I froze. I could not leave the theater. Many people left. The hours passed. I was afraid to move.

A flashlight shone in my eyes. An usher was accompanying my mother down the aisle. I told her what had happened, and she understood. It was the mummy's hand. I reached for my mother, she took my hand in hers, and we headed home. She was not angry.

Earle Silber, psychoanalyst

We lived on Appleton Street. It was a nice, mixed Jewish and Christian rowhouse neighborhood. Easterwood Park was nearby. The Fulton was the first one I remember. Sometimes I'd go with my cousins from South Payson Street. There was a little candy store on the way. In those days, if they gave you a quarter you could buy a lot of penny candy. We'd spend a day at the movies, watching a double feature or just seeing the same movie again, so we wanted candy that would last a long time. They had paper strips with little dots, licorice strips, black licorice pipes, and candy cigarettes. You thought you were smoking. We also bought pickled onions from a jar, pickles from a barrel, and long pretzel sticks. When we were a bit older, we'd get Good & Plenty in a box, but that cost a little more.

Edith Yankelov, retired secretary, Johns Hopkins Bayview Medical Center

Walbrook Theater, 1935. Courtesy of the Baltimore Museum of Industry, BGE Collection. *Opposite:* 3100 West North Avenue, 2014.

WALBROOK

1916–1966

3100 West North Avenue

ORIGINAL SEATING CAPACITY: C. 1,400

ARCHITECT: J. Edward Laferty

The Walbrook is still a commanding presence. The top half of the red Colonial brick exterior is remarkably unchanged from 1916. Six-foot-high posters of Greta Garbo and other stars once adorned the east wall. On the west wall, the crackled lettering is mostly indecipherable, but it once read: WALBROOK THEATRE / PICTURE PLAYS EXCLUSIVELY, PERFORMANCES CONTINUOUSLY. Above this message, a major enticement is still legible: THIS THEATRE IS AIR-CONDITIONED.

Contrast today's gritty North Avenue in West Baltimore with this description from *Motography* magazine in 1916: "The Walbrook Amusement Company . . . on May 29 opened the Walbrook Theatre, which is one of the finest suburban houses in Baltimore." The expanding residential neighborhood was indeed suburban back then. Walbrook's owners tussled with another theater exhibitor, Thomas Goldberg, over the theater permits in this block, but Goldberg had the last laugh. He bought the Walbrook less than a year after it opened.

Goldberg opened a competing moving picture parlor across the street at 3117 West North Avenue, but closed it soon after acquiring the Walbrook. The faded letters of the theater's name, Goldberg's Gwynn's Park Theatre, can still be seen on its west side. In 1941 Goldberg reopened this dinky theater, renaming it the Hilton, to compete with the upstart Windsor next door. In the forties this block had three movie houses, which was very unusual. The Hilton, a third-run house, lasted until 1950; the second-run Windsor closed in 1956.

The Walbrook had an orchestra pit big enough to accommodate a baby grand piano and six musicians. The program, featuring MGM movies, changed daily. You can still find the original seats in the 200-seat balcony.

By 1956 the audience was African American. Lamont Edwards recalls getting a little sherbet at the nearby Arundel Ice Cream store after a movie back in the late fifties, but the real highlight was around the corner. A detour near Ellamont Street led to an alligator, penned inside a fenced backyard behind the Walbrook at the other end of the block. Today a painted sign for the New Beginning Highway Church of Christ, the theater's owner since 1966, has replaced the movie stars on the east wall.

The Walbrook showed three features a week: the first major film would be shown on Sunday, Monday, and Tuesday, and another good one on Wednesday and Thursday. In most cases, the least important film would be shown on Friday and Saturday. I learned later that this is how we missed Fashions of 1934, *with Bette Davis as a blonde. A rare exception,* Fashions *played on a Friday only, and my mother and I went on the following Saturday, at which time they were playing a Western called* Massacre. *I spent the next forty years regretting it.*

Very early on, I had an enormous crush on Bette Davis. I would see her at the Walbrook before she was well known. She made about 22 movies before Of Human Bondage *made her a major star. Bette Davis had mannerisms—they say she had too many. It was the cigarette and the way that she walked and talked. I have probably seen* Of Human Bondage *more than a thousand times.*

We didn't call them theaters unless they were downtown. We called them movie houses. Each one seemed to have its own peculiar smell and the Walbrook had its own, not unpleasant, musty smell. The Walbrook was one of the few neighborhood movie houses that had a balcony and a loge, but it was roped off during weekdays. There were no popcorn or soft drink stands, and very early on, no candy machines.

I'd call the décor "early dingy." It wasn't one of the glitzy places, but it was big and comfortable.

Harry Eliason, retired insurance manager

Regent Theater, 1951. Courtesy of the Baltimore City Archives, BMS 26-7.

REGENT
1916–1974

1601 Pennsylvania Avenue

ORIGINAL SEATING CAPACITY: 500

ARCHITECTS: William O. Sparklin and George S. Childs

The Hornstein family operated the classy Regent Theater for over four decades. Louis Hornstein and his sons, Simon and Isaac, opened the 500-seat theater for African American audiences in 1916. The theater showed photoplays and vaudeville, and it was so successful that by 1921 the Regent had taken over four lots to the south, expanding its seating capacity to 2,250. The Regent was the biggest theater on Pennsylvania Avenue, with almost a thousand more seats than the Royal. The *Afro-American Newspapers* celebrated the expansion of the refined theater, which had its own orchestra, as "an epoch-making one in the history of theatricals among colored folks of Baltimore."

The Hornsteins hired only black employees. Movies that were deemed racist, such as *Song of the South*, were not screened at the Regent. Stars such as Cab Calloway, Eubie Blake and Noble Sissle, Lena Horne, the Mills Brothers, and Sidney Poitier made appearances on the Regent stage.

The Regent lasted until 1974. By then, African American patrons were no longer confined to Pennsylvania Avenue and segregated theaters. There was even less of an outcry when the Regent was torn down in 1980 than there had been when the Royal was razed in 1971. In its place, Baltimore Colts wide receiver Glenn Doughty helped finance the Shake and Bake Family Fun Center in 1980. When its popularity waned, the city took over its management. Only the footprint of the modern building provides a clue about the grand scale of the beautiful Regent.

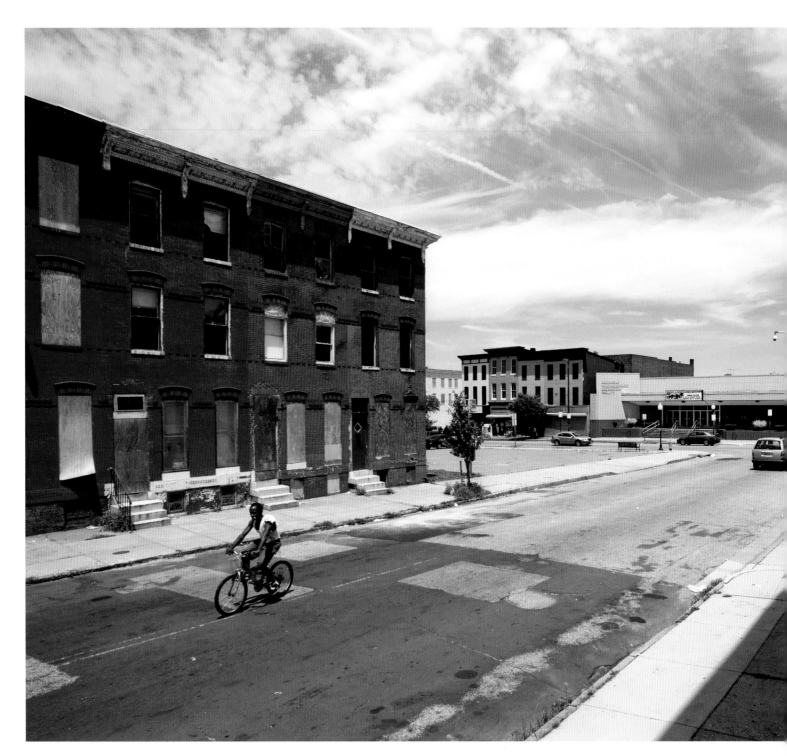

Looking toward 1601 Pennsylvania Avenue from Pitcher Street, 2014.

Louis Hornstein, my great-grandfather, was an entrepreneur who operated three African American theaters along Pennsylvania Avenue—the Lenox, the Diane, and the Regent. The first-run Regent was the largest. My father, Henry Hornstein, joined his father, Simon, in 1938. JF Theaters leased the Regent in the early sixties, but my family owned it until the city bought the property for the rec center.

My father told me that when the Regent opened, they had one projector, so, while they rewound the films to play the second half, they would present a vaudeville show. Bill "Bojangles" Robinson and Ethel Waters appeared on the stage. Later, Canada Lee and Mel Ferrer came for a fundraiser when they showed Lost Boundaries, a groundbreaking film about prejudice.

My father didn't permit white patrons in the theater. They wouldn't allow white men in particular, because they would try to pick up women of color, and they wanted to avoid fights and discourage prostitution. Sometimes a light-skinned person would come to the box office and be refused. They would insist that they were Negro and would have to see the manager, who would let them in. You also had to be dressed well to get in.

Bruce Hornstein, retired veterinarian

You were stepping out when you took your girl to the Regent. I was around sixteen or seventeen. My girl Lillian was quite an artist in the field of clothing. I tried to look my sharpest, the best that I could, other than my Sunday church-going garments. I mostly favored single-breasted suits with wider ties and pocket scarves during the springtime. Dress shoes were wingtips, sometimes two-tone in the summer months. A hat was a popular item. This was around '43 or '44.

Arundel Ice Cream was at Wilson and Pennsylvania Avenue. You'd treat your girl to a sundae before the movie. The Regent and the Royal were tops. The Diane was between the Regent and the Royal, a smaller theater on the same side of the street. They got the second-rate movies, but it was cheaper.

Howard "Gelo" Hall, retired race track official and jockey's agent

I saw Quo Vadis with Robert Taylor, and Peter Ustinov as Nero, at the Regent. When they crucified Peter, upside down, that made an impression on me. In our community they used to have a sculptured haircut called the Quo Vadis. It was well-shaped, close, with small sideburns. I may have gotten it once, but my mother wouldn't have appreciated it. So maybe you got away with it once.

**John "Jake" Oliver Jr., chairman of the board and publisher,
The AFRO-American Newspapers**

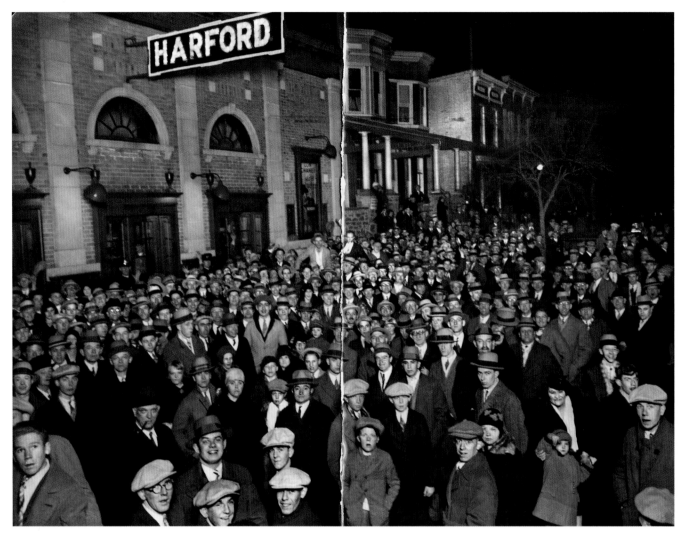

Harford Theater, 1928. A challenge to Sunday blue laws draws a crowd on February 5, 1928. Courtesy of the Jacques Kelly Collection.

HARFORD
1916–1960, 1962–63

2616 Harford Road
ORIGINAL SEATING CAPACITY: C. 500
ARCHITECT: A. Lowther Forrest

Just four years after the dignified Harford opened, Thomas Goldberg, who owned the Walbrook, invested in the modest theater facing Clifton Park and enlarged it. The design changes were made by Baltimore architects Ewald G. Blanke and John J. Zink. The refined neoclassical facade, enhanced by decorative brick and Indiana limestone pilasters, is mostly unchanged except for the removal of its V-shaped marquee and poster cases.

Like most theaters of its day, the Harford had an organ, a two-manual Moller. The remodeled Harford seated 700 and had a petite balcony. On Saturdays the Harford was packed with children who brought their lunches for a day at the movies.

The push to legalize movie showings on Sundays after 2 p.m. gained momentum by the mid-twenties. One of the challenges took place at the Harford on February 5, 1928, when programs rather than tickets were sold for a Sunday evening exhibition of a comedy, *The Dumb-Bells*. (The movie title selected was no doubt a commentary on the supporters of blue laws.) John G. Callan, a feisty plumber who was also a member of the House of Delegates, and his cohorts from the Liberty Defense League, who were

2616 Harford Road, 2012. Bishop Clarence Weston, front, with some of his congregants from the Redeemed Church of Christ Apostolic.

pushing for repeal of the Sunday restrictions, were arrested and fined. Three thousand people crammed Harford Road outside the theater to support the challenge to Sunday blue laws. The overflow crowd spilled onto Gorsuch Avenue.

The legal battle continued for another four years. Advocates for the repeal of blue laws pushed through a city referendum on May 2, 1932, to permit movie exhibition, as well as concerts, plays, sports, and bowling, on Sundays. To support the repeal, all of the downtown movie houses opened for free on the Sunday before the vote. About 140,000 moviegoers filled the theaters, a forty percent

increase in attendance. The referendum passed easily the next day.

The Harford closed in 1960. It was called the Harford Art Theater from 1962 to 1963, and then became an adult theater in its last days. A paradoxical coda to the defiant role played by the Harford in 1928 is that since 1971 the theater has been the home of the Redeemed Church of Christ Apostolic.

I am not conducting this fight for Sunday moving pictures to stir up a religious row or raise a moral issue, but to improve the city. I believe Baltimore could have a population of 1,000,000 persons soon, if the city had Sunday entertainment, but it will never have 1,000,000 persons with a "dead" Sunday . . . I am always in favor of opposing the activities of certain small groups that are so absorbed in their own aims that they will sacrifice the betterment of Baltimore.

John G. Callan, president, Liberty Defense League

The Evening Sun, *February 8, 1928*

The Lord's Day Alliance . . . would have us return to the days of Puritan Massachusetts when even death was the result of breaking Sunday laws and men were sentenced to the stocks for kissing their wives. The Sunday laws do not and will not fill the pews, and if the people do not want to observe them no power can make them . . . The civil government has no more right to determine what constitutes Sabbath and Sunday desecration than it has to decide which religion is true or false.

Rev. Dr. C. S. Longacre, Religious Liberty Association secretary

Excerpt from speech at the New Theater
The Baltimore Sun, *February 13, 1928*

Baltimore has always been proud of its position as a law-abiding city and has been known for its strict observance of the basic principle of the Christian religion. Anything that would rob the day of its strictly religious meaning will call forth the whole-hearted opposition of the people who want to observe this fundamental inheritance of our faith. The chief protagonists of the ordinance have been the careless, indifferent class and those who would profit by commercializing the day.

Rev. Robert E. Browning, pastor of the Protestant Episcopal Church of the Ascension

Excerpt from Sunday sermon delivered before the blue law referendum
The Baltimore Sun, *April 25, 1932*

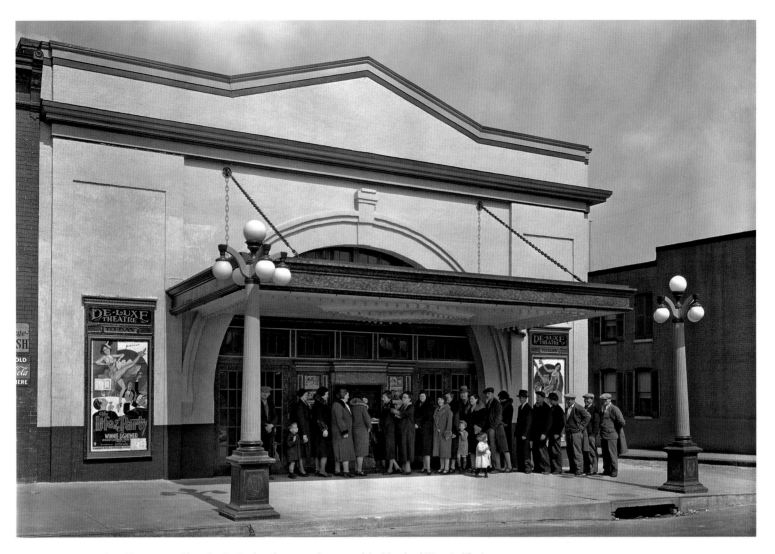

Deluxe Theater, 1931. Photo by the Hughes Company. Courtesy of the Maryland Historical Society, #SVF.

FLAG/DELUXE
C. 1916–1958

1318 East Fort Avenue
ORIGINAL SEATING CAPACITY: 250
ARCHITECT: J. C. Spedden

The Flag Moving Picture Theater began as an open-air theater late in 1913, but movies had already arrived in Locust Point by 1910 when the Latrobe Moving Picture Parlor opened in a rowhouse at 1501 East Fort Avenue. The Latrobe disappeared by the time the Flag was converted to a standard theater by architect J. C. Spedden around 1916.

In 1928, a ruckus occurred when the police confiscated reels of the Dempsey-Tunney and Dempsey-Sharkey fights. The Flag had violated the federal law prohibiting the transportation of fight films across state lines. When Southern District patrolmen raided the theater, the reels were switched. The patrolmen made a show of leaving, only to return minutes later when the contraband reels

were back on the screen. They stopped the show, provoking boos from the audience. However, when the officers tried to make arrests, the theater operator, cashier, and box office receipts had vanished.

Around 1929, the theater's name was changed to the Deluxe. The Deluxe served the insular Locust Point community well until it was shuttered in 1958. The following year, a five-alarm fire ripped through the building, destroying the front and most of the interior. The Deluxe now houses the offices of Southway Builders, Inc. Paul Littmann Jr., Southway's founder, has honored the Deluxe by preserving the ghost lettering on the southeast wall, which trumpets *Deluxe Theatre—Modern Air Conditioning*.

In my day, Locust Point, in the heart of South Baltimore, had a firehouse, a bakery, a seafood market, a funeral parlor, a blacksmith, two dry goods outlets, four ILA union halls, two schools, twenty-two taverns, a Coca-Cola plant, a Procter & Gamble facility, four churches, a drugstore, assorted Mom and Pop shops, including my favorite, Sticky Buns Baumann, and one movie theater, the Deluxe.

I can't remember the reason why, but I once got "barred" from the Deluxe. How was I going to get back into the movie to see the finale of the serials? This was a crisis! I decided to wait till after 6 p.m., when they changed ticket sellers to pull it off. The woman who worked during the day had my number. I was on her "keep-the-hell-out" list.

Bill Hughes, writer and videographer

I felt very sad when [the Deluxe] closed. How great is it to have a movie theater fifteen yards from your house? I remember sneaking in the rear exit ninety percent of the time and not buying a ticket. There was an usher called Dicey who was viewed as the enemy by the local kids who were always aggravating him. His mission was to catch us doing things we weren't supposed to do. He'd be flashing his flashlight back and forth into your face and if he saw you hadn't paid, you'd be thrown out. I remember crawling under the seats and yanking on the girls' legs when I was around ten.

I watched it burn down from my front door at 1425 Lowman Street in December 1959. I remember being very nervous that night it burned down because I had been in the theater that day. It was already closed. Me and a bunch of local kids would break in, play in the seats, and run into the projection room. There were old film canisters. It was always fun being someplace you weren't supposed to be. I was worried someone would be knocking on my door, wondering if I was involved. It took away from the enjoyment of watching the flames! I do believe kids were eventually arrested. Friends of mine had knocked in the door, but not me. It was a pretty big fire. Flames burst through the roof, but it was put out pretty quickly.

Jim Daly, retired sales manager, Verizon

I lived in Locust Point until I was nine. We lived with our business, a ship chandlery, on Hull Street. My Catholic girlfriends and I went to see movies like Joan of Arc *with Ingrid Bergman, and* The Song of Bernadette *with Jennifer Jones. My friends identified with them. I knew the difference between Christians and Jews through the movies.*

Rochelle "Rikki" Spector, retired Baltimore City Council member

1318 East Fort Avenue, 2013.

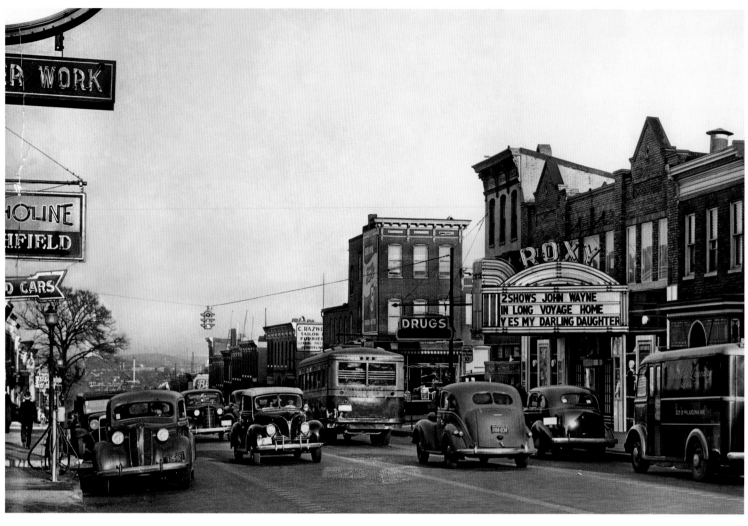

Roxy Theater, 1941. Courtesy of *The Baltimore Sun* and The Photography Collections, University of Maryland, Baltimore County.

FAYETTE/ROXY

1917–1957

2239 East Fayette Street
ORIGINAL SEATING CAPACITY: 385
ARCHITECT: John Freund Jr.

East Baltimore's Roxy shares absolutely no similarity to its namesake in New York City, the lavish Roxy that in 1927 was the world's largest theater palace. Baltimore's Roxy was a simple one-story movie house called the Fayette when it opened in 1917. The Fayette lasted only nine years before being converted into a bowling alley.

In 1932 Leon Zeller revived the theater and tried to give it some panache with the Roxy name. In the forties Zeller also operated the Rex, Roslyn, and Times theaters. This section of East Fayette Street was largely Jewish. There were also some Italians, as well as African Americans in the nearby alley of Mullikin Street.

A flash fire in the projection booth in 1949 was a

reminder of how dangerous film projection continued to be. The operator, Charles Spellman, was winding a reel of film when the fire erupted. He heard a *whoosh*, and suddenly several rolls of film, lying on a table in their tin containers, were in flames. Flames shot through the four projection windows before Spellman closed the window flaps designed to seal the projection room. Spellman escaped, and the audience of about 350 filed out safely.

The theater's final owner, Louis Shecter, sold the Roxy to New Harvest Ministries in 1999. During the lively Pentecostal services, the church founder, Bishop Marcus A. Johnson Sr., observed that the Roxy is still a theater: "It's just a new production, and we are blessed to be in it."

On Saturday mornings we would go to the Roxy. When I was a little girl—and even now—I loved pickles. So my mother would put a pickle in my lunch. That particular day the young people around me started yelling and complaining about it. They could smell the Kosher pickle! The usher told me I had to leave. I cried and said I wanted my nickel back.

I was probably no more than eight or nine years old. It didn't occur to me to throw the pickle out. My father was a tailor. Those years were difficult financially. It was instilled in us that you didn't waste food. I didn't get my nickel back.

Faye Better, retired bookkeeper

My father had a shoe repair shop on Fayette near Broadway. For special shows, the Roxy would ask if they could put a poster in the window. By doing that we got five passes to the Roxy. That was our form of recreation.

On certain nights they would give out dishes. The iridescent carnival ware was beautiful. It came in two colors, orange and green. My mother had a whole set of the orange. When you held it up to the light the glass would shimmer different colors. It drew patrons to the theater.

Betty Zilber, retired secretary and homemaker

I lived next door to the Roxy. I was very young, only five or six, the first time I went to the movies by myself. My older brother gave me a pass. I was enthralled with the cowboy film. I saw people leave so I thought this is what I should do, too. Later my brother came home and asked, "Did you like the newsreel?" "What newsreel?" I responded. "What about the comedies?" "What comedies?" "What about the double feature, the coming attractions?" I felt like a fool. After that I made up for it every Saturday that I could.

The Roxy was very dark, with body smells and food smells and the crunch of peanut shells underfoot. I would bring my lunch. One time my mother wanted to see the movie and she didn't have money, so she packed a lunch and said to the ticket taker, "I'm bringing lunch to my daughter," but actually she sat down, ate the lunch, and watched the movie for nothing. She only did it once.

Even after most theaters became churches, their essence as theaters still permeates the buildings: the drama, the comedy, all the life experiences. Theaters provided an aura, the imagination that nourished people's lives. Now it nourishes their spiritual lives.

Rae Rossen, retired secretary, newspaper columnist, and poet

2239 East Fayette Street, 2014. Where the stage once stood, New Harvest Ministries founder Bishop Marcus A. Johnson Sr., kneeling, conducts the baptism of Dony'e Johnson with assistance from Deacon James Turner, right.

McHenry Theater, 1917. Courtesy of the Jacques Kelly Collection.

McHENRY

1917–1971

1032 Light Street

ORIGINAL SEATING CAPACITY: 1,080

ARCHITECT: Oliver B. Wight

The McHenry is the southern cousin of the Parkway. Architect Oliver B. Wight designed both theaters in a similar neoclassical style for owner Henry Webb. The McHenry, built for $75,000, was the more modest, with no balcony and less ornamentation. One walked down a long hallway from the lobby to reach the auditorium. There, the focal point was a large dome, about 25 feet across.

The McHenry was not South Baltimore's only movie house above Fort Avenue. Five nickelodeons for white audiences predated the McHenry, but the only survivors beyond the silent film era were the Garden (1912–1960) at 1100 South Charles Street, and the Beacon (1906–1957) at 1118 Light Street. The Goldfield, an African American movie house on South Sharp Street, remained in operation as long as the Garden.

The Pacy family, which owned the nearby Garden, bought the McHenry in 1923. Durkee Enterprises managed both theaters. The Garden was the magnet for the children of South Baltimore on Saturdays; the McHenry drew an older crowd. CinemaScope was added later to the McHenry.

After the McHenry closed in 1971, the lobby was turned into a Gino's fast-food restaurant, and later a Goodwill store and a sports arcade. The Blue Agave restaurant is the current occupant.

In 2001, Baltimore developer Patrick Turner turned the auditorium into office space, but retained as much of the interior detail as possible. One of the tenants, Key Technologies, uses the stage as a conference room; gilded columns rise between the desks. The tenants may change, but the McHenry name, inscribed in stone, remains a constant above the bustle of Light Street.

I've lived my whole life in South Baltimore. My sister put a cork in a nipple, and gave it to me as a pacifier to keep me quiet when they took me as a baby to the movies. When I got a little bigger, my father took me, before talkies. He'd read me the dialogue in a whisper. That's how far back I go with the movies.

Shirley Temple drew the most people at the McHenry. On a Sunday afternoon, people would be lined up all the way down to the corner of Light where the Cross Street Market is, and you would have to wait a good while. When you finally got in, it was standing room only.

Later, when I worked at the candy counter in the fifties and early sixties, the McHenry was packed for Elvis Presley and the Beatles. When Elvis or the Beatles played and you bought a quarter box of popcorn, you got a free 8 × 10 glossy. Another big hit was Goldfinger, *with Sean Connery. The assistant manager said to me, "Ann, you have to see him in those blue terry cloth shorts. I'll come in, and you can go out and watch him." He was a knockout.*

This neighborhood used to be the place to shop. You could get everything from a spool of thread to a brand-new automobile on Light and Charles Streets. I could never see leaving here. But the city as I knew it moved away from me.

Anna LaMonte, retired cashier, Montgomery Ward

The three gathering places for young people in the neighborhood they now call Federal Hill were the theater, the drugstore, and soda shops like the Arundel. The McHenry was the showpiece.

You'd take your date to the McHenry. Everyone would be all dressed up, walking down the main drag. Next to the McHenry was a shoe store, Thom McAn, and next to that was the Arundel. So if you were lucky enough to have a date, you'd have to walk by all the guys at the Arundel. They would tease everyone who went by, in a real friendly way: "Here they come, the lovers."

We never went down Fort Avenue. It was tribal. They were from the Point. Locust Point was a longshoremen community with working people, making money. So if you went down there, odds are you were gonna fight before you left, just small fights and intimidation. The McHenry was like a cease-fire zone. Everyone from all the neighborhoods would go to the McHenry. As a rule it was peaceful. No one would bother you there.

Bobby Berger, retired police officer, singer, and club owner

Forest Theater, 1935. Courtesy of the Baltimore Museum of Industry, BGE Collection.

FOREST

1919–1961

3306 Garrison Boulevard

ORIGINAL SEATING CAPACITY: 650

ARCHITECT: Edward H. Glidden

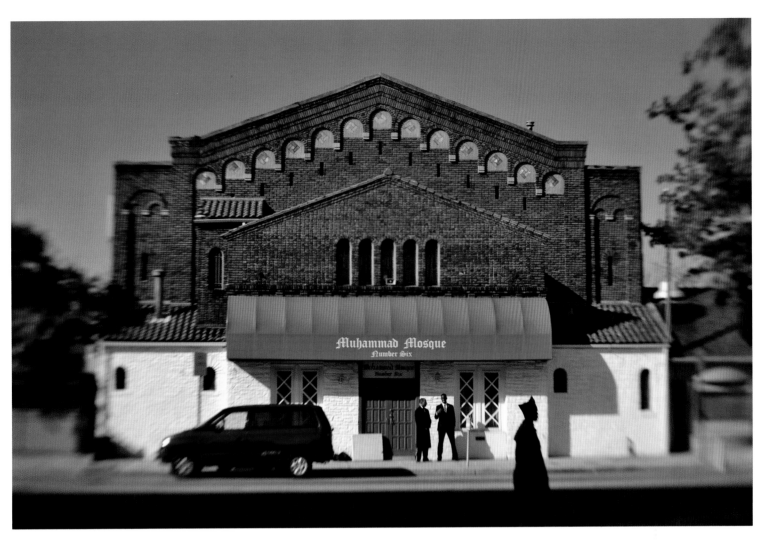

3306 Garrison Boulevard, 2011.

The Forest Park Theater, erected in 1919, was the first movie house to venture into the leafy expanding suburbs in the northwest part of the city. The Forest, as it became known, promised high-class photoplays that would be the equal of any of the fine theaters downtown. The matinee and evening prices of 20 and 40 cents, respectively, reflected management's upscale intentions. It seems to be the only neighborhood theater inspired by medieval Romanesque church architecture. The well-preserved upper portion of the ornamental brick facade with its inset mosaics still contrasts nicely with the green tile roof.

In the decades immediately after the Forest was built, so many working-class and middle-class Jews flocked to Forest Park that it became a predominantly Jewish enclave. There was plentiful shopping near the theater, situated at the intersection of Garrison Boulevard and Liberty Heights Avenue. The Forest was a twenty-one-day, second-run house until the ritzier Ambassador, farther up Liberty Heights Avenue, came along. Then the Forest became a twenty-eight-day house, showing films one month after the first-run downtown houses. It joined the Durkee circuit in the late twenties, and toward the end it featured art house classics and foreign films.

By the 1950s, Forest Park's transition to an African American neighborhood had begun. Like many of Baltimore's erstwhile movie houses, the Forest became a church. Today the Forest has the distinction of being the only former theater in Baltimore to represent the Nation of Islam as Muhammad Mosque Number Six.

Headquarters detectives investigating the robbery of the Forest Park Moving-Picture Theater . . . were searching for finger prints. Instead, they found a human finger. There it was, caught in a trap door that evidently had severed it. In the flesh was imbedded a ring. Finger and ring were taken to headquarters.

Meanwhile, Herbert Barnes, who had been arrested earlier . . . was being questioned about the $138 robbery. Barnes insisted he knew nothing of the crime. The police noted that one of his hands was bandaged. It had been caught under a falling plank, he explained. Then the detectives arrived with the finger and ring. At the sight, the detectives say, Barnes confessed. He was climbing in a window, the police say, when the trap door fell and caught his finger. Barnes admitted, according to the police, that he stole the money for a woman.

The Baltimore Sun, *March 14, 1923*

One of the most amazing events from my childhood, around 1949 or 1950, was when Gene Autry and his horse Champion came to the Forest, and then we watched the movie. He was the singing cowboy. To actually see Champion—he was so beautiful. It was an impossible dream come true. I went with my Aunt Margie and her kids, and we all got autographs. I bought a plastic keychain with a little statue of the horse which I had for a long time.

It was a raucous scene on those Saturday afternoons. Kids would throw things; the screen was patched from kids destroying it. There would be scuffles, kids calling out, talking back to the screen. You could see the spaceship was made out of cardboard. It was obvious. It was fun. There began my lifelong obsession with popcorn. First bag I ever had was at the Forest.

On Yom Kippur, the day of fasting, we were going to Beth Tfiloh synagogue. It was two blocks from the Forest. My friend and I would cut out and go to the Toddle House for hamburgers and hash browns. Afterwards, we'd go to the Forest, and then sneak back into the synagogue. We were not missed.

Michael Tucker, actor and author

1920

CHAPTER FOUR

1924

"Life is made up of small comings and goings,
and for everything we take with us,
there is something that we leave behind."

Narrator Gary Grimes (Robert Mulligan), from *Summer of '42*, 1971
Robert Mulligan, director

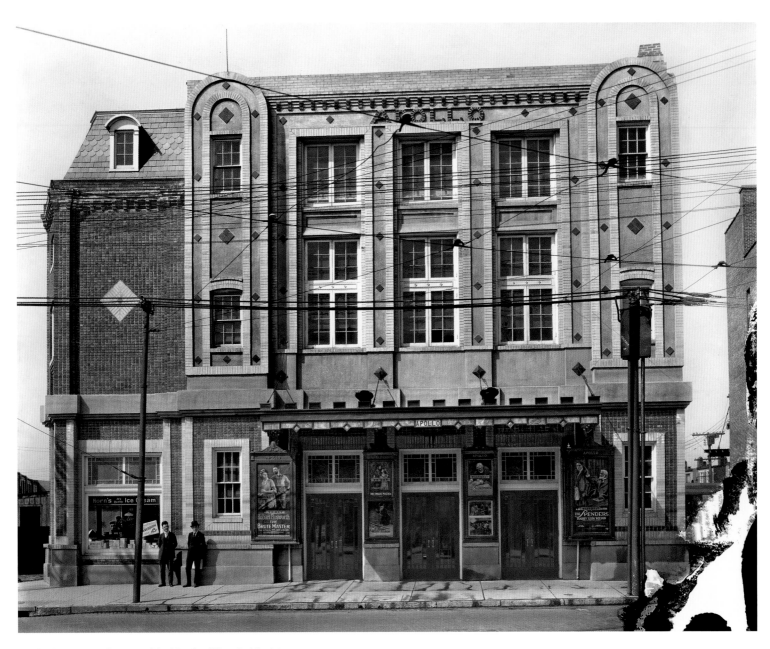

Apollo Theater, 1921. Courtesy of the Maryland Historical Society, #SVF.

APOLLO
1921–1981

1500 Harford Avenue
ORIGINAL SEATING CAPACITY: 1,000
ARCHITECT: Herbert C. Aiken

The Apollo managed to survive as a movie theater for sixty years. Though much worse for the wear, the Apollo still endures with modest dignity in a rather desolate block of Harford Avenue in the Oliver neighborhood. The facade is distinctive but unrefined. A confectionery store was conveniently located in the southern wing of the theater. It is covered up, as are most of the windows in front.

The Apollo interior was decorated in ivory and old rose tones and featured an orchestra and a Moller organ. Soon after the $175,000 fireproof playhouse was built, Morris Klein purchased it and the management passed to the Rome organization until it closed in 1981. (Rome Theaters was the second largest local circuit in Baltimore.) In its waning years, patrons would sometimes call out a warning about rats underfoot. The upside, according to one male patron, was that this was a surefire way to get your date to jump in your lap. A Pentecostal church, the Baltimore Tabernacle of Prayer, has owned the theater since 1982.

Adjacent to the Apollo to the south is a forlorn, boarded-up firehouse, known as Hook and Ladder 5 when it opened in 1905. To the north at 1508 Harford Avenue is Harford Commons, a three-story brick apartment building for seniors that was built in 1918 to manufacture Ouija boards. William Fuld, the inventor of the talking Ouija board, died in a tragic accident when he fell off the roof of the building, where he had gone to check on the replacement of a flagpole. What clues can be revealed, dear Ouija board, about the Apollo's past and future?

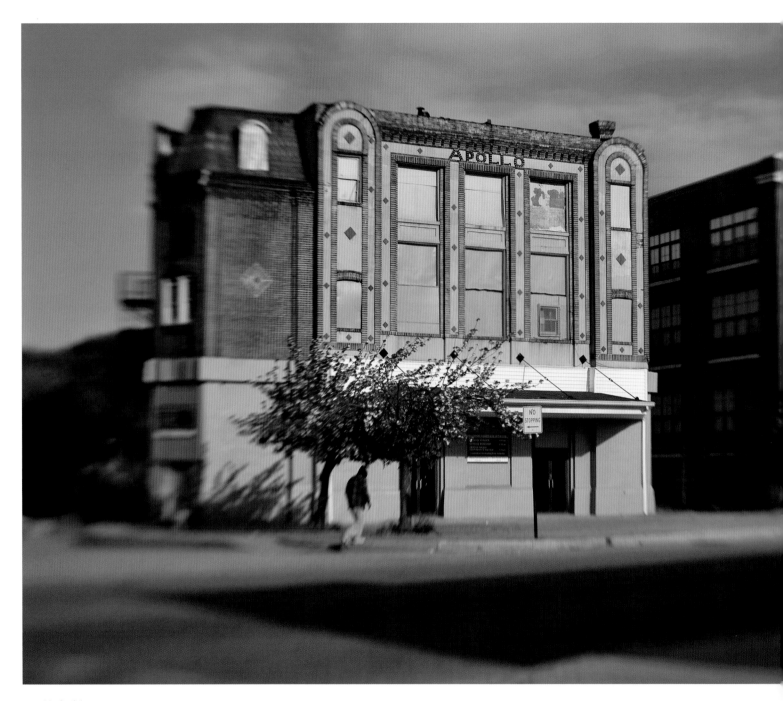

1500 Harford Avenue, 2012.

My mother, Iris Sipes, grew up near the Apollo on Bonaparte Avenue. There was a pretzel factory near there. She and her sister used to get the burnt pretzels that they threw away and take them to the movies and eat them. Their mother would have skinned them alive.

John Sipes, retired paving contractor

I went to the movies at the Apollo every time they changed, three times a week. The movie that I remember the most was My Foolish Heart, with Susan Hayward and Dana Andrews. I still remember the song from the movie. I used to meet a girlfriend at the Apollo. Afterwards I couldn't stop crying as I walked up Harford. She was crying, too, walking down Harford in the opposite direction. I don't know how long she cried, but I cried all the way home.

One thing that wasn't nice was one time when I was sitting under the balcony, and something hit my head. I put my hand up and it was all sticky. Someone had dropped a rotten orange on my head. It made a mess. I never sat under the end of the balcony again.

Across the street from the Apollo was the Arundel, which was a big hangout for young people. But up the street at Lanvale and Harford, on the east side, was an ice cream shop called Bud's. Bud and his wife Polly ran it. I walked in with my two girlfriends and saw this fifteen-year-old boy. I said, "He's mine!" Sixty-two years later, he's still mine. Our first time together was at the Apollo. That was my first date. I was thirteen or fourteen. When we got married I was just nineteen, and Dick was twenty-one. He assured me that we would go to the movies as often as I wanted, because I was a real movie addict.

Lee Keys, homemaker

Capitol Theater, 1932. Courtesy of the Robert K. Headley Theatre Collection.

CAPITOL

1921–1970

1518 West Baltimore Street
ORIGINAL SEATING CAPACITY: 1,200
ARCHITECT: Wyatt & Nolting

No one would identify the elongated building near the corner of North Gilmor Street as a movie house today, but in its prime the Capitol called itself "West Baltimore's Finest Theatre." This 1,200-seat playhouse, which cost approximately $300,000 in 1921, quickly put the West End Theater, its catty-corner competitor, out of business. Within two years, the Capitol owned the West End. The Rome organization, which controlled the Capitol Theater Company, also operated the Apollo and Broadway on the east side of town, the Rialto, just north of downtown, and later, the Astor, to the west of the Capitol.

The Capitol wasn't fancy, but it had tasteful details, including a domed lobby ceiling, fashionable indirect lighting, colored spots on the stage, and a gold fiber screen. A fabulous marquee and vertical sign, both adorned with a neon-outlined Capitol dome, were added in the thirties.

The building included some stores to the right of the entrance. Today the portion fronting West Baltimore Street contains a few small offices and a Laundromat. The deep auditorium, now used as a warehouse, still has its projection booth, though it appears rickety. A second-floor dance hall with a stage is unused but mostly intact. A snowball stand set up outside the building is a welcome sight in the summertime, but the former Capitol cries out for a more imaginative commercial use.

I went to the Capitol every day when I got out of school. My mother and father both worked, so they never knew where I went. You'd go in there on Saturday at 1 p.m. and stay until 11 at night. They never bothered to chase anybody out of the movies. You'd see the same movie about three or four times. The Capitol always got Buck Jones, Tim McCoy, and Ken Maynard cowboy movies.

On the corner of Gilmor and Baltimore there was a drugstore, more like an ice cream store. Hershey's chocolate bars came in blocks, and they'd take a silver hammer, break it up, and give you ten cents' worth in a bag.

Four stores down from the Capitol, there was a Coney Island hot dog place, and I'd get two hot dogs with the works, chili, mustard, and onions. You'd hide them in your coat and keep your arm close so you didn't drop them when you handed in your ticket.

Leo Guinan, retired firefighter

If you were old enough to date, you went to the Capitol. That's where the teenagers went in the late forties. You'd sit in the back. When I was at Western, I'd date boys from Poly. My older brother followed me and my sister, to see if we were neckin' in the movies. He followed us because that's what he was doing, too! I'd look back, and he'd be behind me doing the same thing.

**Nancy Cusic, homemaker and retired recreation leader,
Baltimore City Department of Recreation and Parks**

My father had a package liquor store at 1521 West Baltimore Street, where I was born, called Marshall's Cut-Rate Liquor and Tobacco store. When I was very little, my grandparents lived on the second floor, my mother, father, and myself were on the third floor, and they rented out the fourth floor. My grandmother Sarah Hunovice, who was Romanian, learned English by going back and forth between the Capitol and the Lord Baltimore. She took me to movies all the time.

Later we moved to Dolfield Avenue. After I got to be about seven or eight, I'd get on the No. 51 bus on Saturdays, ride down to Monroe Street and walk to Baltimore Street to take lunch to my dad. I could sell candy and tobacco while he ate his lunch. When I was around 11, I remember making deliveries to H. L. Mencken, who lived around the corner. This was about 1952 or 1953. I'd wheel around a case each of Arrow and Gunther beer, White Owl cigars, and some kind of whiskey in a brown bag. I didn't know that much about Mencken, but he drank a lot of beer. He was kind of gruff, but I got a quarter tip. Afterwards I'd go to the movies, at the Capitol mostly, which was like 12 or 14 cents.

Marty Hunovice, owner of Maryland Equipment Company

Facing page: 1518 West Baltimore Street, 2013. Shawn "Silk" Coombs Jr.

Century and Valencia theaters, 1926. Courtesy of the Jacques Kelly Collection.

CENTURY

1921–1961

18 West Lexington Street
ORIGINAL SEATING CAPACITY: 3,450
ARCHITECT: John J. Zink/Hoffman & Henon

With the arrival of the ornate Century, downtown Baltimore finally had an elegant, big-time movie palace. Unlike the Hippodrome, built seven years earlier as a vaudeville house, the Century was designed to show movies. The Century became Baltimore's largest movie theater when it opened in 1921, eclipsing the 1,900-seat Rivoli near City Hall. The owner, Charles E. Whitehurst, already owned the other two major vaudeville houses on Lexington Street, the New and the Garden (later renamed Keith's), when he constructed the grandiose $2 million theater.

The first-run Century anchored the eastern edge of a teeming shopping and entertainment district. The interior was a Hollywood castle: a resplendent mix of antique veined marbles, tapestried walls, chandeliers, and dark wood paneling, brightened by a mirror-lined lobby that sparkled from lamp reflections. Halfway up the grand marble staircase, patrons were greeted by a massive statue of Laocoön and his sons being attacked by serpents. Upstairs in the mezzanine were sofas, easy chairs, and writing desks for penning "Wish You Were Here" post-cards. Every night, ushers wound up the mechanical bird of paradise that sang in a cage near the ladies' lounge.

In the fall of 1921, the Century Roof Garden opened for dinner, dancing, and vaudeville entertainment. A combination ticket for a movie and dancing cost 75 cents. Ballroom entertainers in the Charleston era included Cab Calloway and his band, as well as Joan Crawford, then a touring company dancer who was known as Lucille LeSueur.

The Loew's organization, eager for a foothold in Baltimore, bought the Century and uptown Parkway theaters in 1926. Under Loew's management, both theaters exhibited MGM films, but they also showed films from United Artists and Famous Players-Lasky, the precursor to Paramount. The largest electrical theater sign in the city, a new vertical blade sign with 4,365 light bulbs, lit up Lexington Street in 1927.

Loew's brought in New York architect John Eberson to remodel the Century and replace the rooftop Garden with the Moorish-style Valencia Theater. In the lobby, a ramp to the left brought patrons up to the Century auditorium, and another long ramp to the right led them down to the ticket booth for the Valencia. Three large elevators transported guests up to the Valencia. Another improvement to both theaters was an expensive air-conditioning system, a significant attraction during steamy Baltimore summers.

In 1955, Morris A. Mechanic, who already owned the Parkway and New theaters, acquired the Century and Valencia. He promptly shut down the Valencia. The Century closed in 1961, forty years after ushering in the era of the lavish downtown movie palace. It was demolished the next year for Charles Center, a fourteen-block urban renewal project. The unit block of Lexington Street gained a spacious, if sterile, plaza, and the crowds that once filled the narrow retail corridor disappeared along with the theaters. Not a trace of the Century or Valencia remains.

133

The Century, for many years Baltimore's prestige movie theater, opened May 7, 1921, with Mae Murray in The Gilded Lily. *During the twenties, variety acts were featured between the movies at the Century. The dressing room was located behind a screen in the Valencia, and it was my responsibility [as an usher] to alert the performers fifteen minutes before they were to go on and to take them down in a small service elevator to the Century backstage.*

I recall one such trip [when] the elevator came to a sudden halt, midway between the two levels. Repeated efforts failed to get it started. In the elevator with me were two dancers in the starring act, wearing ornate white costumes. Finally a ladder was lowered from the top level to the elevator, and the two performers and I were forced to exit by a trap door at the top of the cage and [ascend] the ladder. By that time the dancers were covered with grease from the elevator cables and shaft; they went on stage looking like coal miners.

Charles H. Reisinger, projectionist
"I Remember Two Great Movie 'Palaces'"
The Baltimore Sun, *September 16, 1962*

I saw Jean Harlow in a white satin dress at the Century. It was a matinee. The theater was packed. She came in from the right and crossed the stage. She was just Jean Harlow; you knew she was from Hollywood. She was beautiful and she had a smile from ear to ear. She came out to shimmy and shake and that was all she did. She was something else. She didn't have a stitch on under that dress.

Mildred Billingsley, homemaker and retired insurance adjuster

Clark Gable, film star, arrived in Baltimore last night [for appearances at the Century] in a manner wholly devoid of dignity. He left Pennsylvania Station at a dead run, flanked on either side by a husky policeman, the apex of a flying wedge of a dozen bluecoats. In close pursuit was a crowd of fans the number of which was estimated by the police as approximately 1,000, and as the actor sped away in the automobile of William K. Saxton, Baltimore motion picture exhibitor, a hardy few kept up the pursuit on foot as far as Preston Street. Not since the late Rudolph Valentino nearly lost his shirt at a Baltimore amusement park ten years or so ago has such a demonstration been accorded a visiting screen celebrity.

Donald Kirkley
The Baltimore Sun, *February 16, 1934*

The most thrilling time of all was when we went to the Century to see the opening of Gone with the Wind. *You had to buy your ticket in advance. The whole street was lit up. Lexington Street was partially blocked off for the big searchlights shooting rays across the night sky. It was a mob scene.*

They gave out a nice-sized program, as if you were going to a play, and there was an intermission. All the actors matched the characters from the book, but Vivien Leigh definitely personified what I thought Scarlett would look like. Who could forget that green velvet dress made out of the drapes?

Belle Palmisano, homemaker and retired decorating consultant

18 West Lexington Street, 2016. Lloyd Lillie's sculpture of Tommy D'Alesandro Jr. honors the mayor who championed Charles Center, the redevelopment that ousted the Century, Valencia, and many shops.

After synagogue on Saturday I would meet with four girls, including Sandy, the daughter of political boss Jack Pollack, and go downtown on the streetcar. We'd get a lunch at the White Rice Inn or go to Hutzler's for their famous chicken chow mein. There was a little shop on Lexington Street where Sandy would buy a pair of white gloves and a bag of pistachio nuts, which was a luxury for us. She would put the gloves on, to protect her hands from the red stains, and we'd all eat the pistachios. Then she'd just throw the gloves away. I'll never forget the extravagance of those red-tipped gloves. We'd wind up at the Century for the movie.

Rochelle "Rikki" Spector, retired Baltimore City Council member

Valencia Theater, 1926. Courtesy of the Theatre Historical Society of America. *Facing page:* Century Theater interior, 1926. A Laocoön statue greets patrons at the top of the grand staircase. Courtesy of the Theatre Historical Society of America.

VALENCIA

1926–1952

18 West Lexington Street
ORIGINAL SEATING CAPACITY: 1,466
ARCHITECT: John Eberson

Today we would call the Century and Valencia a twinplex, but when the Loew's Valencia opened six stories above the Century Theater in 1926, it was more poetically referred to as "The Castle in the Air." An old joke began: "What's the oldest and newest theater in the city?" The answer was the Valencia, because it was "over a century." The most enchanting feature, remembered by countless moviegoers in its thrall, was Eberson's trademark "atmospheric" ceiling that conjured up an outing under a night sky.

The movies shown at the Valencia were not expected to draw the big crowds that the Century could accommodate with twice as much seating capacity. The Valencia faced sporadic closures between 1936 and 1942. *Love Is Better than Ever*, starring Elizabeth Taylor, was the last film shown at the magical Valencia, which closed on May 18, 1952. The Valencia and Century were razed in 1962 to make way for the massive Charles Center redevelopment.

In 1926, when the Century Roof was turned into the Valencia movie house, I was sixteen and I got a job as an usher. At 10 o'clock the night before the opening, all the ushers got telegrams telling them to report to a Charles Street men's store the next day. There we picked up the silk shirts which went with the Spanish bullfighters costumes we were to wear.

That first night there were flowers everywhere and a Spanish orchestra. The movie, silent of course, was Valencia, with Mae Murray. The upper lobby was decorated as a Spanish patio, with iron grilles, tapestries, Moorish benches, stained glass, and overhanging balconies from which Spanish moss cascaded.

Charles H. Reisinger, projectionist
"I Remember Two Great Movie 'Palaces'"
The Baltimore Sun, *September 16, 1962*

My mother- and father-in-law, Margaret and Merrill Smedley, were married in 1930. When they were teenagers, probably eighteen and nineteen, they took the streetcar to Ellicott City to get married. Then they took the streetcar downtown and went to the Valencia. Margaret said that was their honeymoon. They could see the stars on the ceiling. And then they went back to their own homes. About a week later they told their family.

Lois Smedley, homemaker

Loew's Theaters was the powerhouse, and Loew's created MGM, the dominant studio. Pictures that they didn't think were going to make it would get specialty treatment at the Valencia. When a picture finished at the Century, it would usually go to the Parkway, not the Valencia.

The Valencia was just a beautiful scene: a ceiling that lit up like heaven, with a blue sky and stars and a moon. When the show was over and the house lights went up, the heaven turned to daylight and the moon turned into the sun. The stars became bright lights for safe exit. I recall that some viewed the Valencia as a firetrap because everyone used the elevator. It did have an internal set of stairs, [but] in that era, the issue of safety was of lesser concern than having an afternoon or evening of pleasure viewing a movie in a beautiful auditorium. Patrons didn't seem to mind standing in line, even in the rain or severe cold for an hour or two, in order to be able to buy a ticket for a couple of hours of heaven.

Aaron Seidler, retired film buyer/booker and theater manager

Valencia auditorium, 1926. The theater's Spanish courtyard décor was enhanced by an atmospheric ceiling with twinkling stars.
Courtesy of the Theatre Historical Society of America.

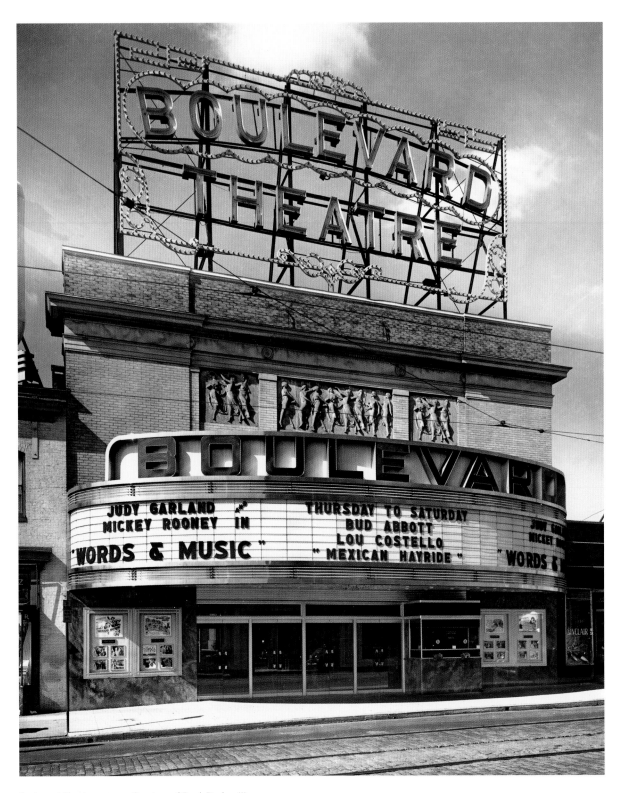

Boulevard Theater, c. 1949. Courtesy of Frank Durkee III.

BOULEVARD

1921–1989

3302 Greenmount Avenue

ORIGINAL SEATING CAPACITY: 1,500

ARCHITECT: Ewald G. Blanke

3302 Greenmount Avenue, 2012.

Grecian maidens still dance on terra cotta bas-relief panels above the two entrances to the Boulevard, at Greenmount Avenue and 33rd Street. The classical theme continued inside, where plaster goddesses, bathed in a lime-green glow, graced each side of the stage. Painted muses of dance, music, song, and myth decorated the enormous dome in the auditorium.

If the Boulevard's elegance drew from Greek classicism, its rocky beginnings could be likened to the Trojan War. Competition between two groups vying to build at this intersection sparked accusations of bribery in the City Council. Cost overruns and other shenanigans led to new ownership in 1922, just a year after its opening. Durkee Enterprises purchased the troubled playhouse in 1926 and ran the theater until it closed in 1989.

For moviegoers who grew up in Waverly, graduation from the raucous Waverly Theater to the more formal Boulevard was like a rite of passage. Floor-to-ceiling mirrors lined the lobby, offering multiple reflections into infinity. In 1984 the auditorium was twinned, hiding its refinements behind dropped ceilings and drywall.

Other than the two friezes with dancing nymphs, only the protruding curved marquee from 1948 remains from the Boulevard's theater days. When the Boulevard was converted into retail outlets, the new owner had to agree to maintain the marquee, by then a Waverly landmark. If only the huge marquee was actually a Trojan horse with preservation-minded soldiers inside, ready to wage a war of restoration.

In the year 1941, when I was ten, I kept a journal in which I would report what I did every day. I can't imagine what my parents were thinking of, but in the 365 days of 1941 I went to the movies 121 times. The Boulevard and Waverly would have been my prime venues, but I also went to the Rex, which was not as close. Now, sometimes if I liked a movie I would go to see it a second or a third time: the Blondie comedies, or Andy Hardy, or the bigger movies.

But I got into the movies before 1941. I still get almost teary-eyed when I think of just how incredible the movie production was in the year 1939. Gone with the Wind, Wuthering Heights, Goodbye, Mr. Chips, The Wizard of Oz, Stagecoach, *the breakthrough movie for John Wayne, and the great British film* Gunga Din *were just a few of the greats from that year. That's why I learned to love the movies. I would have seen almost all of them at the Boulevard.*

Charles E. Moylan Jr., retired judge, Court of Special Appeals

My father, Thomas Elwood Lavin, worked for the Durkee Theaters as a projectionist. He worked at several different ones, but he started at the Boulevard. My mother, Helen Welzel, used to dip ice cream and chocolates next door at Burris and Kemp, the drugstore. They used to dip the chocolates by hand. My dad liked both and would take his breaks there. That's how they met. She was engaged when she met Dad, but I guess his nibbling on chocolates and ice cream won her heart, since she broke her engagement and married Dad. He was an Irishman with a fun sense of humor.

Lynn Lavin, retired service manager, medical instruments company

I think the first film I ever saw at the Boulevard was A Streetcar Named Desire, *because my mother was infatuated with Marlon Brando. My mother and her friends, all homemakers, wanted to see* Streetcar *about a half-dozen times because Brando was so sexy. Compare young Brando to Gregory Peck or Gary Cooper; they were not pure sex like Brando was. That was a revelation,* Streetcar.

My mother didn't care what time the movie started. She'd go in the middle and stay to see the beginning. As I recall, they did not show cartoons, but they had newsreels. They showed a short subject, fifteen to twenty minutes, called Pete Smith's Specialties. *This guy, Dave O'Brien, narrated and built goofy things. O'Brien was also one of the actors in* Reefer Madness.

Steve Yeager, filmmaker and professor

Goldfield Theater, c. 1950. Courtesy of the Baltimore City Archives, BMS 26-7.

ARGONNE/GOLDFIELD

1922–1960

924 South Sharp Street

ORIGINAL SEATING CAPACITY: 750

ARCHITECT: Edward J. Storck

924 South Sharp Street, 2014.

Concrete pylons supporting the highways that swoop around the Baltimore Ravens' football stadium are the only structures left near the 900 block of South Sharp Street. In the middle of this desolate block was the Goldfield, the only African American movie house east of the railroad tracks that separate Federal Hill from the stadium. During the last two centuries, this section of South Baltimore was home to a large, self-sufficient African American community. Much of the area was razed and condensed by urban renewal into a smaller neighborhood called Sharp-Leadenhall.

Farther west, an earlier Goldfield Theater (later called Jean's), in the 900 block of Warner Street, has also been erased for the parking lots south of Oriole Park at Camden Yards. The longer-lived Goldfield on South Sharp Street was named the Argonne when it opened as an African American vaudeville / moving picture house in 1922. Programs included some pictures with a "colored cast" and some vaudeville acts in blackface.

In 1922, hearing the music from the dance hall upstairs, a crowd gathered outside to do the shimmy and other jazzy dances. Several men were arrested for disturbing the peace and blocking traffic. By 1925, when the Argonne became the New Goldfield, dancers were enticed inside for Charleston contests.

Goldfield was a meaningful name among African Americans in the early part of the twentieth century. Joe Gans of Baltimore was the first black man to win a world boxing championship, in a forty-two-round match in Goldfield, Nevada. Boxing matches also took place at the Goldfield in the late 1920s.

Louise Edwards remembers amateur talent nights in the 1930's, before the Goldfield started going downhill. There were long lines before Christmas when the theater would give out free candy and fruit. "When I went back," Thomas Gillard reported, "it looked like a ghost town. You may tear down the buildings, but you can't take the memories."

I grew up around Hanover and Lee Streets. It was just called south Baltimore then, not Federal Hill or Otterbein. There used to be a horse trough at the corner of Sharp and Lee Streets. I used to splash in the horse trough, with all the green foam and slobber from the horses! The black families were in the alleys, like Welcome Alley, one block from my house. We knew who they were. They had their own movie down at Sharp Street, just a few blocks further down from the horse trough. One time I wanted to see the movie that was playing at Goldfield's. The black neighbor kids put a hat on me and snuck me in. I got inside, surrounded by them. Oh my God, it was noisy. This was back in the mid-thirties. Now the area where they lived is a swimming pool for Otterbein.

Mildred Jean Horsman, homemaker and former Garden and McHenry theater employee

We did not need carfare in South Baltimore. The churches, the schools, the markets, your movie, your ice cream parlor, your family, your enemies—everybody was right there. The tracks below the Hamburg Street Bridge divided the east side from the west side. Goldfield's was on the east side, and Jean's was on the west side. You identified where you lived by what side of the tracks you were on.

It was plain inside, brown and beige. Tickets were 35 cents. Mr. Drew was the manager, but the real fixture at Goldfield's was Felt, who worked there from the forties until it closed. His name was William Felter Jr., but everyone called him "Felt" or "Mr. Felt." He was the usher, the attendant, the doorman, and sometimes the ticket taker and manager. Felt was a tall man, very gentle, very polite and unassuming. Everyone would gather around him.

We were mischievous. If we went overboard, Felt came running down that aisle. Felt had an easy mellow voice. The only time I heard him raise it was at us. When we got a little rowdy he'd shine that flashlight in your face. "Shut that noise up, boy! Sit down in that seat and be quiet!" No one disrespected him because he knew our parents. It should have been called Gold-Felt's.

Thomas Gillard, retired Baltimore County substitute teacher

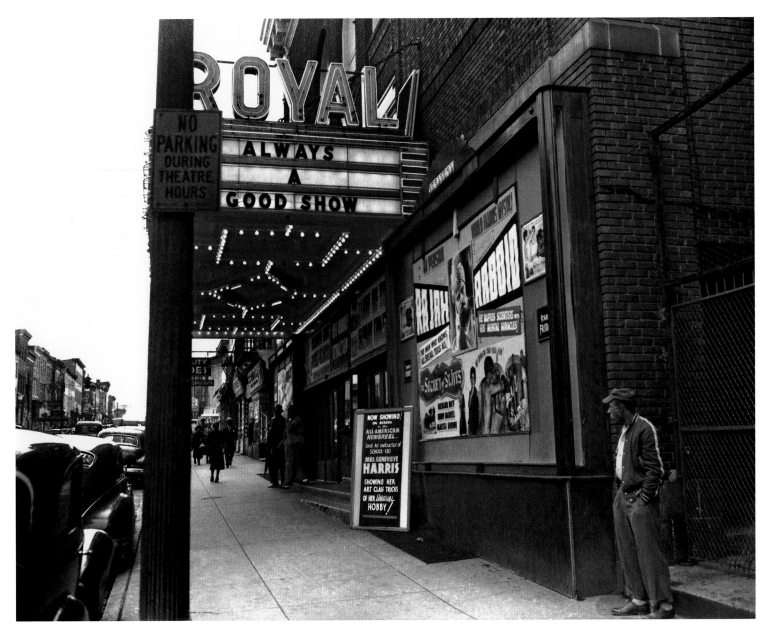

Royal Theater, 1949. Photo by Paul Henderson. Courtesy of the Maryland Historical Society, #HEN.00.B1-001.

DOUGLASS/ROYAL

1922–1970

1329 Pennsylvania Avenue
ORIGINAL SEATING CAPACITY: 1,349
ARCHITECT: Lachman and Murphy

The Royal loomed over The Avenue, its broad marquee acting as a powerful magnet pulling in crowds to see acclaimed performers. Demolished in 1971, the Royal is still a potent symbol of pride and loss. Its heyday and demise represent conflicting forces: historic preservation vs. urban renewal, black vs. white ownership, and an African American showcase that flourished because of Jim Crow laws. Ultimately what fans of the Royal remember most were the sensational shows from the thirties through the sixties.

Originally called the Douglass, the theater was built in 1922 by businessmen who boasted that it was "the finest colored theater in America owned and controlled by colored people." It had a deep stage to accommodate vaudeville as well as first-run movies. The Douglass struggled to attract enough local patronage, and it was sold to white owners in less than four years. They renamed it the Royal in 1925, and increased attendance by lowering the top admission price to 30 cents. *The Scar of Shame*, a 1927 silent melodrama with a black cast, was one of the early "race" movies intended for black audiences that played at the Royal.

The Royal changed hands several times. By the thirties it was hosting live acts for weeklong engagements, together with movies that changed three times a week. It soon became a well-known stop for black performers on the Chitlin' Circuit that included the Apollo in Harlem and the Howard in Washington, DC. From jazz originals like Louis Armstrong and Earl "Fatha" Hines to the Motown sounds of the Temptations and the Supremes, extraordinary talent appeared on the Royal stage over a span of four decades.

The Royal was a casualty of desegregation. The Baltimore Civic Center, built in 1962, was a larger venue that siphoned off the stars. African Americans could go anywhere for entertainment, and the Royal, once an important part of African American life in Baltimore, was never the same. The final stage show, featuring female impersonators known as The Jewel Box Revue, took place on November 12, 1968. Operating strictly as a movie theater was not a winning proposition; the Royal closed on July 21, 1970.

Urban renewal, or urban "removal" as some wryly call it, leveled several blocks of lower Pennsylvania Avenue, including the Royal. The site is now a football practice field. A modest memorial, consisting of a miniature marquee, was erected at the corner of Pennsylvania and Lafayette Avenues. Ask folks about Baltimore's landmark African American theater, and the refrain is always the same: "They should never have torn down the Royal."

I went to the Royal every week. It was so crowded that you had two lines deep, one to buy a ticket and one for ticketholders. It was always standing room only. It was a special place for locals, but you had a lot of other people coming to the Royal to see the shows, too. So you conducted yourself accordingly. No problems whatsoever. Folks upped their game.

Ella Fitzgerald sang here in the thirties with Chick Webb's orchestra. Duke Ellington held you spellbound. Other shows I saw were Count Basie, Lena Horne, Jimmie Lunceford, the Tympany Five, Roy Eldridge, Charlie Barnet, Fats Waller, and Nat King Cole.

I noticed that there was a door on the left side of the orchestra seats that people sitting in this section would use. So one day when the movie was over, I decided to walk through the door. After five or six steps, there was this big opening behind the screen. It was backstage. And there was a man playing the piano: Duke Ellington. We talked, and he said, "You want to go in the dressing room?" He took me back, and they had a doorman there, his name was Walter but everyone called him "Snags." When Snags saw me with Duke Ellington, it was my entrée for going backstage forever. I was in the club.

Ellington was very nice and we became friends. I was in high school at the time. Every time he would come he'd always take me back into the dressing room and give me a necktie out of his wardrobe. When he came to the Royal he had five trunks. Four of them consisted of clothes and the other trunk consisted of shoes. The shoes that he wore on the stage never saw the street.

James Crockett, retired realtor

We had a butler who used to take me to the Royal. I was nine years old. I'd try to be as inconspicuous as possible. In those days, I heard Jimmie Lunceford, Don Redman, and Chick Webb.

By the time I was fifteen, I was hanging out with the musicians. There would be jam sessions late at night after they stopped working. I'd tell them about the solos that I liked on their records, because I really knew them. Across the street from the Royal there used to be a restaurant called Juanita's with good fried chicken. She always used to say, "What does a white boy like you want to come here for?"

At sixteen I had my license and use of my father's car. All the African American musicians played at the Century and the Hippodrome as well as at the Royal. They had no place to stay downtown. For lodging they would stay at Smith's Hotel on Druid Hill Ave., and I used to take them up there from the Hippodrome on their breaks so they could eat. So I drove Johnny Hodges, Lawrence Brown, and Rex Stewart. They were appreciative of my interest, but they were aloof.

Louis G. Hecht, retired owner, Triangle Signs

My father, Cab Calloway, had family roots in Baltimore. His training was at Douglass High School. He came back to see his family and was always interested in getting some gigs. But my father was a fiercely independent person, and show business was not in Baltimore.

I didn't see most of my father's performances at the Royal. I was a child, and his image was fancy-free, sexy, kind of an idol. In the late forties, when he appeared at the Royal, Moms Mabley was usually on the bill. She would talk about him being her boyfriend.

He generally came with a complete show: his band, typically a female vocalist, and the dancers. The Nicholas Brothers used to be a part of his show. Most of the showgirls were tall and gorgeous. If I went backstage the chorus girls would make me up.

The Royal was a tough audience. When you came to the Royal you had to put on a top-grade show or the audience would let you know. His shows were about audience interaction. When he did "Minnie the Moocher," he really engaged the audience. He had the skill to make the audience feel that they were part of what was going on.

Camay Calloway Murphy, educator and arts advocate

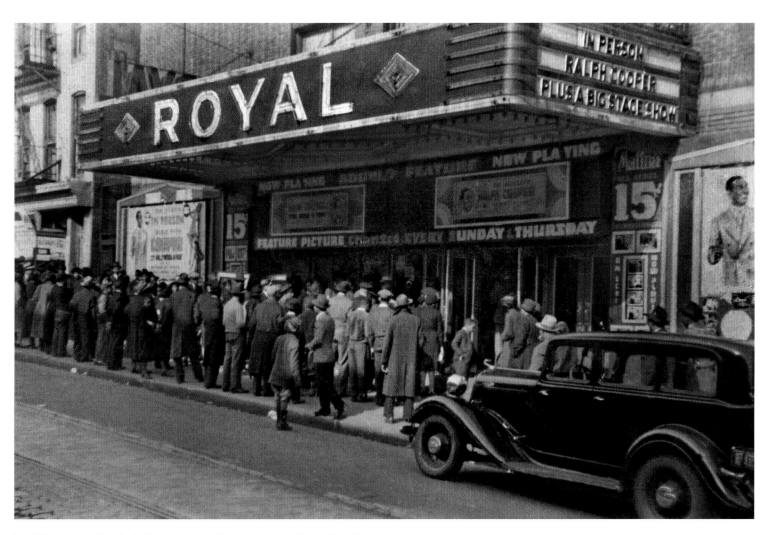

Royal Theater, c. 1938. A double line, one to buy tickets and one for ticket holders, forms to see popular actor and emcee Ralph Cooper. Courtesy of Theatre Talks / Cezar Del Valle.

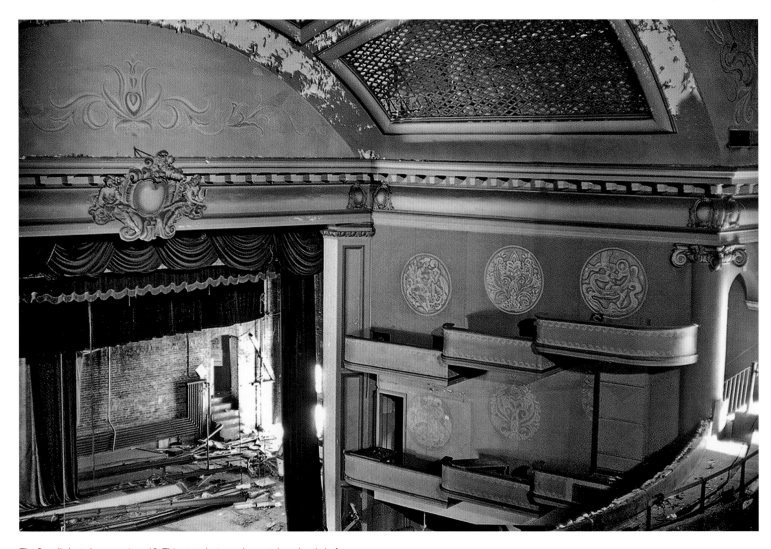

The Royal's last show was in 1968. This 1971 photograph was taken shortly before
the theater's demolition. Photo by Robert K. Headley.

To go into the Royal was like going into the Hippodrome today. It was opulent. Because we lived in that segregated society, the Royal was the place to go. We didn't have many opportunities to get dressed up, except to go to church and the Royal. We had so much pride instilled in us. If your date didn't take you to the Royal at least once, you had to drop him.

The Cadillacs and the Buicks would be lined up. Those were the big shots. They were in gambling, the numbers racket, but by today's standards they were lightweight. The men would wear Stacy Adams shoes, wide-brimmed hats, and suits. The women wore special dresses, almost prom-like. You would save an entire paycheck to get an outfit for the Royal. You had the shoes, the nylons with the seams in the back, little cocktail hats, gloves. It was awesome. This lasted almost until the Royal closed down.

Pennsylvania Avenue was the mecca of Baltimore. The Avenue was more or less self-contained due to segregation. We could see the stars before and after shows when they were relaxing. It was nothing to see Dinah Washington walking down the street. The premier restaurant was Sess's on Division Street, where we hobnobbed. The stars might be at Mom's carryout, or at the Sphinx Club or at one of the other clubs, chilling out. Children could make money by running errands for the stars. If we said we were going to The Avenue we didn't have to say any more than that.

Nzinga, oral storyteller

I saw every show at the Royal from 1954 until 1961, when I went into the service. We lived behind the Royal on Division Street. We'd see the stars when they came out between shows, and some would sit out in back near Brunt Street and talk with the people. Dee Clark came out and played basketball with us. I asked one of the Chantels, Jackie, for an autograph, but didn't have a pen. So she said she'd autograph my cheek and gave me a kiss. I was maybe fourteen. When the stars came to Baltimore to appear at the Royal, they stayed at people's houses. Sam Cooke stayed at the house next door to us and all the girls were going wild.

Every Friday night, when a new act came to the Royal, they'd start their engagement with one midnight show. That's when it was always packed. That line snaked all the way up Pennsylvania Avenue, down to Lanvale Street, and back up to Lafayette Avenue. That was the show when the comedians told the really raunchy jokes.

If an act came on stage and the audience didn't like them, they would get booed off the stage. People would throw things at them from the balcony. That didn't happen regularly. You had to be good.

Melvin Gamble, maintenance worker, Maryland Transportation Authority Police

The noon show at the Royal was a bargain, only 50 cents. When certain stage shows came to town, like James Brown, Ray Charles, or Ruth Brown, nobody showed up in school. If you went to the later show, it would cost more. You couldn't stop a show from coming to town, but you could stop the kids from cutting school. That's what Miss Violet Whyte, the truant officer, would try to do. Officer Whyte was a local institution.

I got caught playing hooky when James Brown came to the Royal. For that show, it seemed that everyone from Dunbar, Carver, and Douglass was there. On that day, Miss Violet Whyte came out from the wings and walked right onto the stage while they were performing. She flashed her badge and said, "Stop the show! Stop the show!" James Brown had to stop. She had one hand up over her eyes because the spotlight was so bright. So they closed the curtain. The lights came on. "First three rows, don't move!" Everyone tried to hide. There was nowhere to hide. She had all the exits blocked off with policemen. They were taking names.

I only played hooky that one time. With Miss Violet Whyte you were not going to be doing that again.

Andy Ennis, musician

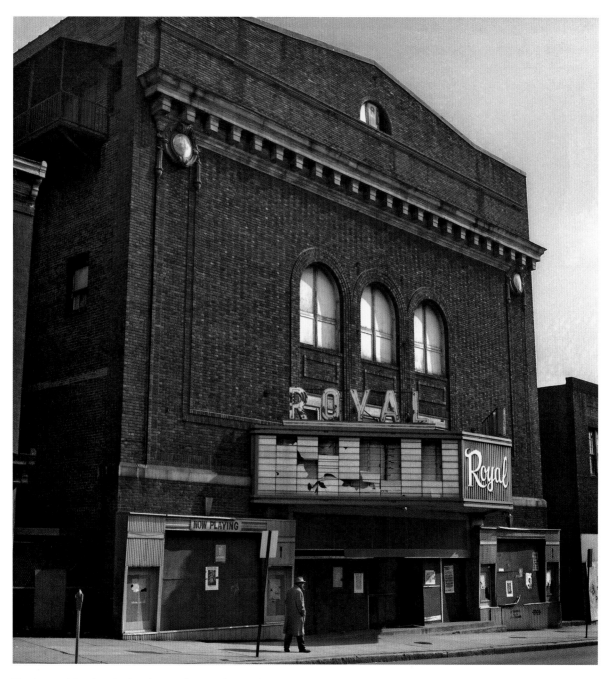

The shuttered Royal awaits demolition in this 1971 photograph. Courtesy of the Theatre Historical Society of America.
Opposite: 1329 Pennsylvania Avenue, 2013. From left, Tyler Saunders, Traveis Howell, and Jawuan Maultsby are ready for football practice on the field that replaced the Royal and other businesses.

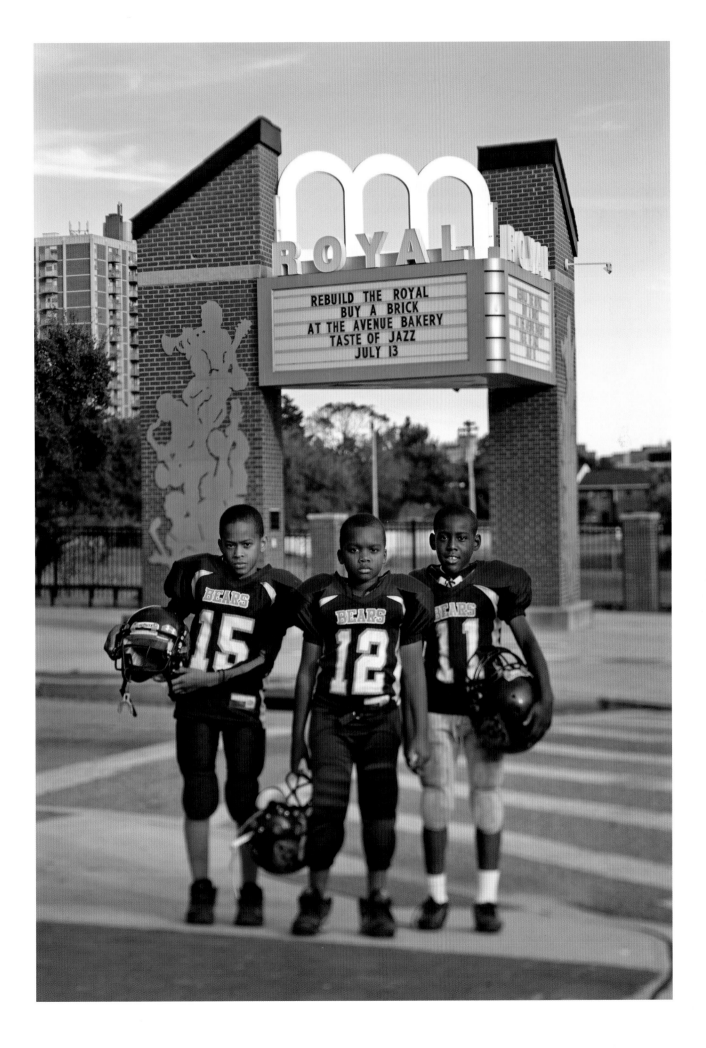

Jimmy Harrell, a tenor sax player in Tracy McCleary's Royal house band, was like a father to me. When we were playing down on The Block, he said, "You've never played in a big band. Why don't you take my place?" I was around eighteen. When I got to the Royal, they gave me his uniform. He was trying to get me into the big time.

Tracy McCleary and His Royal Men of Rhythm played behind people who didn't have their own band. The house band had about seventeen musicians. Tracy McCleary was a wonderful musician and a wonderful guy. He kept a lot of musicians working, and he always had a lot of respect for the musicians and fans. He did a lot of arrangements for the Royalettes, four girl singers, and would try to get them a spot on the show. He kept things together. I played behind Sam Cooke, Patti LaBelle, Gene Chandler (The Duke of Earl), Dinah Washington, Barbara Mason, Erma Franklin, Pigmeat Markham, Moms Mabley, and LaVern Baker between 1956 and 1959.

My big surprise was when I finally got to see what was happening behind the curtains. From the audience, it seems like magic. A big red and gold curtain opens up, and a mic rises up as the stage comes forward. Now I'm sitting down with everyone behind the curtain. The front of the piano is white, but the back that the audience can't see is dirty. While the movie is still on, they are getting ready for the stage show.

After a while, they announce, "Ladies and Gentlemen . . . ," and the stage starts moving. I look back and there are five to eight guys pushing the stage forward with heavy ropes. Then there's a guy in the belly of the theater pushing the mic up. The guys are sweating. Everybody has a job to do. I learned so much behind the stage.

Andy Ennis, musician

We had to recreate the Royal for Barry Levinson's Liberty Heights. I got to use the exterior of the Hippodrome, which was close enough in scale and architecture to stand in for the Royal. For the interior of the Royal we used the Weinberg Center in Frederick. What we did was create a shell with the Royal marquee on top of the Hippodrome marquee. Our neon copy of the Royal sign flickered in different colors. Everybody has signage, but a theater marquee says, "This is the entertainment district." It brings it alive.

The scene was a James Brown concert at the Royal. We filmed there for two days. People were coming up to us and reminiscing. They had to tell somebody their memories. A guy told me about meeting his wife there, and others would say, "We used to go there when we were kids." People would be coming down from the Lexington Market with tears in their eyes, seeing the Royal once again in its full glory.

Vincent Peranio, production designer

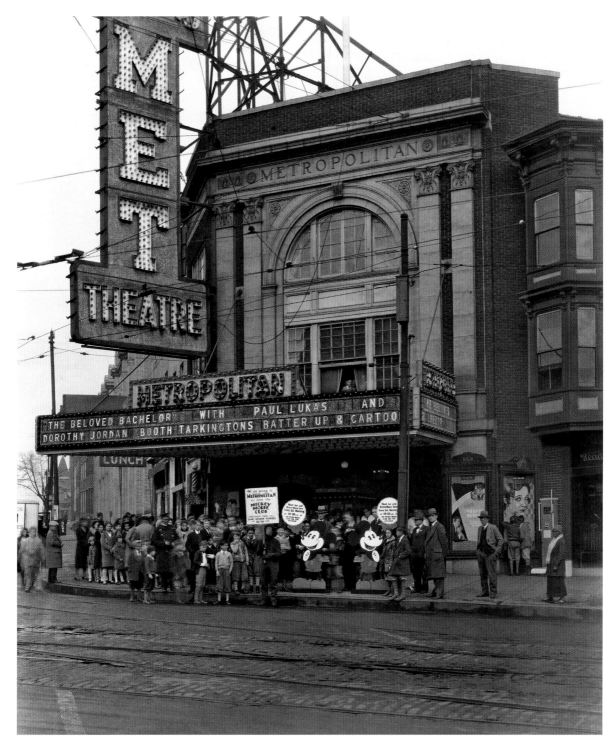

Metropolitan Theater, 1931. Courtesy of the Library of Congress, Motion Picture Division, LaFalce Exploitation Collection, Box G51.

METROPOLITAN

1922–1977

1524–1530 West North Avenue

ORIGINAL SEATING CAPACITY: 1,450

ARCHITECT: Otto G. Simonson

1524–1530 West North Avenue, 2014. The site of the razed Metropolitan is reflected in the subway station window across the street.

The Metropolitan thrived at the hub of North and Pennsylvania Avenues, but ultimately the theater's busy location led to its demise. In 1978 the Met, as it was known, was bulldozed to make way for the Metro's Penn-North subway station. No trace remains of this large neighborhood house. Before the cacophony of traffic, commuters, and a riot in 2015 enveloped this corner of North Avenue, the classy Met was known for another kind of noise. It was here that Baltimore saw—and heard—the first feature films with synchronized sound.

In 1925 Warner Bros. purchased the Met as a showcase for their new sound innovations. *Don Juan*, starring John Barrymore, arrived first in 1927. This Vitaphone production used sound on phonograph discs, synchronized with the film to create a musical background, sans dialogue. The sound barrier for dialogue was shattered when Al Jolson sang and spoke in *The Jazz Singer*, which premiered in Baltimore at the Met on January 8, 1928. Audiences packed the Met to experience this feature-length "talkie," using sound-on-disc technology.

Despite this historic first, the Met lost its prominence and became a second-run neighborhood movie house in the 1930s. It was taken over first by the Rome organization and then by the Schwaber circuit, which turned the Met into a first-run African American theater in 1949. The building incorporated stores at the street level, as well as offices, a dance studio, and a bowling alley. In the late forties, the entry at the corner of Pennsylvania was closed, and a new marquee was added to make the second set of doors on the North Avenue side the main entrance. A subway entrance and plaza has taken the place of the handsome Met.

To go to the Met was Big Time! It cost a dime more. Warner Bros. created a circuit to play their sound movies. They were demonstrating sound with test one-reelers. What I saw as a six-year-old were short subjects, different people talking and singing—just to entice people to this new type of movie. There was no story. People were a little leery. As a promotion, you could get in for free for about the first three days.

You waited in line, sat down, and listened to Vitaphone. This was real sound, not lip-synced like Don Juan, which came out earlier. You saw people talking and sing-ing. Once the seats filled up, they played a single reel, about eight to ten minutes long. Curiosity about sound brought tons of people in from all over the city.

They were giving out free Coca-Colas during that grand opening when they were demonstrating sound. Boy, we all went down there for the free Coca-Colas. I wasn't interested in singing. I was into the cowboy pictures. So I would go out, get in line for another Coke. My friend would save my seat. You couldn't drink in the auditorium. I think I drank a case of Cokes. I got home sick as a dog.

The Jazz Singer came maybe two weeks after that. The Jazz Singer sound was natural. For The Jazz Singer you had to pay. There were no free Cokes. I remember Al Jolson rubbing cork on his face. He was a pretty good singer, but I didn't watch the whole show. When my older sisters heard I was there, they went wild. "How did you get in there?" Later when they saw it, they came home crying, they were so thrilled about it.

Aaron Seidler, retired film buyer/booker and theater manager

It was a typical Saturday morning, sometime around 1950 or '51. Walked up to the ticket booth outside the Met with my 25 or 30 cents, and the ticket taker wouldn't take my money. Other kids got in and I didn't get in. In those days race meant nothing to me. I walked back to my parents' grocery. My father was at the register. I said, "Pop, they wouldn't let me into the movie." Father was checking out one of our customers. I think the customer was a mailman. He heard all this, and said, "Mr. Kolman, if your boy wants to go to the movies, I'll take him back down there." I'm eight years old, this big man took me by the hand, and when we went up to the ticket window, in a very assertive voice he said, "This boy wants to see the movie and he can go in to see it." No argument this time.

I had no comprehension then. It wasn't until years later that I realized it was reverse discrimination. Maybe they were concerned that someone was going to hurt me, or that I would cause trouble. There were never problems when I was growing up because of race. We never exchanged punches. Once a black friend got mad and called me, "You Whitey!" I had to think how to respond, and all I came up with was "You Colored-ey!"

Ira Kolman, audiologist

My earliest movies were the Met. It was dark with plush carpeting and was clean and comfortable. It seemed big. My younger sister Marilyn, we called her "Snookie," and my best friend, Reg Daniels, went with me to see The Thing. We missed most of it the first time because it was so intense that we had to jump under the seats. The man who played the monster was James Arness. He was the personification of your worst dream, especially if you were in third or fourth grade. Snookie ran out to the foyer. After we crawled out from under the seats we went to get her. So we had to watch it again to see the end.

John "Jake" Oliver Jr., chairman of the board and publisher,
The AFRO-American Newspapers

1925

1929

"*Wait a minute, wait a minute, you ain't heard
nothin' yet!*"

Jakie Rabinowitz/Jack Robin (Al Jolson), from *The Jazz Singer*, 1927
Alan Crosland, director

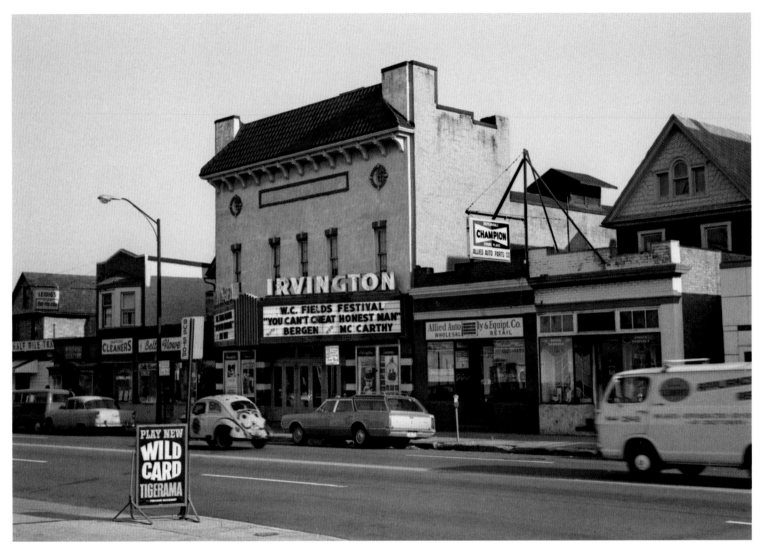

Irvington Theater, 1968. Photo by Robert K. Headley.

IRVINGTON

1925–1971

4113 Frederick Avenue

ORIGINAL SEATING CAPACITY: 575

ARCHITECT: Oliver B. Wight and E. A. Lockhart

4113 Frederick Avenue, 2013.

The southwest neighborhood of Irvington is better known for its cemeteries than its one movie theater, the Irvington. Yet the Irvington, even stripped of its marquee, is still a distinctive presence on Frederick Avenue. The well-preserved, two-story, stucco-clad theater dominates a block that also includes older Victorian houses that bespeak a sleepier, more countrified time.

Silent movies accompanied by an eight-piece orchestra were the draw when the Irvington opened in 1925. It was a clean, well-kept movie house owned by Jack and Irvin Levine for more than four decades. They earned the respect of the largely Catholic and Lutheran community by closing on Good Friday. The area was predominantly a working- and middle-class Irish and German enclave.

The Baltimore Film Society took over the theater in 1967. Like other unsuccessful efforts to show revivals and foreign films in the late sixties, the Irvington Cinema soon devolved into X-rated fare. This did not sit well with the community, and after protests the theater ceased operation in 1971. It's been the home of several churches since then.

Some fixtures from the original theater were still evident during the tenure of its last active church occupant. By 2015, the Irvington appeared abandoned and its future uncertain.

We moved out to the leafy glades around Mount St. Joe in 1941, and it felt like a place where the swells lived. The local movie house was the Irvington, and that felt like a pretty upscale place, too, if you'd been used to raffish theaters like the Horn down on Pratt Street or the Lord Baltimore on Baltimore Street, where there was always chewing gum stuck to the seats or half-eaten Jujubes on the floor under your seat. The Irvington felt like class. You could take your mother there, and in fact I did take my mother there the night before I left to enter the Navy in World War II. The movie we saw was The Magnificent Ambersons—*about a mother whose life is made hellish by a difficult son.*

Russell Baker, former newspaperman

Inside the foyer of the Irvington, a thin old man we called "Pop" collected the tickets. He was the disciplinarian. We'd see the trailers, The Passing Parade, *which were one-reel shorts, maybe an Edgar Kennedy comedy short, and cartoons like* Tom and Jerry *and* Popeye. *On Saturdays they would show a lot of them, plus the chapters. A scary one when I was little was called* Drums of Fu Manchu. *That was around 1940.*

About the same time, I remember people lined up around the theater to see Northwest Passage, *with Spencer Tracy. Inside the vestibule was a little box on a pedestal, with programs of the coming attractions. We'd fold up the programs, make airplanes out of them, and sail them on the way home.*

Michael Clark, retired restaurant manager

My first clear memory of going to a movie is my parents taking me to the Irvington to see The Miracle of Morgan's Creek *in 1944. I remember its shallow mirrored lobby and its hard wooden seats, but most of all I remember sitting in my father's lap and not quite understanding what the movie was all about. Eddie Bracken was one of the stars.*

What I really remember is the preview of The Uninvited, *a horror movie starring Ray Milland. The scenes of doors opening by themselves and candles going out scared the daylights out of me for much of my early life. I don't feel so bad, because I later learned that* The Uninvited *made Martin Scorsese's list of the eleven scariest horror films of all time.*

Robert K. Headley, theater historian

New Nemo Theater, c. 1949. Courtesy of the Baltimore Streetcar Museum.

TAKOMA/NEMO/NEW NEMO/EAST
1925–1955, 1965–1968

4815 Eastern Avenue
ORIGINAL SEATING CAPACITY: C. 297
ARCHITECT: unknown

John Wischhusen, a distiller by trade, called his tiny little theater the Takoma when it opened in 1925. The Eastern Avenue building was already in place and was simply remodeled into a moving picture parlor with a postage stamp lobby. There was a pit for an organ in the silent movie days.

The Takoma was renamed the Nemo in 1933 and then the New Nemo after it was spruced up under a change in management in 1946. The eastern edge of Highlandtown was a mix of mostly German and Greek families, but patrons of Spanish, Italian, Irish, Polish, and English descent also filled the seats. Oscar Boccuti ran the theater for many years until it closed in 1955.

After the neighborhood became the heart of Greektown, Mike Spanos, a local Greek American businessman, bought the slumbering Nemo and renovated it. Spanos added red panels to modernize the front and reopened it as the East in 1965. Melina Mercouri films, such as *Never on Sunday* and *Phaedra*, were some of the hits during the East's two-year run. Happily, most of the Art Deco upholstered metal seats are still in place. Now showing on the boxy marquee: Metropolitan Church of God.

163

4815 Eastern Avenue, 2012. Ray Gabriszeski.

I was infatuated with the ticket seller at the Nemo. In the 1930s we lived about five blocks away on Ponca Street. I was only four or five years old. I would ride my tricycle up to the Nemo, and I would just sit there and look at her in the window. Puppy love. I doubt she noticed me.

John Guerriero, retired, former owner of Continental Foods, Inc.

I worked part-time at the Nemo during high school, from 1945 to '46. When I sold tickets on a Saturday, I would come early, but all the kids would already be lined up, almost around the block. They had six-shooters in holsters and cowboy hats, and as they went in my boss would confiscate the guns, because if they got excited while they were watching the movie they might hit each other on the head.

Kids sneaked in around the back when they would open the exit doors to let people out. You could spot them, because they sat in the front. Some would stay by the front doors on Eastern Avenue, just to see a flash of the movie when the doors opened to let people out. The lobby was so small that you could glimpse the screen from the front.

The wartime newsreels let people know what was going on. It was graphic. The German front, Japanese bombs, the ships, and the small, fast Japanese airplanes—they looked like mosquitoes as they moved back and forth. In the audience there was a lot of cussing from the men, especially when Hitler [was] making all these speeches. They were aghast. They worked in the airplane factories and the shipyards. A lot of people had sons who were overseas.

Dolores A. Kelly, homemaker

I managed the Nemo briefly in the late forties. It was very small, and the air conditioning and heating were awful. Oscar Boccuti owned it for a long time. He was an immigrant. The Baltimore contingent went to Washington on Mondays to book pictures. Boccuti used to come into Washington wearing all kinds of raggedy outfits. He didn't want to look prosperous. He used to come into Twentieth Century Fox with his lunch, just a sandwich, and he'd ask for a Coke. When you saw him someplace else he looked spiffy. He wanted to look like he didn't have two nickels to rub together.

Fritz Goldschmidt, retired film booker

My husband Mike Spanos remembered the Nemo from his childhood. It had been closed for a good while. Mike had to start from scratch. He decided to show American and Greek movies, because he felt with so many Greeks there, including many who didn't know English, that it would be successful. My mother-in-law, Katerina, would go in every day and help sweep up the popcorn.

The theater block was a hub. Every Saturday night people would walk up and down those streets and stop in the bakeries. Greektown was safe.

Emily Spanos, retired teacher and homemaker

RITZ
1926–1963

1607 North Washington Street
ORIGINAL SEATING CAPACITY: 1,175
ARCHITECT: J. H. Stehl

The Ritz extends for almost an entire block in the Broadway East neighborhood. Slivers of trolley tracks along North Washington Street are a reminder of more booming days, when the smell of doughnuts wafted from the bakery at the corner of Federal Street. The bakery and a family grocery on the opposite corner are long gone. Half of the rowhouses in this block are boarded up, and the remaining residents stay behind doors secured with wrought iron bars.

The Ritz was built by E. Eyring & Sons for the Gaertner organization. The Gaertner Brothers, Harry and Louis, had a small circuit on the east side of town that included the Palace, the Vilma, and later the Earle and Carlton. The Ritz interior was understated but pretty, rather like a beautiful living room, as one patron recalled. Modest balconies flanked the projection booth. As a neighborhood movie house, the Ritz was a cut above its sister theater, the Palace at North Gay and Wolfe Streets, and its competitors to the west, the Apollo and the Harford.

In 1956 the Ritz became an African American theater. After closing in 1963, the interior was gutted for a supermarket; later, it functioned as a warehouse. Food importer Pius Ezeigwe, the current owner, hopes to convert part of the unused building into a food marketplace. Such an upbeat transformation would be welcome news to announce on the old marquee.

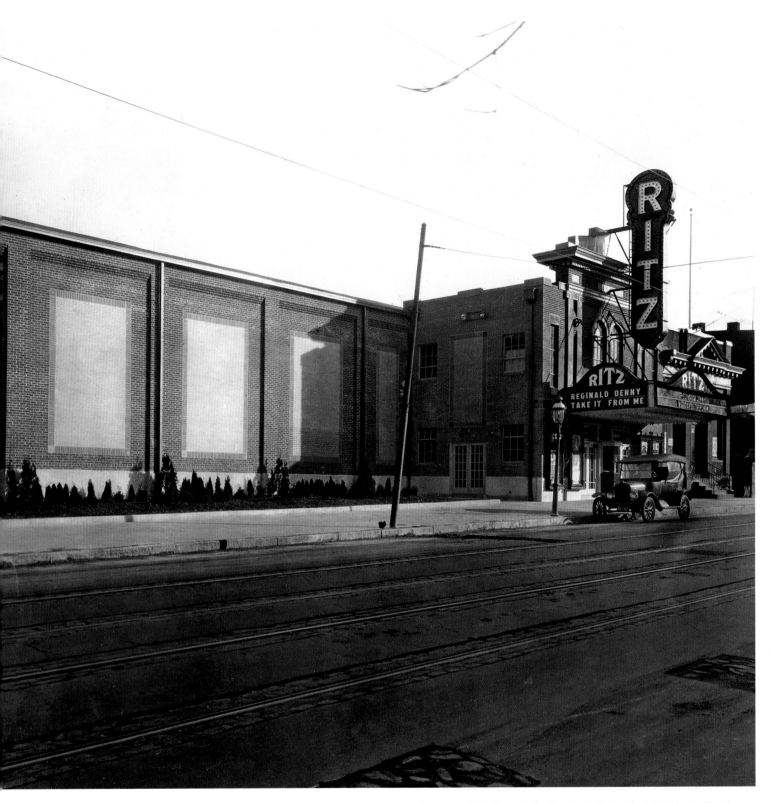

Ritz Theater, 1926. Courtesy of the Robert K. Headley Theatre Collection. *Overleaf:* 1607 North Washington Street, 2010.

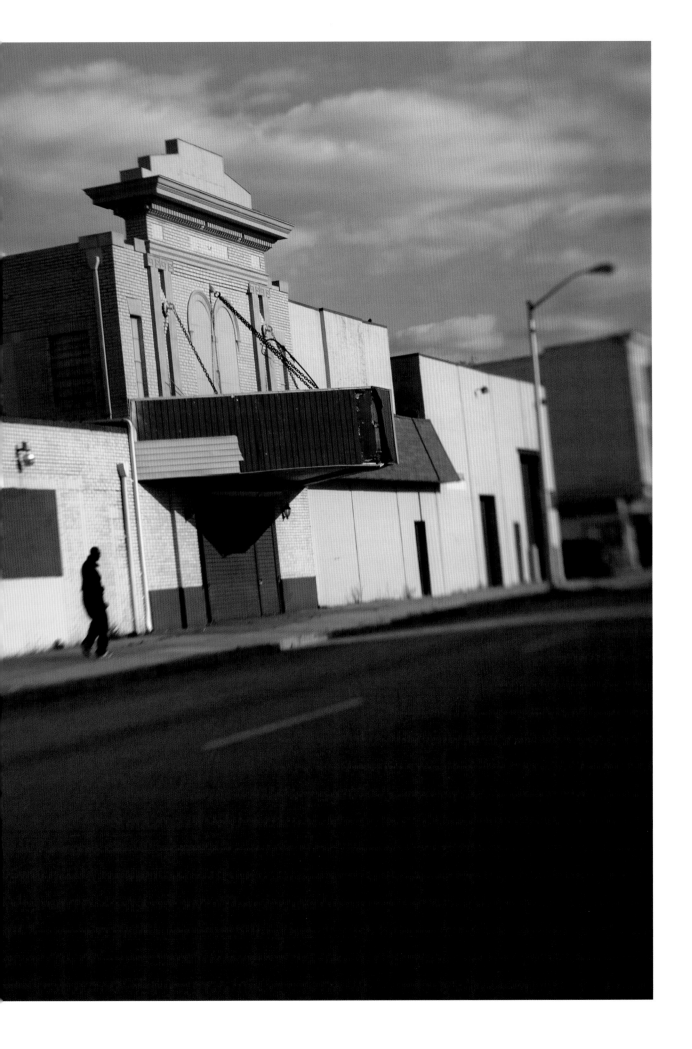

The Ritz gave out free dishes for the ten-cents admission. They were cheap, Depression-era pressed glass, but they were attractive in a way, and every mother in East Baltimore had the same dishes. They came in three colors: pink, blue, and pale yellow. That was something that only the Ritz had. That's why my mother took me to matinees during the week, to get an extra piece. Bette Davis, Joan Crawford, love stories, and dishes.

James "Jimmie" Judd, retired antiques dealer

When I was about twelve or thirteen, I found two tickets on the sidewalk. I had a new girlfriend named Patricia. Playing at the Ritz was a musical with Vera Ellen, who had skinny legs but really could dance.

When the usher started going up and down the aisles, I realized there must be something wrong with our tickets. The tickets had expired, and he was looking for us. So I told Patricia, and we crouched down in our seats, hoping he wouldn't recognize us. But he did, and requested that we leave. I was so embarrassed. I really wanted to impress that girl.

Ron Schollian, retired manager, CSX automotive department

The movies were our outlet for selling papers in the late 1940s. The man would let me inside the Ritz to sell the Sunday News-American when it was cold, usually before the movies closed around 8:30 p.m. The News-American had the eight-star, the nine-star, and the ten-star editions. I was thirteen or fourteen. I could sell about fifty papers, plus I would shine shoes at the same time. I made more money shining shoes.

The manager let me sneak in and watch the movie from the back of the theater. Inside, the Ritz was beautiful! It had thick red carpet and the seats were nice and comfortable. The sound was really good. You felt like you were really going to a big theater. People got used to seeing me.

I lived behind the old Sears Roebuck. Before desegregation, we'd mostly be going crosstown to see the serials at the Lincoln. I just accepted segregation. You mind your own business. I was around a lot of white people. So it had its good moments and its bad moments. But that's life.

Sidney Fields, retired machinist, Western Electric

The Ritz held out so long before admitting blacks that it was like the forbidden territory. You accepted that it was off limits. You'd be out there playing, and you'd see everyone parking their cars and going to the movies, dressed up.

The neighborhood got integrated in the early fifties. By the time the theater became integrated—gradually—the acceptance of blacks was still not there. It was a forced change. "Now y'all can come." But it was not freely done. There was an undercurrent of tension; the black kids were rebellious.

Hayden A. Smith, owner, East Federal Florist

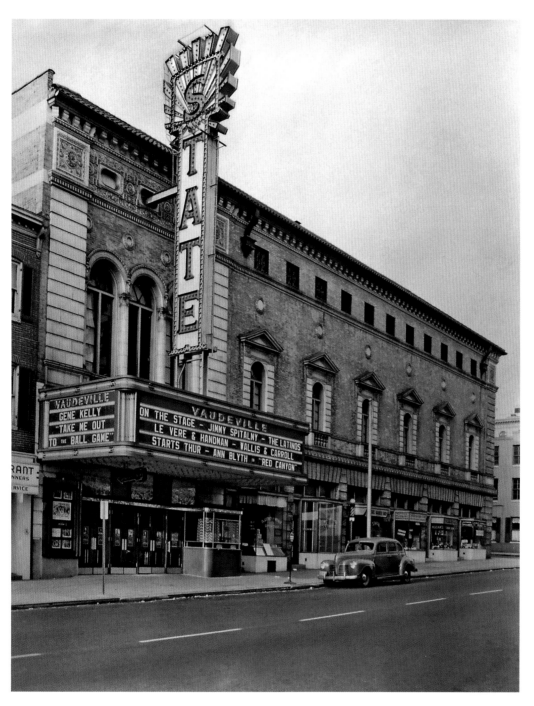

State Theater, 1949. Courtesy of Roy Wagner.

STATE

1927–1963

2045 East Monument Street

ORIGINAL SEATING CAPACITY: 2,044

ARCHITECT: George Schmidt and C. C. Fulton Leser

2045 East Monument Street, 2014.

"Will Baltimore like it?" That's the question cigar-smoking Fred Schmuff, the State's manager, always asked. The answer was "yes" for thirty-six years. Schmuff opened the State for Durkee Enterprises in 1927, and he was still working for the Durkees when the State went dark in 1963. The State was the biggest neighborhood movie house in the city, and its old-time vaudeville drew patrons from beyond East Baltimore.

Much of the vaudeville was second-tier, but plenty of great talents played at the State early in their careers, including Donald O'Connor and Abbott and Costello. There were three stage shows daily, each containing three or four acts, following the movie. Vaudeville lasted at the State until around 1954—longer than at the Hippodrome.

The cavernous $450,000 State Theater had an Italian Renaissance exterior and the ubiquitous Spanish Revival décor inside. East Baltimoreans didn't need to go downtown when they could see vaudeville in palatial surroundings, complete with a grand staircase, a mezzanine promenade, and a spectacular crystal chandelier. Another attraction was the twenty duckpin bowling lanes in the basement, which could sometimes be heard in the auditorium. The State drew from the crowds that thronged the shopping district around the Northeast Market.

The most mesmerizing show took place on February 9, 1936, when Ruthie, a lioness in the vaudeville act of illusionist Grover George, burst out of her cage unbidden. Her roar could be heard backstage even before she stole the spotlight from a pair of comedians. She escaped down a side aisle and leaped 12 feet into the lap of a fifteen-year-old boy sitting in the fourth row. His leg was slashed. One lady fainted, but most of the screaming patrons raced for the exits. Fortunately, patrolman Alexander Jezierski, who had ducked into the theater to warm up, reacted quickly when face-to-face with the snarling beast in the lobby. His shot from 15 feet away stilled the animal. Ruthie survived, but was not invited for a return engagement.

Later confrontations at the State took the form of major boxing matches broadcast via closed-circuit TV in the 1950s. The State was eventually used for revival meetings and then as a church. In the mid-1980s, Johns Hopkins Hospital converted the vast building into office space. The handsome exterior, devoid of marquee and vertical sign, has been nicely preserved.

When I worked as an usher at the Grand as a teenager from 1971 to 1973, Carroll Fuller was the projectionist. He had started working for the Durkees when they opened the State in 1927. He had a great story about Red Skelton.

This was in the vaudeville days, near the end of prohibition in the early thirties. Red liked to drink. There were several speakeasies on Monument Street. Shows would start at ten in the morning. So, Red would do a show, and off to the speakeasy he would go. Before the next show, his wife would find Carroll Fuller and his fellow stagehand, Timmy Rosenberg, and say, "Go find Red. We have to get him ready." Carroll and Timmy would bail him out of the speakeasy. He would fight and argue and resist all the way up Monument Street. As soon as he got on stage he seemed sober. He could drink heavily but when it came time to work he didn't give the appearance of being drunk. This went on for every day of his engagement there.

Carroll and Timmy were tired of the abuse. Red did this pantomime where he would sit on a cane chair and pantomime being a woman changing clothes. The two boys decided they would get back at Red. Before the show, they sawed the legs of the chair about three-quarters of the way through. Red sat down, and of course it broke into a million pieces. These two were hysterically laughing. Red immediately put two and two together, and he picked up the remnants of the chair and chased them out into the theater, up and down the aisles. The audience was in hysterics, because they thought it was part of the act.

Gary Helton, manager for radio station WHFC, Harford Community College

Growing up in the late thirties, early forties, I couldn't go in the Preston, Apollo, or Ritz. And I dared not go to the State. All that area around the Northeast Market was white. I tell you the God's honest truth: I always wanted to go to the one on Monument Street, the State. It was so big. That was the one I wanted to attend.

Nathan C. Irby Jr., former Maryland state senator

The silent movie houses started with piano accompaniment. Some added orchestras. That became too expensive. Rudolf Wurlitzer saw that there was a niche: "We can give you an orchestra with one person!" Since the movies needed special effects such as car horns, thunder, police sirens, birds, cymbals, etc., one person could do this with what he produced. He called it the Unit Orchestra. About 10,000 theater-style pipe organs were built worldwide. Today, only about twenty survive unaltered.

The State Theater's Wurlitzer pipe organ was first heard at its opening on April 16, 1927. It is still an unmodified and complete Wurlitzer Style E, Opus 1539 instrument. The organ has nearly 500 pipes in seven rows, or ranks. With the threat of the State being razed, I purchased the organ in 1969. With a crew of about fifteen friends, we accomplished the daunting job of removal in three days.

At my house in Glen Arm, with more help from friends, we restored all the parts to make it as new. I maintained it until I could find a proper new home for the Wurlitzer. In 2012 it was moved, very carefully, to the Engineers Club at the Garrett-Jacobs mansion on Mount Vernon Place.

Before we dismantled the organ, my wife Dee and I held one last concert for our friends. Four professional organists, John Terwilliger, Don Kinnier, Dick Smith, and Michael Britt, played it for the last time. For the final number, I played "I'll See You in My Dreams." Now the public can hear it again. I was just the caretaker.

Roy Wagner, retired general manager of Cooper's Camera Mart and organ aficionado

The Wurlitzer 2/71 style "E" (Opus 1539) theater organ was rescued from the State Theater in 1969 and installed forty-three years later at the Engineers Club on Mount Vernon Place.

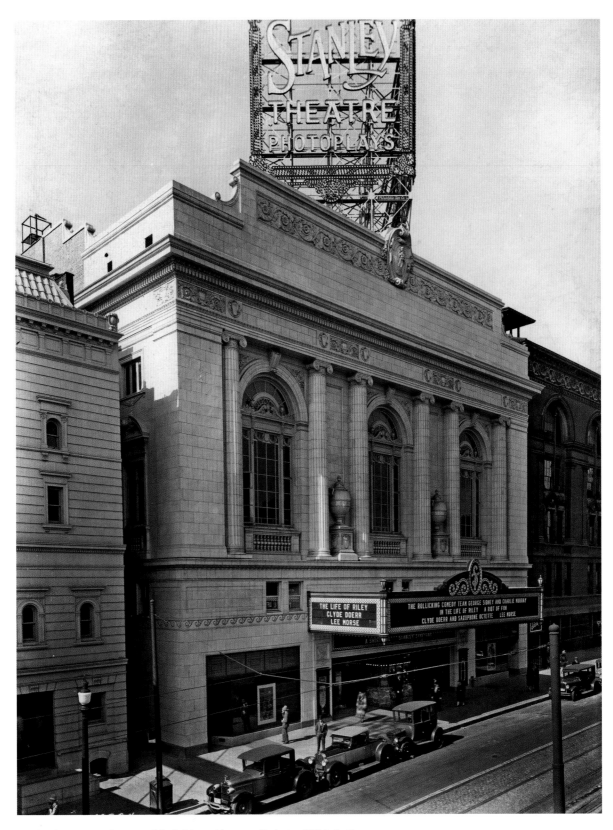

Stanley Theater, 1927. Courtesy of the Baltimore Museum of Industry, BGE Collection.

STANLEY/STANTON

1927–1965

516 North Howard Street

ORIGINAL SEATING CAPACITY: C. 4,000

ARCHITECT: Hoffman & Henon

How many drivers who park their cars in the lot sandwiched between the partially demolished Mayfair Theater and the Chesapeake Commons apartments (formerly Baltimore City College) know what once existed at this address? Very few are likely aware that from 1881 to 1926 the Academy of Music, a towering Victorian concert hall, stood here. By the 1920s its audiences were captivated by the latest entertainment, moving pictures. In 1927, the Academy came down, and the Stanley, Baltimore's most opulent theater palace, took its place.

Talkies had not yet arrived in 1927, nor had the Depression. Movies were doing a phenomenal business, and for the first time theaters that could truly be called movie palaces were being built. A colossal electric roof sign announcing Stanley Theatre Photoplays made its presence known from afar. The expectation of an exalted experience began as patrons approached the Stanley's massive, 120-foot-wide, Romanesque white marble facade. Under a broad marquee was a ticket booth ample enough to seat four cashiers. The admission price, from 40 to 75 cents, bought more than a movie—it transported the ticket holder into a realm of fantasy.

The auditorium had four thousand seats, a 50 × 30 foot stage, a vaulted ceiling, a huge backstage, and capacious dressing rooms. A triple set of arches, framed by columns, replicated the exterior design. With so much decoration to admire, it seems a shame that the lights were dimmed most of the time. A thirty-five-piece orchestra provided live music. The Stanley boasted that its $50,000 Kimball pipe organ was the third-largest in the east, surpassed only by those at Radio City Music Hall and Atlanta's Fox Theater. A fifteen-minute organ recital preceded the first show every day.

Sadly, the Stanley was too large to be a financial success. It was rarely filled to capacity and the upkeep was daunting. After only a year, the Stanley-Crandall organization, which was part of Warner Bros., leased it to Loew's. This meant that in addition to its primary fare of Warner Bros. Pictures, the Stanley also showed movies from MGM, United Artists, and Paramount. Loew's ceased operation of the Stanley by 1934.

In 1958, Morris A. Mechanic purchased the theater from Stanley-Warner. He could no longer use the Stanley name, so the theater was renamed the Stanton and JF Theaters took over its management. By this time, every downtown theater was struggling. Exclusive road shows helped for a while. Sammy Davis Jr. and Judy Garland appeared in solo concerts. The last show at the Stanton was the musical *Oliver*, which ended its run in April 1965. That summer Morris A. Mechanic decided to bulldoze the monumental marble palace to make way for a big expanse of black asphalt.

When I was at City College, the Stanley Theater was built. City College was right next door to it. While I was upstairs in my biology class, one day we noticed that our teacher spent most of his time not looking at us, but standing at the window looking over at the Stanley. So we looked out. They had forgotten to put glazed glass—dark glass—in the dressing rooms where the chorus girls changed their clothes. That's where I got my first biology lesson. It took them about two weeks to find out about that, and then they put in glazed glass.

Arthur Gutman, retired insurance broker

When you entered the theater, music would be playing to create an atmosphere. There was a curtain out front, the big velvet one. Then there was the inner silk curtain. They were used to introduce the short subjects. When the lights dimmed, you still didn't see the screen. All this built the excitement. When the trailers were coming to an end, the inner curtain would start to close. Then the big curtain would close too. All of a sudden, flashed on this curtain as it slowly opened was the Warner Bros. logo. When the movie ended, the big velvet curtain would close on the ending titles. Lights from below would flood the curtain with color as the credits faded out. Then the house lights would be turned on. You never saw the screen naked. You weren't supposed to see the screen because the screen is the illusion. When you left you felt like you were coming out of another world.

Billy Colucci, pianist and composer

On Sundays I would go downtown to the movies on the No. 8 streetcar with my friend Mayer Posner. I was ten. We always blew our whole week's allowance on Sundays. Usually we went to the movie first, then to the White Tower just north of the Stanley on Howard Street for a pre-dinner snack. The hamburgers were real small. I can taste them now: thin patties with mustard and a slice of pickle on a thick, doughy roll. Then we'd go bowl one or two games at the Recreation Bowling alley, which had four floors of duckpin bowling, and get home by five or six p.m.

On this Sunday we chose the Stanley because The Maltese Falcon was playing. We loved Humphrey Bogart and liked exciting movies. When we came out of the Stanley in the afternoon, there was a young man with a stack of Sunpapers, yelling, "Extra! Extra! Japs Bombed Pearl Harbor!" We didn't know what Pearl Harbor was, but we did know it was ominous news if there was an Extra out on Sunday. It sounded serious, so we hurried home. We skipped getting hamburgers and we did not go bowling that day.

Julian L. "Jack" Lapides, attorney and former Maryland state senator

One time as a kid I was having a contest with myself to see how many movies I could see in one day. I think my record was five.

I'd rush out fairly early on a Saturday to see only strictly new films. Maybe [I'd go] first to the Stanley, which was not far from my Bolton Hill home, then, say, trek down to Keith's, then over to the nearby New, or to the Century or Valencia, or, perhaps, if need be, all the way back up to the Mayfair, depending on how the starting/ending times jibed with each other. I pursued my worthy quest entirely on foot, and really had to hop to it occasionally, to arrive at the next venue by its listed starting time.

Owen Fuqua, retired administrator, Pediatric Cardiology,
at Johns Hopkins University School of Medicine

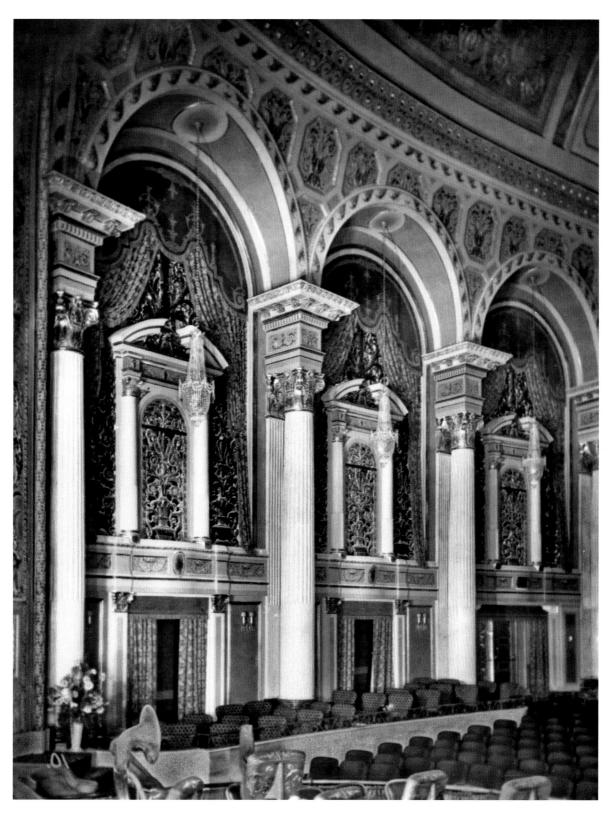

Stanley Theater interior, 1927. The 4,000-seat Stanley was Baltimore's grandest movie palace. Courtesy of the Theatre Historical Society of America.
Overleaf: 516 North Howard Street, 2013.

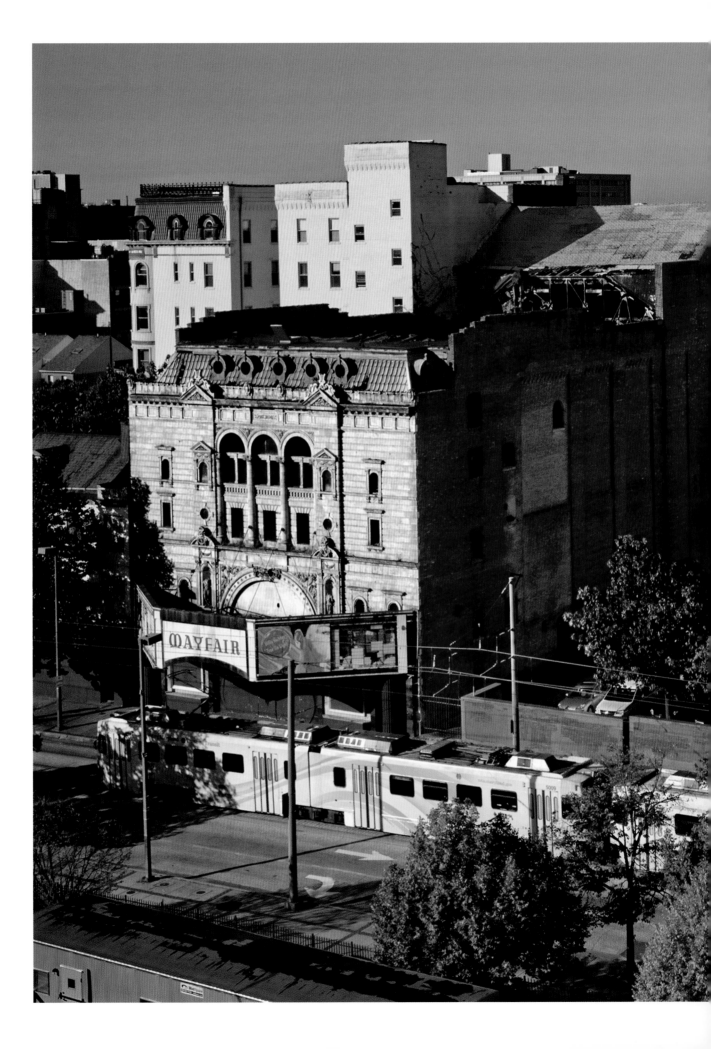

When you walked into the Stanley Theater, you were taken to another world, a palace in Versailles. You were waiting for the royalty to come down those great balcony steps. Sometimes the architecture of the building was more exciting than the movies.

In the early 1950s, when I was in high school at St. Joe's, I was an usher at the Stanley. They copied Radio City Music Hall by calling us "attachés," not ushers. The uniform was a gray double-breasted coat with brass buttons, and maroon trousers with a gray stripe down the leg. We wore a celluloid bib with a red bow tie and we wore a hat—very military. If you wore long hair, you'd get a demerit slip.

There was an art to showing people to their seats. We faced each other, standing with our shoulders back. We had a flashlight, and as they came up the aisle and would stand in queue, we'd tell them what was available. They would follow the beam of your flashlight aimed at the floor to their seat. Then we would click it off until the next one.

People would actually come in the middle of the movie and stay until they came to the part they had seen. There were continuous shows and people didn't care. Back then movies were written in such a way that they repeated information, so you were never lost. If you listen to the dialogue it was more artificial, not a real conversation. That is why people could come and go.

Don Walls, retired film critic

I saw Rebel without a Cause *at the Stanley. That changed my life. Because of that film I got into theater and eventually into film. To this day, I'm still a huge James Dean fan. There wasn't a category of teenager before* Rebel without a Cause. *Blue jeans, white T-shirt, red windbreaker: red, white, and blue. Natalie Wood, Sal Mineo . . . kids who were having trouble with their parents that you could relate to. I went down to the Stanley many times; probably saw it a half-dozen times. I still have the windbreaker from that time, fifty years later.*

Steve Yeager, filmmaker and professor

I won an organ scholarship to the Peabody Conservatory and came east in 1963. I was seventeen. The only working organ left in Baltimore in 1963 was at the Stanton. I was asked to become the house organist. I played show breaks in the evenings on Friday, Saturday, and Sunday from 1963 to 1965.

It was the most opulent, most beautiful theater I have ever seen. It was a jewel, and it was still in marvelous condition when I played there. The organ was huge. It was a Kimball, with three manuals (keyboards), and a battery of percussion. The organ was in the center, and the organ lift was adjacent to the orchestra lift to the left.

The acoustics were produced by the architecture of the building. The sound hit the parabolic reflector in the ceiling and bounced back down to the audience. You could hear every word without a microphone.

In 1964, I was playing with no one around before the theater opened. In the background, I heard a man say, "Can you play 'One O'Clock Jump'?" "Sure," I replied, so I played it from stem to stern. The voice said, "My God, you can certainly play that thing!" The voice was Count Basie. They were getting ready to do a show.

During the show, the orchestra's last number was the "One O'Clock Jump." I brought the organ up to stage position. There was a spotlight on me at the console, and a spotlight on Basie at the piano. It just knocked that place on its keister. There were about 2,000 people in the audience. Everyone got up and cheered.

Dick Smith, organist

I was there when the large wrecking ball took the first swing against the sturdy front of the Stanton Theater. I was manager of the Mayfair at that time. Though they started around midnight, there was a large crowd across Howard Street. The atmosphere was somber. I was amazed that the first swing of the ball bounced right back. It took two or three more swings before chunks of concrete began to fall. Reality finally set in, that this was truly the end of an era.

A salvage expert was brought in from New York to oversee the sale of every possible item of value. One of the first treasures to go was the beautiful, recently restored pipe organ. Piece by piece, the organ was carefully dismantled and packed for sale. Next to go was the box office. I heard it was installed as a bar in a home. Day by day other items left the building. Some outdated equipment that apparently had no salvage value was simply buried in the rubble and covered over with asphalt.

It was heartbreaking. In my opinion the Hippodrome didn't come near the grandeur of the Stanley. They don't build them like that today.

Don Gunther, retired Harford County Schools administrator

Astor Theater, c. 1943. Courtesy of the Robert K. Headley Theatre Collection. *Opposite:* 613 Poplar Grove Street, 2010.

POPLAR/ASTOR

1927–1955

613 Poplar Grove Street

ORIGINAL SEATING CAPACITY: 500

ARCHITECT: J. F. Dusman

The Astor, sandwiched into a triangular plot bounded by Poplar Grove Street and North Franklintown Road, offers a few clues to its past. One is its name, faintly visible above the first floor where it is inscribed in a weathered concrete block. Robert Kanter built the two-story theater in 1927 at a cost of $85,000. It had a Spanish-inspired interior with an organ, a balcony fitted with boxes for private parties, and a nursery where children were supervised while their mothers took in the show.

Abel Caplan, who ran the Westway, purchased the Astor from Kanter in 1954. It became an African American theater. After closing a year later, the Astor was converted into a grocery store.

The original 200-seat moving-picture theater that occupied this site was called the Poplar. It opened around 1914 as rowhouses began to proliferate. A 1916 ordinance prohibited the driving of cattle, sheep, or hogs on Poplar Grove Street between Edmondson and North Avenues. A second clue about the supermarket's earlier life can be seen in the rear of the building, where faded lettering appears to spell Popular Theatre, a variation of the theater's first name that was also in use in the early days. (The profiles of the Astor, as well as the Bridge and Patterson in chapter six, have been placed in the chapters that correspond to the dates when the current buildings were erected. Doing so places these theaters within the context of the architectural styles of the late 1920s and early 1930s, even though earlier theater buildings on these three sites date back to c. 1914, 1915, and 1910, respectively.)

In 2008, English Arnold passes by the rear of the former Astor, where "Popular," a variant on the theater's first name, is still legible.

My dad, Robert Kanter, was an attorney. He was very shy, not a showman. He owned the Astor and Cameo, but they all came under the operation of the Rome organization by the early 1940s. My father also owned the Gwynn in partnership with Rome Theaters. I would go with my father to the Astor on Saturday and to the Cameo on Sunday. Once when I was a small child my father took me to the Astor and left me all day. He forgot I was there.

If one of the studios didn't like you, they wouldn't sell you your pictures. At one time he got a letter from one of the distributors regarding their policies. It said something like, "If you have any complaints or comments, write to us." My father wrote back: "Your half is bigger than my half. It is not fifty percent each way."

It became a black neighborhood in the fifties. I know he had Johnny Mathis at the Astor, but he didn't draw a big crowd. So Johnny Mathis must have been very young.

Phyllis Rubin, homemaker and retired interior design instructor

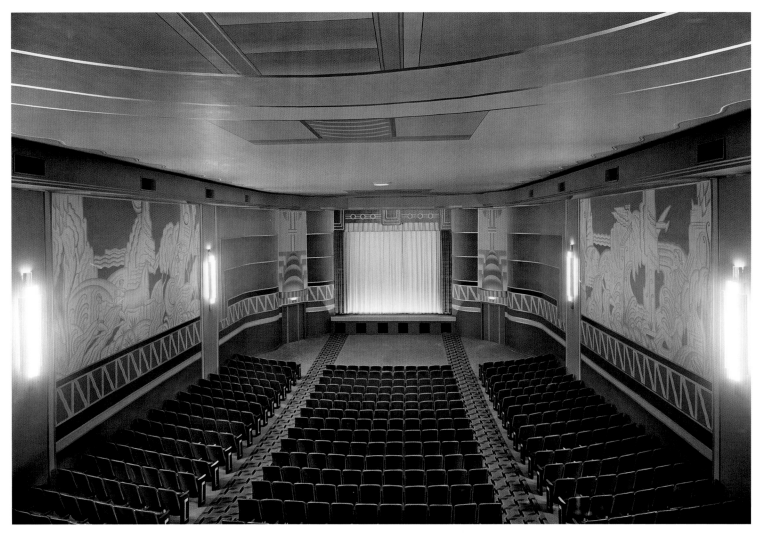

Brooklyn Theater, c. 1928. Courtesy of the Baltimore Museum of Industry, BGE Collection.

BROOKLYN

1928–1959

3730 South Hanover Street
ORIGINAL SEATING CAPACITY: C. 400
ARCHITECT: unknown

Working-class Brooklyn got its first movie house in 1928, ten years after this northern tip of Anne Arundel County was annexed by Baltimore City. The exterior was plain brick, but the style of the ticket booth, double doors, and poster cases was gleaming Art Deco. Two large-scale canvas murals of horses and mythical human forms delineated in flat, ribbon-like patterns were accentuated by the repetition of striped bands encircling the auditorium. A pair of smaller murals flanked the stage, and the painted ceiling completed the mood, with rhythmic concentric circles and a wavy border. The Brooklyn had a Kimball organ and a balcony with about 150 seats. An expansion in 1937 increased the overall seating capacity to 700.

Louis Tunick, a Russian immigrant, recognized the potential of the moving picture business in its early years. Before building the Brooklyn, he operated the Poplar (later called the Astor) and the Overlea. In 1936 he opened the Hollywood in Arbutus. During and after World War II,

Tunick ran two other larger Brooklyn theaters, the Patapsco and the Victory, both on East Patapsco Avenue. The Brooklyn was the first to close in the neighborhood in 1959. Portions of the decorative ceiling and other architectural elements from its theater days survived under Acme Ladder & Equipment Company, which occupied the movie house from 1963 to 2016. As redevelopment looms under new ownership, the prospects for saving the Brooklyn appear dim.

Miraculously, sections of the handsome Art Deco murals can be seen at Club Charles, near the Charles Theater. In 1981 artist Vincent Peranio was enlisted to redecorate Club Charles, a colorful dive bar frequented by John Waters. Peranio heard about the faded, torn canvas murals from the Brooklyn and restored several panels for the interior of the bar. For his labors, Peranio got free martinis from the proprietor, Esther Martin, for the next twenty years.

Louis Tunick, my grandfather, was a classical Talmudic scholar in Russia. He came here, started with a pushcart, ran a corner store, borrowed money at a usurer's rate, and bought a movie theater. Grandpa Louis was old country, stentorian, proud, and honorable. The theaters he ran that I remember as a child in the fifties were the Brooklyn, Hollywood, Patapsco, and Victory. One family story was that Grandpa got a second run of King Kong. This was a coup. It was a fantastic moneymaker, saved the theater, and paid off the loan.

My grandfather had no sons, but his three daughters worked at the Brooklyn after school or at night. Aunt Esther was the oldest, so she stepped in to fill whatever position was needed on any given day. Aunt Paula sold concessions. The youngest sister, my mother, Marion, was the ticket taker. She was very quick at making change, but she was also out there because of her beauty. My grandmother Bertha was this short, tough, Russian peasant who had survived the Cossacks and pogroms and wasn't scared of anything. She wasn't afraid to shoo people out of the theater if they brought in verboten food, or the tipplers if she spotted their little flasks.

I always loved film. We were shaped by the family heritage. I'm a documentary filmmaker for public television. My sister, Millicent "Penny" Marcus, is a professor at Yale who has written four books on Italian film. I did go to all of the theaters at least once. I would go into the projection booth at the Brooklyn, mostly. The projection guys smelled like cigars. I'd watch the black and white serials and the machine. It was a happy time.

Glenn Marcus, documentary filmmaker and faculty member, Advanced Academic Programs, Johns Hopkins University

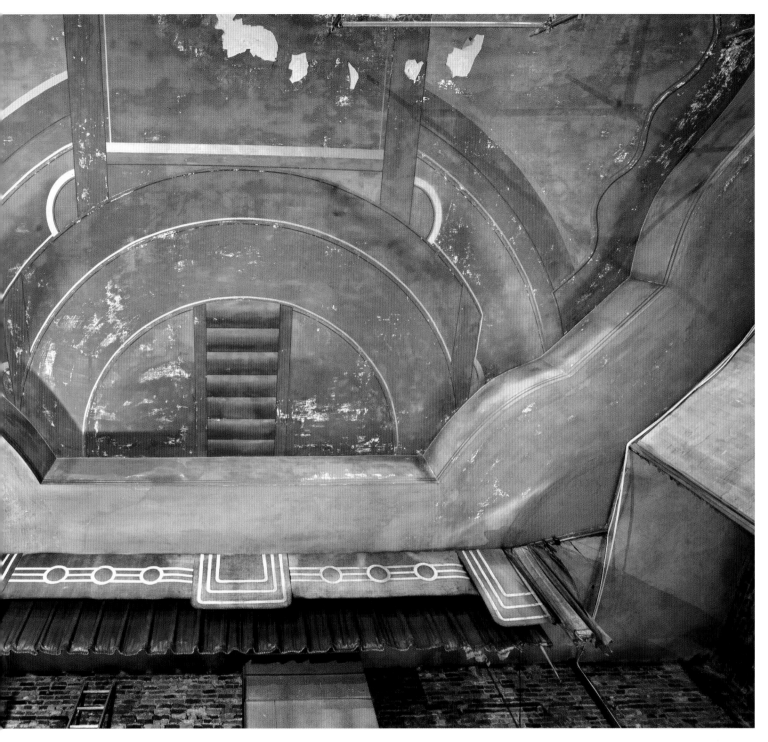

3730 South Hanover Street, 2014.

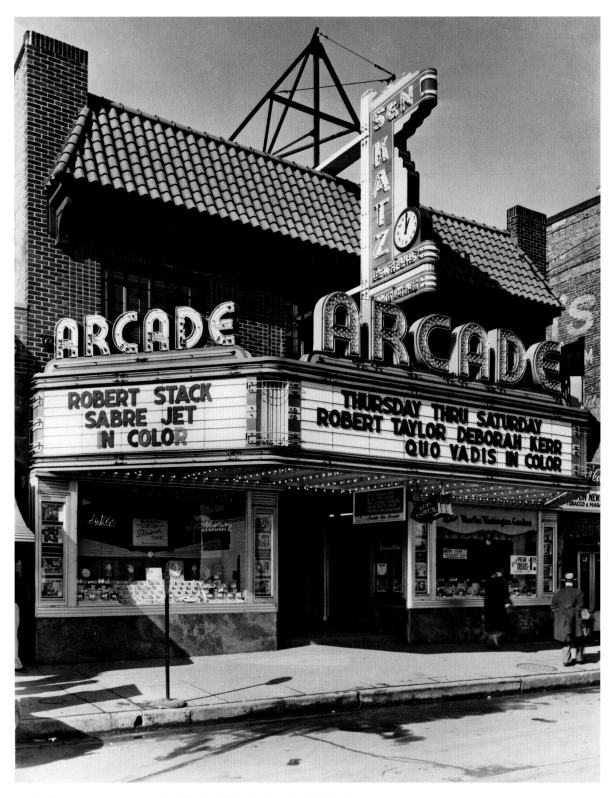

Arcade Theater, c. 1953. Courtesy of Frank Durkee III. *Overleaf:* 5436 Harford Road, 2012.

ARCADE
1928–1979, 1981–1983

5436 Harford Road
ORIGINAL SEATING CAPACITY: 1,000
ARCHITECT: Oliver B. Wight

Movie patrons entering the appealing Arcade Theater first stepped inside a long terrazzo hallway with shops on either side. For many years, S&N Katz Jewelers anchored the left side at the Harford Road entrance. On the right was Martha Washington's Candies, which was replaced later by a sporting goods store and then an optician. Hamilton residents fondly remember the Arcade's shoemaker, milliner, tailor, barbershop, beauty salon, and bakeries.

Two different brilliantly lit marquees over the years established the Arcade's presence on Harford Road, but the 1,000-seat theater was actually a separate building in the rear. Past the stores, moviegoers arrived at the ticket window. An elevated passageway over the alley behind the arcade functioned as the theater lobby, linking the shops to the auditorium.

The inaugural program, on May 18, 1928, featured Victor McLaglen in *A Girl in Every Port*. The program also warned, "Don't try to tip an Arcade Usher. You'll only be offending a little Gentleman." Less than a year after opening, the Arcade underwent renovations for the arrival of sound. Its $12,000 Kilgen organ was no longer needed.

The offices for Durkee Enterprises, the theater's owner, were on the second floor above the arcade. The theater chain set up a printing business in 1958 in the basement of the theater. Arcade Press printed movie programs for theaters up and down the East Coast.

Despite the stability of the Hamilton neighborhood, the Arcade turned to skin flicks in the 1970s when attendance dropped. Local businesses and religious leaders banded together to get rid of the X-rated movies by pledging increased patronage of the theater. This kept the Arcade afloat until 1979. Attempts to resuscitate the Arcade as a repertory or 99-cent house were short-lived in the early 1980s, and the Arcade finally closed in 1983.

The Bethel World Outreach Church, the current owner, has been a respectful caretaker of the Arcade. The old-fashioned theater décor has been lovingly maintained on a limited budget. Even the arcade that inspired the theater's name, though rather barren, has not been destroyed. The church deserves praise for its preservation efforts.

I still dream about that damn place. I went to a lot of movies there between ages five and nine. The Arcade had pretty good lines on Saturday, down to Harford Road. You had to go down a lot of stairs for the exit. It was pretty easy to jimmy those doors to get into the theater, and it was dark so you wouldn't be noticed. Big advantage.

Dick Higdon, telecommunications consultant

With my older brother and sister leading the way, I remember my anticipation as we walked into the promenade to our destination, the Arcade movie theater. From the moment we stepped under the large marquee into the long hallway, I could feel that excitement grow. The distant aroma of warm popcorn was the first smell to greet us, intermingled with the smell of leather from the shoe repair shop, then the lingering smell of perfume from the ladies in the hat shop, followed by the sweet smell of baked goods.

We purchased our tickets, then handed them to the man in uniform at the glass door entrance to the theater. The smell of popcorn now became overwhelming.

After our eyes acclimated to the darkness, we would see school friends and neighbors scattered throughout the theater. The richness of the theater now became apparent. Dimly lit sconces on the walls, wooden arm rests surrounding fabric-covered seats — seats with just enough bounce in them to be annoying to any adult who made the poor choice to attend a Saturday afternoon matinee.

One of the most exciting movies we saw at the Arcade was William Castle's 13 Ghosts, released in 1960. A pair of 3-D paper glasses made the experience quite special. Every movie we saw there was enhanced by the theater itself. We got lost in the darkness as we were pulled into the experience on the big screen.

Regina McCloskey-Lansinger, director, Hamilton-Lauraville Main Street

"Memory! Strange that the mind will forget so much of what only this moment has passed, and yet hold clear and bright the memory of what happened years ago."

Narrator Huw Morgan (Irving Pichel), from *How Green Was My Valley*, 1941
John Ford, director

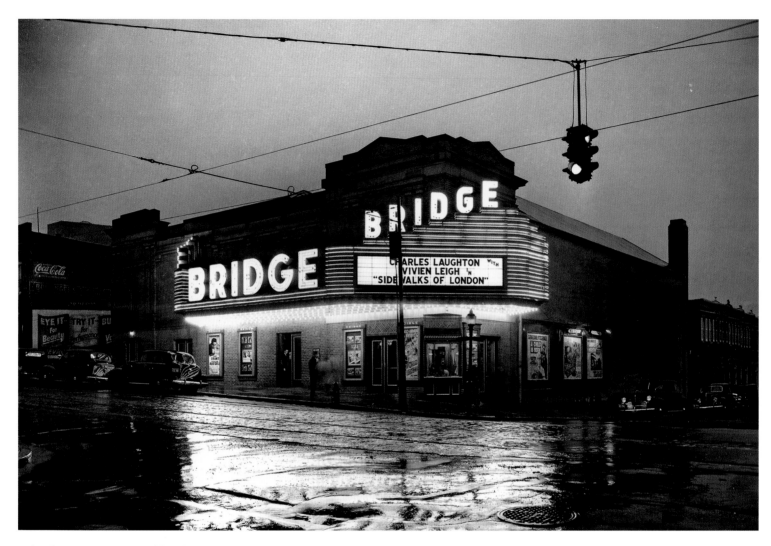

Bridge Theater, 1940. Courtesy of the Robert K. Headley Theatre Collection.

BRIDGE
1930–1968

2100 Edmondson Avenue
ORIGINAL SEATING CAPACITY: 912
ARCHITECT: John J. Zink

MARC Penn Line trains rumble under the bridge that gives this West Baltimore theater its name. The former Bridge Theater still sits above the tracks on a gritty stretch of Edmondson Avenue that bisects the tattered rowhouse neighborhood of Midtown-Edmondson. The Life Celebration Church is a far cry from the Colonial Revival theater that once beckoned moviegoers inside with its oversized neon marquee. Nonetheless, the church, which took over the theater soon after it closed, is the most uplifting sight for several blocks.

The 912-seat Bridge was not the original theater on this site. First came the Edmondson in 1914, a 400-seat playhouse. The area was prosperous enough for the owner, the Edmondson Amusement Company, to add a second, 700-seat theater called the Bridge in 1915. Metal cylinders attached behind the seats dispensed, with the turn of a knob, penny candy. These adjoining theaters were torn down to build the present building. (The modern styling of the 1930 replacement theater dictated its inclusion in this chapter, which celebrates other outstanding examples of Art Deco design.)

The exterior of the new Bridge, designed by architect John J. Zink, was not showy, but its Art Deco interior was spectacular. It featured a recessed domed ceiling, with multiple horizontal speed stripes that encircled the auditorium like gift wrap. A bold zigzag pattern framed the proscenium.

The Hicks circuit operated the Bridge from 1936 until it closed in 1968. It became an African American theater by late 1949, offering double features and the occasional midnight horror movie in the early 1960s.

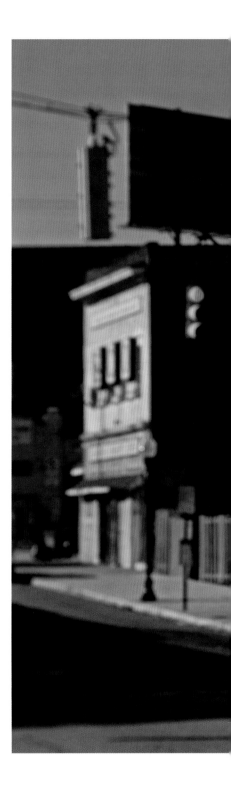

My three brothers and I used to see Tarzan *and* The Lone Ranger, *and then we'd go home to act out the serials. My older brother hung me on the porch roof: he put a rope around my belly like Tarzan. I was flailing away until my mother came out with a butcher knife and got on a ladder to cut me down.*

Martin Mintz, pharmacist

"Laffs, Thrills, Chills! Zombies' Screams, Spirit Séance, Vampires, and Floating Ghost Girl . . . You Will be Scared STIFF!" These were some of the hooks for the Midnight Spook Shows I presented from 1952 to 1961 with the magician Dantini, a Baltimore fixture. We performed in about a dozen Baltimore movie houses. The Bridge Theater was one of the last, in 1961.

Spook shows had been around since the Depression, but now theaters were hurting. Television was coming in. It gave theaters a way to make some extra money after closing time. They could empty the house at 10:30 p.m., reopen, and bring in a new audience for the Spook Show. It was a time when horror films were very popular.

They were really magic shows, with a horror movie thrown in. The ghosts were made of fabric that had been treated with Stroblite, a phosphorescent paint, and attached to an extending pole. Paint that glowed in the dark was comparatively new. We covered the exit lights—illegal of course. It had to be total darkness for those fluorescent things to show up. You moved, you waved the pole and went up the aisle. People would try to grab it if they could. The spooks would swoop out from an exit or two by the stage, fly around, and then disappear again by flying back to the same exits.

We had dancing skeletons, bats, and large snakes. We'd tell the audience we were going to let the snakes loose to get them excited, but it never happened. Dantini had a big wooden ratchet sound maker or a bell to call the spooks in. That meant to get off the stage. Then the movie would come on immediately. The movie would provide a little light so we could pack our suitcases and leave. It was a lot of fun.

McCarl "Mac" Roberts, retired minister and magician

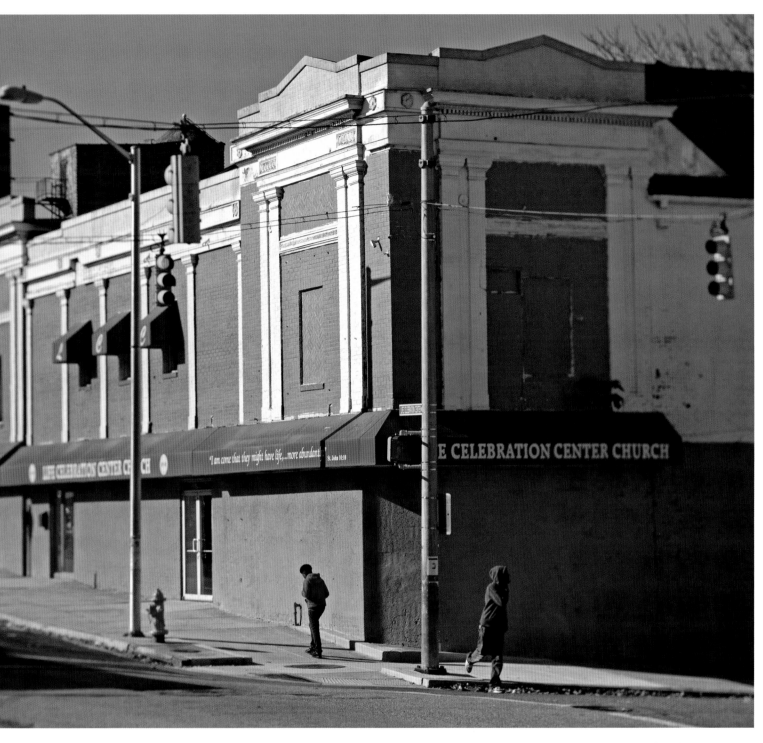

2100 Edmondson Avenue, 2013.

Baltimore - theaters - Patterson

Patterson Theater, 1930. Courtesy of the Baltimore Museum of Industry, BGE Collection.

PATTERSON/CREATIVE ALLIANCE

1930–1995, 2003–PRESENT

3134 Eastern Avenue
ORIGINAL SEATING CAPACITY: C. 900
ARCHITECT: John J. Zink

At night the Patterson's vertical sign, rimmed with blinking light bulbs framing blue neon letters, entices from blocks away. The original blade sign was too badly deteriorated to salvage, but a meticulous copy fabricated by the Gable sign company took its place. The brick theater building is plain, but no matter. One only needs a simple dress when wearing a jeweled accessory like this classic blade sign, the last of its kind in Baltimore.

Similar to the Bridge Theater on the west side, the Patterson was designed by the architect John J. Zink on the site of a previous theater of the same name, built in 1910. Durkee Enterprises, which already operated the Grand in Highlandtown, opened the modern Patterson on September 26, 1930.

For Highlandtown residents, the classy Patterson felt like a first-run theater, although pictures arrived about a month after they had completed their downtown run. In 1958, half an hour after patrons departed from the last evening show of *Cat on a Hot Tin Roof*, a four-alarm fire ripped through the Patterson roof, causing serious damage.

The Patterson was wide enough to twin, a strategy that helped some single-screen theaters compete with suburban multiplexes for a while. The first films shown after the theater was divided in 1975 were *Star Wars* and *Saturday Night Fever*. In 1995, it was the last theater in the Durkee circuit to close.

The Creative Alliance, a dynamic community arts center, moved into the Patterson in 2003. The interior was gutted to make way for galleries, classrooms, artist-in-residence studios, a lounge, and a flexible theater space. The Alliance's lively programming has helped to revitalize East Baltimore.

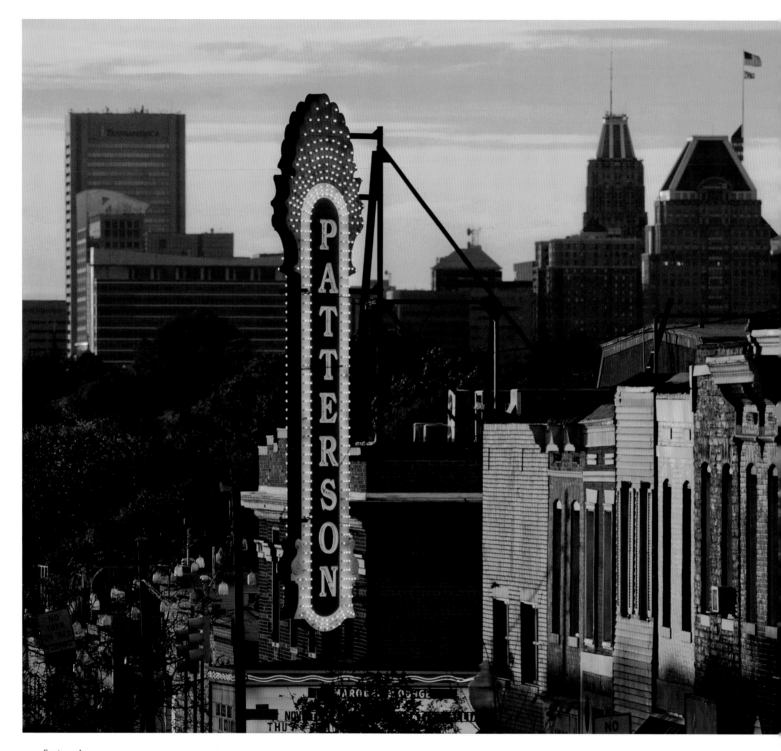

3134 Eastern Avenue, 2013.

At the beginning of the week we would go to the Grand. We went to the Patterson at the end of the week, date night out. After the movie we'd go across the street to Matthew's Pizza.

There's a little step as you come out the door onto Eastern Avenue. Many a time we'd stumble on it, because it would be so bright when we'd come out that we'd miss it. I had a friend who broke her ankle. Her friends recommended that she see Tom Selleck in Three Men and a Baby. It was a harmless movie. She was very religious, and apparently the Church frowned on it. When she slipped on that step, she thought the Lord was punishing her.

Marlene Hronowski, retired, McCormick Consumer Affairs

My grandfather, Charles Elmer Nolte Sr., got in the movie business very early. He had a theater on South Broadway called the Palace, where he would hand-crank the movie projector. He joined up with Frank Durkee Sr. and Walter Pacy to form Durkee Enterprises. My father, Gus Nolte, was the manager of the Patterson when I was little. My grandfather's brother, Henry Nolte, was the projectionist—we called them operators—at the Patterson. My son, David Charles Nolte, and his aunt, Joy Nolte Kirk, were the last generation of Noltes to work for Durkee Enterprises.

Charles Elmer Nolte III, retired food broker

Up until the 1960s, when everyone got TV, the theaters were the main game in town. Next the rise of the mall theaters put the urban theaters out of business. Home video cassettes in the 1980s created additional pressure. Then you started getting these other avenues for distribution. The theaters' share of the pie became smaller. It became riskier for the single-screen operators. Ultimately they all went away.

The other big thing that happened was technological automation. When I started, you'd pick up the films in a case with twenty-minute reels. The projectionist spliced them together to make the hour reels. Then equipment came out to automate that process. You had one continuous loop that ran on platters. You could have a twelve-screen theater with one operator who walked around and checked the platters.

When I started in September 1980, the only city theaters that the Durkee organization had left were the Senator, Boulevard, Patterson, and Grand. The Patterson was the last one.

David Charles Nolte, businessman

Edgewood Theater, 1930. Courtesy of the Robert K. Headley Theatre Collection.

EDGEWOOD

1930–1961

3500 Edmondson Avenue
SEATING CAPACITY: 1,250
ARCHITECT: John J. Zink

The Edgewood retains more of its original structure than most of the theaters that became churches. Its handsome neoclassical facade offers a dignified presence on a languishing stretch of Edmondson Avenue. Gone are the marquee and blade sign. Edgewood's vertical sign closely resembled the blinking Patterson theater sign. Baltimore architect John J. Zink designed both theaters for the Durkee organization. The Edgewood opened on October 3, 1930, a week after the Patterson.

A second-run house in West Baltimore, the Edgewood added CinemaScope in 1954. About half the seats were

removed in 1960 for its conversion to a first-run art house, where coffee was served in a well-appointed lounge. The inaugural screenings for the Baltimore Film Society, founded in 1960 by Ronald Freedman, were held at the Edgewood. René Clair's 1930 *Under the Roofs of Paris*, followed by Luis Buñuel's 1950 *The Young and the Damned*, were the first two classic art films shown by the Society.

The Edgewood was in a heavily Catholic neighborhood. Edmondson Village was the site of intense blockbusting in the sixties, which surely accelerated the theater's decline, despite the switch to art films in its final year.

3500 Edmondson Avenue, 2013.

Governor William Donald Schaefer was the manager or the assistant manager of the Edgewood. He also took tickets. Schaefer was ten years older than me, probably in his early twenties. He didn't mean anything to me, except he watched the kids very closely to see who was trying to get in without paying. We found a way to sneak in by kicking in the side door. It sprung open if you kicked it the right way. They finally wised up and fixed the door. It didn't take Schaefer long to figure it out and he policed it pretty closely. That was Schaefer's way of operation: "Do it now!"

Stan Taylor, retired disability claims manager, Social Security Administration

I remember bursting into tears when the Edgewood went from 12 cents to 14 cents. I was about six or seven and couldn't get into the movie. Pennies were huge money back then. I was sitting on the curb crying, and a man gave me a nickel. My mother used to like to push me out the door and say, "Go see it twice!" My head was filled with celluloid.

Around fourth grade I used to go to the Edgewood with a friend named Philip, who later became a priest. We had to go to his house first, where his mother made us kneel on the floor, put our hands on the rosary, and promise we were going to see the film we said we were going to see.

Forever Amber was condemned by the Legion of Decency. After Amber went into a house where the rich guy lived, the sun set, then the sun rose and she came out. Who knew what happened in that house? The nuns at St. Bernardine's warned us that they had rented a room in a house across the street and could see the entrance to the Edgewood. If they saw any of us go into the theater while that film was showing, they would deal with us later. I knew better.

Paul Kreiner, retired high school teacher

I saw Shane, with Alan Ladd, when stereophonic sound came in. It is one of the great Westerns of all time. Jack Palance is a hired killer. He forces Elisha Cook Jr. into a gunfight. When Palance fires, the sound is electrifying. He blows the guy into the muddy street. When the guns went off, it blew you out of your seat.

Michael Clark, retired restaurant manager

Facing page: Harlem Theater, 1970. Photo by A. Aubrey Bodine © Jennifer B. Bodine. Courtesy of Maryland Historical Society, B1617-1.

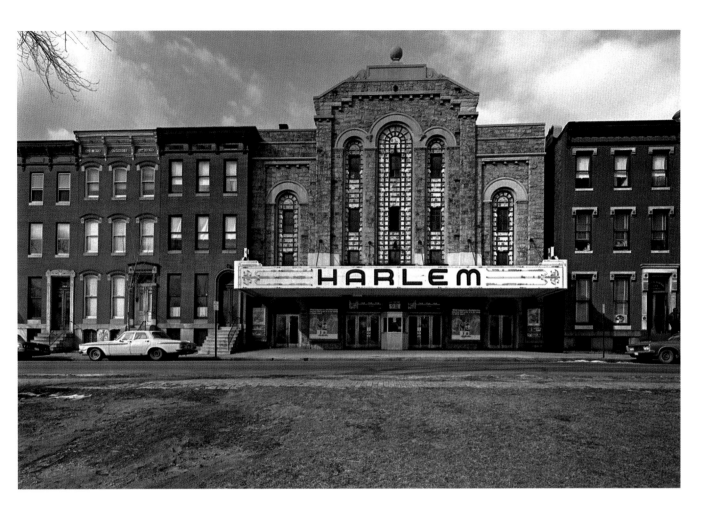

HARLEM

1932–1975

614 North Gilmor Street

ORIGINAL SEATING CAPACITY: C. 1,500

ARCHITECT: Wilson Porter Smith

Although many old movie houses are now houses of worship, the Harlem is the only one that began as a church. The Harlem Park Methodist Episcopal Church, a Romanesque edifice of craggy Port Deposit granite, opened on North Gilmor Street across from Harlem Square Park in 1904. The church endured two fires; the second one, which gutted the interior in 1924, hastened the congregation's move westward. It then became a movie theater until, a half-century later, the building reverted to its original purpose when the Harlem Park Community Baptist Church took ownership in 1975.

In between the church years, the Harlem was a beautiful, first-run showpiece for African American audiences. Rome Theaters, Baltimore's second largest circuit, created the $150,000 theater within the shell of the original church.

A 40-foot blade sign and a 65-foot marquee studded with more than 900 bulbs lit up the adjacent park. Inside the huge auditorium, an atmospheric ceiling twinkled with electric stars and floating projected clouds.

The new movie emporium was eagerly welcomed by the populous Harlem Park community, which appreciated having an upscale theater closer than Pennsylvania Avenue. An estimated 30,000 people flocked to the grand opening on October 7, 1932. The next day, a parade of 5,000, including Pythians, Elks, Antlers, Monarchs, and other social clubs, celebrated the theater's arrival. The Harlem also featured live shows, but over the years its grandeur diminished, particularly after desegregation. The balcony and many decorative interior details, now delicately faded, have survived.

209

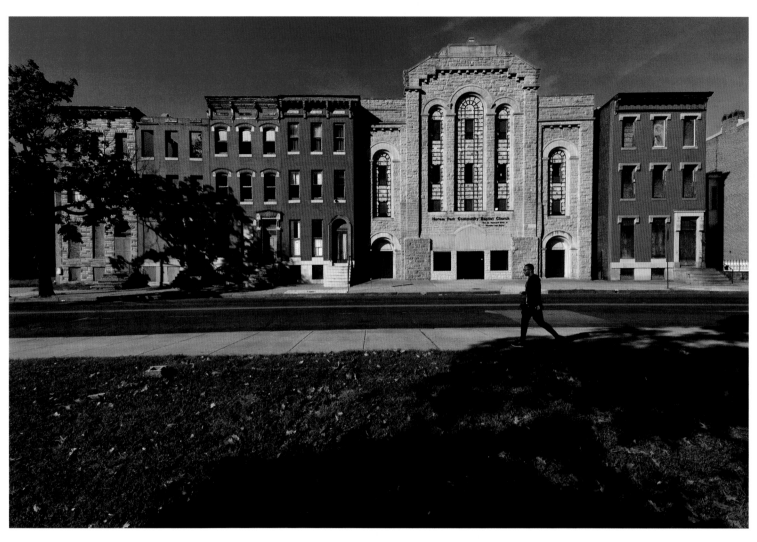

614 North Gilmor Street, 2015.

When I went to work in theaters in 1947, the Harlem was a nice neighborhood house in a non-commercial area. It did a lot of business with blacks who were afraid to go to Pennsylvania Avenue. It was not quite as big as the Regent.

When the Harlem got a hot picture, folks would be lined up for blocks. It was a densely populated area. After segregation ended it stopped doing any business. Competition opened up then for all of the Pennsylvania Avenue theaters.

Aaron Seidler, retired film buyer/booker and theater manager

I saw a black and white film, Native Son, starring Richard Wright as Bigger Thomas, when it was re-released in the early seventies, at the Harlem. I was really amazed to see Richard Wright. I was probably college age. The opening is riveting. The book begins with an alarm clock going off; they are not awake long before a rat runs across the floor. It becomes symbolic of the Bigger Thomas character.

You could tell how the economy was doing in those days by the size of the audience in movie theaters, such as the Harlem, during a regular work day. When unemployment was high the theaters were crowded. When jobs were plentiful, you could sink into your seat in a nearly empty movie house and enter into the world of the film. The only worry was that a rat could come scurrying across your feet. The Harlem was a true adventure, a true competition for any action on-screen.

Ralph E. Moore Jr., community activist

The Harlem's three-story ceiling with twinkling stars and projected clouds mimicked a planetarium, dwarfing the occupant seated beneath this celestial sky. Carpeted floors, thickly-cushioned chairs, a balcony view, air-conditioned comfort—the Harlem was a showcase fit for the golden age of Hollywood movies.

As a schoolboy, I once wept furtively in the Harlem during Imitation of Life, a classic "tragic mulatto" tale of a black woman who made a separate peace with Jim Crow racism by "passing" for white. The prodigal daughter returned home to her black mother's funeral, despite the stigma of black inferiority. The pathos of her tears was contagious.

However, most of the time the movie fare was light and breezy, a romp in the fantasy realm of cowboys, secret agents, vampires, gangsters, adventurers, warriors, funny men, monsters, and other assorted potboilers. And then there were the hot dogs. Like gumbo in New Orleans, the Harlem's steam-cooked kosher hot dogs were a gastronomical must. They were served on hot, chewy buns that you heaped with condiments without the slightest concern for calories.

Gregory L. Lewis, attorney

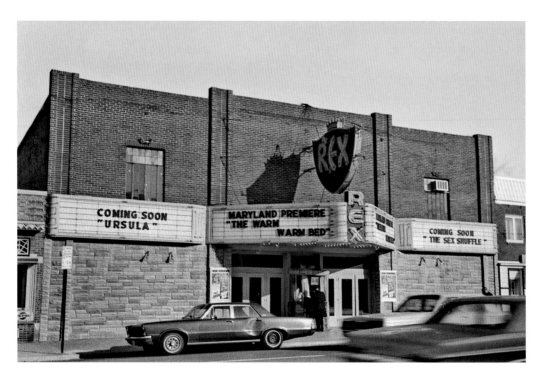

Rex Theater, 1968. Photo by Robert K. Headley.

REX
1933–1974

4617 York Road

ORIGINAL SEATING CAPACITY: 482

ARCHITECT: J. F. Dusman

A significant First Amendment battle began on York Road in Govans at the Rex, a nondescript neighborhood theater. Theater operators had chafed under the tyranny of the Maryland Censor Board since its inception in 1916. By 1962, censorship guidelines had loosened, but the manager of the Rex, Ronald Freedman, felt that the Censor Board should not be dictating what could be shown in his theater. Freedman's test case challenged the requirement that exhibitors submit films for the Censor Board's approval before they were screened. Ultimately the case was decided in Freedman's favor in the US Supreme Court.

The Rex was a typical second-run movie house when it opened in 1933. In the early 1950s, the Rex brought back D. W. Griffith's *Intolerance* and other old films. By the early 1970s, after Freedman left, the Rex switched to X-rated movies. After closing in 1974, the Rex was taken over by the Victory Ministries International church.

A curious paradox connected the ownership of the Rex to its role as a First Amendment champion. Louis Shecter, who built the theater, also owned the Roslyn on North Howard Street, which was named for his wife. Shecter got his wife appointed to the Maryland Censor Board. This was a political plum. During the Freedman test case, Roslyn Shecter was serving on the Board. A film distributor, Robert T. Marhenke, argued that this was a conflict of interest. The Board disagreed, noting that Louis Shecter was only the landlord, not the operator, of the Rex. The Maryland Censor Board finally expired in 1981.

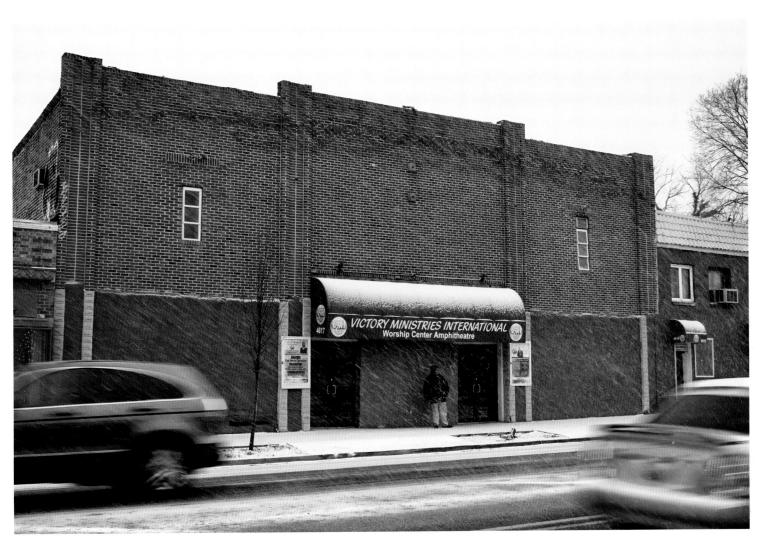

4617 York Road, 2016.

I was about nine. I had just gotten a brand-new jacket from Robert Hall's, a tan windbreaker with a zippered breast pocket. My friends and I were smoking Camels out in front of the Rex. I'd seen fellows cup their cigarettes and take them inside and finish them off in the restroom. So I stuck my cigarette in the breast pocket, lit. We got into the bathroom, but my jacket was on fire.

I got home with the jacket and hid it in the woodpile in the garage. My mother wanted to know where my brand new jacket was. I told her I left it in the movie, so she beat me. Dad got home and was getting wood, and he found my jacket. He brought it in and showed it to my mother. He wanted to know when I got it. He looked at her, and there was a little friction going on, because money was tight. Then I got a beating from my dad. He made us get switches from the little apple tree. That's the way it was. I think it was a $3.98 jacket.

Bob "Mad Dog" Garrett, retired truck driver

My father, Ronald Freedman, made the Rex into an art theater from 1956 to 1961. He loved movies and he took movies very seriously. As the manager, he played old films like Renoir's The Rules of the Game and brought in art films, Bergman films. They started showing nudist camp films. What opened the floodgates was The Immoral Mr. Teas, the first film by Russ Meyer. It had a comedy plot, but sexualized enough. Every time he sees a woman, she's topless. That was a big hit. Then came the flood of "nudie cuties," topless burlesque comedies. My father showed everything, every soft-core film, from around 1960 to 1964. The films got more violent, because the censor board didn't censor violence. They could get away with whippings and beatings, but not regular sex. Roughies. Kinkies. Ghoulies. That was right at the cusp before hard-core came in.

Then the censor board started to crack down. Up until Dad's case, every local exhibitor had to submit a film, sight unseen, to the local state censor board to be passed. If you had to make cuts, you would make the cuts. In order to test the constitutionality of that, my dad picked the film Revenge at Daybreak, a non-pornographic French film about the Irish revolution. I think he picked it at random. He didn't submit it to the censor board. Hence, it didn't have a censor seal on it. He was duly arrested for that. He lost at the Maryland Court of Appeals, and the state of Maryland fined him. Ultimately the case went to the Supreme Court.

It was a Pyrrhic victory in Maryland, because of local politics and patronage jobs. Mary Avara, head of the Maryland Censor Board, saw it as her singular mission to combat the onrushing tide of smut. She still sat on the Board sixteen years after the decision. You still had to submit films to the local censor board. It was unconstitutional but Maryland was an anomaly—the last holdout state to have a censor board. To a lot of people Ronald Freedman won the day, but he was bitter because he couldn't profit from the ruling. He was resigned, but cynical about it.

The day Mary Avara retired, my dad and I went up to see her. I was in my early teens. Mary Avara hugged him. In some weird way he had affection for her. He'd say, "One thing about her, she's a great cook." She gave him a lot of trouble, but my father told me, "That's Baltimore. What are you going to do?"

Ross Freedman, writer

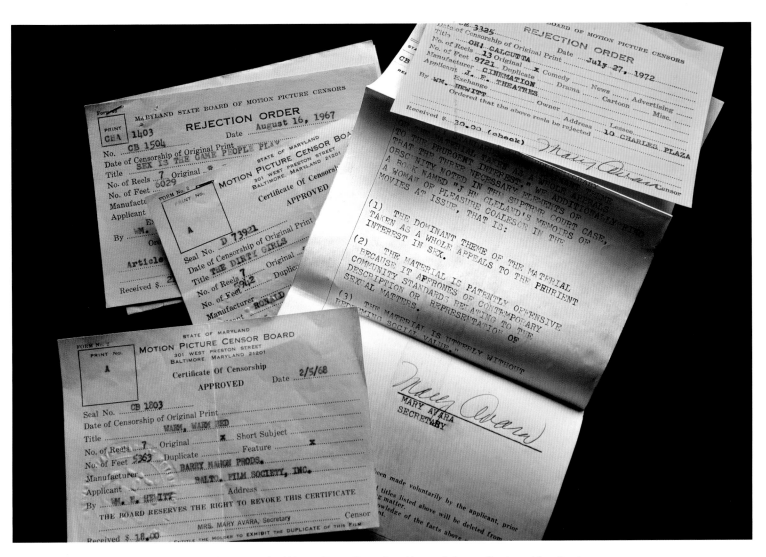

A sampling of approval and rejection slips issued by the Maryland Motion Picture Censor Board from 1965 to 1972. Courtesy of Ross Freedman.

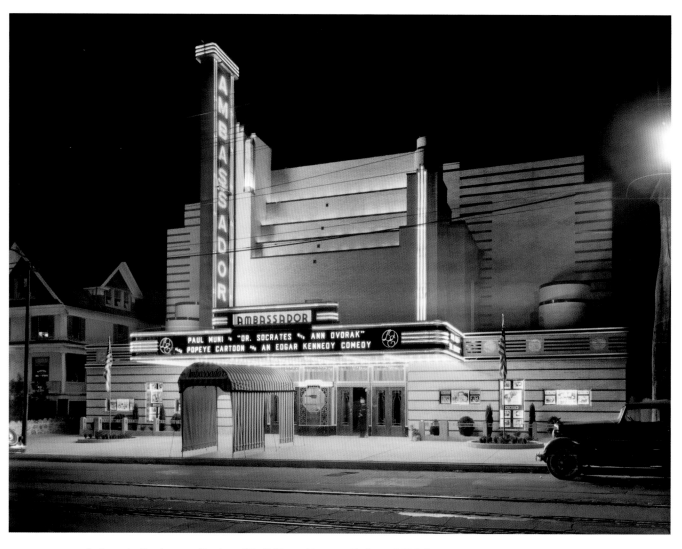

Ambassador Theater, 1935. Courtesy of the Baltimore Museum of Industry, BGE Collection.

AMBASSADOR

1935–1968

4604 Liberty Heights Avenue

ORIGINAL SEATING CAPACITY: 925

ARCHITECT: John J. Zink

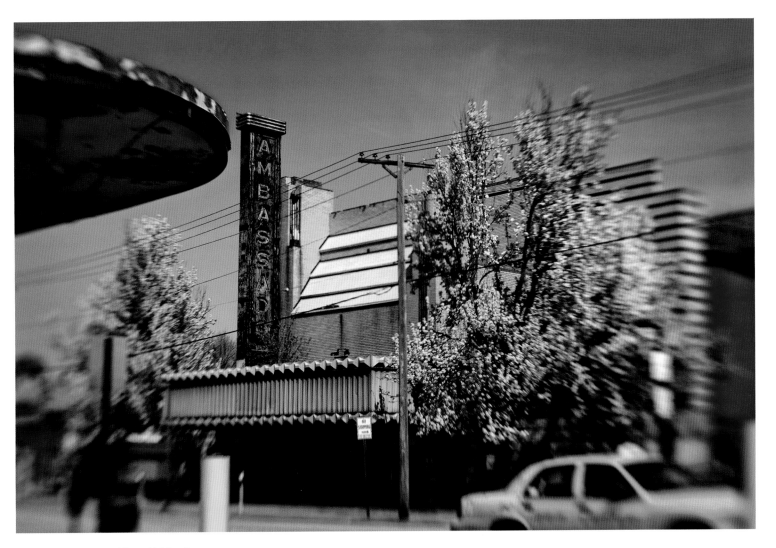

4604 Liberty Heights Avenue, 2010.

Despite the tumbled bricks and charred entrance, it's still easy to fall in love with the vacant Ambassador. Buff glazed bricks, accented with horizontal ribbons of black brick, wrap around the exterior in streamlined, voluptuous curves. Too much architectural detail remains to give up on this sleek 1935 beauty.

The Ambassador was the twentieth theater in the Durkee circuit and the most daringly modern. Multicolored lights recessed behind four stepped-back walls, now covered by asphalt shingles, added an alluring glow. John J. Zink designed about thirty Streamline Moderne theaters in the mid-Atlantic region. This is one of his best.

Inside, a spacious soundproof nursery accommodated children. The Ambassador began showing first-run films, which was unusual for a neighborhood movie house, in 1963. It was padlocked five years later. The black Vitrolite ticket office, the lounge with an electric log fireplace, and the seats are long gone.

The building suffered one indignity after another as a catering hall, roller rink, cosmetology school, and church. A 2012 fire destroyed what little remained inside of the entrance and foyer. Whether one of Baltimore's best Art Deco buildings will be preserved remains an unanswered and troubling question.

When I lived [near] Lake Ashburton in the 1950s, I had my choice of five different neighborhood movie theaters. The Windsor and Gwynn were the action houses, while the Walbrook and Forest showed the classier films. The Art Moderne Ambassador was the classiest of them all. You bought your ticket at the other theaters without much thought, but you approached the ticket booth of the Ambassador with a sense of awe. Passing through the high-ceilinged lobby you could pick up some of the best ice cream sandwiches before entering the auditorium. It was a very comfortable auditorium with superb sightlines and acoustics.

I must have seen a hundred movies there, but the most memorable was the 1963 Tony Randall film Island of Love. I broke up with my girlfriend over the phone in the lobby of the Ambassador. I lost a girlfriend, but more importantly, I missed the middle of the movie. If I could have one theater come back to life, it would have to be the Ambassador.

Robert K. Headley, theater historian

I was a night relief manager at the Ambassador in the early days of trying to integrate the theaters. I knew they had just had a lot of trouble over at the Northwood with all the protests. Black students showed up ready to picket. They sent someone up to buy a ticket. I told the cashier to sell it. The cashier protested; she said her orders had been not to sell to black people. I told her, "Sell it to her. If you don't, I will." So she did. The people got back in their cars and left.

I thought desegregation would ruin business, and it did. I saw it as an economic issue. Blacks had a right to go into the theaters, but I knew we'd lose our jobs. As assistant relief manager at the Ambassador and the Edgewood, [I saw that once] they started letting black people in, the white people stayed away in droves. There wasn't enough of a black population to keep the theaters afloat. These white customers weren't rational about it. "Why were we doing this?" they wanted to know. Our reply: "We have to."

Philip Gaynor, retired projectionist

I thought the Ambassador was the most beautiful theater in the city. It stands alone, so you can really see it—so sleek and modern. The stripes inside reflect the banded brick exterior. As a designer I love that sense of continuity. When you see it, you don't forget it.

There is so little real Art Deco in Baltimore. There was a surreal quality about sitting in this space. It was like a 1930s ocean liner, all curvilinear and striped and modern. Deco was all about simplified elegance.

It was incredible to go by it at night, almost imaginary and dreamlike. It was like a shrine, all lit up. The Ambassador was magnificent until the day it closed.

Lee Warfield, retired graphic designer

Lord Calvert Theater, 1954. Courtesy of Norman James.

LORD CALVERT
1936–1953

2444 Washington Boulevard
ORIGINAL SEATING CAPACITY: 650
ARCHITECT: Oliver B. Wight

The opening of the Lord Calvert in 1936 was welcome news during the Depression in southwest Baltimore's Morrell Park neighborhood. The only local place for movies had been the Morrell, which was known as the Lincoln Highway Theater when it opened in 1919 near the train tracks that ran under Washington Boulevard. It closed a year before the Lord Calvert opened a block away.

Oliver B. Wight, the Baltimore architect whose earlier theater commissions included the Parkway, McHenry, Irvington, and Arcade, designed the Lord Calvert. The owner, Philip J. Scheck Enterprises, operated the Lord Baltimore, which perhaps inspired the new theater's name. The Hicks circuit took over the Lord Calvert from 1942 until it closed about a decade later.

The original Art Deco facade was concealed when the movie house was swaddled in Formstone in the early 1950s. In contrast, the interior is delightfully intact. The original poster frames are still in the lobby, but now they hold messages for the Church on the Boulevard, which moved into the building in 1959. The stage with its red velvet curtain, the Art Deco light fixtures and trim moldings, and even the original leather seats have all been maintained. Maybe those attending church need the same reminder to refrain from talking as moviegoers did in the old days: the sign above the auditorium entrance says, "Let us be silent that we may hear the whisper of God."

Morrell Park in the 1930s was considered country. It was all woods. When I was about five or six we moved onto 2519 Washington Boulevard, about two blocks from the Lord Calvert. My mother and father would have to walk my little sister and me across the street to go to the theater. We wouldn't dare cross on our own. Washington Boulevard traffic was so heavy because that was the only way you'd get to Washington in those days. Just one car after another, creeping along, especially on weekends in the springtime with people going to see the cherry blossoms. There were no traffic lights at all.

The Lord Calvert used to have a little talent show with prizes on Saturdays, before the matinee. My father always said, "You can't carry a tune in a bucket," but in those days you didn't care, you just got up and sang.

I think The Wizard of Oz was the first color movie I saw. I was about twelve, the same age as Dorothy. I was fascinated with her little gingham outfit, her little dog in the basket, Toto, and the Technicolor. The last movie they had at the Lord Calvert was The Greatest Show On Earth, starring Betty Hutton.

Rose Marie Daehnke, homemaker

We were dirt poor, so we didn't come often. I started to scrub floors when I was five years old. I would get half of whatever money I made and the other half would go toward food. There was no allowance. We were so poor that I would look at the food in the magazines and would want to eat the pages.

One of my most vivid memories from the fifties was watching Mighty Joe Young, the original version, four times. It was a story about a young girl who found a baby gorilla and raised it as her pet, but he gets big, bad people try to take him, and he goes crazy. When he saves a little girl on a Ferris wheel they realize he's a good gorilla. I was probably six or seven. I wasn't allowed to be out after dark. I went to the matinee and watched it over and over again until my mother came into the theater, grabbed me by my ponytail, and yelled at me all the way home.

Josie Wilke, associate pastor and outreach minister, Church on the Boulevard

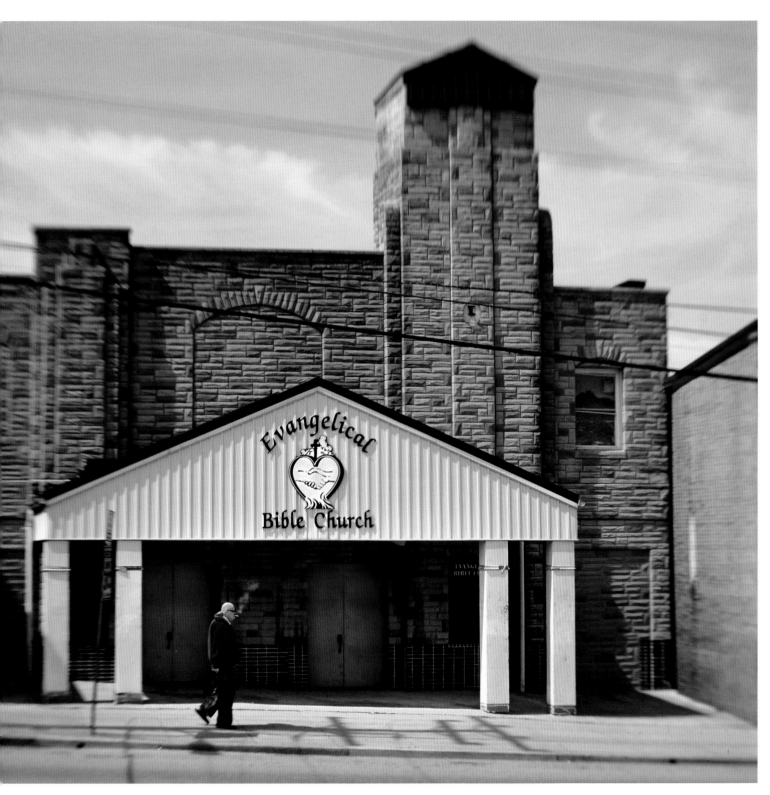

2444 Washington Boulevard, 2013.

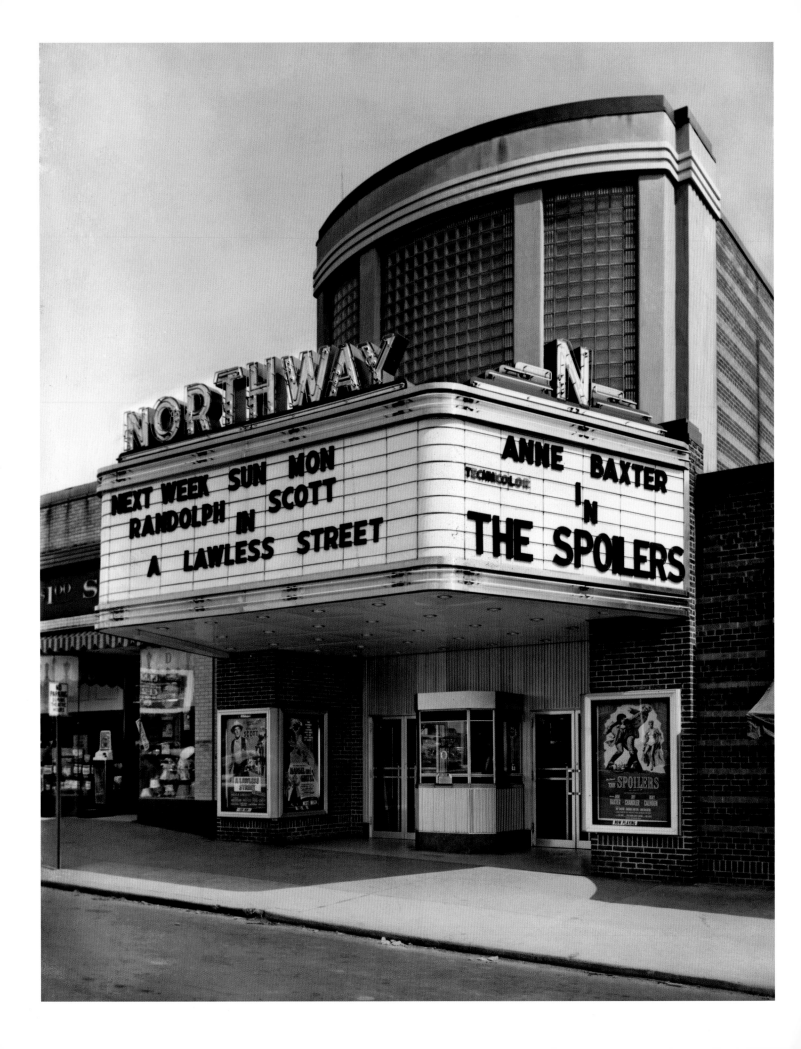

NORTHWAY

1937–1979

6701 Harford Road
ORIGINAL SEATING CAPACITY: 655
ARCHITECT: John J. Zink

The Northway, built for Durkee Enterprises in 1937, wrapped around a corner pharmacy at Harford Road and Northern Parkway. The original entrance was on the Harford Road side, but the entrance was switched later to Northern Parkway. John J. Zink, who created the memorable Ambassador and Senator theaters, designed the smaller Northway in an Art Moderne style. It pales, though, beside the other two outstanding designs. Even the glass block tower over the marquee, reminiscent of the 1939 Senator, was an afterthought. Zink added this distinctive feature when the Northway was remodeled in the early 1940s.

The curved glass block facade is now partially obscured by a top-heavy facing that wraps around the second floor of the original theater and adjoining buildings. Only the two small Ns, bereft of neon tubing, remain on the ends of the marquee. In later years the theater suffered from a lack of parking as the neighborhood establishments grew less dependent on foot traffic. The drugstore's soda fountain disappeared around the same time that the Northway was transformed briefly into an X-rated house.

Northern Pharmacy outlasted the theater, which closed in 1979. The pharmacist, Martin Mintz, bought the building and converted it into the expanded Northern Pharmacy and Medical Equipment store. The marquee now advertises medical supplies and flu shots. Part of the Northway was converted into warehouse space, and the auditorium was torn down to expand the parking lot. The heavy door to the projection room is still in place, but regrettably there was no effort made to salvage any vestige of the Art Moderne interior.

Facing page: Northway Theater, 1956. Courtesy of Frank Durkee III.

My dad moved to Hamilton in 1937. He leased a farm where we lived at 3411 East Northern Parkway for a florist business. There were three farms between Belair and Harford Roads. I watched the Northway being built as I walked to Harford Road to catch the No. 19 streetcar to Poly for high school.

I'd go to the Northway every Saturday after I got the porches scrubbed at my house to get movie money. It was a three-story house and it had three big porches.

After the Northway was built, they added a Murphy's Five & Ten and a bakery, both on Harford Road. Just above those stores was a putt-putt course, miniature golf. That later became a bank. Doc Glick had the drugstore on the corner. They had a soda fountain where you could get a vanilla phosphate or a root beer float. I loved the toasted tuna fish salad sandwich with a cherry Coke.

On Saturdays, I hung out with a group of guys at Glick's; we called ourselves the Northern Parkway gang. When some of the guys were ushering, they'd say, "Just stand by the exit, maybe the door will open." Maybe the wind did it. That's probably why they made the Northern Parkway side the entrance, to watch us.

The most fun time would be going there with my wife, Marie Elizabeth. That was better than with the guys. We would sit in the back of the theater where it's dark and hold hands. Got out of the service in June 1946 and got married in May 1948. TV was just starting. By 1950 we probably didn't go to the Northway anymore.

Joe Simon, retired certified broadcast engineer

On one particular occasion with my parents, we were watching some black and white musical, and all of a sudden, the screen went blank. The lights came up and the manager came out on the stage. He said, "Ladies and gentleman, we are at war and you must go to your homes." I thought, "What about the movie?" I had no idea they had just bombed Pearl Harbor. So we went home. My parents tried not to show their concern to me, I'm sure.

Joy Kaplan, homemaker

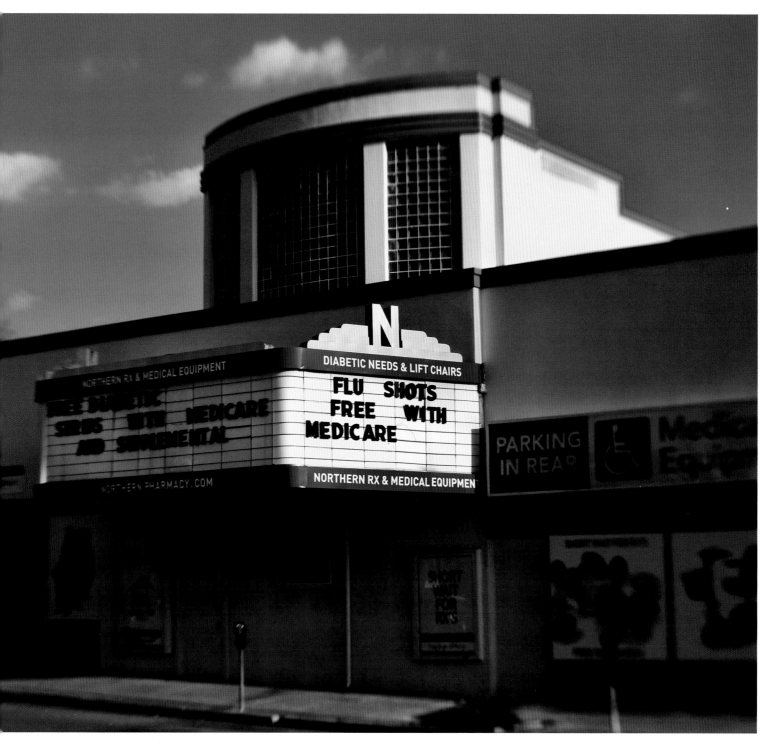

6701 Harford Road, 2012.

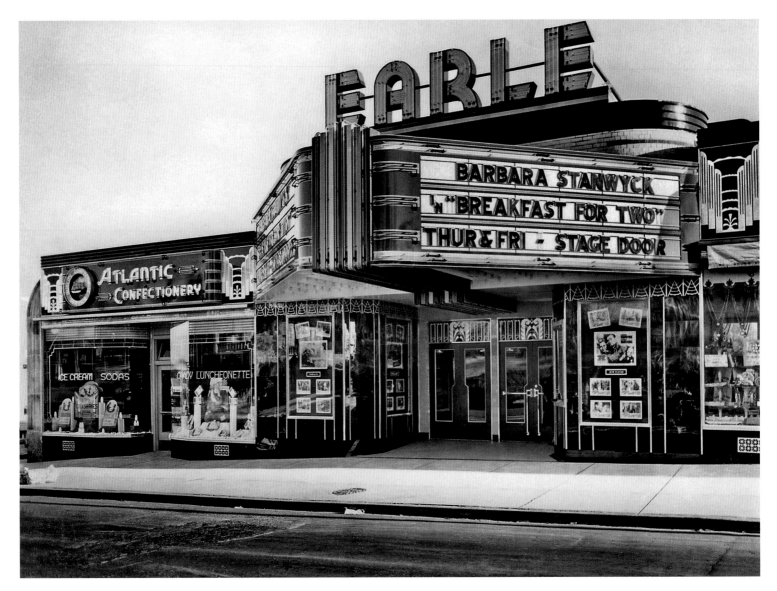

Earle Theater, c. 1937. Courtesy of the Robert K. Headley Theatre Collection.

EARLE

1937–2006

4847 Belair Road
ORIGINAL SEATING CAPACITY: 796
ARCHITECT: John F. Eyring

The new Earle Theater was the perfect backdrop for the Chevy Coupes and Chrysler Airflows cruising Belair Road, the commercial stretch of Route 1 in northeast Baltimore. Its three curved setbacks and low-slung scalloped silhouette perfectly expressed Art Moderne on the go. Thin stripes of black brick race across the buff brick front of the theater's second story, which emerges seductively behind two storefronts on either side of the entrance. The beautiful street-level facade, including an attached ticket booth, is deteriorating, but some of its swirled green Vitrolite panels and etched black marble trim are intact.

The Earle was designed by Baltimore architect John F. Eyring, whose family's construction company, E. Eyring & Sons, built many of Baltimore's theaters, including Art Deco gems like the Ambassador, Senator, and Uptown. Inside, the Earle offered a mirrored lobby, lounge, and oversized auditorium seating arranged in a concave semicircle to ensure a clear view of the screen. The Celotex walls were a checkerboard of tan and ivory.

The Gaertner organization built the Earle and later had its office in the Atlantic Confectionery store on the north corner adjoining the theater. Moviegoers at the 1937 opening were treated to a Mickey Mouse cartoon, a Three Stooges comedy, and Pat O'Brien and Joan Blondell in the feature *Back in Circulation*. A steady stream of B pictures played at the Earle, but the fare changed radically under independent ownership in the early 1970s. From this period until it closed, the Earle was an adult cinema, with an especially loyal gay clientele. In 2010, a few years after the Earle's long run as a porn house ended, the Tabernacle of Praise Church moved in.

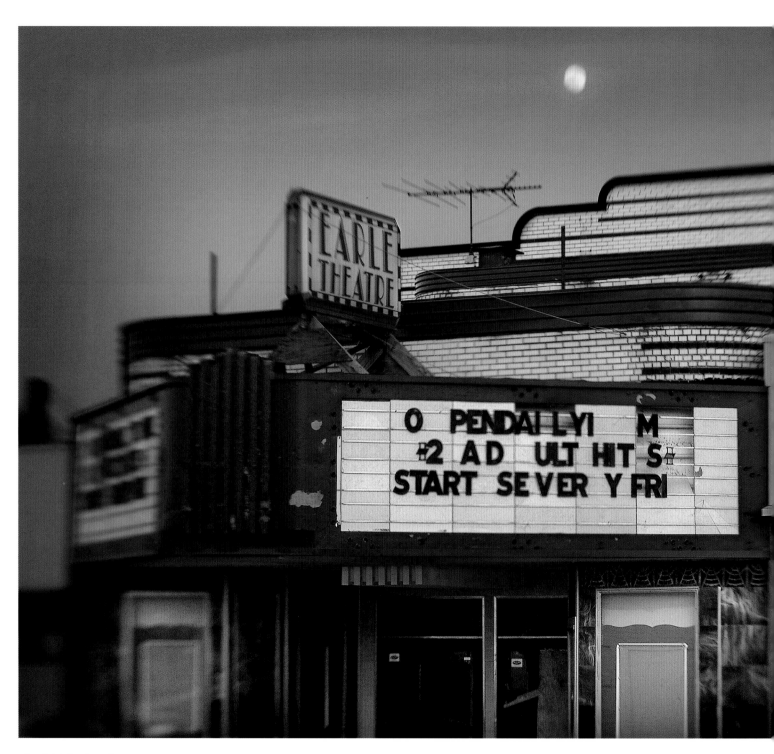

4847 Belair Road, 2008.

When I was seventeen, I saw Duel in the Sun *at the Earle. It was bitterly cold, but that movie was so hot that I kept warm all the way home. This steamy story was supposed to be David O. Selznick's answer to* Gone with the Wind. *It was one of the few movies where Gregory Peck played a villain. Jennifer Jones played a "half-breed." Joseph Cotten was the good brother and Lillian Gish was the mother. There was no happy ending, but I blamed that on Texas. It was a pretty big hit, but it didn't surpass* Gone with the Wind. Duel in the Sun *was one of the five trashiest movies of all time, but I definitely remember it.*

Pat Paul, homemaker

I loved the Earle Theater. Everybody in Baltimore went nuts when the historic Senator Theater announced it might shut down, but not a peep was heard when the Earle closed its doors forever in 2006 without warning. This lovely porn theater in a working-class neighborhood had definite audience participation that somehow never, as far as I know, got the owners in trouble with the law. And believe me, a lot went on in the Earle. You could even go to the lobby and get your popcorn in the nude if you felt like it. The sexual preference on screen had little to do with the public sex acts that went on in the theater itself, and the loyal (if troll-like) audiences seemed proud to carry on the old-fashioned gay tradition of sex at the movies. Nobody complained when the theater was open. Now, I'm complaining that it's not.

John Waters, film director and author

Cinema Theater, c. 1955. *Physical Theatre Magazine.* Courtesy of the Theatre Historical Society of America.

LINDEN/CINEMA/CAPRI/SUTTON

1938–1965

910 West North Avenue

ORIGINAL SEATING CAPACITY: 884

ARCHITECT: John J. Zink

West North Avenue was thriving when the Linden opened in 1938. One block east of the corner of Linden Avenue where the new movie house was built was the Rialto Theater, a smaller playhouse dating back to 1916. By the time the Linden arrived, the biggest draw was Nates and Leon's deli, conveniently positioned between the two theaters. A late-night hangout, the deli had a dedicated following for its corned beef, pastrami, chicken salad, and desserts. The Linden, though barely recognizable now, was not razed when Nates and Leon's, the Rialto, and many other shops were obliterated in the name of urban renewal.

The Linden was the first theater built by Milton Schwaber, a shrewd real estate man. John J. Zink designed the Art Moderne house with buff brick and black accents similar to the motifs used in the Ambassador and the Earle. The theater was a simplified one-story affair with no great architectural flourishes. It boasted extra-wide seats, spaced thirty-four inches apart.

When it opened, the adult ticket price for two features was 15 cents for matinees and 25 cents after 6 p.m. Children were admitted for 10 cents. A 1939 program advertised, free to the ladies, 22-karat gold-edged dinnerware on Wednesday and Thursday nights. In addition to standard B fare, the Linden also played pictures like *The Singing Blacksmith*, starring Yiddish radio star Moishe Oysher.

In 1953 the Linden was completely remodeled into an art house called the Cinema. Ten years later, the Linden became the X-rated Capri. Still under Schwaber ownership, the short-lived Capri was reconceived as a first-run theater called the Sutton that same year. The Sutton folded in 1965, and this stretch of West North Avenue sank into blight.

The original theater entrance on West North Avenue is sealed. A Laundromat, entered from the rear, along with a bar, liquor, and cigarette outlet, are now in the western end of the former theater, closer to the original entrance. Some of the striped buff brick is still visible on the eastern corner, above a convenience store where employees are shielded behind thick Plexiglas dividers.

I was born in Germany, Upper Silesia, and came here when I was almost thirteen. The area was middle class, mostly Jewish. My first job was being an usher at the Rialto. The Linden offered me more money, twelve dollars a week. I worked there during the war, when they showed a lot of newsreels. The Linden had a bigger seating capacity than the Rialto. The ceiling was bulbed with small fifteen-watt, alternating green and red bulbs. The Linden had no stage, but it had a curtain.

The Linden and Rialto may have fought over the various pictures that were available. The Rialto was part of a circuit that was a little older, the Rome circuit. The Linden could play ones that didn't make it to the Rialto.

I had to change the marquee. I was up with another guy and the ladder fell down. We landed on the sidewalk. I know I hit my head.

Fritz Goldschmidt, film booker

In 1945, when I was fourteen or fifteen, we'd go to the movies, knowing and hoping that there would be pretty young girls who had recently come with their families to Baltimore from West Virginia. Their fathers were working at the shipyard or Bethlehem Steel in the war effort. If you saw a young girl sitting alone, you'd walk over, sit down, and say, "Good movie. You live around here?" And then you'd stretch your arm out so it was on the back of the chair. Then your arm would get tired, and kind of fall down a little bit. Then your arm would fall a little more. Hopefully you got below the shoulder. That was the end game. Half the time they'd push you away. Then you got up, went back to your friend, and said, "I made it." Maybe I did this once or twice. After "the move," I ate popcorn and went home.

Stanley Morstein, attorney

910 West North Avenue, 2013.

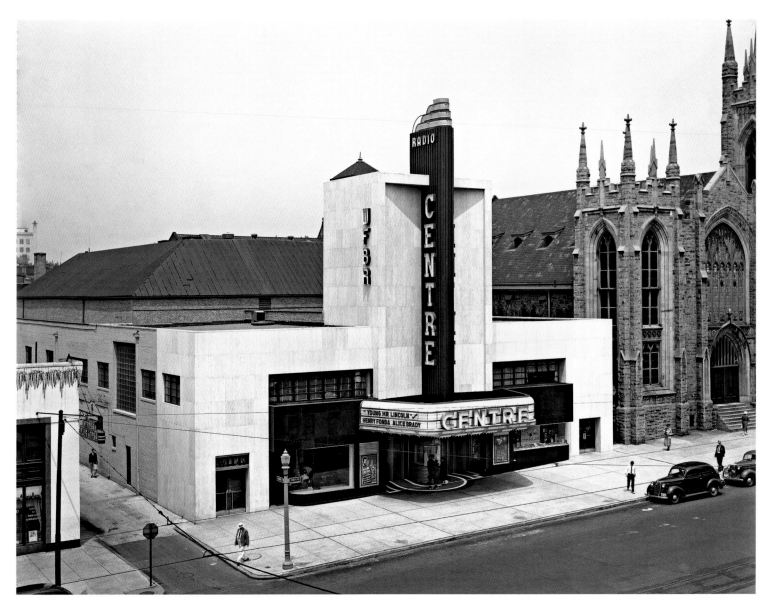

Centre Theater, 1939. Courtesy of the Baltimore Museum of Industry, BGE Collection.

CENTRE/FILM CENTRE
1939–1958

10 East North Avenue

ORIGINAL SEATING CAPACITY: 975

ARCHITECT: Armand Carroll

For an elegant twenty-year interlude, the Centre was the epitome of modern sophistication on North Avenue. Fred Astaire and Ginger Rogers would have been at home twirling across the stage under the unique gold-leafed, circular proscenium arch of this soothing Art Moderne masterpiece. The spirit of the 1939 theater was captured in the inscription for the lobby mural by Baltimore muralist R. McGill Mackall: "Man Works By Day; Night Is For Romance."

Morris A. Mechanic's $400,000 radio-theater complex was created from a 150-car garage built by the Colonial Motor Company in 1913. It extended back to 20th Street, where Baltimore's first radio station, WFBR, had an entrance to its second-floor broadcast studios. The two most popular entertainments of the 1930s, radio and motion pictures, came together in the auditorium, where speakers could broadcast breaking news from the studio above, or present live programs to the theater audience. A searchlight at the tower's peak helped give North Avenue its nickname, North Baltimore's Great White Way.

Initially, the Centre was a second-run house. Isidor Rappaport, owner of the Hippodrome, Town, and Little theaters, leased it in 1954 as a chic first-run house he renamed the Film Centre. Todd-AO, an early wide-screen 70mm format, premiered in Baltimore in 1956 with *Oklahoma!* Todd-AO used just one camera, instead of the three synchronized cameras needed for Cinerama. Mike Todd

attended the Centre's screening of *Around the World in 80 Days*, his second Todd-AO feature. The musical *Gigi* had a reserved-seat run for three months before the Film Centre closed for good in the fall of 1958.

Mechanic, never one to be sentimental about his playhouses, gutted the beautiful theater to make way for a check-processing center for Equitable Trust Company. Both the bank and WFBR stayed on into the 1990s. A church used the space for a while, but by the early twenty-first century, the sealed facade of black marble and off-white travertine limestone looked like a mausoleum.

Developer Charlie Duff, president of the nonprofit Jubilee Baltimore, was undeterred when he bought the dank, moldy, asbestos-laden building at auction in 2011 for $93,000. A $19 million renovation led by Jubilee Baltimore, with the help of area stakeholders and historic tax credits, turned the decrepit building into an incubator for the arts and community development when it opened in 2015.

The transformed Centre houses the film programs run by Johns Hopkins University and Maryland Institute College of Art, along with the Baltimore Jewelry Center, game developer Sparkypants Studios, and several community nonprofits. The glowing white neon of the rebuilt marquee and refurbished tower proclaim that a little romance has returned to the long dormant intersection of North Avenue and Charles Street, once one of the city's busiest crossroads.

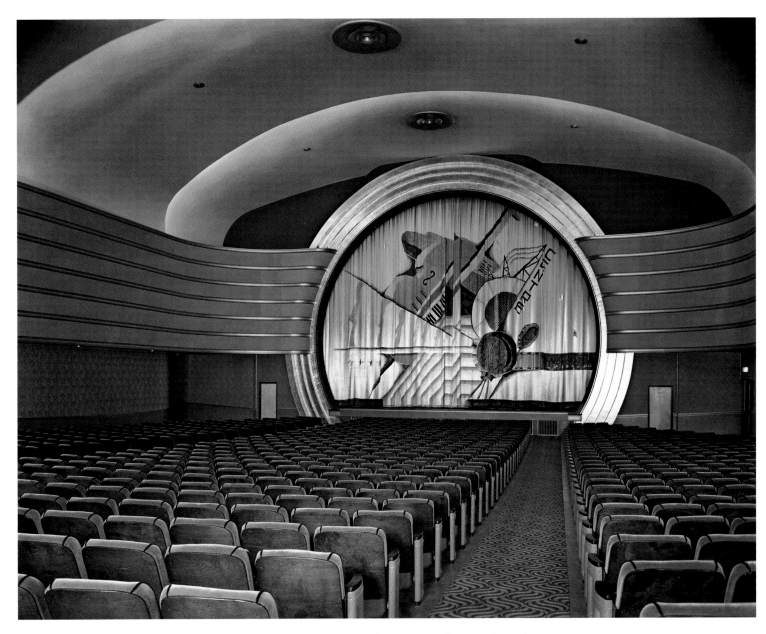

Centre auditorium, 1939. The highlight of the Centre's Art Moderne design was a circular proscenium arch framed in gold leaf. Photo by the Hughes Company. Courtesy of the Maryland Historical Society, #SVF.

The Film Centre introduced me to the love of my life, Georgene Gonzales. She was beautiful and vivacious. Georgene served the coffee and showed moviegoers to open seats as an usherette. The movie was Doctor in the House, *an English comedy with Dirk Bogarde. I kept coming back so often to see her that the manager just let me in. It took a month before I asked this Towson Teachers College student for a date. She said "Yes." It was kismet. I miss her every day.*

M. J. "Jay" Brodie, former president, Baltimore Development Corporation

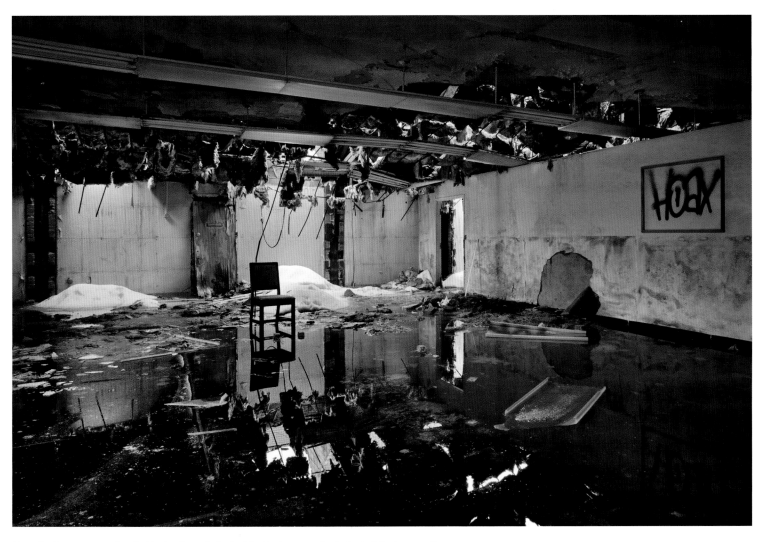

Mounds of snow accumulate inside the decrepit Centre Theater in 2014, prior to the building's renovation.

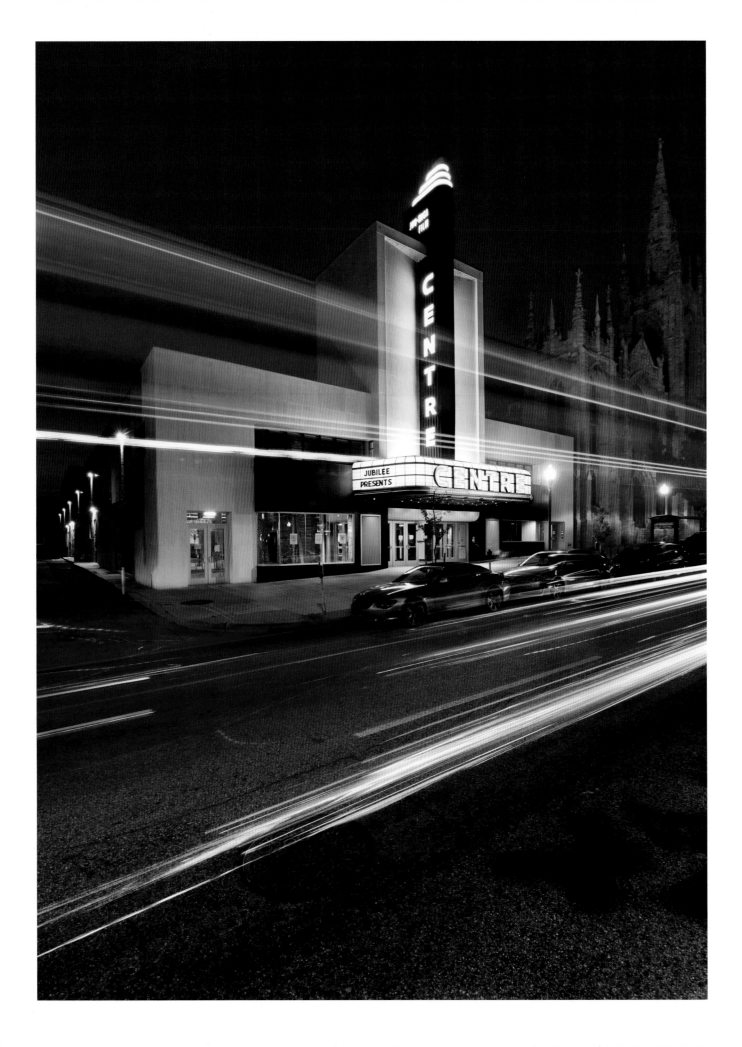

Westway Theater, c. 1973. Photo by Robert K. Headley.

WESTWAY
1939–1978

5300 Edmondson Avenue
ORIGINAL SEATING CAPACITY: C. 700
ARCHITECT: Jonathan E. Moxley

Under its current robe of white paint as the Family Bible Ministries Worldwide church, much of the Westway's Art Deco detailing has been obscured. The front was clad in two-toned tan brick with horizontal striping. Sadly, the three vertical rows of backlit glass block in the center of the tower have been painted over.

The Pasco family owned the Westway for about three decades. As an independent and spirited family-run house, the Westway held many special promotions, such as an onstage pie-throwing contest in the early sixties. In the late sixties and early seventies, the theater hosted screenings for the Nelson Eddy–Jeanette MacDonald Fan Club, attracting fans from all over the country.

The theater, which straddles the city-county line, was hampered by limited availability of parking. Even as a discount house, it was no match for the suburban Westview Cinemas and Edmondson Drive-In, both nearby. The closing show in December 1978 was *Grease*.

Facing page: 10 East North Avenue, 2015.

5300 Edmondson Avenue, 2011. Cousins Karl Smith, left, and Jalen Jones strike a pose for the camera.

My grandfather, Nathan Pasco, owned the Westgate Food Market, in the same block as the Westway. After the Westway had a major fire in the late 1940s, my grandparents restored it and took over its operation. My father, Abel Caplan, became the general manager and booked the pictures. My brothers and I all worked there. It was a great neighborhood theater. The Westway had a stage, and in the fifties and early sixties, my father would book stage acts that would perform before the movie. There were long lines of kids on Saturdays waiting to get in for 15 cents to see a double or triple feature, cartoons, a magician named Marco the Magnificent, and receive a free bag of popcorn.

We had two projectionists, Joe Neuberger and Rick Hild, who liked to play tricks on the audience. One day they switched the ladies' and men's room signs, so that the regulars went to the correct bathrooms but the new patrons followed the signs, causing pandemonium. My grandfather was so mad. When we were playing Easy Rider, just as the motorcycles on the screen were riding off into the distance, they both rode Joe's motorcycle up and down the aisles to screaming crowds.

My brother Aaron ran the midnight shows. We played 200 Motels, Woodstock, Zachariah, a rock Western, Billy Jack, and a Woody Allen double-feature night with Take the Money and Run and Bananas, to sellout crowds. Aaron would get a little feisty at midnight. During some of these shows, he would intersperse the advertised movie with a light porn flick on one projector, and The Little Rascals on the other. He'd move back and forth between the two, so you'd hear Little Rascals dialogue with some unexpected visuals. They had fun. Aaron tried to convince our dad to book the X-rated Fritz the Cat and Pink Flamingos, but he would never agree because the neighborhood was sensitive to X-rated movies.

There was an opening at the bottom of the screen. You could crawl through it onto the old stage and I would sometimes sit on the stage and watch a movie from behind the screen. It was really cool, because there were thousands of colored dots that would jump all over the old stage and on me.

Neil Caplan, founder and executive director, Bannerman Castle Trust
Additional contributions from Caplan and Pasco family members

I was thirteen when the film Bonnie and Clyde came out in 1967. My younger brother Doug and I went to see it. I was a different person walking out of that theater after that one showing. I was transfixed by the combination of the image and the sound. When the first chase scene happens with these two old 1930s cars, and the banjo music comes in underneath it, "Foggy Mountain Breakdown," by Lester Flatt and Earl Scruggs, the wedding of those two things was perfect.

I was already a budding guitarist, but I had never heard this banjo sound before. I did not know about bluegrass music. It was the summer, and I went back and saw the film fourteen times. I paid more attention each time, picking out something new visually and musically each time. It was my own film festival with one film.

I am thankful for the Westway, because if that theater hadn't been nearby, I might not have gone back to see that film fourteen times, and it might not have had such a deep influence on me.

Billy Kemp, musician

Senator Theater, c. 1953. Courtesy of Frank Durkee III.

SENATOR

1939–PRESENT

5904 York Road
ORIGINAL SEATING CAPACITY: 1,024
ARCHITECT: John J. Zink

The prettiest glimpse of the Senator is on a rainy night, when its neon sign and glowing red, green, and gold bands of backlit glass block shimmy on the wet pavement. It was pouring down rain, as Baltimoreans like to say, when the theater, then seventy-four years old, reopened on October 10, 2013, after a year and a half of darkness. A twenty-fifth anniversary benefit screening of *Hairspray* showcased the $3.5 million restoration.

Durkee Enterprises spent about $250,000 on the limestone and brick structure, which opened in 1939 as a second-run movie house. Architect John J. Zink's use of glass block as the curved facade's signature element is unlike any building in Baltimore. The Streamline Moderne theater is listed on the National Register of Historic Places, and it represents Baltimore's most intact example of this late Art Deco style.

Inside, the two-story circular lobby still has its original terrazzo floor, walnut veneer panels, and wall niches that once contained tropical fish. A stylized mural depicting the progress of visual entertainment encircles the room at the mezzanine promenade level. Prismatic rays of red, green, and blue crisscross the recessed ceiling in the main auditorium. Many people fondly recall attending birthday parties in the two soundproof viewing rooms.

The Senator started showing first-run films in the 1960s. As the Durkee chain dwindled, the Senator's stature rose. The 40-foot screen was saved from the destructive twinning that split the auditoriums of Durkee's Boulevard and Patterson theaters. In a sea of suburban multiplexes, the Govans landmark became Baltimore's proud beacon: the city's last single-screen theater.

Tom Kiefaber, the grandson of the chain's founder, purchased the Senator with partners in 1988. He brought passion and showmanship to his childhood movie house, delivering top-notch presentation and Dolby Digital sound with surround EX. All this was not enough to keep the Senator afloat, however. The theater staved off foreclosure several times, but in 2009 the city purchased it at auction for $810,000. The city sold the theater in 2012 to the operators of the Charles, James "Buzz" Cusack and his daughter, Kathleen Cusack Lyon.

The Cusacks embarked on a renovation that added three smaller screens, while restoring the original auditorium. The total seating, which had been reduced to 764 by 2012, has returned to its original capacity of slightly more than 1,000, but is now divided among four screens. Although the Senator has not completely returned to its 1939 appearance, great effort was made to bring back as much as possible.

I watched the Senator being built. They tore down a big white house on the corner where the Blair family lived. Every day when I got off the streetcar from Poly I'd see what progress they had made. I was particularly interested in watching the masons do the curved brickwork. They didn't build fast in those days like they do now. One of the things that got me interested in doing structural drawings as a draftsman was watching the Senator's construction.

On opening night the place was packed. They were showing Spencer Tracy in Stanley and Livingstone. The Senator's seats were impressive because they moved back, unlike the rigid seats at the Rex and Boulevard. You could see the screen from any seat in the house. There was more aisle space, and the acoustics were much better than most of the theaters.

I used to go to every movie that they had. I was cutting lawns on Rosebank for 35 cents. I shoveled snow for 35 cents. I babysat for two little boys, 35 cents. Everything was 35 cents because that was the price of a movie. I loved work, and I loved the relaxation of the movies. It was the one time I could completely forget what I was worrying about.

David Dilworth, retired draftsman for precast concrete

When I was about sixteen, we would go to the Senator on Friday nights. We always sat down on the left-hand side because that's where the guys were. We didn't know them, but that's where the fields were greenest.

We had to leave early to catch the bus so we could get home before my father returned from law school on Friday nights. So I usually didn't get to see the end of movies. We would pray the bus would come so we'd get home in time. My mother would say, "If you are going to do this don't tell me, so I don't have to lie."

Frances Wroblewski, retired senior high school teacher

We lived across the street from the Senator on Orkney Road. The movie I saw more than twenty times was Lawrence of Arabia. I hooked Northern High School, stole some dollar bills from my dad, and sat in the back left corner, eating popcorn, a box of Junior Mints and a large Tab. What a giant film in a grand theater! Peter O'Toole was such a wonderful actor. It stayed there a long time.

I was a hippie. We all had long hair and used to sit on the wall across from the Senator, between Hochschild's parking lot and Read's drugstore. They called us the Wall Gang. People would come down the street and scream at us. It was a little Haight-Ashbury at Belvedere and York; a lot of head shops, plus there was a record store next to Read's.

Star Wars was the best. You could never get in for the lines of people. It was crazy. Fans dressed up in Star Wars stuff, like Darth Vader, and camped out in sleeping bags and tents. I must have seen a hundred movies there on that big screen. What a proud Baltimore landmark.

Michael J. McDonough, retired CSX locomotive engineer

Opposite: 5904 York Road, 2014.

Times Theater, 1940. Courtesy of the Baltimore Museum of Industry, BGE Collection.
Opposite: 1711 North Charles Street, 2013.

TIMES/CHARLES

1939–PRESENT

1711 North Charles Street

ORIGINAL SEATING CAPACITY: 725

ARCHITECT: Jackson C. Gott (Baltimore Traction Company)

The Charles began life as the Times, Baltimore's first all-newsreel theater. The Times was built within the defunct 1892 Baltimore Traction Company powerhouse and cable car barn. The newsreels, typically about nine minutes long, drew commuters from nearby Penn Station.

JF Theaters, a major player in Baltimore's theaters after World War II, converted the Times into an art house in 1958, renaming it the Charles. The theater was remodeled several times, most drastically in 1969 when the facade was refaced in brick and the lobby and lounge were enlarged. In the 1970s the Charles became a first-run house, showing films like *Star Wars*. After closing briefly, it became a successful art house again in 1979. The Charles remained profitable until the rise of crime, video rentals, and competition led to its closure in 1993.

John Standiford, a former manager at the Charles, and his uncle, James "Buzz" Cusack, leased the theater in 1994.

Five years later they added four new screens in the portion of the old car barn that had housed a bowling alley and, later, the Famous Ballroom, a popular jazz hangout. The $1.6 million expansion preserved the original auditorium with its 30-foot screen. A renovation in 2014 reduced the seating in this auditorium to slightly under 400, but the total five-screen seating capacity is now more than 1,000. The old lobby became the Tapas Teatro restaurant.

The Charles continues to offer a mix of foreign films, first-run specialty films, and revivals. The architect Alex Castro's design for the 1999 expansion pays tribute to the industrial roots of the Romanesque Revival structure, bringing the Charles full circle. The power generated to pull steel cables as they wound endlessly around wheels has become the symbolic power of film reels, constantly unspooling ideas.

The Charles was an old powerhouse that provided the cable traction through steam power to pull cable cars, and the north end of the building was used to store extra cable cars. When the cable company failed in the late thirties, my stepfather, Louis E. Shecter, bought the building and turned it into a newsreel theater. When World War II broke out, he saw an opportunity. My stepfather kept the theater open until 4 a.m. to accommodate Bethlehem Steel workers when they got off work. They did a big business in the middle of the night, between the theater and the 110-lane bowling alley next door. The Times later showed double features with Fox Movietone News, Bowery Boys and Charlie Chan films, Westerns, and later, the Hope-Crosby "Road" movies.

Jack Fruchtman leased the theater in the late fifties and ran it for almost twenty years. During that time television got big, the neighborhood changed, and finally JF Theaters went bankrupt. I had an idea that there ought to be a niche audience for an art theater. We got David Levy, who ran the Biograph in DC, and Pat Moran. They did a helluva job building up the Charles. In 1993, Levy closed up and it sat empty for a while. One of the employees, John Standiford, came to me and said, "My uncle and I would like to talk to you about renting it." I made the decision to go with them rather than Loews, who had the Rotunda at that time. It turned out to be the right choice.

Alan Shecter, landlord of the Charles Theater

It was a freezing cold night, February 3, 1968. I was on a blind date with a young lady named Sally. You purchased tickets outside then at the Charles, and on Saturday nights there was a long line. She was wearing stockings and a dress, and I had on my iridescent green and blue suit. Sally was cold, so she started to snuggle up to me, not because of my sexual magnetism, but to keep warm. This was a novel experience, to be touching on the first date. So I'm thinking, "This is working out pretty well."

The movie was Wait until Dark. We are sitting there, prim and properly, not touching, these two shy people. When the scary part happened, Sally leaped up in shock and grabbed me. Then I knew things were really going well. Afterwards, we went to the Harvey House for a little snack, and I took Sally home. Emboldened, I gave her a kiss goodbye. Back then you didn't kiss on first dates.

It was the perfect movie for me, because I needed all the help I could get. We had the second date. We go to movies a lot, including Cinema Sundays at the Charles. We've been married for forty-five years.

Morton Katz, retired orthodontist and professor, Howard University

I knew there was a market in Baltimore for an art house. When David Levy took over the Charles, I became the theater director, responsible for programming and publicity. We opened in 1979 with Girlfriends, which was red-hot at the time. We mixed art films, obscure films, foreign films, oddball films, and retrospectives.

We showed Fellini, Fassbinder, Godard and other New Wave directors, and anything that Jack Cardiff shot. We did Hitchcock's Dial M for Murder in 3-D. We also had a silver screen; these were designed for black-and-white film in the old movie houses. We premiered Polyester there. It was profitable—we never lost a penny.

The Charles was accessible to everyone, because we had a discount ticket book. No one else had that. There were certain people that I'd let in for free. Mr. Johnson used to work at the library and didn't have his own funds, so we let him in for free. He had his own chair. He would tell a paying patron, "Excuse me, you are in my chair."

The theater opened with good programming in a bad neighborhood. We were the only people left there, [other than the] dive bars. To get people out in the middle of the week in Baltimore you had to be clever with what you were exhibiting.

Pat Moran, casting director

1940

1949

"I tried to stop them, to keep them just as they were when you left, but they got away from me."

Millie Stephenson (Myrna Loy), from *The Best Years of Our Lives*, 1946
William Wyler, director

Uptown Theater, 1941. Courtesy of Sylvia Piven.

UPTOWN
1941–1975

5010 Park Heights Avenue
ORIGINAL SEATING CAPACITY: 1,100
ARCHITECT: John F. Eyring

When the imposing Uptown joined the robust retail center of Pimlico, the middle-class, largely Jewish area already had the Avalon and Pimlico. The Uptown was under the same ownership as the other two theaters. The tan brick and steel Art Deco edifice, however, was strikingly modern compared to these older movie houses on Park Heights Avenue.

The innovative Uptown had a ticket booth indoors, eliminating outside lines, and an adjacent parking lot. Deluxe touches included a decorative fountain in the spacious lobby, plush carpets, embossed fabric walls, oversized seats, and a 24-foot screen. A showy curved staircase in the lobby led to glass-enclosed loges and private boxes. Another distinctive touch was the pioneering use of ultraviolet lighting, which added a third dimension to the designs on the curtain and proscenium.

Before its first decade was over, the Uptown was eclipsed by a new theater to the west, the tony Crest. A twenty-one-day house, the Uptown limped into the 1970s before closing in 1975. The stately theater was well suited to become a church, and the Lord's Church of Baltimore deserves credit as a good steward of the building. The only jarring change has been the shingled roof overhangs that replaced the unusual trio of marquees.

My father, Benjamin Beck, co-owner of the Uptown, was very proud of [it]. One of the things that made a strong impression on my young mind, before the movie started, was the music. It was always the same music, probably "In a Persian Market," by Albert Ketèlbey, a British composer in the early part of the twentieth century. The operator up in the control booth must have had the record. Lights played on the orange-brown curtain while the music was playing. His luxuriant Ketèlbey program music really put the moviegoer in the mood to be transported elsewhere.

Stanley Beck, former US Navy JAG Officer and retired staffer, Department of Defense/NATO

I was an usher at the Uptown, around 1948, when I was sixteen. We got paid 75 cents for two hours. We had a uniform, with a black bowtie, jacket, and pants with a stripe. That was really cool, because the guys all felt that the girls liked the boys in the uniforms. I was stationed on the steps to the loges, which cost an extra dime. In those days you could smoke in the loges, but not downstairs. They were glassed in, like stadium skyboxes, and they had ventilation, with speakers to hear the movie.

They eventually put a television screen up on the wall in the big inside lobby, maybe 4 × 4 feet. Nobody knew what television was going to be. At the Pimlico you walked in anytime, but the Uptown was stricter about that. They didn't let the folks go in during the middle of the movies, so the TV entertained them. Nobody had a screen that big at home in those days. Compared to the Pimlico, the Uptown was like Hollywood.

Bill Irwin, retired industrial manager

One of the first movies I saw at the Uptown was The Tingler with Vincent Price. The Tingler came out in 1959, but I saw it in the re-release. It was set in a movie theater so the thing about the Tingler terrorizing people was that here you were in a theater with the lights out and people were thinking, "Oh my God, the Tingler is in the room!" It only took one person to start screaming to get everyone else to start screaming. That was scary, boy.

One thing that's really missing now in urban areas is neighborhood theaters. You felt ownership of your neighborhood theater. You'd try to sit in the same seats every time. There were other theaters, but you felt that this was your theater, like your baseball team or your school. You took it personally when they closed.

David R. Blumberg, chair, Maryland Parole Commission

5010 Park Heights Avenue, 2014. Zaria Kelly, at left.

Apex Theater, c. 1962. Photo by Paul Henderson. Courtesy of
the Maryland Historical Society, HEN.00B1-029.

APEX

1942–2013

110 South Broadway

ORIGINAL SEATING CAPACITY: 640

ARCHITECT: Hal A. Miller

110 South Broadway, 2013. Andrew Gore, one of the visitors to the Apex on auction day.

On October 11, 2013, a small crowd gathered inside the Apex for the auction of the seedy movie house. Everyone refrained from sitting on the decrepit seats that had seen more action than the average theater. After all, the Apex had been a porn house since 1972. A year later the Apex, Baltimore's last adult cinema, was converted into a convenience store.

Real estate developer Milton Schwaber built the Apex in 1942 as a sub-run house on upper Broadway. The location wasn't ideal. The architect Hal A. Miller designed the Apex and three look-alike utilitarian tan brick boxes for Schwaber in the 1940s: the Paramount on Belair Road, the Colgate in Dundalk, and the Homewood, later known as the Playhouse, on 25th Street.

In its final years, the Apex screened X-rated pictures from DVDs. Even the angular letter "A" on the triangular marquee was slightly phallic. The new owner trashed the marquee—the theater's best feature—in 2014.

It's remarkable that the anachronistic Apex stayed in business for more than four decades, considering the availability of similar material on home computers or television. As business waned, the surrounding upper Fell's Point neighborhood grew more vibrant due to the huge growth of the Latino community. If only the Apex could have been revamped as a Spanish-language theater.

On the opening day for the Apex all of the kids went in for free. The movie was Remember Pearl Harbor. No love story; all men in the picture. They showed a lot of independent, low-budget films made by Lone Star productions. These were pictures made in three to four days. John Wayne was in them before he became a movie star. The only thing I liked at the Apex was the soft seats.

Conrad Brooks, actor

When the Apex first opened, I was nine years old. We were so excited about having a new theater, but we weren't even allowed to go by it. From the Apex [Theater] up to Baltimore Street were rooming houses. These housed a lot of merchant seamen and single men, so my mother said, "Don't you dare go up there." The Leader had the better cowboy movies, anyway.

Gloria Weber, retired logistics manager, Rukert Terminals Corporation

I was relief projectionist at the Apex. In 1980, the owner, Leo, told me, "Hey, I have to leave town and I need some money." So I gave him $4,000 and the theater was mine. It was already a porn house. I tried to make it a legitimate theater, but no one in the neighborhood would support it because of its reputation.

My cashier, Ed, told me a story about how the Apex got raided before I started working there. He was running hard-core pornographic stuff. Channel 11 called: "Have you been raided yet? Because we are sending a news crew." So he tells the owner real quick, and they take the reel of 16mm film they were running, and hide it up in the ceiling in the projection room. The vice squad shows up and they are just showing what they normally show, soft porn. So when the vice guys climb up the fire escape to go to the roof, they think, "We're busted." The film was up there in the crawl space, but they never saw it.

The majority of my clientele was gay. Once when I took my motorcycle to work, it was raining and a friend gave me a ride home. I put it in the ladies' room since it was seldom used. Later, one of the local customers asked, "When are you bringing the motorcycle back? We liked having sex on the motorcycle."

Dominic Wagner, projectionist and former theater owner

I was an extra in John Waters' 2000 film Cecil B. Demented, in a scene at a porn house, filmed at the Apex. It was so seedy. Your feet stuck to the floor. I washed my hands every time I left the theater. Cecil B. Demented was also filmed at the Senator, Hippodrome, Town, Patterson, Earle, Grand, Rex, and Bengies Drive-In.

Bob Adams, artist, author, and secondhand dealer

Playhouse Theater, c. 1961. Courtesy of Rick Wagonheim.

HOMEWOOD/PLAYHOUSE/ HERITAGE PLAYHOUSE/ KOBKO/PARAGON/SHOWTIME/ AUTOGRAPH PLAYHOUSE

1946–1985, 1997, 1999, 2002–2004, 2011–2013

9 West 25th Street

ORIGINAL SEATING CAPACITY: 700

ARCHITECT: Hal A. Miller

9 West 25th Street, 2011.

Milton Schwaber opened the Homewood, one of a flurry of modest post–World War II neighborhood movie houses, in 1946. The architect, Hal A. Miller, replicated the plans from the no-frills Apex. It became a moneymaker after Schwaber's son-in-law, Howard "Boots" Wagonheim, transformed it into an art house in 1951. The renamed Playhouse rode the wave of popular foreign art films in the 1950s and early 1960s.

The intimate foyer resembled a living room, with sofas and local artwork on display. Free imported teas, coffee, and crumpets replaced candy. The seating capacity was halved to accommodate extra-wide "Airflo" rocker chairs. Ads cited its proximity to the northern suburbs, where many of its cultured patrons lived.

The art house concept worked well enough to spawn other conversions, but by the 1980s competition from suburban art houses and home video ended this alternative to mainstream Hollywood film exhibition. David Levy, operator of the Charles, made a failed attempt to change the Playhouse into a first-run art house from 1982 to 1984. Lack of parking also stymied others who attempted to revive the theater.

The Playhouse became a church from 1989 to 1994. The most promising revival attempt was Michael Eugene Johnson's 1997 Heritage Playhouse Theater, which featured African American films accompanied by live jazz. Next came a short stint as the Kobko, an Asian film theater, in 1999. The theater hosted live performances from 2002 to 2013 for groups such as the Baltimore Rock Opera Society. Figure 53, a company that creates software for performing artists, purchased the Playhouse in 2015. Their renovation plans include a state-of-the-art black box venue for live performances.

My father learned [how to be a projectionist] from his father, who learned it from his father. My grandmother wrapped up a hot supper for my grandpa, and took it on the streetcar to the Lord Baltimore. So my father, Jack Hawkins Jr., expected the same service. I remember my mother putting this hot dinner of meat cakes with gravy and mashed potatoes and two vegetables on a blue willow dish. They thought that was their job, to get a hot meal to their menfolk. This was when my father worked at the Homewood after World War II.

My father worked six days a week, usually from 11 a.m. to 11 p.m. He earned about $100 a week in the fifties. It was good pay at that time. They could never leave the booth during those twelve hours. Even their washroom and toilet were there in the booth.

There came a time when my father was afraid he would die working in the booth. His father had died of a heart attack at age 55. So in the mid-1960s, he left the Playhouse and tried other jobs. He died in 1971 at the age of 53.

Virginia L. Ingling, retired social worker

The Playhouse was a big social phenomenon in the fifties and sixties. More art films were being shown for young, college-educated, professional couples. You wanted to have the film experience, but it was also the place to be seen. There was a sparkle that you didn't get anywhere else. You lingered, talking about the movie, wanting to hang on to that excitement.

There were long lines for a lot of these foreign films. If it were something extra special, the line would stretch along 25th Street. Sometimes a car would come by, and someone inside would yell, "How long have you been waiting?" No other theater was like this for our generation.

Betty R. Sweren, book artist and lecturer, Goucher College and Johns Hopkins University

Howard "Boots" Wagonheim was a real film enthusiast. When a movie did reasonably well, Boots kept it and kept it. Boots would say, "It has legs!" Back in the day when word of mouth really meant something, cult films like King of Hearts *and* Harold and Maude *kept playing. More of the profit goes to the exhibitor further into the run. The Greek film* Never on Sunday *played for about forty-five weeks in the early sixties.*

Mike Giuliano, educator and arts journalist

Carlton Theater, c. 1962. Courtesy of Chuck Kaczorowski.

CARLTON

1949–1985

1201 Dundalk Avenue
ORIGINAL SEATING CAPACITY: 810
ARCHITECT: John F. Eyring

Many are bemused by the transformation of X-rated theaters into churches. The denouement for the raunchy Carlton was different. The house of porn became a place to mourn. The Kaczorowski family converted the beige brick theater built by E. Eyring & Sons into a tasteful undertaker's establishment in 1992. The Kaczorowski Funeral Home has handled large crowds, but never a line like the one that stretched down Dundalk Avenue for a glimpse of a blonde *Playboy* cover girl in 1976. This was when Kristine DeBell made a personal appearance for *Alice in Wonderland: An X-Rated Musical Comedy*.

The screen entertainment was family-oriented when Lou Gaertner opened the Carlton on February 22, 1949. The first program offered a sports reel special, *Football*

Magic, a color cartoon, *Mouse Trappers*, a travelogue titled *Canada Calls*, previews, and Abbott and Costello in *Mexican Hayride*. In this postwar period, the Gaertner organization operated the Lane and Strand in Dundalk and the Ritz, Palace, Vilma, and Earle theaters in Baltimore City. In 1951, the Gaertners also took over the Colgate, abandoned but still standing on Dundalk Avenue, about a half-mile south of the Carlton.

JF Theaters leased the Carlton in 1970, and turned the Graceland Park neighborhood house into an X-rated theater. Longtime residents recall naive mothers who brought their kids to see films such as *Cinderella*, only to discover that the Carlton's version was for adults only. They got refunds.

1201 Dundalk Avenue, 2013. Sony Phommavanh.

I grew up on Broening Highway in the latter 1950s. As a young teenager, my older sister took me to see the Herman's Hermits' 1966 movie Hold On!, *and of course, the Beatles movie* Help! *Other memories include* Mark of the Devil, *the first movie I attended with friends and no adult supervision. The draw to that horror movie was that they handed out a "barf bag" because they touted the movie as so gross it would make you vomit. At one point, a girl's tongue gets ripped out. I remember us all screaming, though it seems so funny to me now. We actually stood in line on Dundalk Avenue for over an hour to see* Jaws.

My parents have been gone for over fifteen years and we held services for both of them at Kaczorowski's. Even during those solemn times, I remembered my visits to the movies there fondly.

Eileen Betz, risk control analyst, Citibank

I reopened the Carlton in September of 1979. Then I got a rude awakening. That year the Orioles went into the World Series. Everyone stayed home to watch. After cable and video arrived you couldn't bring back pictures over and over again anymore. We tried to keep it family but we had to play a lot of midnight shows: Dawn of the Dead, *and rock concerts like Led Zeppelin, Pink Floyd. It was subleased as a 99-cent discount house for a while, and stayed open until my five-year lease was up in 1984.*

Bob Wienholt, theater owner

The Kaczorowski family bought the Carlton in 1991. The building was in relatively good shape. The triangular marquee extended out from the building line about 17 feet. There wasn't a spot of rust on the steel after more than forty years of being exposed to weather, but the marquee had to come down. How would you like to be driving up Dundalk Avenue and see "Coming Soon" with your name on it?

The housings for two Peerless gas-fired carbon-arc projectors remain. The floors, walls, and ceiling of the projection room are all designed so that no fire could get out. There is a chain that hangs from the top to the door. In the middle of the chain is a heat sink, so if it ever got too hot it would melt, causing the heavy door to drop down. The metal door is particularly heavy. It must have been hot up there. There's a certain history with the building that you have to honor. It has its own kind of life.

Chuck Kaczorowski, director, Kaczorowski Funeral Home

Crest Theater, c. 1970. Photo by Robert K. Headley.

CREST
1949–1976, 1980–1981

5425 Reisterstown Road
ORIGINAL SEATING CAPACITY: 1,700
ARCHITECT: Julius Myerberg

The showpiece of the Hilltop Shopping Center was the glamorous Crest. While building subdivisions, the Myerberg Brothers added a strip mall on Reisterstown Road and Rogers Avenue that catered to the Jewish community as it migrated toward Pikesville. Saler's Dairy, Scherr and Dreiband kosher butchers, and Holzman's bakery augmented the larger grocery stores, bowling center, and other businesses. The center's Mandell-Ballow delicatessen and the Hilltop Diner across Reisterstown Road both had a symbiotic relationship with the Crest.

The only remnant of the Crest is the prominent curved brick facade above the mobile phone store now occupying the former lobby. The etched-glass mural above the entrance is hidden. In the vanished lobby, two dramatic curved staircases led to the television lounge and twin glass-enclosed smoking loges. Recessed lighting illuminated the plush fuchsia stage curtain.

In 1953 the Crest lost an antitrust case against the downtown theaters in its battle to show first-run films. JF Theaters took over in the 1970s, and the Rome organization bought the fading Crest in 1975. The theater that brought glitz to northwest Baltimore closed in 1976, only to reopen for a short stint in 1980 and 1981 as a dollar discount house. A church used the auditorium before it was bulldozed.

In its heyday, the Crest's patrons could relax in overstuffed chairs in a semi-circular upstairs lounge, facing the novelty of the decade, a 6 × 8 foot television screen. It's hard to imagine a greater contrast to the stylish, curvaceous Crest than what took its place in 2010: a sterile Motor Vehicle Administration service center. Once again there are long lines at the Crest, but now they represent the obligatory pilgrimages of weary motorists, not eager moviegoers.

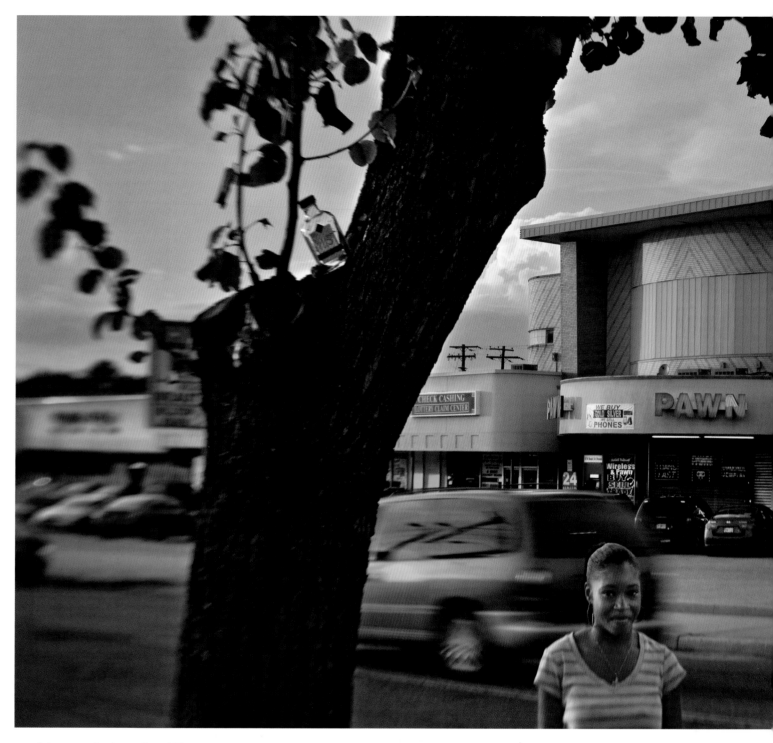

5425 Reisterstown Road, 2010. Crystal Wynn.

Exciting news, a new movie house coming to the Pimlico neighborhood! I remember that on the Saturday that the Crest opened, they had a swashbuckling film with Errol Flynn, Adventures of Don Juan, *and a multitiered cake, similar to a wedding cake, for all who came. I was there that day and the next day as well with my parents and brother for the same show and more cake.*

Bobbie Lichter, retired medical transcriptionist

The Crest was where you went with a date. You'd run into dozens of people you knew. There was always a line on Friday and Saturday nights. You didn't start going to the Crest until someone in your group could drive. It was outside of your own neighborhood. It wasn't far, but it was a drive.

Growing up in Forest Park, the closest theater was the Ambassador. The other theaters nearby were the Gwynn, which used to show all the B movies, and the Forest. That one was small. The Ambassador was the biggest. It was really gorgeous, one of the greats. The Crest was a big theater, too, its design a leftover from the thirties modern, streamlined style. It wasn't extremely ornamental.

The first real date that I ever had where I took someone out was at the Crest. I just got my driver's license, around '57. It was a Friday night. I picked up a girl in the family car and drove up to the theater. She was a terrific person. We dated for a while, but I never saw her after she graduated. You'd get some popcorn—they were small bags back then—and a small Coke. For the life of me I don't remember the movie. It was one of those bright Technicolor movies from the late fifties. After the movie we'd walk to Mandell's, the big deli place, about three doors down. I'd drive the girl home, and then go across the street to meet the guys at the diner.

Barry Levinson, film director and producer

The Crest was really done up right. You'd be kept behind a velvet rope, and the guy who took your ticket was actually dressed up. It was like going to dinner at a high-class place. There were three things they didn't want you to do. First, smoking: you could smoke in the lobby, but you were not allowed to smoke in the auditorium. The second thing that they would get very upset about was chewing gum. It was the bane of their existence. They'd also tell you, "Don't talk loudly." Compared to the Uptown, I guess you could say that the Crest was not only bigger, it was also more in the center of Jewish life.

David R. Blumberg, chair, Maryland Parole Commission

EDMONDSON VILLAGE
1949–1974, 1980–1981

4428 Edmondson Avenue
ORIGINAL SEATING CAPACITY: 1,205
ARCHITECT: Kenneth Cameron Miller

The Edmondson Village became Baltimore's top-grossing neighborhood theater during the 1950s. As one of the first theaters incorporated into a major shopping center, the Edmondson Village marked a turning point in movie exhibition. The theater opened in 1949 on the Edmondson Village Shopping Center's second anniversary, with Bing Crosby in *A Connecticut Yankee in King Arthur's Court*.

Ads boasted of "acres of parking" at Baltimore's first large, modern shopping center, which had a Hochschild-Kohn department store, Food Fair, Tommy Tucker five-and-dime, and many specialty shops. Later in the summer of 1949, after the theater had opened, a fourteen-lane bowling center and "Dugout" snack bar were added in the basement.

Movie attendance in Baltimore peaked shortly after World War II and began to decline in the 1950s. The Edmondson Village was one of the theaters that tried to counter the lure of television by showing championship fights and the Indianapolis 500 via satellite.

In the 1960s, the suburban exodus was in full swing. Predatory housing practices accelerated the transition of the Edmondson Village area to a predominantly African American community. The Westview Cinema, in a new 1965 shopping center located next to Baltimore County's Edmondson Drive-In, expanded from one to ten screens. Westview pulled in the same patrons who had abandoned the main street neighborhood houses to flock to Edmondson Village.

The Edmondson Village, run by JF Theaters after 1967, remained open until 1974. By then the shopping center had become run-down. The theater reopened briefly as a 99-cent house, with gimmicks like midnight shows, in 1980 and 1981. It sat vacant for many years, but now houses a medical office and two carryout restaurants.

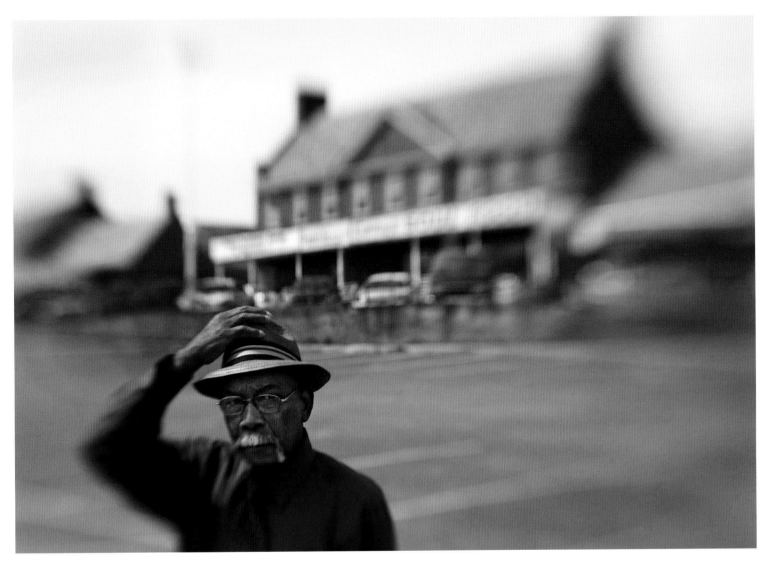

4428 Edmondson Avenue, 2014. Laurence Cross. *Opposite:* Edmondson Village Theater, 1953. Courtesy of the Robert K. Headley Theatre Collection.

The Edmondson Village was a beautiful theater, with a ticket counter, not a booth, inside the lobby. The theater was plain, but quite luxurious. The auditorium had a very good incline, very wide, with concealed lighting on either side of the ceiling. The color scheme of the lighting changed; it was pink and rosy between the films, and during the movie, it was blue-green and more dim.

Women would come in with their shopping, so they had a deep freezer where you could leave your frozen food and claim it after the movie. A lot of people in Catonsville stopped going downtown when this center was built.

Bob Gist, retired English teacher, Baltimore Opera costume supervisor, and Hippodrome docent

Edmondson Village gave you free cigarettes. You couldn't smoke in the auditorium, but you could smoke in the lounge. They had big sofas and chairs, and there were little tables with dispensers for loose cigarettes. We used to steal the cigarettes. Adults were supposed to take one to smoke, but we were grabbing them to put in our pockets. I was in my early teens. At the end I was smoking three packs a day, before I quit.

Michael Clark, retired restaurant manager

Edmondson Village Shopping Center looms large in my childhood. As a little kid, I would beg to go over there because it was just so pleasant. The whole place was geared to baby boomers, though there was not a name for that generation yet.

The aesthetic of Colonial Williamsburg was very popular at that time. It found its way into this wonderful new model of a suburban shopping center geared to the automobile. You don't find this in later suburban designs outside the city. They were more modern. This was on the edge of suburbia, and reflected a more traditional colonial America fantasy.

The whole family would go to the movies there, and my most vivid memory was Mary Poppins. We came out with umbrellas, singing and trying to fly. In junior high school I saw The Graduate with a girlfriend and we felt really grown up.

It was quite sad to see a place that was so rich with pleasant experiences decline. Change is inherent in everything. Edmondson Village hasn't completely fallen apart. It's just sort of hanging in there. It's no longer a destination, so all you are left with are fond memories, formative memories.

Kathleen G. Kotarba, historic preservationist and artist

1950

2017

"If you look in this place tomorrow, and it's gone, you mustn't be sad, because you know it still exists, not very far away."

Rima the Bird Girl (Audrey Hepburn), from *Green Mansions* (1959)
Mel Ferrer, director

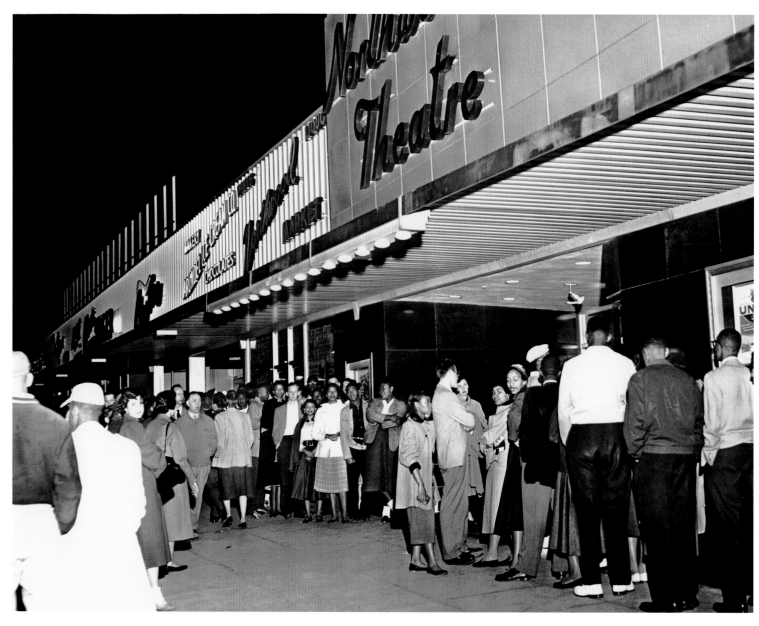

Northwood Theater, 1955. About 150 students, mostly from Morgan State College, are denied entrance to the Northwood on April 29, 1955, in a challenge to segregation laws. Courtesy of *The Baltimore Sun.*

NORTHWOOD
1950–1976, 1980–1981

1572 Havenwood Road
ORIGINAL SEATING CAPACITY: 1,144
ARCHITECT: Fred Dixon

If the Northwood Theater hadn't been located near the campus of Morgan State University, it would be notable only as another early example of a theater melded into a strip mall. The postwar Northwood Shopping Center, touting free parking for 1,000 cars, drew customers from well beyond the surrounding neighborhoods. To cater to shoppers, the Northwood Theater offered lockers for parcels and refrigeration for purchases from the center's two supermarkets, Acme and Food Fair. These conveniences may have pulled in as many patrons as the attractive "ultramodern" interior or the large, state-of-the-art Cycloramic screen, which promised a brighter picture from every seat in the house.

What makes the Northwood Theater worthy of a historic marker is its role in the civil rights movement in Baltimore. Morgan students, under an umbrella organization called the Civic Interest Group, targeted the Northwood in their campaign to end segregation in Baltimore theaters. The intense picketing culminated in mass arrests of students in 1963. This was not the first instance of mass arrests as a deliberate tactic, but its sustained use on a large scale proved its effectiveness as a strategy. The public stir it caused led to the desegregation of all theaters in Baltimore.

The Morgan community, once the unwelcome outsider at Northwood, is now the shopping center's most significant anchor. In 2015 the Morgan Business Center replaced the original 1954 Hecht's department store, just a stone's throw from the vacant theater.

1572 Havenwood Road, 2013.

Posted at the Northwood in February, 1963:

"Until the Motion Picture Theatre Owners of Maryland, of which this theater is a member, and the courts of Maryland advise otherwise, this theater reserves the exclusive right to select its patronage." A second sign added, "Please refrain from any activity that might require police action."

The desegregation of the Northwood Theater was an eight-year struggle. Protest started in 1955, and it wasn't until February 22, 1963, that the first African American students from Morgan State College were able to buy tickets. A Disney movie, In Search of the Castaways, *was playing.*

Morgan students had been picketing the Northwood Theater regularly, joined by students from Goucher, Hopkins, and Coppin State. Other businesses at the Northwood Shopping Center had been desegregated, but the theater remained a holdout. Starting on February 15, 1963, the students added a new tactic: mass arrest. In a span of six days, over 400 students were arrested for the simple act of asking to buy a movie ticket. The Baltimore City Jail was overflowing with students, crowded three to four to a cell. The pressure increased on city and jail officials.

The picketing at Northwood led to the desegregation of the downtown theaters first. There was a downtown theaters association. They all approved desegregation of their theaters. At the same time Ford's Theater ended its segregated seating policy. Up until then, blacks could only sit in the second balcony. Picketing at Ford's had started in 1947. The imprisoned students were released on February 21, 1963. Baltimore's Mayor Goodman pressured the owner of the Northwood to desegregate. It was the finale. Baltimore passed the 1963 Public Accommodations Act, and all this ended with the 1964 Civil Rights Act.

Larry S. Gibson, professor, University of Maryland School of Law

We queued up. We were told we were trespassing. At that point we were escorted to a waiting wagon by the Baltimore police and transported to the Northeast police station. I remember spending the night in jail behind bars.

The next morning we were given a quick hearing and were charged with trespassing and disorderly conduct. We were not disorderly. There were no nightsticks involved. At twenty I was not scared of anybody, not nervous. We were loaded into buses and transported to Baltimore City Jail. $600 was the bail set [for each of us].

So we arrived en masse at the lockup downtown. We were incarcerated. What really sticks in my mind was the terrible hamburger meat we were served. There was camaraderie; it was like a rite of passage. Some kids made up decks of cards. They segregated the male and female population. Monday night, we arrived. Tuesday morning was the hearing, then that morning we were transported to Baltimore City Jail. We got out Thursday evening.

They had resolved the legal issues. Northwood had capitulated to our demands. There was some amount of satisfaction. Segregation was wrong. I'm proud of my very small role; that small role added up to a change. Our country has come a very long way.

Marvin Redd Sr., retired human resources professional, NSA

I went to work for Joe Grant in 1960-something. Grant had leased and built the Northwood. Morgan was about two blocks from the theater. A Morgan college group wanted to get into the Northwood and Grant said, "No." I told him, "This is silly."

I didn't know why he wouldn't let it go. They're people. Washington, DC, and Philly had black theaters, but blacks could go to white theaters. Baltimore, like Richmond, still had segregation. The owners thought their business would go downhill. I thought, "You are going to get hurt, but time will heal everything."

So many people tried to get in. They were locked up. They ran out of places to put them. Every day they were trying to get in. I was the manager. I was nervous about the big glass doors. I was there day and night, locked in. People brought me food through the rear door.

We kept it open. The real racists of the day would show up every day, buy tickets, and walk away, with words of encouragement. It was still a racist city in those days. One of Joe Grant's brothers said, "Let's give in." But Joe refused. Bobby Kennedy called one of the brothers. That stopped it. And the whole city began integrating theaters.

Aaron Seidler, retired film buyer/booker and theater manager

I'd just come from a sociology class. "Hey, they are arresting students!" The demonstration had been going on for a couple of days. As students at Morgan we felt that we should be able to go to the theater at the shopping center we were patronizing anyway. Curtis Smothers, one of the coordinators of sit-ins at the Northwood Theater, was in need of students to come out and participate.

I'd been thinking about going. I think we were told we could possibly be arrested. Then I decided I had no choice morally but to do it. In the South people were risking their lives just to be able to vote and go to school. What we were doing was just asking for some of the human decencies. Why can't we go here?

We just stood in line at the ticket box office and they wouldn't sell us tickets. So we just stood there. This meant that the regular customers didn't show up either, because they didn't want to get involved with trouble or they were empathetic. It must have affected business. We were told that we were trespassing, so if you didn't step out of line, you would be arrested. They didn't have enough handcuffs for everybody. They took us away to the City Jail. We were prepared to go to jail, for whatever length of time it took.

We were there four days. It was crowded, but they kept us separated from the prisoners on a separate tier. I do remember some of the hardened criminals looking down and saying, "Send those Morgan boys up here."

Richard E. Timmons, retired Eastern Airlines executive

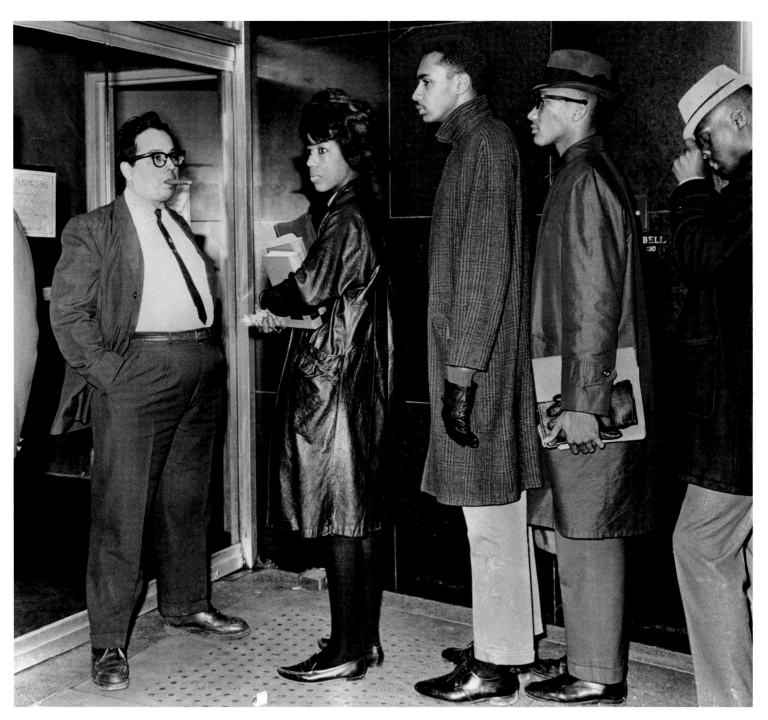

Assistant manager Israel Batista-Olivieri blocks the entrance as Morgan State College students, from left, Latifah Lois Chinnery, Marvin Redd, and Richard E. Timmons attempt to buy tickets at the Northwood on February 18, 1963. Photo by William L. LaForce Jr. Courtesy of *The Baltimore Sun*.

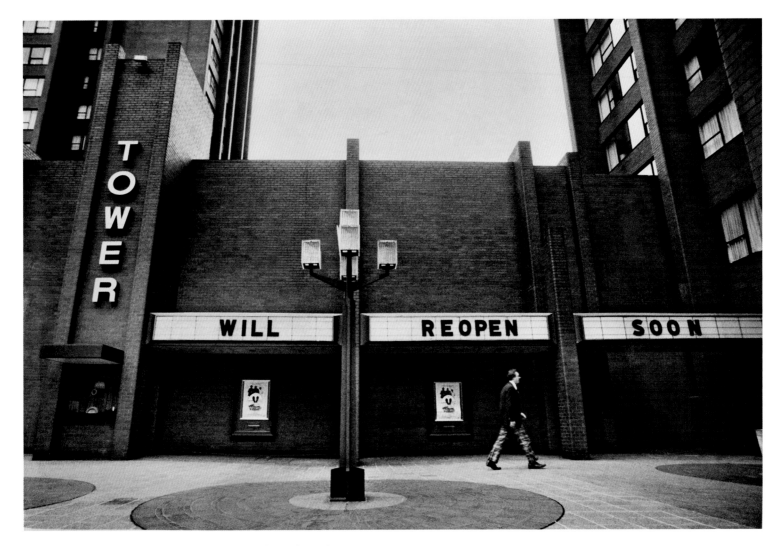

Tower Theater, 1978. Photo by Jed Kirschbaum. Courtesy of *The Baltimore Sun*.

TOWER
1967–1977, 1981

222 North Charles Street
ORIGINAL SEATING CAPACITY: 605
ARCHITECT: unknown

The $500,000 Tower was trumpeted in 1967 as a symbol of rebirth for the city. It was the first theater to open downtown since the Town, two decades earlier. The compact cinema opened with fanfare as part of the 33-acre Charles Center redevelopment, but it never attracted crowds. Set back from North Charles Street at the base of a pair of residential high-rises at 2 Charles Center, the Tower lacked visibility. It was a flop.

JF Theaters, which developed the Tower, operated all of the major downtown theaters at this time. In newspaper interviews, the owner, Jack Fruchtman, cited several reasons for its failure. Predictions of residential apartment construction downtown never materialized. Film distributors demanded certain guarantees that favored suburban locations over the Tower. The 1968 riots didn't help.

The Tower lasted a mere decade. By 1978 JF Theaters had filed for bankruptcy protection. Another exhibitor, Charles Productions, reopened the cinema briefly in 1981. The Tower was shuttered again until the late 1980s, when it was reconfigured into a 222-seat auditorium for the Johns Hopkins University Downtown Center. When Charles Towers was renovated, the former theater disappeared.

The Tower was like a white elephant. When I was booking films for JF Theaters, Warner Bros. came to us and gave us the chance to play The Exorcist *exclusively in Baltimore for a $100,000 guarantee. Jack Fruchtman asked me where we should play it. I said, "The Tower." Fruchtman said, "If you are wrong, this might cost you your job." They were lined up on Charles Plaza and Charles Street, and we sold out every show, every seat.* The Exorcist *ran about twenty-two weeks, and we did over a half-million dollars, easy, with that movie. That was the only movie we made money with at the Tower.*

The week before, on a cold winter night, I watched it alone in our small screening room in the Charles Center. I never saw special effects like that. It scared me to death. I started climbing over the seats, trying to get out of there. The manager, Roy Adams, heard screaming and came to see if I was all right. He said, "I've never heard anyone scream like that."

The Tower never worked. We could never find the right picture. A lot of times we would get exclusive films, like Emmanuelle. *The rent was so high we could never make any money. We tried everything.*

Ira Miller, Horizon Cinemas theater owner

For many years, my father, Donald, a founder of the mighty law firm Gordon, Feinblatt and Rothman, represented the irrepressible movie exhibitor Jack Fruchtman. More than the modest fees he earned and the kick of arguing before the hidebound Maryland Censor Board, Dad loved the free pass card Jack gave him. It made him feel like a Hollywood big shot, and he would occasionally, with great ceremony, offer it to his kids as we ventured out into the Baltimore night.

One such night in 1974, my older brother, John, who I worshiped because he was cool and I was not, was gifted the magic card and with it took me to the Tower Theater. On the outside, nothing about the Tower's functionalist architecture spoke of romance. But inside, we watched Brian De Palma's rock opera Phantom of the Paradise, *a film that perished in obscurity then, but lives large in cult glory now. Early in the film, a girl appears, the debut of a young actress named Jessica Harper. She is breathtaking and sings like an angel. The Phantom falls immediately in love and now, four decades and a continent away, I remember with perfect clarity, I did likewise.*

I was nineteen. It took me fifteen years, but in 1989, I married that very girl. We just had our twenty-fifth anniversary. We have two grown daughters who look like their mother, one more beautiful than the next. My dad, Jack, and the Tower are all gone, but the romance of film never dies.

Tom Rothman, chairman, Sony Pictures Motion Picture Group

222 North Charles Street, 2013. Renee Sydnor-Henry.

Movies at Harbor Park, c. 1985. Photo by Anne Gummerson.

MOVIES AT HARBOR PARK

1985–2000

55 Market Place

ORIGINAL SEATING CAPACITY: 2,250

ARCHITECT: Land Design / Research, Inc.

United Artists Communications, the largest national theater chain, gambled on Baltimore for its first urban location in 1985. Harborplace, the tourist magnet built in 1980, spurred their interest. The UA deal was clinched when the city promised discounted parking to attract suburban patrons to the $3 million theater complex situated below a six-floor parking garage.

Movies at Harbor Park played mainstream, big-budget Hollywood fare. A 35-foot mural of Baltimore scenes by Raoul Middleman was the most memorable feature in the bland brick and terra cotta tile lobby. The nine shoebox theaters, seating about 250 patrons each, had 30-foot-wide, wall-to-wall screens. Alcoholic beverages were sold—a first for a Baltimore city theater—although they couldn't be taken into the auditoriums.

Ultimately Harbor Park appealed more to inner city residents than suburbanites who could park for free at shopping mall theaters. The drug trade, which escalated in the late 1980s, found its way into Harbor Park. Once there seemed to be more action off the screen, middle-class patrons vanished.

By March 2000, when Harbor Park folded, there were six city theaters left. One, the Reisterstown Road Plaza 5 Star Cinema, a 1985 seven-plex in northwest Baltimore, closed three months after Harbor Park. Two of the hangers-on were X-rated houses, the Apex and the Earle. This meant that Baltimore City was down to three general-audience theaters: the Charles, the Senator, and the Rotunda twin cinema.

Harbor Park was taken over by Baltimore City Community College. It closed just before the uptick in waterfront residential development beyond the Inner Harbor. A seven-screen Landmark Theater arrived in trendy Harbor East in 2007, less than a decade after the nine screens of Harbor Park, a half-mile to the west, went dark.

I moved here in 1985 to open the Movies at Harbor Park. Having a nine-plex was pretty big then. We tried different things to make it upscale, attractive to tourists. They had to change the marketing over to movies like Beverly Hills Cop II.

I realized I wasn't running a theater. I was running some kind of arena. I remember one Sunday afternoon I had nine crying babies in an R-rated film in Theater No. 8. I couldn't hear the movie. I had a lot of battles and complaints about talking during the films.

Whoopi Goldberg was in town in 1987, filming Clara's Heart. We were showing the film Burglar, which she was also in. Her people came by and told us they wanted to bring Whoopi Goldberg in. They asked, "Can you save a couple of rows? We want to cause as little disruption as possible, maybe bring her in by a side door." I told them, "Once the previews start and the house lights are dimmed, we'll go into the back rows and she can slip in. No big deal."

I knew that everyone was going to be screaming in there. I thought to myself, I've got to be able to keep this crowd quiet. I was so worried. So when I went out to meet her, I said, "I will tell you that my audiences here have a lot of rollicking fun. We really need an actor of your caliber to prepare an etiquette trailer." Whoopi Goldberg says, "That's a really good idea."

I stood in the back. There was only one person who talked. Whoopi. She talked through the entire movie, commenting about herself. Everyone was quiet, wanting to hear her. After that, I just gave up. I came to the conclusion, who's to say that's not the right way to enjoy the film?

Doug Murdoch, executive director, Mid-Atlantic National Association of Theatre Owners

Yeah, we've always talked in theaters. My white friend would say to me, "Why are you all talking and yelling at the screen?" Because we don't get it: we never understood why the white characters in films were so slow when something like Frankenstein would be trying to catch you. Black folks, because of our socioeconomic experience, would say, "RUN!"

Michael Eugene Johnson, executive director, Paul Robeson Institute for Social Justice

55 Market Place, 2013.

Orpheum Theater, 1991. Photo by Herbert Harwood. Courtesy of the Theatre Historical Society of America.

ORPHEUM

1990–1999

1724 Thames Street
ORIGINAL SEATING CAPACITY: 90
ARCHITECT: unknown

"I am big. It's the pictures that got small." How fitting that Norma Desmond's defiant diatribe from *Sunset Boulevard* was part of the opening triple bill at the Orpheum, the intimate repertory cinema in Fell's Point. Jean Cocteau's *Orpheus* and Fellini's *Roma* also played on November 9, 1990, for the bargain price of $4.50. For a decade, movie buffs came to see what George Figgs, the high priest of celluloid, was offering at his tiny temple of film. They became cinephiles just by absorbing the eclectic mix that spanned the history of flicks. The cozy waterfront movie house was small, but the films were big.

As you climbed the stairs, the smell of coffee and popcorn wafted down. A Deco rug, comfy chairs, and movie books filled the colorful lobby. A gentle ticket seller cautioned a couple before selling them tickets to Todd Solondz's *Happiness*, a very bleak film: "Are you sure you are ready to see this?" The Orpheum developed a loyal following, but was forced to close in 1999 when the landlord donated the building. It's now the Fell's Point Visitor Center.

The Orpheum was never profitable, but that wasn't the point. Figgs wanted everyone to abandon their televisions and be enveloped by the film experience in a communal setting. As film viewing has shrunk from television to laptop to cell phone, his vision remains prescient. With the evanescent Orpheum, our survey of flickering treasures is complete. George Figgs's little cinema paid homage not only to incomparable films, but also to those first storefront nickelodeons that brought the magic of movies to new audiences a century ago.

The Orpheum was a direct response to my longing to give people the movie theater experience. The name Orpheum comes from Orpheus, the god of music and poetry, and Lyceum, the Greek name for theater. We got a group of investors and put the Orpheum together for 50 grand.

The building had been a car barn for horse-drawn omnibuses. The mules went up a great big ramp that ended where our lobby was. It just worked out serendipitously that each stall was an aisle, so where you were watching the movie was where the mules had been. Blaze Starr sold us eighty seats from the old Clover Theater on Baltimore Street. They were filigreed wrought iron, wool mohair seats, all pitched differently for the tilted floor.

The most expensive item was the $20,000 Elmo Super 16 projector. It was rear projection, because I had to build the theater into the low-ceilinged space. We needed a special periscopic rear projection lens that makes an extreme right angle. Inside is an optically ground prism that turns the image upside down and backwards and shoots it out. You have to be exactly 16 feet from the screen. The rear projection was reality. The people in the theater were the actors.

The size of the translucent rear projection screen was exactly the size of my old nabe, the Ideal, 15 × 20 feet. At that distance and at that resolution, it looks like 35mm. The edges were perfect. The color was beautiful. The black and white was luminescent.

I would ride to the library and bring back five or six films, about twenty pounds each, strapped to my bike. I showed newsreels, cartoons, and serials that I tried to get from the decade that the film was made. In those days, they were starting to make blockbusters that were pushing decent films off the screen early. I would snap them up when they came off regular screen, but before they went on tape. At the time there was no Netflix, but I had stiff competition from video rentals.

I ran Children of Paradise and The Dead around Christmas time. My double features always had something to do with one another that wasn't immediately apparent. One of my most successful pairings was Saturday Night Fever and Shaft. Every year we did a Bogart double feature like The Maltese Falcon and Casablanca. I could hear people repeating the lines, and it was as if they were in a bubble, suspended in time. Everybody laughed and cried at the right time. At the end I was in tears.

George Figgs, artist, film historian, and former operator of the Orpheum Cinema

"Just waiting for you!" That's what George Figgs said on my first visit in 1995, after I rushed up the stairs asking if the 2 p.m. Sunday matinee had already started. I had just returned to Baltimore after four years and discovered the Orpheum, very close to the house I had moved into the previous day. George's enthusiastic response assured me that, although my belongings were in that nearby house, the Orpheum was destined to become my new home.

Everything about the Orpheum appealed to me. I was a film student at the University of Maryland, and the Orpheum's quirky, 16mm rear projection setup was a throwback to an era of independent art house exhibition that was vanishing with the advent of digital cinema in the 1990s. Of course, not everyone shared George's cinematic sensibilities. I remember arriving for an Andrei Tarkovsky double feature in April 1996; I was the only person there. George said, "You really ought to work here." I began working as a projectionist the following week.

Along with another projectionist, Rebecca Leamon, I did everything I could to keep the Orpheum afloat during the next three years. Sometimes we'd spend hours repairing damaged frames and splicing them back together. By the late '90s, many films were available on DVD, without the sprocket damage and focus issues we often had. In May of '99, the Orpheum went out of business. Rebecca and I, however, have been together ever since. During a crucial point in our lives, the Orpheum was our refuge. I think there are probably a lot more like us who will always cherish its memory.

Joseph Christopher Schaub, professor of media studies,
Notre Dame of Maryland University

1724 Thames Street, 2013. George Figgs, the high priest of celluloid, revisits the site of his repertory cinema.

I set out to examine the past, aided by beautiful, wistful words and images from others, as a way to decipher the puzzle of neglect and decay that my camera has captured over the past eight years. We celebrate our assets, as a few of our theaters are resuscitated, but the balance sheet is still dishearteningly negative. The dissonance we find in the stark contrast between the early and recent photographs raises uncomfortable and complex questions. The legacy of race relations, an intractable issue in our society, cuts through this book as piercingly as the projected mote-filled beam of light from the operator's booth.

Baltimore, a notoriously provincial town, proudly proclaims itself "a city of neighborhoods." Our roots shape our identity and enhance our sense of belonging. Most Baltimoreans feel attachment only to a particular part of town, their own turf. This brings support to pockets of the city, but such an insular perspective has its downside. Not every neighborhood has the same resources. Ethnic and racial groups have always created their own boundaries. Ask someone from South Baltimore about the northwest side of town, a span of perhaps seven miles, and you might as well be asking about Pennsylvania. If you inquire about a neighborhood movie house outside of a Baltimorean's own stomping grounds, chances are you will get a blank look.

The tendency not to venture beyond what seems familiar—and safe—is understandable. We seem unable to cast a broader net, to identify the entire patchwork of the city as ours. Until its residents feel ownership of the city in its entirety, mending the frayed fabric of worn sections of Baltimore will be a daunting endeavor. Our once-cherished theaters, mostly found on streets that have unraveled, won't get mended.

At one time, each of the theaters portrayed in these pages was a vital communal anchor on a lively commercial corridor. Yet most of the surviving theater buildings will never again beckon us inside to enjoy films. About two dozen of the former theaters portrayed in this book contribute to the spiritual life of the community as churches. Others, especially the decrepit movie houses surrounded by equally rundown buildings, are not appealing prospects for reinvestment.

Even theater shells can spur neighborhood revitalization, with some imagination and financial support. My fiscal sponsor, Creative Alliance, a vigorous nonprofit arts organization housed in the former Patterson Theater, serves this function for East Baltimore. The reinvention of the Centre into a hub for education, community development, and the arts has encouraged further investment in the Station North Arts and Entertainment District. The ravaged Ambassador and dismantled Mayfair have strong architectural bones and offer great potential in districts already stirring with promise. A few other theaters currently underutilized are the Capitol, Harlem, Irvington, Lenox, and Lord Baltimore on the west side, and the Apollo, Arcade, and Ritz on the east. They deserve a closer look.

Economic gain can't be the sole objective for the reuse of our derelict theaters. Rather, it must be the long-term reward for societal investments that fix broken buildings and broken spirits. I hope *Flickering Treasures* will spark a dialogue about how we can transform more of our forgotten theaters into catalysts for building thriving communities. In the movie version of the musical *Man of La Mancha*, based on Cervantes' *Don Quixote*, Peter O'Toole declares, "To surrender dreams—this may be madness; to seek treasure where there is only trash. Too much sanity may be madness! But maddest of all—to see life as it is and not as it should be."

ACKNOWLEDGMENTS

The film ends. As moviegoers stumble toward the exits, I stay, mesmerized by the endless stream of names in the scrolling credits. A book is an extremely modest effort by comparison, yet the cast involved in bringing this volume to fruition is very large. *Flickering Treasures* belongs to the hundreds of good-hearted people who gave me stories and suggestions, financial support, photographs, mementos, and enthusiasm during the past eight-plus years. This book is theirs as much as mine.

I am so thankful to everyone who shared their vivid memories and for the welcome afforded me at the retirement communities and senior centers where I discovered many of these voices. Regrettably, due to space limitations, it is impossible to acknowledge each storyteller. Every person who recounted their experiences, whether recognized specifically in these pages or not, has my deep gratitude for illuminating this subject.

Barry Levinson's delightful foreword captures the joy of movies and the unexpected but profound ways they can shape your life. Levinson also shared memories of his first movie date. I am honored to have these reflections from the renowned filmmaker whose Baltimore series helped inspire this book. John Waters, whose films pay homage to many Baltimore theaters, happily came through with a reminiscence that is a tad less respectable than the rest.

The first Baltimoreans who spurred me on to create this book were the readers who responded to my 2008 *Baltimore Sun* photo essay on forgotten movie houses. Letters written in feathery penmanship poured in, recounting favorite theaters and chiding me on the omissions. Chris Kaltenbach, who wrote the accompanying article, offered unflagging encouragement, as did colleagues Jacques Kelly and Fred Rasmussen. Working with so many talented *Sun* writers, editors, and photographers taught me many skills that I put to use in this book. The *Sun*'s editors kindly accommodated my request for some months of leave.

My indebtedness to the body of work created by theater historian Robert K. Headley is acknowledged in the Notes on Research. From the beginning, Bob Headley was extraordinarily gracious about sharing his collection of rare photographs, offering research tips, and answering my never-ending questions. Bob began as my mentor, but he became a cherished friend. He spent considerable time making new digital scans of his own photographs, some of which have been published here for the first time. Bob also patiently read the original 100,000-word manuscript.

His numerous suggestions greatly improved the text and saved me from a number of glaring mistakes.

Three dear friends, Gloria Bonelli, Lillian Bowers, and Joan Jacobson, provided steady encouragement. Joan also read early drafts and the final manuscript and could always be depended upon for solid guidance. Gregg Wilhelm, founder of CityLit Project, supplied sage advice at various stages. Artist-designer Nancy Van Meter selflessly gave her time and talents to designing a prototype of the book for early credibility. Valuable insights came from graphic designer Ellen Lupton, Lauren Schiszik and Eric Holcomb of the Baltimore City Commission for Historical and Architectural Preservation (CHAP), and Station North cheerleader-restaurateur Kevin Brown. Jed Dietz and the Maryland Film Festival staff aided this project by providing access and information.

I sought letters of support for a research fellowship at the Theatre Historical Society of America, as well as for various grants and reviews. These were graciously proffered by Bob Headley; David Haberstich, Curator of Photography, the National Museum of American History; architect Hugh Hardy; Fran Holden, formerly of the League of Historic American Theatres; and Johns Hopkins, executive director of Baltimore Heritage.

The Creative Alliance played a pivotal role as my fiscal sponsor, enabling me to raise the funds needed for publication. This dynamic organization, based in the former Patterson Theater, has been the ideal partner. I am fortunate that director Margaret Footner and her energetic staff welcomed me into their fold.

Producing a fine quality book of color photography is a costly endeavor. The Robert W. Deutsch Foundation, led by the visionary Jane Brown, was an early patron and donated considerable matching funds at a critical fundraising juncture. Wendy Jachman, Elizabeth K. Moser, and Scott Plank, local philanthropists who are devoted to Baltimore and imbued with creativity, each bestowed significant support. More than one hunded additional supporters expressed confidence in the volume with donations, keeping my spirits aloft and making this book possible.

Many owners, tenants, caretakers, and neighbors of former theaters were very obliging in granting me access to theater interiors or views from nearby windows or rooftops. Patient help in this regard was given by Lorian Coombs, Robert Hayes, Chuck Kaczorowski, Andres F. Londoño, Joy Martin, Alan Shecter, Elissa Strati, and Dominic Wiker, as well as the Acme Ladder & Equipment Company, Arch

Social Club, Baltimore Boxing Club, Key Technologies, Inc., and Ziger/Snead Architects. Numerous pastors welcomed me warmly into their churches, and two of these, Bishop Marcus A. Johnson of New Harvest Ministries (Roxy) and Bishop Clarence Weston of the Redeemed Church of Christ Apostolic (Harford), are documented in this book with their flocks. Reverend Alex O. Stone of the Olivet Baptist Church (Edgewood), outreach pastors Josie and Ray Wilke of The Church on the Boulevard (Lord Calvert), Pastor Marline Francis of the Baltimore Tabernacle of Prayer (Apollo), and the staff of the Bethel World Outreach Church (Arcade) were especially cooperative.

Other important participants were my subjects, who accidentally nabbed starring roles in the photographs when they walked in front of my camera. In every neighborhood I was reminded that Baltimore is filled with good and courteous people. Countless drivers cheerfully gave up perfect parking spaces after I dashed across the street to ask them to find another spot that didn't block my vantage point. Doing so required me to abandon my tripod-mounted camera, but it never disappeared while my back was turned.

When I began this project, I didn't realize how many wonderful friendships I would gain along the way. Movie theater insiders Ira Miller, Aaron Seidler, Don Walls, George Figgs, and Dominic Wagner were patient teachers. Dick Smith and Roy Wagner introduced me to the grand world of theater organs. The passion of Bob Adams, James Crockett, Herman Heyn, Denny Lynch, Camay Calloway Murphy, Greg Otto, Thomas Paul, Wayne Schaumburg, Donna Beth Joy Shapiro, Marc Sober, and Mark Walker for this topic continues to be invigorating.

Locally, a dozen gifted photographer friends who meet regularly in a group called Fotofocus have broadened my creative outlook. Other influences for this book are too numerous to list, but the work of four photographers was already imprinted in my mind's eye when I began to survey Baltimore's theaters. Walker Evans made me realize how much the examination of the constructed environment tells us about the human condition in a given time period. I can't claim to own Baltimore the way Evans owns the Depression, or the great Eugène Atget possesses vanished Paris, but I hope the patina of time will add to the resonance of my images. I tip my tripod to all of the photographers whose vintage images in this volume have achieved that quality.

Clarence John Laughlin's photographs convey a potent mix of lost worlds and the vicissitudes of time that I have attempted to explore through the metaphor of movie houses. Plantations and movie palaces became as unsustainable as the dubious romantic notions they perpetuated. More recently, the work of Camilo José Vergara relentlessly examines urban change and its impact on communities. His books, such as The New American Ghetto, gave me a sense of urgency about photographing Baltimore's streets.

Knowing that the staff at Full Circle Ltd. would consistently deliver superb results for all my imaging and framing needs was the security blanket that every photographer requires. Brian Miller's impressive digital skills and sensitivity to the nuances of each image made the photographs sing.

The talented people who polished the final product deserve particular recognition. Alan Finder, a former New York Times editor and reporter whom I am lucky to count as a longtime friend, used his superb editing skills to judiciously trim and deftly recast the text. Robert J. Brugger, editor emeritus, and Elizabeth Demers, senior acquisitions editor at Johns Hopkins University Press, expertly guided me through the early stages. Hilary S. Jacqmin, associate production editor, and managing editor Juliana McCarthy meticulously shaped the final product.

The design concept and layout of gifted book designer Maia Wright far exceeded my expectations. John Cronin, the dedicated design and production manager at JHU Press, and Martha Sewall, the Press's art director, shepherded the book and an anxious author through every stage with infinite patience.

Finally, my deepest thanks go to my family. My daughter and son, Julie and Paul Cronan, cheered me on every step of the way. Paul also designed preliminary pages to help me visualize the layout. The stunning map and timeline graphic are the creation of my husband, Bob Cronan, courtesy of his company, Lucidity Information Design, LLC. However, my profound gratitude goes beyond his terrific design talent. Bob's love, amazing patience, and unwavering faith in our partnership have made possible everything good in my life, including this book.

. . .

**WITH GRATITUDE TO THE SPONSORS
OF *FLICKERING TREASURES***

You are holding this book because more than one hundred donors enthusiastically embraced it as a celebration of Baltimore and its moviegoing past. Their generous financial contributions have made this book possible. Every check, large or small, was an affirmation that this project was worth pursuing. I deeply regret that space does not permit recognition here of every sponsor, but please know that I offer my most heartfelt thanks to each of you.

Stanley Club
Robert W. Deutsch Foundation
Moser Family Philanthropic Fund
War Horse, LLC

Royal Club
ACE Theatrical Group, LLC
Anonymous
Gable
Lensbaby
Ruth R. Marder
Families of Edward, Julius, Sidney, and Harry Myerberg

Grand Club
Barbara Blom and Susan Rosebery
Shoshana Shoubin Cardin
Susan E. Davis and Miles Gerstein
Charles Duff
The Marion Tunick Marcus Family
Nancy and Morris W. Offit
Jean and Sidney Silber
The Toby and Melvin Weinman Foundation

Lincoln Club
David, Donna, and Alena Anderson
Anonymous
Andrew and David R. Blumberg
Evelyn Weil Browne and Bill Browne
Cardinal Sound and Motion Picture Systems, Inc.
Richard A. Davis and Edith Wolpoff-Davis
Esther and Brian Finglass
Gina and Dan Hirschhorn
Kaczorowski Family
Key Technologies, Inc.
Victor J. Lancelotta
Robert E. Meyerhoff and Rheda Becker
Sayra and Neil Meyerhoff
David B. Shapiro
Joanne, Alan, and Michael Shecter
Edgar and Betty R. Sweren
T. Rowe Price Foundation
Transdev North America, Inc.

1 **Aldine** (Pictorial) – 3310 E Baltimore St
2 **Ambassador** – 4604 Liberty Heights Ave*
3 **Apex** – 110 S Broadway*
4 **Apollo** – 1500 Harford Ave*
5 **Arcade** – 5436 Harford Rd*
6 **Astor** (Poplar) – 613 Poplar Grove St*
7 **Aurora** (7 East) – 7 E North Ave*
8 **Boulevard** – 3302 Greenmount Ave*
9 **Bridge** – 2100 Edmondson Ave*
10 **Broadway** – 509 S Broadway*
11 **Brooklyn** – 3730 S Hanover St*
12 **Capitol** – 1518 W Baltimore St*
13 **Carlton** – 1201 Dundalk Ave*
14 **Centre** – 10 E North Ave*
15 **Century** – 18 W Lexington St
16 **Charles** (Times) – 1711 N Charles St*
17 **CinéBistro** – 711 W 40 St[2]
18 **Creative Alliance** (Patterson) – 3134 Eastern Ave*
19 **Crest** – 5425 Reisterstown Rd*
20 **Deluxe** (Flag) – 1318 E Fort Ave*
21 **Earle** – 4847 Belair Rd*
22 **Edgewood** – 3500 Edmondson Ave*
23 **Edmondson Village** – 4428 Edmondson Ave*
24 **Electric Park** – Belvedere Ave
25 **Everyman** (Empire/Palace/Town) – 315 W Fayette St*
26 **Forest** – 3306 Garrison Blvd*
27 **Fulton** (Gertrude McCoy) – 1563 N Fulton Ave
28 **Gayety** – 405 E Baltimore St*
29 **Goldfield** (Argonne) – 924 S Sharp St
30 **Grand** – 511 S Conkling St
31 **Harford** – 2616 Harford Rd*
32 **Harlem** – 614 N Gilmor St*
33 **Hippodrome** – 12 N Eutaw St*
34 **Horn** – 2016 W Pratt St*
35 **Howard** (New Pickwick) – 113 N Howard St*
36 **Ideal** – 905 W 36th St*
37 **Irvington** – 4113 Frederick Ave*
38 **Keith's** (Garden/Keith-Albee) – 114 W Lexington St*

39 **Landmark Harbor East** – 645 S President St[2]
40 **Linden** (Cinema/Capri/Sutton) – 910 W North Ave*
41 **Lord Baltimore** – 1110 W Baltimore St*
42 **Lord Calvert** – 2444 Washington Blvd*
43 **Mayfair** (Auditorium) – 508 N Howard St*
44 **McHenry** – 1032 Light St*
45 **Metropolitan** – 1524–1530 W North Ave
46 **Movies at Harbor Park** – 55 Market Pl
47 **Nemo** (Takoma/East) – 4815 Eastern Ave*
48 **New** – 210 W Lexington St
49 **New Gem** – 617–619 N Duncan St
50 **New Preston** (Flaming Arrow) – 1108 E Preston St*
51 **Northway** – 6701 Harford Rd*
52 **Northwood** – 1572 Havenwood Rd
53 **Orpheum** – 1724 Thames St*
54 **Paradise** – 1727 Fleet St*
55 **Parkway** (Five West) – 5 W North Ave*
56 **Pic** (Crown/Imperial/Roy) – 756 Washington Blvd
57 **Playhouse** (Homewood) – 9 W 25th St*
58 **Plaza** (Lubin's) – 404–406 E Baltimore St
59 **Regent** – 1601 Pennsylvania Ave
60 **Rex** – 4617 York Rd*
61 **Ritz** – 1607 N Washington St*
62 **Roxy** (Fayette) – 2239 E Fayette St*
63 **Royal** (Douglass) – 1329 Pennsylvania Ave
64 **Schanze** (Morgan) – 2426 Pennsylvania Ave*
65 **Senator** – 5904 York Rd*
66 **Stanley** (Stanton) – 516 N Howard St
67 **State** – 2045 E Monument St*
68 **Tower** – 222 N Charles St
69 **Uptown** – 5010 Park Heights Ave*
70 **Valencia** – 18 W Lexington St
71 **Walbrook** – 3100 W North Ave*
72 **Waverly** – 3211 Greenmount Ave
73 **West End** – 1601 W Baltimore St*
74 **Westway** – 5300 Edmondson Ave*

[1] AT RISK OF DEMOLITION AS OF 2017
[2] LANDMARK HARBOR EAST AND CINÉBISTRO ARE NOT PROFILED IN THIS BOOK.
*RETAINS ARCHITECTURAL ELEMENTS

More than a century of movies in Baltimore ...

From 1898, at least 243 movie theaters have operated in the city, peaking at an estimated 129 in 1916. By 2017, only 5 remain.

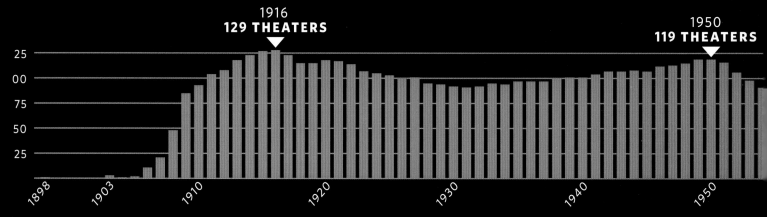

1916
129 THEATERS

1950
119 THEATERS

NOTE: TIMELINE DOES NOT INCLUDE VENUES THAT SCREENED MOVIES SPORADICALLY, OUTDOOR THEATERS THAT PROLIFERATED IN THE EARLY 1900s, OR CARLIN...

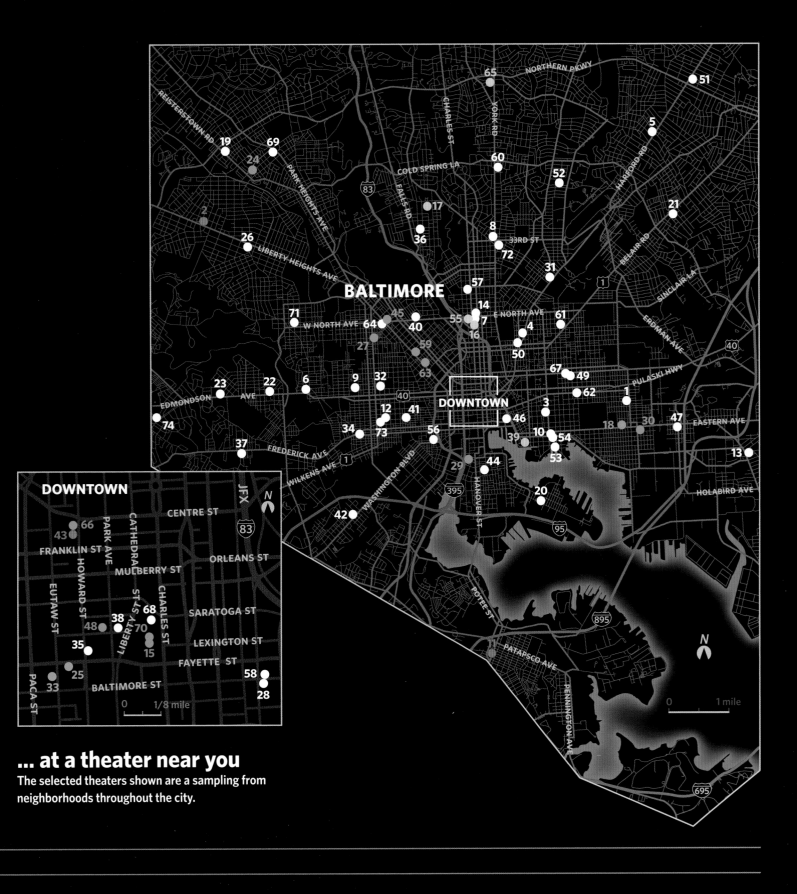

NORTHERN PKWY

65 51

REISTERSTOWN RD 5

CHARLES ST YORK RD HARFORD RD

19 69 60

24 52 21

83 COLD SPRING LA

2 FALLS RD 8 33RD ST BELAIR RD SINCLAIR LA

26 17 ERDMAN AVE 40

LIBERTY HEIGHTS AVE 36 72 31

BALTIMORE 57

71 45 14 E NORTH AVE 61

W NORTH AVE 64 55 7 4

27 40 16 50 67 49 PULASKI HWY

59 62 1

23 22 6 9 32 63 3 18 30 47 EASTERN AVE

EDMONDSON AVE 63 40 **DOWNTOWN** 46 10 54 13

74 12 41 39 53

34 73 56 44 HOLABIRD AVE

37 FREDERICK AVE 1 29 HANOVER ST

WILKENS AVE WASHINGTON BLVD 20

42 395 95

DOWNTOWN JFX *N*

CENTRE ST 83

66

43 FRANKLIN ST PARK AVE CATHEDRAL ST ORLEANS ST

MULBERRY ST

HOWARD ST ST PAUL ST SARATOGA ST

EUTAW ST 48 38 68 LEXINGTON ST

35 70 FAYETTE ST

25 15 58

33 PACA ST BALTIMORE ST 28

0 1/8 mile

PATAPSCO AVE *N*

PENNINGTON AVE POTEE ST 895

0 1 mile

695

... at a theater near you

The selected theaters shown are a sampling from
neighborhoods throughout the city.

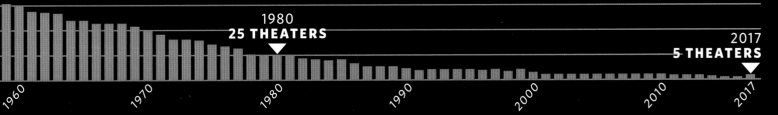

1980
25 THEATERS

2017
5 THEATERS

1960 1970 1980 1990 2000 2010 2017

HISTORICAL DATA FROM *MOTION PICTURE EXHIBITION IN BALTIMORE* BY ROBERT K. HEADLEY LUCIDITY INFORMATION DESIGN, LLC

NOTES ON RESEARCH

My principal resource for researching the history of Baltimore's theaters was Robert K. Headley's *Motion Picture Exhibition in Baltimore: An Illustrated History and Directory of Theaters, 1895–2004* (Jefferson, NC: McFarland & Company, 2006). His other books on the subject, including the self-published *Exit* (1974) and *Maryland's Motion Picture Theaters* (Charleston, SC: Arcadia Publishing, 2008), also proved invaluable.

When I could not find information from other primary sources or discovered conflicting facts, I usually deferred to *Motion Picture Exhibition in Baltimore* as the final arbiter. I am particularly indebted to Headley's exhaustive research for information about seating capacities for each theater, an ever-changing and elusive, but important, descriptive detail. I also drew heavily from his work for attribution of the architects for the neighborhood theaters. His rich theater descriptions, combined with his narrative of the evolution of the movie theater business, informed my thinking at every stage.

Newspapers were a key source of information on theater openings, legal battles, and trends. My dedicated colleague at the *Baltimore Sun*, librarian Paul McCardell, gave me many pointers as I tackled various research challenges. I relied extensively on the *Sun*, but also consulted the *Afro-American Newspapers*, the *Evening Sun*, and the *Baltimore News-Post*. Newspaper movie listings and advertisements were another reminder of Baltimore's segregation, as the only source for information on African American theaters was in the *Afro-American*. Other essential reference works were R. L. Polk & Co.'s Baltimore City Directories, later city directories, and Sanborn Insurance Maps.

For information about the early days of film exhibition, I turned to the extraordinary online database of the Media History Digital Library, hosted by the Internet Archive. Through this site, industry publications such as *Exhibitors Herald, Motion Picture News, Motography,* and *Moving Picture World* offered fascinating details about the silent film era. The *Film Daily Yearbook of Motion Pictures* and *Motion Picture Herald* carried news of Baltimore from the 1920s through the early 1960s. The digital vaults of *BoxOffice* and *Variety* also contained useful material. In addition, the old-fashioned vertical files at the Theatre Historical Society of America and the Enoch Pratt Free Library provided articles that would otherwise have been missed.

Kilduffs, an admirable compendium of Baltimore theaters created by Thomas Paul (kilduffs.com/ MdTheatreIndex.html), and *Cinema Treasures*, a national website (cinematreasures.org), were both helpful for the photos, ads, and comments posted by theater buffs. The *Internet Movie Database* (imdb.com) was a convenient source for film release dates and other movie facts.

The profiles of each theater were developed through archival research, scrutiny of countless databases and websites, and vibrant oral histories gathered from more than 320 interviews. I am grateful for the patient assistance of the staffs at the Maryland Room of the Enoch Pratt Free Library and the Maryland Historical Society. Jenny Ferretti, the former digitization coordinator for the beautiful photo collection at the Maryland Historical Society, was particularly helpful.

The BGE Collection, at the Baltimore Museum of Industry, and the DPW collection, at the Baltimore City Archives, yielded a great number of vintage photographs. Thanks to archivist Matt Shirko, former archivist Catherine Scott Dunkes, and Jane D. Woltereck, director of collections, for welcoming me into the deep recesses of the archives at the Baltimore Museum of Industry. Jerry Kelly and the other knowledgeable volunteers at the Baltimore Streetcar Museum were a delight to spend time with as I delved into their unique photo library.

At the University of Maryland Libraries, College Park, Ann Hanlon, Joanne Archer, Amber Kohl, and other staffers guided me through the vast *Baltimore News-American* photo archive. Under chief curator Thomas Beck, the excellent Special Collections staff at the Albin O. Kuhn Library, including Susan Graham, Lindsey Loeper, and Robin Martin, helped me navigate the Hughes and *Baltimore Sun* photo collections at the University of Maryland, Baltimore County. On behalf of Baltimore Sun Media Group, Marilyn Schnider kindly granted permission to reproduce the paper's photos and articles. At the AFRO-American Newspapers Archives and Research Center, Shelia Scott and former director Ja-zette Marshburn accommodated several research requests. Web Phillips connected me with the remarkable legacy of images his grandfather, I. Henry Phillips Sr., produced in the African American community.

As a recipient of the 2013 Thomas R. DuBuque Research Fellowship, sponsored by the Theatre Historical Society of America, I spent four magical days immersed in the Society's extensive archive, then located in Elmhurst, Illinois. Archivists Kathy McLeister and Patrick Seymour helped me discover much-needed material not available in Baltimore.

In addition to public archives, a number of private collectors were exceptionally accommodating about sharing their impressive collections of theater-related photographs and ephemera. I am beholden to Cezar Del Valle, Robert K. Headley, Stuart Hudgins, William Hollifield, Jacques Kelly, Thomas and Pat Paul, Russ and Jane Sears, and John Sipes for their preservation efforts and generosity.

I gleaned much information about the Durkee circuit through photographs that Frank Durkee III and Paul Wenger both had the foresight to save. My thanks also extend to others connected to the movie exhibition business through relatives, such as Brent Baron, Lynn Hollyday Battaglia, Shoshana Shoubin Cardin, Ross Freedman, Lynn Gittings, Catherine Graham, Frank Hornig III, Virginia L. Ingling, Bobby Klein, Sylvia Piven, M. Robert "Bob" Rappaport, Bill Schanberger, Emily Spanos, and Mark and Rick Wagonheim for sharing precious photographs and documents.

Author and civil rights historian Taylor Branch and law professor and author Larry S. Gibson helped me place the Northwood Theater desegregation battle in the proper historical context. My research was also enriched by theater-related material bestowed by other interview subjects, including Bob Adams, Billy Colucci, James "Buzz" Cusack, Owen Fuqua, Marty Hunovice, Chuck Kaczorowski, Linda Lapides, Ira Miller, Alan Nethen, McCarl "Mac" Roberts, and Mark Walker. In addition, my picture hunt led me to Jennifer B. Bodine, Michael Cusimano, Michael Grady, Anne Gummerson, Richard Haines, Norman James, and Charles and Pat Wrocinski, who all graciously made their historic photographs available. Rob Moore let me peruse fascinating scrapbooks from the Empire and Don Strathy shared rare posters from the Pic. Joan Schoppert offered her mother's delightful diary, which provided a vivid picture of movie-going in the 1930s.

TEXT CREDITS

Excerpts from the *Sun*, the *Evening Sun*, and the Sunday *Sun* magazine's "I Remember When" column are used courtesy of *The Baltimore Sun*. All rights reserved.

The excerpt by Earle Silber on the Fulton Theater is used with Dr. Silber's permission from his memoir, *The Baker's Son: Tales of My Baltimore Childhood* (McLean, VA: Miniver Press, 2013).

FILM DIALOGUE CREDITS

Some of the film dialogue that opens each chapter was selected from *The Dictionary of Film Quotations*, by Melinda Corey and George Ochoa (New York: Crown Trade Paperbacks, 1995), and *The Movie Quote Book*, by Harry Haun (New York: Lippincott & Crowell, 1980).

Chapter One: 1896–1909
Avalon (1990): Barry Levinson, screenwriter
© 1990 TriStar Pictures, Inc. All rights reserved.
Courtesy of TriStar Pictures

Chapter Two: 1910–1914
The Cat and the Canary (1939): Walter DeLeon and Lynn Starling, screenwriters
NBC Universal

Chapter Three: 1915–1919
City Lights (1931): Charles Chaplin, screenwriter
Used with permission of Roy Export SAS.

Chapter Four: 1920–1924
Summer of '42 (1971): Herman Raucher, screenwriter
Courtesy of Warner Bros.

Chapter Five: 1925–1929
The Jazz Singer (1927): Alfred A. Cohn, screenwriter
Courtesy of Warner Bros.

Chapter Six: 1930–1939
How Green Was My Valley (1941): Philip Dunne, screenwriter
Twentieth Century Fox Film Corporation

Chapter Seven: 1940–1949
The Best Years of Our Lives (1946): Robert E. Sherwood, screenwriter
Samuel Goldwyn Jr. Family Trust

Chapter Eight: 1950–2017
Green Mansions (1959): Dorothy Kingsley, screenwriter
Courtesy of Warner Bros.

INDEX OF CONTRIBUTORS

INDEX OF THEATERS

9 8 7 6 5 4 3 2 1

Johns Hopkins University Press
2715 North Charles Street
Baltimore, Maryland 21218-4363
www.press.jhu.edu

All color photographs by Amy Davis.
Book design and cover by Maia Wright.

Endpapers: Ticket stubs. Courtesy of the Robert K. Headley Theatre Collection and Owen Fuqua. *Pages ii–iii:* Inside the decaying Mayfair Theater, 2013. *Page vi:* View from the Parkway Theater stage before renovation, 2012. *Page viii:* Housing for a Peerless carbon-arc projector at the former Carlton Theater, 2012. *Page xi:* Ambassador and Gwynn theaters, Liberty Heights Avenue, c. 1947. Courtesy of the Baltimore Streetcar Museum. *Page 288:* Plaster ceiling fragments from the Ambassador Theater, 2010. *Page 290:* Motion picture film found among the debris at the Parkway Theater, 2013. *Page 301:* Nature reclaims the Mayfair Theater, 2013.

Library of Congress Cataloging-in-Publication Data

Names: Davis, Amy, 1956– author.
Title: Flickering treasures : rediscovering Baltimore's forgotten movie
 theaters / Amy Davis.
Description: Baltimore : Johns Hopkins University Press, 2017. |
 Includes bibliographical references and index.
Identifiers: LCCN 2016028461| ISBN 9781421422183 (hardcover :
 alk. paper) | ISBN 9781421422190 (electronic) | ISBN 1421422182
 (hardcover : alk. paper) | ISBN 1421422190 (electronic)
Subjects: LCSH: Motion picture theaters—Maryland—Baltimore. |
 Baltimore (Md.)—Buildings, structures, etc. | Baltimore
 (Md.)—History.
Classification: LCC NA6846.U62 B353 2017 | DDC 725/.82309097526—
 dc23
LC record available at https://lccn.loc.gov/2016028461

A catalog record for this book is available from the British Library.

Special discounts are available for bulk purchases of this book.
For more information, please contact Special Sales at 410-516-6936
or specialsales@press.jhu.edu.